# Color and Its Reproduction

by
Gary G. Field

Graphic Arts Technical Foundation
4615 Forbes Avenue
Pittsburgh, Pennsylvania    15213-3796
United States of America
Telephone: 412/621-6941
Fax: 412/621-3049

# Contents

# Dedication

Williamson Printing Corporation is honored to participate in producing this book, *Color and Its Reproduction,* for the Graphic Arts Technical Foundation. We have been members of GATF for years and have used many of their products and services. We have continuously availed ourselves of GATF Technical Plant Audits, which has helped to make us a better printer and better serve our clients needs.

Since GATF has been most instrumental in the education and training areas, and in the research and technical areas of the printing industry for so many years, we feel that we have an obligation to help GATF continue its fine work by giving something back to the industry. The opportunity to print this book is an expression of our appreciation for the good work of GATF. It is our pleasure to make this gift to GATF and the printing industry.

Jerry Williamson
Chairman of the Board
Williamson Printing Corporation

# Preface

The purpose of this book is to provide a fundamental understanding of color and color reproduction as it applies to the printing and related industries. It is not intended as a "how-to-do-it" book, but rather, covers the material essential to making informed judgments about color reproduction.

*Color and Its Reproduction* is written for all those involved in the process of color reproduction, including designers, art directors, technologists, skilled craft workers, technical management, and sales personnel. It is hoped that this text will provide individual readers with a deeper understanding of their particular field of expertise, and, more importantly, an appreciation of the interrelated nature of all stages in the color reproduction process.

Students of printing technology will find this book to be a useful introduction to issues that they may study in depth through the sources listed in the bibliography. The book should also be of particular value to graphic design students, as it describes the printing characteristics that influence how their artwork will appear when reproduced.

A number of key people provided expert advice to the author in organizing and writing this book. In particular, George W. Jorgensen, retired supervisor of the Physics and Quality Control Division of the GATF Research Department, provided many hours of discussion on the theory and practice of color reproduction as well as specific advice on the organization of this text. Frank M. Preucil, also retired from GATF, supplied some of the historical information for Chapter 1.

A former associate of GATF, Bruce E. Tory, now a consultant and the retired technical director of Leigh-Mardon Pty. Ltd., of Sydney, Australia, together with Richard D. Warner, assistant director of research at GATF, provided a technical review of the original manuscript. Donald R. Voas, manager of graphics technology for the James River Corporation of Neenah, Wisconsin, and also a former associate of GATF, reviewed Chapters 1–5. Lloyd P. DeJidas, GATF production director, also reviewed Chapter 5. Many of the reviewers' suggestions were adopted for the final version, but any errors or omissions are the responsibility of the author.

Editorial direction for this project was provided first by Charles Shapiro for the outline, and then by Raymond N. Blair and Thomas M. Destree for the manuscript. Patricia S. Farner

and Bonetta D. Winters edited the manuscript, and Matthew E. Spangler produced many of the illustrations. Frank V. Kanonik was responsible for much of the photography.

Several companies and individuals generously provided photographs and other materials to help illustrate the text. Their contributions are noted where they appear.

The author expresses his thanks to these persons and all others who have been directly or indirectly involved in the production of this publication. He also extends his special thanks to his wife, Mary Ann Ashcroft, whose patience, encouragement, and editorial advice did much to make this project a reality.

Gary G. Field

San Luis Obispo, California
1986

# 1 Introduction

Before embarking on a detailed study of the individual technologies and materials that are used for color reproduction, it is useful to review the theoretical and historical background of this complex process.

In the following section, a brief history of color reproduction, with emphasis on printed color reproductions, is presented. Television and photography are also reviewed because of the importance of these technologies to today's color scanning and proofing processes. Basic explanations of how these color reproduction systems work are also included.

Apart from color reproduction itself, the other major thrust of this publication is the visual phenomenon of color. Some elementary color theory is reviewed in this chapter to provide a foundation for the more detailed coverage in later chapters.

Finally, some key concepts from the field of systems engineering are introduced. It has long been the contention of GATF that successful color reproduction requires that each of the stages in the process be thought of as links in a total system. In order to produce high-quality color work, the system elements—such as inks, separations, paper, proofs, and final printing—must be chosen or made while keeping all the other elements in mind. This thought is carried throughout the book.

**Definition of Color Reproduction**

**Color reproduction** can be defined as an optical process of producing a close color representation of some original scene or object. Photography, electronics, and the physical transfer of a colorant to a substrate may each play a role in this process, depending on the form of the reproduction. In a broad sense, the process includes making photographic transparencies and prints, television images, and printed reproductions.

The reproduction of artwork (or other intermediate images) fits the above definition. However, the production of an original series of artistic prints obtained, for example, from a lithographic stone or by the screen printing process, is not counted as color reproduction. The mass production of such color images as flat-color soap wrappers is not color reproduction; it is, however, covered in this book.

**Short History of Color Reproduction**

The first-known color reproduction was demonstrated by the Scottish physicist James Clerk Maxwell. Maxwell photographed a scene three times, once through a red filter, once through a green filter, and once through a blue filter. These black-and-white negatives were each contacted to produce positives that were each mounted as lantern slides. Each slide was placed in a

different projector and the three images focused together, in register, on a screen. Red, green, and blue filters were placed over the lenses of the respective projectors that contained the red, green, and blue positive images of the scene.

The exact date of Maxwell's first color photograph is not clear. He first published details of how to make a trichromatic reproduction in the *Transactions of the Royal Society of Edinburgh* during 1855. A well-publicized demonstration of this technique was made on May 17, 1861, at the Royal Institution of Great Britain in London. However, there is evidence that Maxwell demonstrated color photography for the first time during a lecture to the Royal Society in 1859. The 1859 demonstration used four color separation positives. In addition to the red-, green-, and blue-filter separations, a yellow-filter separation was made. All four separation positives were projected in register through the same filters that were used to make the separation negatives. It is not known why Maxwell used the yellow-filter separation. Presumably, it was used to help improve the color rendition of the photograph. This was no doubt required because of the lack of emulsions that were sensitive to all colors.

Therefore, it is likely that the first color photograph was that demonstrated in 1859 by Maxwell. This was made by projecting *four* positives in register through the appropriate filters. The focus of the 1861 demonstration was Thomas Young's theory of color sensation rather than color photography, thus accounting for the use of *three* color separation positives.

The first single film image for color photography was patented in France by Louis Ducos du Hauron in 1868. In his system, the image on a black-and-white panchromatic emulsion was broken up by a series of red, green, and blue transparent dots or lines that formed a screen in front of the emulsion. The dots and lines were so small that they could not be resolved by the eye. After exposure, the film was reversal-processed to yield a colored positive transparency. This additive-color transparency principle eventually found commercial application with such processes as the Lumière Autochrome process of 1908 (a random pattern of red, green, and blue grains), the Finlay plate of 1908 (a ruled red, green, and blue screen), and the Dufay process (printed red, green, and blue screen) of 1935. The additive-color transparency was reintroduced in 1983 by Polaroid Corporation with their 35-mm Polachrome slide process.

It was also du Hauron who pioneered development of the subtractive color system. The first book on color photography, titled *Les Couleurs en Photographie: Solution du Probleme,* was published by du Hauron in 1869. He suggested making separation negatives through red, green, and blue filters, then making positive transparencies from each, and dyeing them with colors that absorb each respective primary (i.e., cyan, magenta, and yellow). The two systems that received widespread popularity were the carbro process (1925) and the imbibition methods first applied in 1925 by Jos Pé. The imbibition methods include the Technicolor process and the dye transfer process.

The subtractive methods described were difficult to use because they required the accurate registration of the colored positives (carbro) or the accurate registration of images from dyed positive matrices (imbibition processes). The solution was a three-emulsion film, each layer made sensitive to a different color (red, green, or blue) and then dyed a different color (cyan, magenta, or yellow) in processing. The first successful film of this type was Kodachrome, introduced by Eastman Kodak Company in 1935. This film used a complex processing cycle that involved processing each emulsion separately (although on a common support). The I.G. (Interessen Gemeinschaft, now Agfa-Gevaert) Agfacolor process of 1936 used color couplers within the emulsion, which made possible a much simpler processing procedure. Both these films were reversal materials, the first color negative material being Kodacolor, introduced by Eastman Kodak Company in 1942. The most recent major development in color photography was the Polaroid Corporation Polacolor "instant" system of 1957.

Early experiments with color television resulted in the development of the successive frame method, where a rotating red-, green-, and blue-filter wheel was placed over the lens of the television camera. This produced successive red, green, and blue color separation images. A similar filter wheel in the receiver was rotated in synchronization with the frames. The result was a full-color television picture. The Columbia system was standardized in 1950 by the Federal Communications Commission (FCC) for use in the United States. The system was not widely used, and subsequently the FCC set aside its 1950 decision and approved the National Television Systems Committee (NTSC) system in 1953.

This system uses three receptor cameras and in the receiver three electron guns, a shadow mask, and a screen consisting of

a mosaic of red, green, and blue phosphors. The NTSC system was followed by the German PAL system. Another refinement was the French SECAM system, introduced in 1967. All three systems have many common features. The tube phosphors and shadow masks have developed from a series of red, green, and blue dots to red, green, and blue strips, but otherwise the basic technology of the system remains little changed.

The first use of color in printing dates back to the fifteenth century. This use was generally restricted to solid colors for decorative purposes. It wasn't until the early eighteenth century, when Jacob Christoph Le Blon introduced what can be described as the first form of halftone three-color printing. Le Blon, who was influenced by the work of Isaac Newton, chose yellow, red, and blue inks as his primary colors. These inks were the forerunners of today's yellow, magenta, and cyan colors. The halftone effect was obtained by using the mezzotint technique to hand-engrave copper plates. The first specimen prints produced by this process were made about 1704.

Le Blon, of French extraction, was born in Germany in 1667. His process was not a success in Europe, so he moved to London in 1719. It was in England where the three-color printing process became an artistic success, but for a variety of reasons, Le Blon was not financially successful. In 1722, he published details of his work in the publication entitled *Coloritto, or the Harmony of Colour in Painting.*

In 1735 Le Blon moved to Paris, where he is believed to have used a black plate as a key for the colors.

Le Blon was the founder of process-color printing; the only major difference from modern techniques was that he had to engrave his plates by hand copying, whereas the copying and engraving are done today by photomechanical techniques.

The nineteenth century saw the successful commercial use of chromolithography (1819), wood-block color printing (1823), and stencil printing. Many other processes and variants were introduced during this century; while they are all examples of process-color printing, they generally do not fit our definition of color reproduction. They were all hand methods and could be best classified as original color prints rather than reproductions, although some were produced as copies of original paintings.

From about 1870 on, major developments were made that laid the foundation for today's color printing processes. In 1869, du Hauron made a crude three-color reproduction by

lithography using a photomechanical process. No screen was used, and the tonal gradation relied on the grain of the original subject, the photographic emulsion, and the lithographic stone. A major breakthrough for color reproduction came in 1873 when Professor Hermann W. Vogel of Germany developed improved color-sensitive photographic emulsions.

In 1881, Frederick E. Ives of Philadelphia patented the halftone screen, which allowed him to develop and exhibit the first example of trichromatic halftone color printing at the Novelties Exhibition in Philadelphia in 1885. Max Levy of Philadelphia succeeded in 1890 in developing a precision manufacturing process for these screens.

The first commercial photoengraving was probably that produced by William Kurtz during 1893 in New York. Kurtz developed this process with Ernst Vogel, the son of Hermann Vogel.

A reproduction of the first commercial halftone color reproduction

The original was produced by William Kurtz in New York for *The Engraver and Printer* of Boston in 1893. It used single-line screens and employed three colors.

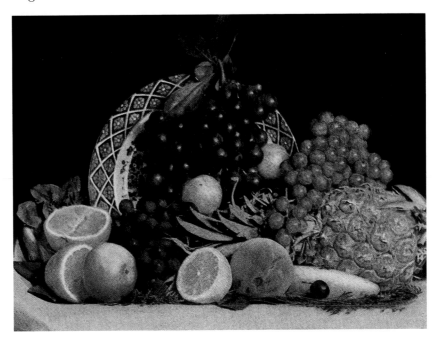

Dr. E. Albert and H. Ulrich of Germany are credited with first using the four-color photomechanical process. A patent was issued in 1899 to Albert for undercolor removal and the use of the black printer. The four-color process initially proved to be more popular in the U.S. than in Europe, but today virtually all process-color printing is in four colors. The use of the black helped to achieve neutrals as well as to increase the picture contrast.

Printed color reproduction grew rapidly in popularity in the late nineteenth and early twentieth centuries to today, when (excluding newspapers) the great bulk of all pictorial reproduction is in color. The basic principles of photomechanical color reproduction remain the same today as they were in 1900, but there have been many important advances over the years that have led to improved quality and lower costs.

A major achievement in color reproduction was the development of photomechanical color-masking techniques. The first of these was patented by Dr. E. Albert in 1900. Over the years about 100 masking patents have been issued, all with the objective of correcting the unwanted color absorptions of the process inks, in particular, magenta and cyan. For a variety of reasons, these processes did not become popular until developmental and educational efforts by Alexander Murray of Eastman Kodak and Frank Preucil of the Lithographic Technical Foundation made masking very common in the United States. These techniques resulted in greatly reduced time and costs, as compared to the laborious hand retouching methods.

The original pigments used in printing inks were mainly inorganic pigments that had a restricted gamut, and, in some cases, poor transparency. The development of organic pigments increased the available color gamut while still retaining reasonable permanence. The major developments were as follows:

- The azo colors for ink manufacture developed between 1899 and 1912. Most yellow pigments are of this class.
- The discovery of the tungstated and molybdated pigments in about 1914. The best process magentas fall into this class.
- The discovery in 1928 of phthalocyanine pigments, which made possible the first really permanent brilliant cyan suitable for process-color printing.

The most recent major development in color reproduction was the development of the electronic color scanner. The first machines were developed in the late 1930s by Arthur C. Hardy of the Massachusetts Institute of Technology together with F. L. Wurzburg, Jr. of the Interchemical Corporation, and by Alexander Murray and Richard C. Morse of the Eastman Kodak Company. The Kodak scanner was further developed into the first commercial scanner—the Time-Springdale scanner of 1950. The first commercial color separations to be produced by a scanner were printed in *Life* and *Fortune* magazines during 1949. Now the majority of all color

separation films are produced on color scanners. Their use has resulted in faster, more predictable color separations. Less film is needed than with photographic systems and the operator has more control over the separations.

Other developments that led to greater use of process-color printing included the four-color press. The first recorded use of a four-color lithographic sheetfed press was by the Traung Label and Lithograph Company of San Francisco, California, during early 1932. This offset press was made by the Harris-Seybold-Potter Company of Cleveland, Ohio (now Harris Graphics). Four-color web offset presses preceded sheetfed presses. In 1926 the Melbourne, Australia, daily newspaper *The Argus* installed the German-built Vomag web offset machine that had four perfecting printing units. This press was used to print weekly color supplements and magazines. The Berlin, Germany, company of Messrs. Dr. Selle and Company were reported as printing four-color work by web offset in 1926.

The Cottrell Company reportedly made a four-color common impression cylinder rotary letterpress sheetfed machine about 1912, but the thick letterpress ink films made wet-on-wet process-color work impractical.

The first three-color intaglio prints were produced on a web machine at Siegburg in 1914. A common impression cylinder was used on this machine. Around the same time, a multiunit Goss intaglio press was installed at *The Chicago Tribune*. This machine had separate-unit type construction for each color. However, it is thought that the first successful gravure process four-color work on a multicolor machine was not produced until the late 1920s or early 1930s, probably on a machine made by the Albert Company.

## Light and Color

To understand the process of color reproduction, it is first necessary to gain an appreciation of the phenomenon of color. To do this, it is necessary to examine the nature of light, without which color would not exist.

**Light** is radiant energy that is visible to the normal human eye. For the purposes of this discussion it can be assumed that light travels in wave motion, with the color of light varying according to the length of the wave. This wavelength can be measured and classified with other forms of energy on the electromagnetic or energy spectrum, as shown.

The scale ranges from the extremely short waves of gamma rays emitted by certain radioactive materials to the radio waves,

the longest of which can be miles in length. Light, the visible spectrum, ranges from 400 to 700 nm (millionths of a millimeter) in length. Below 400 nm are the ultraviolet rays, which are important when dealing with fluorescent materials. Some materials absorb ultraviolet radiation, which is invisible, and emit radiation that is part of the visible spectrum. Above 700 nm are the infrared rays, which have significance in certain kinds of photography.

The electromagnetic spectrum

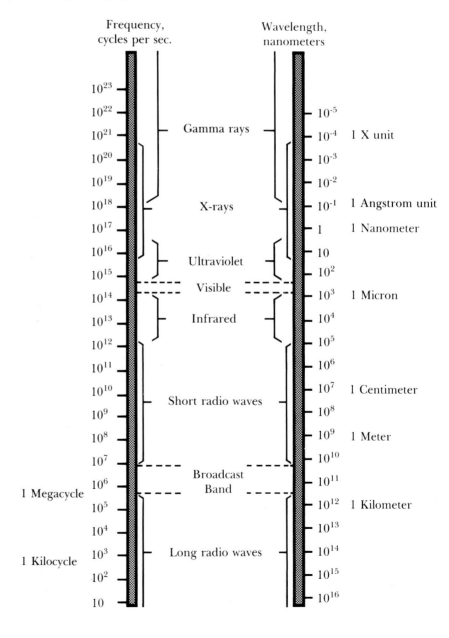

| Frequency, cycles per sec. | | Wavelength, nanometers |
|---|---|---|
| $10^{23}$ | | |
| $10^{22}$ | | $10^{-5}$ |
| $10^{21}$ | Gamma rays | $10^{-4}$   1 X unit |
| $10^{20}$ | | $10^{-3}$ |
| $10^{19}$ | | $10^{-2}$ |
| $10^{18}$ | X-rays | $10^{-1}$   1 Angstrom unit |
| $10^{17}$ | | 1   1 Nanometer |
| $10^{16}$ | | 10 |
| $10^{15}$ | Ultraviolet | $10^{2}$ |
| $10^{14}$ | Visible | $10^{3}$   1 Micron |
| $10^{13}$ | Infrared | $10^{4}$ |
| $10^{12}$ | | $10^{5}$ |
| $10^{11}$ | | $10^{6}$ |
| $10^{10}$ | Short radio waves | $10^{7}$   1 Centimeter |
| $10^{9}$ | | $10^{8}$ |
| $10^{8}$ | | $10^{9}$   1 Meter |
| $10^{7}$ | | $10^{10}$ |
| $10^{6}$ | Broadcast | $10^{11}$ |
| 1 Megacycle   $10^{5}$ | Band | $10^{12}$   1 Kilometer |
| $10^{4}$ | | $10^{13}$ |
| $10^{3}$ | Long radio waves | $10^{14}$ |
| 1 Kilocycle   $10^{3}$ | | |
| $10^{2}$ | | $10^{15}$ |
| 10 | | $10^{16}$ |

The visible spectrum occurs in nature as a rainbow. It can be duplicated easily in a laboratory or classroom by passing a narrow beam of white light through a glass prism. The spectrum appears to be divided into three broad bands of color—blue, green, and red—but in fact is made up of a large number of colors with infinitesimal variations between 400 and 700 nm. The colors in the spectrum are physically the purest colors possible. The splitting of white light into the visible spectrum, and the recombining of the spectrum to form white light, was first demonstrated and reported by the English scientist Sir Isaac Newton in 1704.

The visible spectrum

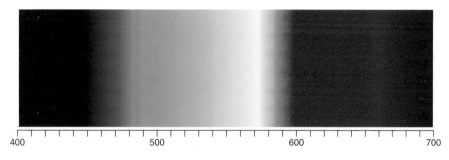

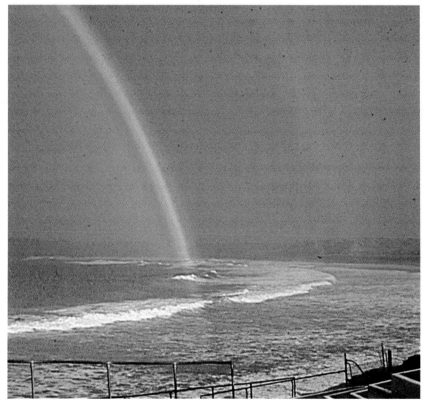

A double rainbow, Phillip Island, Victoria, Australia

The primary rainbow is on the bottom, the secondary on top. The area between the two rainbows is Alexander's dark band.

The reason that a spectrum can be formed by passing white light through a prism has to do with the refraction of light as it passes from one medium (air) to another (glass). The prism bends light of the shorter wavelengths more than light of the longer wavelengths, thus spreading the light out into the visible spectrum, as shown. Drops of rain act in a manner similar to a prism when a narrow beam of sunlight breaks through the clouds to form a rainbow as the beams are refracted by moisture in the air.

Refraction of a beam of white light by a prism, forming a spectrum

When wavelengths between 400 and 700 nm are combined in nearly equal proportions, we get the sensation of **white** light. But the human eye is very flexible on this point: we often accept the light from a tungsten lamp as white; at other times we accept the light from a cloudless blue sky as white. Clearly, the human eye is very adaptable to different illuminants. For the purposes of graphic arts color reproduction, compromise white light has been defined—a specification needed to help minimize color perception and communication problems.

When wavelengths of light are combined in unequal proportions, we perceive new colors. This is the foundation of the **additive-color reproduction process.** The primary colors of the process are red, green, and blue light. In addition to these three colors, secondary colors can be created by adding any

two primaries: red and green combine to give yellow; red and
blue combine to give magenta; and blue and green combine to
give cyan. The presence of all three colors will result in white,
and the absence of all three will produce black. Varying the

Additive color
combinations

Red + Green = Yellow
**R + G = RG**

Red + Blue = Magenta
**R + B = RB**

Green + Blue = Cyan
**G + B = GB**

Red + Green + Blue = White
**R + G + B = RGB**

The principles of
additive color
reproduction

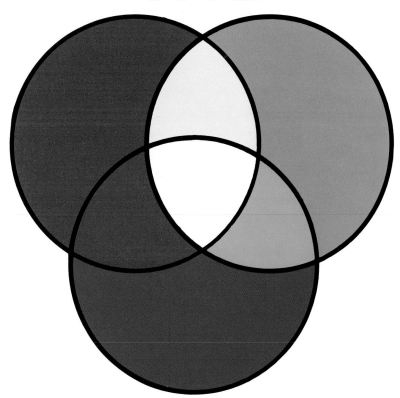

intensity of any or all of the three primaries will produce a
continuous shading of color between the limits. This is the
principle of color television, which can be readily observed by
examining the red, green, and blue mosaic on the screen with a
magnifying glass.

The red-, green-,
and blue-filter
mosaic of a color
television screen

The drawback with the additive-color reproduction system is that it needs high-intensity illumination in order to produce whites and colors of acceptable lightness. Television systems do not have the problem of low lightness values because self-luminous sources make up each element of the picture. The overall luminosity of these elements can be simply adjusted by the controls for contrast and/or brightness. Also, television is usually viewed in a darkened room, thus creating the illusion of greater luminosity in light tones because of the increase in contrast.

Transparency photographs made by the additive process appear to be low contrast because of the limitations of having a red, green, and blue filter in the whitest areas, a relatively low maximum density, and practical restrictions on how intense the viewing light source can be. Reflection color photographs and color printing cannot be produced by the additive process. (Red, green, and blue rotating reflection disks are often used to illustrate the principles of additive-color reproduction, but it is necessary to illuminate the disk with an extremely intense light to achieve satisfactory results.)

The limitations of the additive process can be overcome with the **subtractive process.** The additive system starts with black (a blank TV screen, for example) and adds red, green, and blue to achieve white. By contrast, the subtractive system starts with white (for example, white paper illuminated by white light) and subtracts red, green, and blue to achieve black.

The subtraction of red, green, and blue is achieved by using colorants that are their opposites. For red, this is a color that is made up of blue and green (i.e., minus red), which is called cyan. For green, this is a color that is made up of red and blue (i.e., minus green), which is called magenta. For blue, this is a color that is made up of green and red (i.e., minus blue), which is called yellow.

Colors are achieved by subtracting light away from the white paper (which reflects red, green, and blue). For example, a combination of yellow (minus blue) and cyan (minus red) will result in green. The accompanying table shows the possible combinations.

Subtractive color combinations

White + Yellow + Cyan = Green
**RBG − B − R = G**

White + Magenta + Cyan = Blue
**RGB − G − R = B**

White + Magenta + Yellow = Red
**RGB − G − B = R**

White + Yellow = Yellow
**RGB − B = RG**

White + Magenta = Magenta
**RGB − G = RB**

White + Cyan = Cyan
**RGB − R = GB**

White + Yellow + Magenta + Cyan = Black
**RGB − B − G − R = 0**

Any color in between the limit, or gamut, colors may be obtained by varying the proportion of any or all of the colorants. The subtractive color principle is used for most modern color photography and all color printing processes. The following illustrations depict this technique.

Both color television and printing make use of a regular pattern of image elements to create the points in a given

The principles of
subtractive color
reproduction

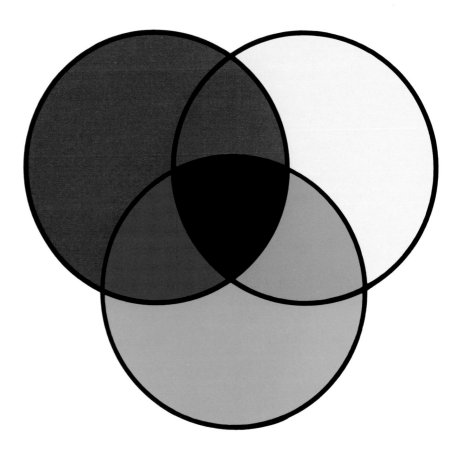

reproduction. For color television, this consists of uniform-size
elements of red, green, and blue that vary in intensity. At a
proper viewing distance the eye does not resolve the individual
elements and essentially mixes the red, green, and blue to form
a composite color.

In color printing, the process is more complex. For most
color printing, the area covered by the yellow, magenta, and
cyan ink varies, but the thickness of ink remains constant.
Unlike television, these colors overlap each other, producing
secondary colors of red, green, and blue. Where all three
primaries overlap we have black, and where no ink is present
we have the white paper. Thus we have as many as eight
separate image elements—white, yellow, magenta, cyan, red,
green, blue, and black. Again, at a proper viewing distance the
eye does not resolve the individual elements but essentially
mixes them to form a composite color.

The overlapping halftone dots of yellow, magenta, and cyan in color printing

## How Color Printing, Photography, and Tele-vision Work

The objective in printing is to produce yellow, magenta, and cyan printing plates that are negative records of the amounts of blue, green, and red in the original. This is achieved by first photographing the original, in turn, through blue, green, and red filters. These films may go through subsequent photographic stages to achieve color and tone correction or to convert the continuous-tone photographic image into a halftone dot image suitable for the given printing process. The films are then used to make the image carriers, which may be plates, cylinders, or stencils. Each plate is inked with its appropriate ink, which is transferred, in turn, to a white substrate.

In printing it is also normal to use a black printer. This is made by photographing the original sequentially through red, green, and blue filters and then following procedures similar to the other colors. The black adds contrast to the reproduction. Because of limitations in the thickness of yellow, magenta, and cyan inks that can be applied to paper, the black printer is usually required to achieve a satisfactory reproduction. The accompanying illustration shows the procedure in schematic form.

In photography, color reproduction is achieved by using three emulsions coated on a common base. Each emulsion is sensitive to a different color, and in processing, each is dyed a corresponding color. The top layer is sensitive to blue light and is dyed yellow, the next layer is sensitive to green light and is dyed magenta, and the bottom layer is sensitive to red light and is dyed cyan. Actually, the second and third layers are also

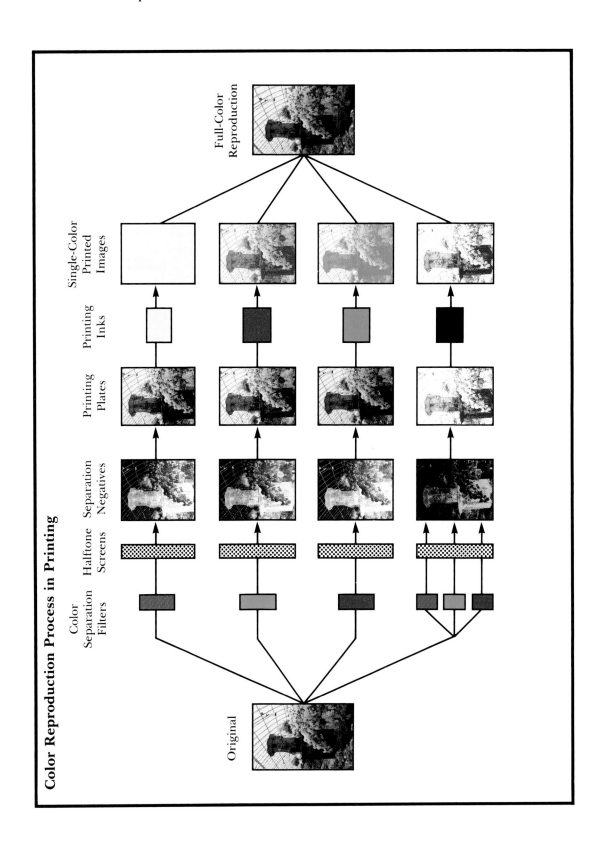

sensitive to blue light, but a yellow filter (which is removed in processing) between the first and second layers stops any blue light from affecting the middle and bottom layers. The foregoing description applies to negative and reversal processes for both reflective and transparent photographs.

The processing of
reversal color film

Original subject represented schematically by color patches.

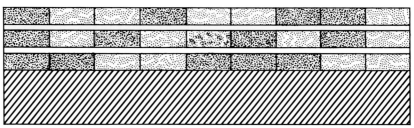

Cross section of color film after the silver halide grains exposed in the camera have been developed to produce negative silver images.

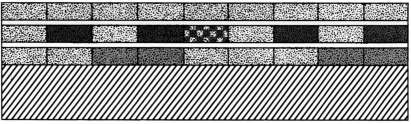

Cross section of color film after the remaining silver halide grains have been exposed to light and developed to produce positive silver and dye images.

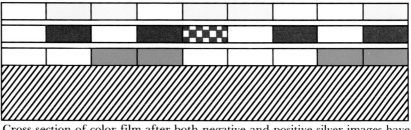

Cross section of color film after both negative and positive silver images have been removed leaving only the positive dye images.

Dye images as they appear when the film is viewed by transmitted light.

Some photographic methods (dye transfer in particular) use methods very similar to printing in order to produce a print. The only differences are that three colors are used, the image is not screened, gelatin matrices are used as image carriers, and dyes replace the inks.

For color television, a special camera is used that scans a scene very rapidly line by line. The light beam that passes through the lens of the camera is split into three by the use of prisms or dichroic mirrors and then passes through red, green, and blue filters. The subsequent light beams are converted into electrical signals by photoconductive materials in the camera tubes. These signals are processed at the studio and then transmitted to the television receivers. The cathode ray tubes of the receivers each contain three cathodes that emit a stream of electrons corresponding to the red, green, and blue signals that make up the image. The electrons strike the red, green, or blue phosphors on the inside face of the tube, causing them to glow; hence, a full-color image is reproduced. Each electron stream is aligned to strike only its respective phosphors.

## A Systems Approach to Color Reproduction

In order for a color reproduction to be successful, there must be control and balance between all the stages in the cycle from the original scene to the final reproduction. This is probably most true in the printing processes because of the large number of imaging stages and the great variation possible with both different input originals and the variety of printing processes and materials that can be used.

In order to exercise control over printed color reproduction, it is necessary to think of it as a system. A **system** can be defined as a group of interrelated elements forming a collective entity. A **control system** is an arrangement of elements connected or related in such a manner as to command, direct, or regulate itself or another system. A **closed-loop control system** is one in which the control action is somehow dependent on the output. Finally, **feedback** is the property of a closed-loop system that permits the output to be compared with the input so that the appropriate control action may be initiated.

In this system there is a *process* that is subject to a disturbing influence and to a restoring influence of a manipulated variable. The process sends information to the controller about its condition. The controller compares the signal of process condition against a desired standard or set point and makes proper adjustment to the manipulated variable in order to restore the process to its desired condition.

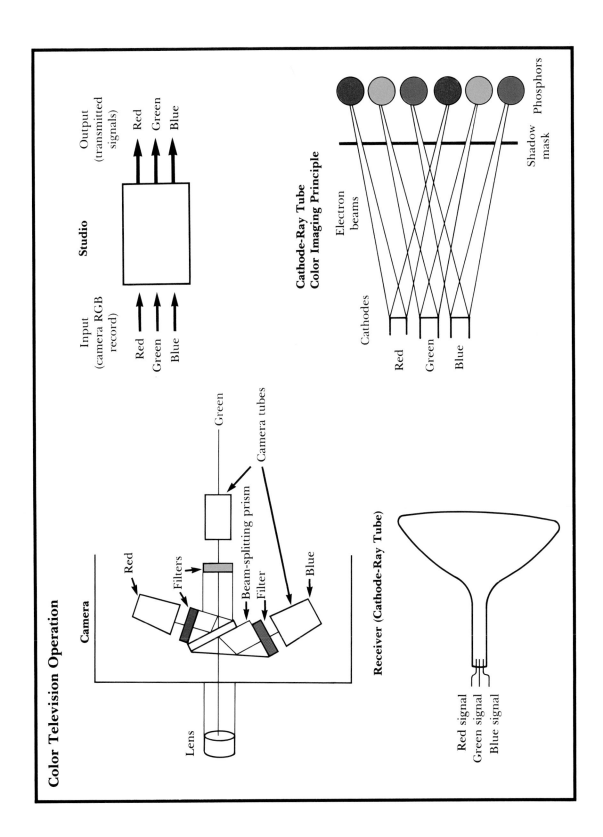

A control system

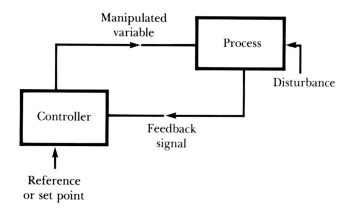

A specific control system can be constructed for the process of color reproduction in the printing industry.

The illustration shows the interrelationship of elements necessary to achieve controlled results in a printing color reproduction system. The process in this system is the combination of the paper, ink, plate (or, more generally, the image carrier), platemaking procedures, and press controls and printing procedures. A general objective is to keep this process constant, and, indeed, this is theoretically possible when a printer is engaged in printing the same kind of product week after week.

Color reproduction control system

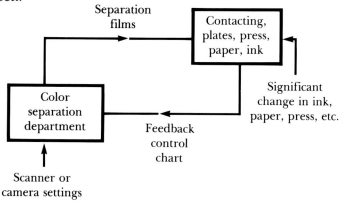

In practice, however, changes or disturbances occur in the process. These could be a change from a coated paper to an uncoated paper, a change in color sequence, a change from a sheetfed press to a web press, or many other similar shifts. Even if these changes do not happen for any given color reproduction system, it is common for a particular plant to produce a variety of color printing using different materials and processes, hence necessitating the establishment of several

color reproduction systems. Of course, the presence of a new system only occurs if the disturbance to the process has been significant. Changing from one brand of coated paper to another probably would not be significant.

The effect of the disturbance on the process is indicated by feedback from the process. This is a printed sheet, which is more useful if it takes the form of a special feedback control chart such as a color chart. If these charts are produced under stable conditions, they represent the absolute tonal and color range of that particular color reproduction system.

The process-color chart, a typical feedback control chart (or signal) in a color reproduction system

The feedback control chart can be interpreted by the *controller,* compared to *standards* or *set points,* and then used as a guide to *manipulate a variable,* which, when fed into the process, compensates for the effects of the disturbance. For the color reproduction system, this involves the camera or scanner operator first assessing the color chart and comparing it against the previous standard printing for any significant deviation in appearance. If, for example, the color chart appears darker than the previous standard, the scanner or camera operator will then manipulate the various controls to produce a set of color separation films that compensate for the darkening effect of the disturbance on the process.

Standard printing, as used in this discussion, means printing conditions for which the color reproduction system has been

previously adjusted. If these conditions remain constant, and if the input originals are also constant, no adjustments to the color separation controls are needed.

In summary, a significant change in the printing process can be indicated by a feedback control chart, which, in turn, can serve as a guide to produce color separation films that will compensate for the effects of this change. Of course, there are some changes in the process for which it is not possible to compensate fully in the color separation stage. For example, if a change is made to an ink set with a much reduced gamut, an adjustment to the separation films can in no way restore that gamut. Also, this discussion ignores the role of the original in the reproduction system. This is done for the purposes of simplicity; a more complete treatment of a systems approach to color reproduction, including the role of original photographs or artwork, is fully discussed in Chapter 8.

# 2 The Perception of Color

**Color** is not simply a physical phenomenon dependent on the sample and illuminant. It is essentially a complex visual sensation, influenced by physiological and psychological factors that probably make one person's perception of color slightly different from another's. To understand the sensation of color, it is necessary to examine the illuminant, the characteristics of the sample, and the human factors, physiological and psychological.

## The Light Source

Printed matter is viewed under all forms of illumination, including tungsten light, fluorescent light, a wide range of daylight and sunlight, and mercury vapor or similar discharge lamps. In addition, color separations are made with such illuminants as pulsed-xenon or tungsten-halogen lamps. The factors that determine the characteristics of illuminants include color temperature, intensity, color rendering properties, and degree of diffusion.

## Color Temperature

The **color temperature** of a light source is a measure of the integrated spectral energy distribution of that source. The standard for measuring color temperature is a black body radiator that is heated. As the heat is increased, the color of the radiator changes from red hot to white hot. The temperature, in degrees Celsius, is recorded for each given energy distribution; hence, a given temperature reading correlates with a particular color. The temperature reading is expressed in the Kelvin (K) scale (the same as the Absolute scale), which equals the Celsius reading plus 273°.

Correlated color temperatures of natural and artificial illuminants

| Natural illumination | Color Temperature (K) |
|---|---|
| Clear blue sky, midday | 12,000–26,000 |
| Overcast sky, midday | 6,700–7,000 |
| Noon sunlight plus light from a clear blue sky | 6,100–6,500 |
| Noon sunlight on a clear day | 5,400–5,800 |
| Sunlight at sunset | 2,000 |
| **Artificial illumination** | |
| Metal halide | 4,300–6,750 |
| Xenon | 5,290–6,000 |
| Carbon arc | 5,000 |
| Fluorescent | 3,000–6,500 |
| Tungsten | 2,650–3,400 |

In practice, most light sources do not duplicate the energy distribution of a black body radiator, so the term **correlated color temperature** is often used to mean the color temperature that most closely resembles the light source in question.

**Color Rendering**   Color temperature alone is not sufficient to specify the effect a given illuminant will have on a sample. The factor of **color rendering** also plays a part. Color rendering is a general term used to express the effect of an illuminant on the color appearance of a sample, based on a comparison to that sample's color appearance under a standard, or reference, illuminant. Many illuminants (especially fluorescent lamps) do not have smooth energy distribution curves but have areas of *spike* or *bar* emission, as shown. To the eye, two given sources with the same color temperature, but different in color rendering, may look identical. However, identical samples illuminated by these sources may result in a different appearance due to the effect on the sample of the spike energy.

Spectral energy distribution curve for a typical fluorescent lamp

Note the area of *spike* or *bar* emission.

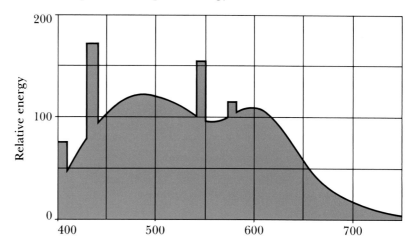

The Commission Internationale de l'Éclairage (CIE) has defined a method of measuring the Color Rendering Index of any given light source. The method basically consists of measuring the color of a series of Munsell chips both with a standard source and the one under test. The differences in the measurements are used to derive the index. The optimal Color Rendering Index (that for continuous sources) is given as 100.

Color rendering index of common artificial illuminants

| Tungsten illuminants | 100 |
|---|---|
| Xenon | 93 |
| Fluorescent | 54–94 |
| Metal halide | 62–88 |

**Intensity and Surround**

It has been reported that the perception of color (especially reds) can change at very low levels of illumination. For normal viewing levels, however, the intensity of the illuminant can be assumed to have no significant effect on the appearance of a *flat color.* The intensity level is critical in the viewing of pictorial subjects such as printed matter and photographs. *The contrast and the saturation of the image will appear to increase with an increase in the level of illumination.*

A related factor is the surround of a pictorial subject. In printing it is commonly white paper, but in photography, especially in a darkened room where slides are being projected, the surround is often black. Problems arise when a comparison is made between transparencies designed to be viewed with a black surround and printed matter designed to be viewed with a white surround.

By varying the intensity and the surround, it is possible to get a transparency to look like a print (and vice versa). Some of these points are discussed further in Chapter 7, "The Objectives of Color Reproduction."

**Diffusion and Viewing Geometry**

Printed matter is often produced on textured paper or other rough surfaces. If a nondiffuse illuminant is used when viewing the printed sample, its appearance will be highly dependent on the geometry of the illumination and viewing conditions. The orientation of the sample is also important. A high-gloss sample is subject to appearance shifts with changes in the viewing geometry. In general, diffuse illumination is always preferred for viewing color reproductions.

In some cases (for example, reproducing an oil painting where it is necessary to capture the texture of the brush strokes), a highly directional nondiffuse light source may be desirable for camera illumination. Illumination for color separation is discussed in more detail in Chapter 10, "Color Separation and Correction."

**Viewing Standards**

It is clear from the above discussion that it is possible to alter the appearance of a color, and especially of a color reproduction, by varying the viewing conditions. The problems for color reproduction become severe if the reproduction and the original are compared under incompatible light sources. **Metamerism,** where two colors may match under one illuminant but not under another, is an additional problem. Even when a print is being evaluated without reference to an original, it is possible that a critic will judge it satisfactory under

one illuminant but unsatisfactory under another. Standard illumination for judging the quality of color reproduction is an obvious answer to these problems.

In the United States, the first color viewing standard for the graphic arts industry was the American National Standards Institute (ANSI) standard ANSI PH2.32-1972. This standard specified the viewing conditions for comparing transparencies [4×5 in. (102×127 mm) and larger] or reflection originals with photomechanical reproductions. The standard also specified the viewing conditions for comparing OK press sheets with the subsequent pressrun. Eleven industry associations recommended the use of the standard, including the American Association of Advertising Agencies, the Association of Publication Production Managers, the Magazine Publishers Association, and the Professional Photographers of America. The printing industry associations and research institutes such as GATF also endorsed the standard.

In 1979 another standard, ANSI PH2.45-1979, was issued for viewing small [35-mm and 2¼-in. (57.2-mm) square] transparencies. The standard specified that the transparencies should be enlarged from four to twelve times for viewing. Most viewers made to this standard enlarge the image six times.

A consolidation of the graphic arts viewing standards (and some from the photographic industry) was approved by ANSI in 1985. This new standard specifies 5,000 K color temperature for all evaluations, and a 90–100 color rendering index for all light sources.

The transparency viewer's surface luminance is specified as $1,300 \pm 300$ cd/m$^2$. Transparencies should be surrounded by a neutral gray border when they are placed on the viewer. The luminance of the surround should be no more than 10% of that of the surface of the illuminator.

For reflection prints and photomechanical reproductions, the illuminance should be $500 \pm 125$ lux for critical appraisal under normal viewing conditions. A provision is also made for a $2,000 \pm 500$-lux level for critical appraisal of dark tones in a print or reproduction. The light source, print, and observer's eyes should be positioned to minimize the amount of light specularly reflected toward the observer. The surround used when evaluating prints should be a matte gray with a reflection density of 0.50 or above. The surround is to extend beyond the print on all sides by at least one-third the print dimension in the same direction. To minimize extraneous influences, room lights, walls, ceilings, and floors are to be baffled so they

Proof being viewed
under standard
lighting conditions

contribute negligible amounts of light to the print-viewing
surface and are not in the observer's field of vision.

The 500-lux level should be used for evaluating the quality
of the printed reproduction. This level of illumination
corresponds to that in a well-lit home, library, or office, thus
representing the conditions under which most people will view
the final reproduction.

The 2,000-lux level should be used for evaluating the
consistency of the printed reproduction. The OK press sheet is
compared with samples selected randomly from the pressrun.
The 2,000-lux level should not be used to evaluate the quality
of the tone and color reproduction qualities of the press sheet.
A press sheet that looks satisfactory when illuminated with
2,000 lux will look "muddy" when illuminated by only 500 lux.[1]

The revision of the international color viewing standard, ISO
3664-1975, is likely to agree closely with the specifications
contained in ANSI PH2.30-1985. Late in 1986, ANSI
PH2.30-1985 was withdrawn; ANSI will meet in 1987 to revise
it.

## The Sample

The appearance of the object or sample is due mainly to the
attributes of spectral absorption and gloss.

**Spectral Absorption**

**Spectral absorption** is the measure of the absorption of a sample as determined on a wavelength-by-wavelength basis across the visible spectrum. The hue, saturation, and lightness measures of a color can be derived from the attribute of spectral absorption.

White colors have very low spectral absorption and are close to being nonselective (i.e., the absorption is uniform across the spectrum). Blacks are also reasonably nonselective, but they have high absorption. A color takes on a particular hue and saturation because of the selectivity in spectral absorption. For example, a green color absorbs blue and red (and reflects or transmits green) and a magenta color absorbs green (and reflects or transmits blue and red).

The spectral absorption of a sample is measured with a **spectrophotometer.** This instrument illuminates the sample with light from one particular point of the spectrum. The amount of this light reflected or transmitted by the sample is measured and compared to the amount incident to the sample. The reading is expressed as a percentage; for example, a reading at 550 nm could be 60%, meaning that the sample reflects (or transmits) 60% of the 550-nm radiation that illuminates it. Measurements are made at every wavelength of the spectrum until a complete *spectrophotometric curve* of the sample can be constructed. The illustration presents spectrophotometric curves from printed ink film and paper samples.

**Gloss**

**Gloss** is a property of reflection samples that influences the perceived lightness of the sample. Some light (4%) incident to a sample is always reflected from the surface without being allowed to penetrate the sample. This scattered reflected light (in this example) is of the same spectral quality as the illuminating light source. If the sample has a very high gloss, the surface reflection will be highly directional at the same angle as that of the light incident to the sample (e.g., reflecting sunlight with a mirror). If a sample has a very high gloss (and the viewing geometry is correct), the surface reflection will not reach the eye, and thus not influence the perceived color of the sample.

In cases where the surface of a sample has a low gloss (low smoothness), it is called a **matte finish.** Such finishes are characterized by multidirectional surface reflections. The angle of reflection of the light scattered at the surface of the sample bears virtually no relationship to the angle of illumination. In

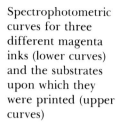

Spectrophotometric curves for three different magenta inks (lower curves) and the substrates upon which they were printed (upper curves)

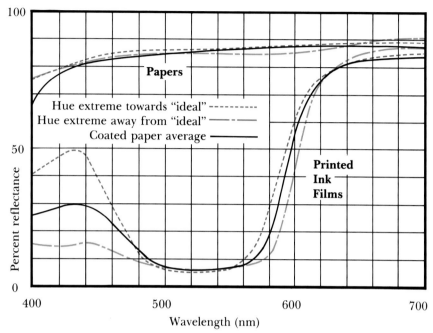

**Papers**

Hue extreme towards "ideal" -------
Hue extreme away from "ideal" — · — · —
Coated paper average ————

**Printed Ink Films**

Percent reflectance

Wavelength (nm)

this case, the light scattered at the surface reaches the eye of the observer. The scattered light (of the same spectral characteristics as the illuminating source) is mixed with the light that passes into the sample and is selectively reflected. This results in, among other things, lower densities of printed ink films.

Gloss is measured with a **glossmeter,** indicating percent specular reflection. The sample is illuminated with a beam of light from a specific angle, most commonly 60° or 75° and occasionally 20° or 45° (from normal) for specific purposes. A photocell collects the light reflected from the surface at the same angle in the opposite direction. Because glossmeters do differ, it is important to specify the manufacturer and the angle when using gloss measurements.

In printing we often deal with pictorial images rather than a simple flat color. In addition to the factors considered above, the following also affect our perception of the picture: overall size, area of image colors, contrast of the picture, sharpness, resolution, and the presence of interference patterns, such as moiré patterns, in halftone printing. These factors are discussed fully later in the book.

## The Observer

The aspect of color perception that is most difficult to define and measure is the eye-brain combination of the human observer. Some of these human factors are physiological in

Reflection of
incident light as
determined by
surface smoothness

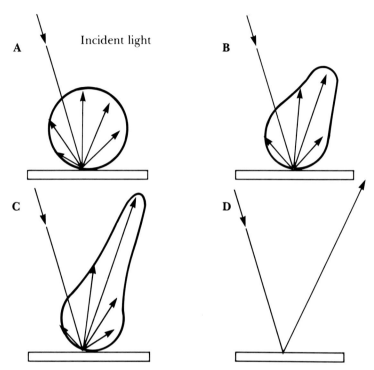

**A.** Reflection will be equal in all directions if the surface is perfectly
diffusing.
**B.** and **C.** Increasingly smooth surfaces cause the reflection to be
increasingly more directional.
**D.** A perfectly smooth surface causes all incident light to be reflected at
an angle equal to the angle of incidence.

Principle of the
glossmeter

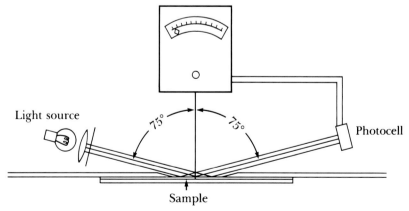

nature, and over the years of research some plausible color
vision theories have been developed. But other human factors
are psychological in nature, dealing with the areas of aesthetics

and cultural factors. Such perceptions tend to be highly personal and very difficult to quantify.

**Physiological Factors**

Much of the following material has been adapted from *Color Vision*, by Leo M. Hurvich. Professor Hurvich, together with Dorothea Jameson, is a pioneer in the opponent-process theory of color vision.

A diagram of the human eye is shown in the illustration. The **iris diaphragm** regulates the amount of light that passes through the lens to strike the retina. The **retina** is made up of a complex network of cells and neurons, and covers the entire back half of the eye (with the exception of the blind spot where the optic nerve joins the eye). The retina in cross-section contains ten levels of nerve cells. The cells that are sensitive to light are called the **rods** and **cones**—an estimated 120 million of them. The distribution of the rods and cones varies according to their position on the retina. The central area of the retina (called the **fovea**) contains cones exclusively. The cones are primarily concerned with vision at daylight levels of illumination, and as we move away from the foveal region, the number of cones per unit area drops off sharply. The foveal area is the area of sharpest vision. The rods, completely absent from the fovea, increase in number as we move toward the edge of the eye. The rods are most numerous about 20° from the fovea and fall off rapidly in number from this region out to the extreme periphery.

The rods are mainly concerned with night vision. Experiments have shown that the rods contain a photopigment called **rhodopsin.** When molecules of this pigment absorb light, they change their structure or form. These changes, in turn, trigger a physiochemical reaction, with an accompanying electrical change in the receptor itself. Different wavelengths of light affect rhodopsin differently.

For the cones, which are involved in normal color vision, it has not yet been possible to isolate a corresponding photopigment. This is mainly due to there being a much smaller number of cones than rods (6 or 7 million cones and over 110 million rods), thus making it difficult to extract the pigment. However, researchers agree that there must be three different kinds of light-sensitive pigments for color vision and that they are segregated into three different types of cone receptors.

The existence of three cone photopigments has been virtually proved by using a technique called **microspectrodensitometry.** A minute spot of light is imaged on individual receptors taken

The human eye:
(**A**) horizontal section
through center;
(**B**) enlargement of
dotted area in **A;**
(**C**) enlargement of
dotted area in **B.**
*Adapted from* Colour
*by Hazel Rossotti*

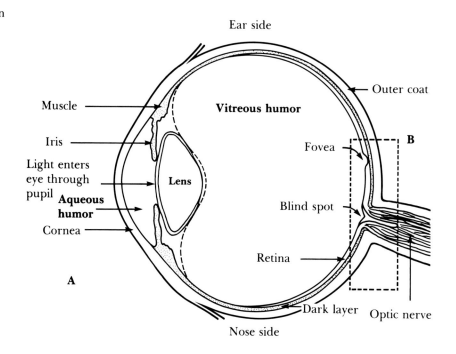

Ear side

Outer coat

Muscle

Iris

**Vitreous humor**

Light enters
eye through
pupil

**Aqueous
humor**

**Lens**

Cornea

Fovea

Blind spot

Retina

Dark layer

Optic nerve

**A**

**B**

Nose side

**C**

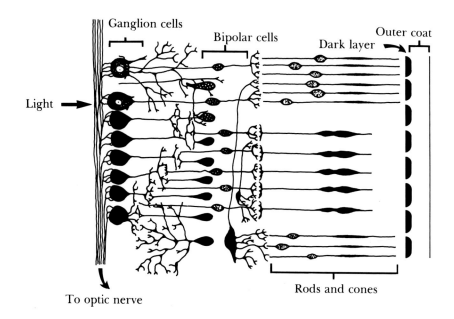

Ganglion cells

Bipolar cells

Dark layer

Outer coat

Light

To optic nerve

Rods and cones

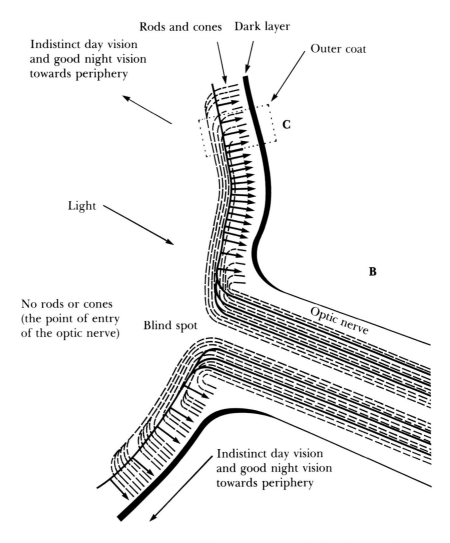

Rods and cones    Dark layer

Indistinct day vision
and good night vision
towards periphery

Outer coat

C

Light

B

No rods or cones
(the point of entry
of the optic nerve)

Blind spot

Optic nerve

Indistinct day vision
and good night vision
towards periphery

from the eye, and the absorption spectrum of the pigment is measured by rapidly scanning the spectrum. This technique has shown the existence of three pigments with peak absorptions at 450 nm, 530 nm, and 560 nm. It can be presumed that the action of light on these photopigments gives rise to electrical charges that travel to the brain.

The human color vision process is very complex and is still not completely understood. Over the years, a number of color vision theories have been advanced as explanations for how we see color. These theories have ranged from the simple to the complex, with the latter providing us with a reasonably good explanation of color vision phenomena. Because the complex theories build on the simple models, it is advisable to examine the simple before proceeding to the complex.

**Young-Helmholtz theory.** This approach to color vision is sometimes called the *retinal approach* or *component theory*. It was developed in the nineteenth century, initially by Thomas Young, and then refined by H. L. F. von Helmholtz.

The theory postulates the existence of three kinds of receptors in the retina that are respectively stimulated by red, green, or blue light. These receptors are linked directly to the brain to produce red, green, and blue signals that are proportional to the color of light reaching the retina. The accompanying illustration shows this relationship.

As previously discussed, experiments have shown that the cone receptors in the eye do indeed have different color responses. However, they are not unique red, green, and blue responses and tend to be much broader than suggested by the Young-Helmholtz theory. The theory does not offer a good explanation for abnormal color vision, nor can it explain satisfactorily how we perceive certain unique colors such as spectral yellow.

**Hering theory.** Ewald Hering developed his theory of color vision in the 1870s. It is called the *opponent theory*.

This theory suggests that the three kinds of color receptors in the retina have opponent sensitivities or reactions. That is, one receptor is red-green sensitive, another is blue-yellow sensitive, and the third one is white-black sensitive. By a process known as **assimilation** or **disassimilation**, the red or the green section (for example) of the red-green receptor sends a signal to the brain that represents the redness or the greenness of the light falling on the retina. The system is called opponent because it is not possible to have a reddish green or a bluish yellow; hence, these colors must oppose each other. The black-white receptor works slightly differently (it is possible to have a whitish black, or a gray). A black response is produced by a successive contrast effect. That is, a dark area next to a white area will tend to look black because the white-black receptors in the white area will induce the opposite effect in the same kinds of receptors on adjacent parts of the retina. The accompanying illustration summarizes the Hering theory.

No evidence of any visual substance that can produce two separate effects by assimilation or disassimilation has ever been found. The bipolar cells that connect to the cones could help initiate the opponent signals, but no solid evidence has been advanced that this mechanism will account for all color vision phenomena. In particular, this theory cannot explain the two

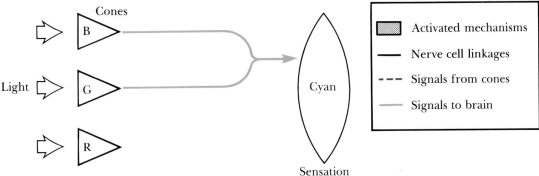

Young-Helmholtz color vision theory

The three cones respond in varying degrees to red, green, and blue wavelengths and send these signals to the brain, where they are mixed to create the color sensation.

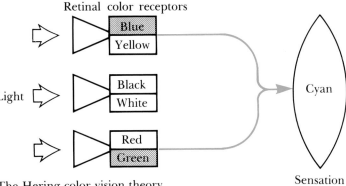

The Hering color vision theory

Retinal color receptors, which include the cones, are capable of discriminating between yellow-blue, red-green, or white-black. When a stimulus reaches a receptor, a coder is switched in one direction or the other depending on the color of the stimulus.

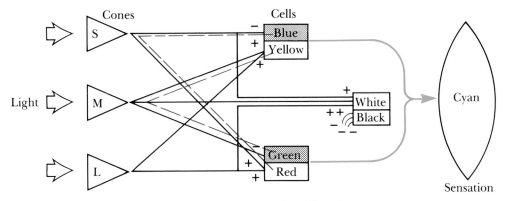

The opponent-process model (Hurvich-Jameson color vision theory)

In this composite theory, the cones are each linked to three color discriminators. The signals from the cones stimulate or inhibit the discriminator cells, and the dominant factor causes the discriminators to switch in one direction or the other.

different kinds of red-green blindness. According to the Hering theory, there should only be one kind.

**Opponent-process theory.** This approach has also been called the *zone theory* or the *Hurvich-Jameson theory* after the primary proponents of this model, Leo M. Hurvich and Dorothea Jameson. This approach combines elements of both the Young-Helmholtz and the Hering theories.

The three individual response cones of the Young-Helmholtz approach are incorporated into this model. The responses of each cone are very broad, however, with peaks occurring at 450 nm, 530 nm, and 560 nm. Thus, rather than calling the cones red, green, and blue receptors, they should be more correctly called long-wavelength, medium-wavelength, and short-wavelength receptors.

The opponent idea from the Hering theory is incorporated at the nerve cell level. Some nerve cells are always in an active state, despite the lack of stimulation. If they are stimulated the pulse frequency increases, and if they are inhibited the pulse frequency decreases. Thus, two opposing types of information can be transmitted by the same nerve. It has been suggested that the ganglion cells, which are each connected to three cones, act as opponent cells.

The suggested linkages between the cones and the opponent cells are shown in the illustration. The color vision mechanism can now be explained in algebraic terms. Consider the blue-yellow opponent cell. Assume that the top half represents yellow and the bottom half represents blue. The top half (yellow) receives output from the long (L) and medium (M) wavelength cones. Let us assume that this output reacts to stimulate the cell. The stimulation can be represented as $L + M$. The lower half of the cell (blue) receives the output from the short (S) wavelength cones. We assume that this output tends to inhibit the cell, thus it can be represented by $-S$. The net activity of the cell can be represented by:

$$\frac{\text{Yellow } (+)}{\text{Blue } (-)} = (L+M)-S$$

If the right side of this equation is positive (i.e., if $L + M$ is greater than S) then a yellow (stimulation) signal is produced. If S is greater than $L + M$, then a blue (inhibition) signal is produced. The red-green opponent cells work in a similar manner, thus:

$$\frac{\text{Red }(+)}{\text{Green }(-)} = (L+S) - M$$

Black is perceived because of lateral inhibition. Cells on one part of the retina induce the opposite kind of activity in similar cells on adjacent parts of the retina. Therefore, black is a contrast effect. The red-green and blue-yellow cells also have lateral connections that are not shown in the illustration.

The opponent-process theory has valid explanations for abnormal color vision, as well as for negative afterimages and simultaneous contrast. To demonstrate this effect, refer to the illustration. Stare at the spot in the green square for about 20 seconds. Quickly shift your eyes to the spot in the adjacent white square. You should see a red square, the opponent of green.

Afterimage
demonstration

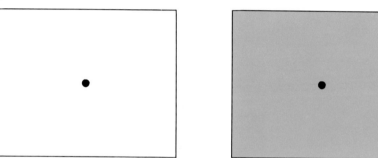

This experiment can be repeated with any color to verify that the opponent color will always be visible in afterimage—red-green, yellow-blue, black-white.

The factors known as simultaneous color contrast and edge contrast present another aspect of vision that is important for color reproduction. **Simultaneous color contrast** is the effect that occurs when colors that are identical appear different because of their different color surrounds. **Edge contrast** occurs when two even tones that meet each other appear to have a higher contrast at the edge. These effects are illustrated.

The explanation for these effects starts with the fact that the retina is made up of groupings of cells called **receptive fields.** These vary in size, with the ones near the fovea being about one-twentieth the size of those at the periphery of the eye. The opponent-process theory of color vision suggests that the neural systems are linked to each other to produce reciprocal lateral influences. Thus, the center of a receptive field may perceive red, whereas the edge of the field may record green; hence, if this red color surrounds a green dot, the dot will appear more

intense than the same dot on a neutral background because the influence of the red is greater than the green. The same sort of reciprocal interaction is suggested as explaining the apparent change in density at the edges of two gray tones that adjoin each other.

Simultaneous color contrast effect
*Courtesy Leo M. Hurvich,* Color Vision, *1981*

The four small colored disks are the same on the left- and right-hand sides. The apparent color differences are caused by the different surround colors.

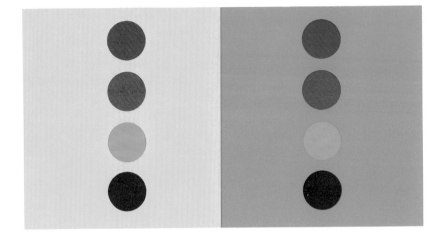

Edge contrast effect
*Courtesy Leo M. Hurvich,* Color Vision, *1981*

The gray scale steps actually have uniform intensity, but at each edge there is a relative enhancement and darkening on the two sides of the edge.

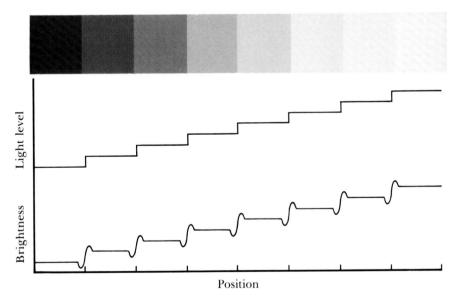

To conclude the section on color vision, it is necessary to consider the case of those with abnormal color vision (the term "color blindness" is no longer a preferred term). This problem is essentially one affecting males—about 8% of the male Caucasian population, 5% of the male Asian population, and 3% of the male black population have a form of deficient color

vision. For females (of all races), those with abnormal color vision only number about 0.4% of the female population. Studies of the incidence of anomalous color vision have been summarized in *Color: A Guide to Basic Facts and Concepts,* on page 102.

This abnormality is inherited. The normal heredity pattern is for the deficiency to be inherited by sons of daughters whose fathers exhibit color-defective vision. Fathers pass this abnormality on to their daughters, who act as carriers. As stated above, very few females actually have color-defective vision, but a much larger number are carriers. In some families it is possible that not all the sons will inherit the abnormality from their mothers and that some of the daughters in the same family may inherit the defective gene and become carriers.

The most common type of defective color vision is red-green confusion. Its various forms are **protanopia,** in which red and bluish green are confused, and relative luminosity of red is much lower than that for the normal observer (affects about 1% of Caucasian males); **protanomalous,** where in a red-green mixture more than a normal amount of red is required to match a particular yellow (affects about 1% of Caucasian males); **deuteranopia,** where red and green are confused, but the luminosity curve is nearly normal (affects about 1% of Caucasian males); **deuteranomaly,** where in a green-red mixture more than a normal amount of green is required to match a spectral yellow (the most common form of anomaly, affecting about 5% of Caucasian males). The other forms of defective color vision are **tritanopia,** where blue and yellow are confused and relative luminosity for blue is much lower than for normal vision (extremely rare, probably affecting no more than 0.0001% of the male population); and **monochromatism,** where discrimination of hue and saturation are completely lacking (also very rare, affecting about 0.003% of Caucasian males).

There are several testing devices available for detecting abnormal color vision. The best instrument for this purpose is the Nagel anomaloscope; however, its use is restricted to research laboratories because of its expense. The most popular form of testing is by using *pseudoisochromatic plates.* These come in booklet form, are inexpensive, and are easy to administer. The best known of these tests is the **Ishihara** test, where numbers composed of dots of varying sizes and colors are superimposed on backgrounds made up of similar dots. The ability to discern the numbers from the background is a

measure of normal color vision. Another version of this type of test is the American Optical Company's **Hardy-Rand-Rittler** set of plates. In this version triangles, circles, and crosses are used on gray dot backgrounds. Another widely used test is the **Farnsworth-Munsell 100 Hue test,** where the observer is required to arrange a series of small color chips in consecutive order according to hue. The test may be used to test aptitude for color matching as well as for diagnosing color vision anomalies. All tests *must* be carried out under daylight illumination. The tests are generally very reliable, but in some cases a misdiagnosis is possible.

Apart from abnormal color vision discussed above, it should be remembered that, among those with normal color vision, one person does not see color the same as another. Much of this interobserver variation is probably due to the macular pigment, which is a yellow pigment that covers about a 5° elliptical area around the fovea. It has been shown to vary in amount from one individual to the next. Also, as we age, the lens of the eye becomes yellower in appearance and less and less of the blue wavelengths are transmitted to the retina. Fatigue also affects our ability to discriminate between colors.

The key remaining point concerning color vision, especially for color reproduction and color printing, is what problems can arise when people with abnormal color vision are used to make color judgments. It is difficult to generalize about this, but the following statements are probably reasonable guidelines.

• **Judging color quality.** For judgments concerning the quality of a color reproduction or the harmony of a color design, a judge should have color vision as close to normal as possible.

• **Color matching.** For matching one color with another, some persons with anomalous color vision are actually better than some of those with normal color vision. While this may be true for colors composed of the same pigments, it does not, however, apply where different colorant systems are being compared, such as between artwork or a photograph and a printed color reproduction. Therefore, it may be acceptable to have a press operator with defective color vision as long as one press sheet is being compared with another, but it is not acceptable to have a retoucher/dot etcher or a designer/artist making comparisons between, for example, a hand-painted piece of artwork and a printed reproduction. The ability of an observer to match nonmetameric colors can be assessed by such

tests as the Inter-Society Color Council Color-Matching Aptitude Test Kit.

The Farnsworth-
Munsell 100-
Hue Test

**Psychological
Factors**

As difficult as the physiological factors are to explain, there is a well-defined science that has produced some very plausible and useful theories of color vision. For the other human factors, we enter the fields of art, anthropology, and psychology. In art, we find various rules, such as those of color harmony, which have been accepted by many professions that deal with the aesthetic aspects of color. From anthropology we can discover how particular cultures use color and of what significance it is to them. From psychology and medicine a new understanding of the emotional aspects of color is starting to emerge. One example is the Lüscher Color Test, which claims to reveal personality by the sequence in which a series of eight colors is arranged. Such claims are considered doubtful by some, but at least they have opened the question of fundamental links between colors and human behavior.

What many people believe about particular colors can be undoubtedly connected to some cultural tradition that has linked colors with events, feelings, or countries. Some examples of these are red and green, the colors of Christmas; black, the color of mourning (in Western countries); blue and gray, the colors of the North and the South in the American Civil War;

green for feelings of envy; blue for feelings of depression; white for purity; etc.

More recently, particular colors have been associated with products, such as green for menthol cigarettes; pastel colors for cosmetics; vivid colors for laundry detergents; and earth tones for natural foods. Colors are also used to identify the products of a particular company. For example, graphic arts film manufacturers use the following colors to identify their film boxes: yellow for Eastman Kodak, green for Du Pont, blue for 3M Co., reddish orange for Agfa-Gevaert, and light green for Fuji.

The question is not whether colors can evoke certain associations—most people would agree that they do—but rather, are these associations merely ones of habit, or is there an innate human feeling about color? This question is difficult to answer. It is probable that most of our feelings about colors are simply explained by tradition, but evidence is emerging that shows there may be some fundamental human feelings about color. For example, placing disturbed persons in rooms of particular colors has been shown to alter their behavior. Apparently, the same effect has also been observed with infants who have not been taught color associations. Reported use of color therapy dates back to the nineteenth century, but little systematic research has been done until recently.

The principles of color harmony—colors that are closely adjacent in hue and those that are complementary form the most pleasing combinations—have a logical explanation. If two colors that are not harmonious are placed together, the hues may seem to change when the eye is shifted from one to the other. The afterimage of one color will momentarily affect the perception of the other color. Because the afterimages are complementary to the color, harmonious colors will not exhibit any hue shift. The afterimages of complementary colors will appear to reinforce each other, while closely adjacent colors will not produce afterimages significant enough to induce a noticeable hue shift. The foregoing is meant to apply to color having uniform area, high saturation, and medium lightness. Naturally, the relative hue, brightness, saturation, and area are all factors that must be considered as explanations for color harmony, or the lack of it.

The final human factor concerning color is the creativity involved in the use of it. To be effective, the user must first understand the underlying principles of color, next know the purpose of the project or assignment, and finally apply

imagination. In the printing and allied industries we think of the creative aspects of color as coming from the designer, the photographer, and sometimes the printer. Of course, color is also used by others such as interior designers, fashion designers, artists, architects, industrial designers, and many more. Knowledge, purpose, and creativity are the keys to successful use of color in all of these fields.

**Summary**

The illuminant, the sample, and the observer are the three pillars of color perception. Of these, the observer provides the largest variable in color perception. Not only does a certain percentage of the population have defective color vision, but those persons of normal vision suffer from changes in color vision with both age and fatigue. Even after standardizing these factors, we still find individuals differ from each other in their color vision. This should not be too surprising—individuals differ in other senses such as hearing, and in physical characteristics such as height, skin color, weight, sex, etc. The nonphysiological factors can add more variables—aesthetic beliefs, cultural background, and even possible innate color preferences. These are probably the most difficult factors to predict and control.

The next biggest color vision variable is the light source. Colors can undergo dramatic shifts when a different light source is used as an illuminant. A standard has been established for viewing printed matter, which, if followed, should do much to eliminate confusion and problems in color judgment and communication.

The sample, which would appear to be a constant, can change in appearance depending on the degree to which gloss is present. Specifying a fixed viewing position helps to reduce this problem.

The problems that result from the above factors range from the predictable to the unpredictable. For example, with metamerism, the problem is well understood. Different spectral absorptions of the two colors in question cause these colors to match under one light source but not under another.

However, the problems of color that involve personal differences between two people are more difficult to deal with. It is possible that one or both have defective color vision, something people are often not aware of unless they have been tested. More likely, the dispute will center around the use of a color or the actual achievement of a color in the final result. It is hoped that education in color theory will help reduce these

differences for color production, but for the selection of color, it is probably both inevitable and desirable that differences of opinion exist.

**Notes**

**1.** A. J. Johnson and J. W. Birkenshaw, "The Influence of Viewing Conditions on Color Reproduction Objectives," *14th IARIGAI Conference Proceedings* 1977 (Plymouth, Devon: Pentech Press Limited), pp. 48–72.

# 3 Color Measurement and Specification

Because color is such a complex phenomenon, it is difficult to control and specify. Wide differences in illuminants and considerable variation in human visual processes create a need for a standard measuring system and instrument. Such a device would at least permit communication of color specifications and tolerances and lay the foundation for the science of color. Some pioneering in the use of numerical specifications for color measurement was done in the early 1930s. However, the difficulty with numerical specification is that it tends to be shunned by such people as artists and designers, who have a need for a system made up of physical samples that allow direct selection and comparison. Many of these color sample systems have been developed over the years, the first probably dating back to the color atlas of the Swedish scholar Brenner in 1680. The final and most common method of color specification is verbal. This is the least accurate of all specification methods, and little progress has been made toward a general acceptance of standardized terminology.

The printing industry has a special need for good measurement and specification systems because of the close interaction between design and manufacturing. Another reason is that printing deals with colors having various properties—i.e., pictorial and flat forms, high and low gloss, and metallic and fluorescent characteristics—on a wide variety of substrates. Thus, the demands for a universal specification system are quite high. Unfortunately the progress toward the identification and adoption of such a system by the industry has been very slow.

## Attributes of Color

Over the years, a considerable body of scientific information has been assembled concerning the specification of color appearance. From the printing industry viewpoint, we have primary interests in the colorimetric, surface, fluorescent, and pictorial aspects of color perception. Other factors include size, shape, and location. The four major factors are discussed in detail below.

## Colorimetric Properties

The **colorimetric properties** of color are those that apply to *hue, saturation,* and *lightness.* The **hue** of a color is the name of a color. It identifies whether a color is red, blue, green, yellow, or some combination term such as greenish yellow. Other terms such as magenta or crimson are often used as hue names. Hue may have an infinite number of steps, or variations, within a color circle. Such a circle displays all the hues that exist;

The hue component
of color shown on an
abridged color circle

The divisions are
approximate.

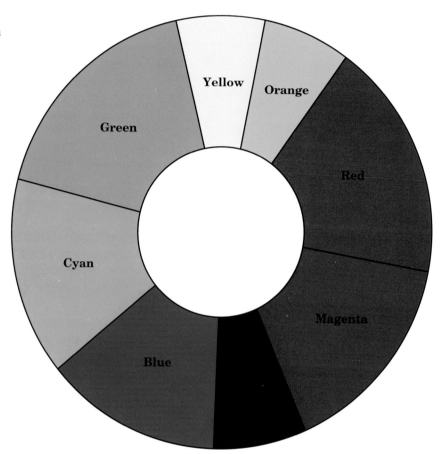

indeed, it can be said that any reproduction process is capable
of matching any given hue.

The **saturation** of a color is its purity property. For example,
a gray-green has low saturation, whereas an emerald green has
higher saturation. A color gets purer or more saturated as it
gets less gray. In practice this means that there are fewer
contaminants of the opposite hue present in a given color. To
illustrate this concept, imagine mixing some magenta pigment
with a green pigment (the opposite hue). The green will
become less and less saturated until eventually a neutral gray
will be produced. A gray scale has zero saturation. The
illustration shows the magenta-green saturation continuum.
Magenta becomes desaturated by the addition of green in the
same way green becomes desaturated by the addition of
magenta. As a color becomes less saturated, it can be said to be
dirtier or duller, and as it becomes more saturated, it can be
described as cleaner or brighter. While there is no limit as to

The saturation component of color for the magenta-green hue axis

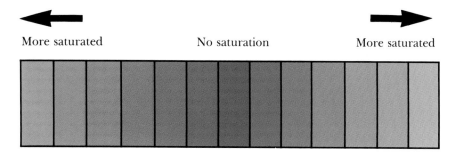

More saturated   No saturation   More saturated

how desaturated a color can be (it will always reach neutral gray), there are practical limits in reproduction processes as to how saturated a color may be. These limitations in printing are due to the saturation limits of the ink-substrate combination.

The **lightness** of a color describes how light or dark it appears (e.g., a light green as compared to a dark green). In fact, the terms lightness and darkness are synonymous. In practice we can change the lightness or darkness of a solid color by mixing either white or black ink with the color. In process-color printing this is achieved by printing a color at various percentages from 0 to 100 (mixing with white), and

The lightness component of color for a green

Darker   Lighter

then overprinting the 100% solids with increasing percentages of black (mixing with black) until the saturation starts to shift along with the lightness. The bottom illustration on page 47 shows the lightness aspect of color.

In practice both lightness and darkness have limits. In printing, the lightness of a color is limited by the properties of the substrate. For example, it is generally possible to achieve lighter colors on a good coated paper than on newsprint or uncoated recycled paper. The darkness of a printed color is limited by the gloss of the substrate and the ink, and the amount of ink (and pigment) that can be practically printed on the substrate. Drying, trapping, dot spread, and economic factors restrict the thickness and number of ink films that can be sequentially printed.

**Surface Properties**

The **surface** characteristics of an ink-substrate combination are *gloss, texture,* and *luster.*

The effect of gloss on color is mainly confined to the lightness dimension. A color with a glossy surface appears darker than one with a matte surface. This is because the matte surface scatters some of the incident light back to the eye of the observer. This light "dilutes" the light reflected from below the surface of the colored object and, for example, turns a dense black into a gray.

Some printed matter is overprinted with a high-gloss varnish in order to improve the color gamut. This practice, along with using high-gloss papers and inks, generally improves pictorial reproduction but can have the drawback of creating glare. In practice glare is not a major problem for pictures, but it is a serious problem if a moderate amount of text accompanies the picture.

The **texture** of a surface is related to its gloss—the more texture, the lower the gloss. Texture can be deliberate or unwanted, regular or irregular.

Regular texture patterns include silk, pebble, and grained finishes generally created by rotary embossing. One intent of such finishes is to add a tactile element to the product. In printing, such textures are sometimes used for greeting cards, annual reports, and calendars. These finishes lower the lightness range of the reproduction and reduce resolution. Although the human eye (subjective) and the glossmeter (objective) agree in ranking the gloss of smooth surfaces, they usually disagree in evaluating embossed paper.

The irregular textures are usually encountered on uncoated papers, commonly called vellum, antique, natural, etc., finishes. The paper fibers form an irregular texture that varies according to fiber type, degree of calendering, paper additives, and other papermaking factors. Artist's watercolors or designer's drawings that are themselves prepared on uncoated paper usually reproduce well on this type of paper surface.

Deliberate textures can be either regular or irregular. They are chosen by the designer to enhance the tactile properties of the printed piece with the knowledge that this choice will degrade the lightness dimension of color. This degradation is desirable when reproducing wash or pencil drawings but is undesirable for photographic subjects.

Unwanted textures usually come from the use of lower-grade (and cost) papers. They are always irregular.

**Luster** is the property of a sample that results in selective spectral reflection from the surface of the sample. For printed samples, this effect is best represented by the metallic inks such as gold or silver. However, it also can be characterized by the **bronzing** that occurs inadvertently with some inks (this is caused by toner migration to the surface of the ink). In both cases, light strikes the particles on the surface of the printed ink film, and, unlike the case of gloss, is selectively absorbed. The reflected light is mixed with the light that passes into the sample and is selectively reflected. Thus, colors from the surface of the ink film and from the ink film itself are integrated by the eye. The surface reflection component is highly dependent on the viewing geometry; therefore, the perceived color will change as the sample is moved. This is desirable for metallic finishes but may not be so for other ink films. Luster cannot be measured satisfactorily by instruments.

**Fluorescence and Metamerism**

The appearance of some colors is strongly influenced by the color temperature of the incident light. Actually, all colors change appearance if they are illuminated by different light sources; however, in many cases the eye adapts to the source in question and perceives the color as being the same as it appeared under a different source. For example, the eye readily accepts the same piece of paper as being white when illuminated alternatively by noon sunlight and indoor tungsten light. The eye adapts within limits, so that the paper appears white regardless of the illumination. This phenomenon is called **approximate color constancy.**

A **nonadaptive** system, such as the emulsion of color film, records two very different colors when photographing the white paper under the two illuminant conditions described above. However, there are instances when, regardless of the adaptation of the eye to a reference white, a color is perceived as different under a different illuminant.

**Fluorescence** occurs when a pigment has the property of absorbing radiant energy of a given wavelength and then emitting this energy at a different wavelength. Some papers, particularly bond papers, have these pigments added in the manufacturing process. Energy in the near ultraviolet region (380–400 nm) is absorbed and then emitted as visible energy around 420–430 nm. This extra blue-light reflection helps to neutralize the natural yellowish color of most papers. Fluorescence also occurs when visible radiation is converted into visible radiation at a longer wavelength. Generally, the fluorescence process converts short-wavelength, high-energy radiation into longer-wavelength, lower-energy radiation. Hence, light rich in short-wavelength radiation (noon sunlight) produces more fluorescence than light rich in longer-wavelength radiation (tungsten sources). Therefore, even though the eye may adapt to a reference white under different illuminants, the accompanying colors may be perceived as different because of the presence of fluorescing agents in the samples in question.

Metamerism occurs when two or more color samples match under one illuminant but appear different under another illuminant. Generally, the colors most likely to show this effect are near neutrals. Metamerism occurs when different pigments that have relatively complex spectrophotometric curve shapes are combined to produce a new color. For example, it is possible to combine various proportions of green and magenta ink in order to achieve a neutral gray under a given light source. Another gray can be prepared to match the first by mixing black and white inks. If the illuminant is changed, the *black-white* gray will still be neutral, whereas the *green-magenta* gray will no longer be neutral. This problem of the metameric match is most likely to occur when mixing inks to form a special color, or when making comparisons between the original and the reproduction.

A major purpose of using the ANSI standard illuminant when judging color in the graphic arts is to overcome the problems of fluorescence and metamerism. A standard source produces a standard fluorescent effect for a given pigment.

Likewise, a standard source reduces many of the metamerism problems.

**Pictorial Considerations**

The discussion in this chapter so far has been primarily concerned with flat color areas, i.e., those devoid of any tonal separation or pictorial detail. The points addressed also apply to pictorial subjects, but they do not form a complete explanation as to how color is perceived in a complex field like a photograph.

One aspect of color perception in photography is the influence of surround colors. The same green within a picture surrounded by blue appears quite different when surrounded by yellow. The influence of the surround not only depends on the colors of both the surrounded area and the surround, but also on the size, shape, and position of both colors. Viewing distance has an influence, especially when trying to make comparisons between small originals and large reproductions or vice versa. In addition, the brightness of the illumination used to view a reproduction influences perception. Higher intensities create the appearance of higher contrast, thus resulting in higher color brightness.

Influence of surround colors

The adaptation of the eye to the brightness of the illuminant and the reproduction is influenced by the area around the reproduction. If the picture has a black (or opaque) border (such as a 35-mm transparency still in its mount), we tend to perceive this picture as having high contrast and brightness. If the black border is replaced with a white (or transparent) border, perceived contrast and brightness are lower.

The ANSI standard viewing conditions recognize the problems that can be caused by brightness changes; therefore,

Influence of
brightness levels on
color perception

the standard specifies both light intensity and white surround allowances.

The sharpness of a reproduction also influences color perception in pictorial subjects. As sharpness increases, brightness and saturation also increase.[1]

The psychophysical process, especially in reference to the evaluation of color pictures, is still not perfectly understood. Some of the relationships outlined so far have only been hinted at by research. Other factors that also may be important still remain unknown.

## Color and Appearance Measurement

The measurement of color and appearance by instrumental methods is necessary if we want to quantify these factors. Quantification is particularly useful when we need to communicate color specifications or establish quality control limits. If the numbers are related to a universal standard, and the measuring instruments are precise, then numerical specification is the least ambiguous and most flexible of all the color measurement and communication systems. Unfortunately, color and appearance are not easy attributes to measure. Many aspects of the human visual system are still not clear to vision scientists, hence making it very difficult to develop instruments to simulate this complex system. However, reliable instruments have been developed that allow us to quantify certain aspects of color.

**Spectro-photometers**

The **analytical spectrophotometer** is used to quantify, on a wavelength-by-wavelength basis, the radiation reflected (or absorbed) by a given object. In practice, *abridged spectrophotometers* are frequently used to make these measurements. Readings are taken every 20 nm instead of continuously.

The light reflected (or absorbed) at a given wavelength is expressed as a percentage of the incident light at that point. For example, a perfect white would reflect 100% of the incident light at every wavelength, regardless of the color of the illuminant.

The percentage of light reflected by an object is plotted against the corresponding wavelength where the measurement was made. A curve drawn through the resulting points is said to be a **spectrophotometric curve.**

The spectrophotometer is the most accurate method of characterizing the absorption characteristics of any given color. The spectrophotometric curve, however, is an abstraction that does not lend itself to easy color visualization. Furthermore, spectrophotometers are expensive instruments that need skilled operators. In the printing industry, the primary use of the spectrophotometer is for ink color quality control. This use is largely confined to ink manufacturers, but some of the larger packaging companies also employ spectrophotometers for this purpose.

Spectrophotometric curves of two colors that appear alike under north sky daylight and different under tungsten illumination

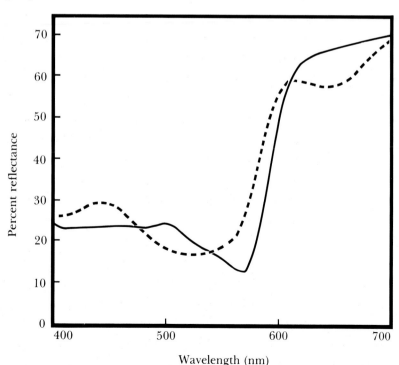

**Colorimeters**          **Colorimeters** are designed to "see" color the same as the
human eye. The foundation for the development of this
instrument was established in 1931 when the Commission
Internationale de l'Éclairage (CIE) established their *standard
observer* for a 2° field of view (in 1964 a standard observer for a
10° field of view was established). A series of experiments on
color matching were conducted, where three primary colors of
444.4 nm, 526.3 nm, and 645.2 nm were independently varied
to match a given spectral color. The average of these results
was used to define the CIE color-matching functions. The
resulting curves were transformed to eliminate negative
portions and to make one $\overline{Y}$ of the transformed functions
identical to the brightness response of the visual system. The
illustration shows the CIE 2° standard-observer color-mixing
functions. The color-mixing functions are simulated by placing
appropriate filters over the photosensor of the colorimeter.
Alternatively, spectrophotometric data can be converted into
colorimetric data by using appropriate computer programs.

The values X ("red"), Y ("green"), and Z ("blue") derived
from the three filters of the colorimeter are converted into
chromaticity coordinates through the following formulas:

$$x = \frac{X}{X+Y+Z}$$

$$y = \frac{Y}{X+Y+Z}$$

The values for x and y are now plotted on a chromaticity
diagram. The resulting point is an indication of the hue and
saturation of the color.

Lightness is the third dimension (Y) of color and can be
visualized as points suspended in space above the diagram.
Lightness is represented by a number next to a point on the
chromaticity diagram. The higher the number, the lighter the
sample.

Colorimeters measure a sample in terms of different color
temperature light sources. The original CIE standard sources
are source A (2,856 K), source B (4,874 K), and source C
(6,774 K). In recent years a series of D illuminants has been
defined by the CIE. These illuminants exist as mathematical
specifications and cover the range of 5,000 K to 7,500 K. They
are called the CIE Daylight Illuminants. In practice, most
modern colorimeters and spectrophotometers will use the

The weighted functions used to convert spectro-photometric data to colorimetric terms; that is, the tristimulus values X, Y, Z

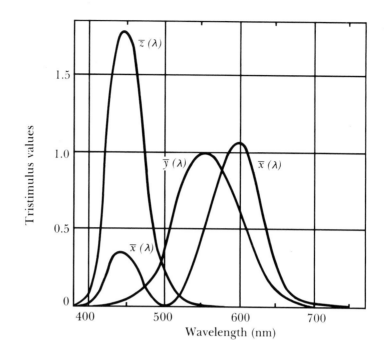

The CIE chromaticity diagram showing the locus of a black body at different absolute temperatures

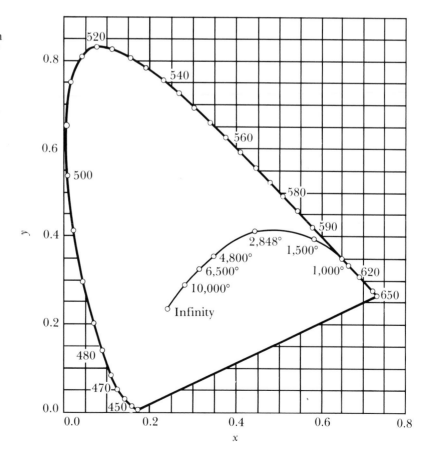

6,500 K specifications. This source is recorded as D65 in the technical literature.

The CIE chromaticity diagram has several drawbacks; namely, it was designed for measuring the color of light sources rather than the color of objects, equal distances on the diagram do not correspond to equal visual differences, and it is conceptually awkward to explain in terms of normal color descriptors.

Several transformations of the CIE system have been proposed over the years. The 1947 Hunter L,a,b system has gained considerable popularity in some industries. The illustration shows the rectangular dimensions of the L,a,b solid. The values of $L$ for lightness, $a$ for redness or greenness, and $b$ for yellowness or blueness may be read directly from the sample with some instruments.

The Hunter L,a,b Color Solid
*Courtesy Hunter Associates Laboratory, Inc.*

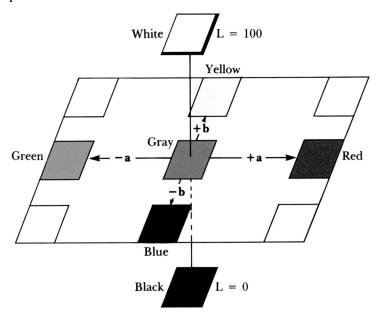

In 1976 the CIE introduced two new transformations of the chromaticity diagram. They are the L*, a*, b* system (CIELAB) and the L*, u*, v* system (CIELUV). These systems are somewhat similar to the Hunter system in that a* or u* indicate redness-greenness and b* or v* indicate yellowness-blueness.

There is general agreement that either of the successors to the original chromaticity diagram is an improvement. However, the "perfect" color-space system does not exist. None of the present systems will represent equal visual differences as equal distances on the color diagram for all regions of color space.

A detailed description of color and color-difference measurement systems is provided by Fred W. Billmeyer, Jr. and Max Saltzman in their book *Principles of Color Technology*, 2nd ed. (New York: Wiley, 1981, pp. 47–66, 85–106). Billmeyer and Saltzman suggest that CIELUV might be preferred when measuring color reproductions and that CIELAB might be preferred for measuring flat colors such as paints or plastics. The CIE Colorimetry Committee intended CIELAB for the measurement of small color differences and CIELUV for the measurement of larger color differences such as those found in color reproductions. Billmeyer and Saltzman report that there is little difference in how well (or how poorly) CIELUV and CIELAB agree with visual data.

Colorimetric systems and instruments often incorporate color difference formulas in the computer section. These formulas express, in terms of just noticeable differences, how far a given color is from some reference standard that had been previously incorporated into the memory.

A just noticeable difference (or a just perceptible difference) is usually referred to as a MacAdam unit after David L. MacAdam's research that was conducted in 1942 and later. MacAdam and other workers have derived ellipsoids that represent the spread in color difference perceptibility from one observer to another within the range of normal color vision. These ellipsoids vary in size according to the color being matched. That is, the human color vision system is not equally sensitive to all colors.

In practice, color differences are usually expressed in units that are from two to four times as large as MacAdam units. Among these larger units are the CIELAB, CIELUV, Hunter, and NBS. None of the color difference formulas has gained universal acceptance; therefore, colorimeters usually compute color difference in terms of two or more individual equations.

In the printing industry the use of colorimeters has generally been restricted to large package-printing companies. The paper industry has also made use of colorimeters for quality control purposes. The lower-cost computer systems (which are an integral part of most colorimetric measurement systems) have led to some companies experimenting with the colorimeter as a device for measuring halftone color variation on press.[2] Such usage is likely to increase if it becomes possible to link changes in the measured color to adjustments of the press controls necessary to correct the color change.

**Densitometers**

Strictly speaking, densitometers cannot be used to measure color. Spectrophotometers measure the physical absorption characteristics of a color. Colorimeters measure a color relative to how the human visual process sees that color. A **densitometer** is not related to either of these basic color measurements but is more associated with photographic and color correction requirements. It is an electronic instrument used to measure optical density.

Densitometers are frequently used in the printing industry to control ink film thickness on press. A sufficiently good relationship exists between the density scale and the physical ink film thickness (IFT) for this to be a successful application of densitometry. The measurements that are made of IFT are not measures of color because they are made through only one filter, usually the color complement of the ink being measured.

A color measurement system based on densitometry was developed by Frank Preucil of GATF. The system involves making measurements of a printed ink film through each of the red, green, and blue filters. These measurements are converted to *hue error* and *grayness* values by using these formulas:

$$\text{Hue Error} = \frac{M - L}{H - L} \times 100$$

$$\text{Grayness} = \frac{L}{H} \times 100$$

where L = the lowest densitometer reading, M = the middle reading, and H = the highest reading.

| Ink | Blue Filter | Green Filter | Red Filter | Hue | Gray |
|-----|-------------|--------------|------------|-----|------|
| Yellow | 1.04 | 0.06 | 0.02 | 3.9 | 1.9 |
| Magenta | 0.45 | 1.14 | 0.08 | 35.0 | 7.0 |
| Cyan | 0.08 | 0.30 | 1.02 | 23.0 | 7.8 |

Density matrix and color coordinates for the Preucil measurement system

Hue and gray values are then plotted on appropriate color diagrams. The lightness dimension extends vertically from the page.

If the original density values are actinic densities, the diagrams may now be used to calculate masking percentages. The triangle is also useful for describing the color gamut of an ink set and studying ink trapping behavior. The circle has been

*(Text continued on page 62)*

The GATF Color
Triangle

The GATF Color
Circle

The GATF Color
Hexagon

used for displaying data obtained during industry-wide color surveys.

Densitometric measurement of colors, however, is not related to the visual appearance of these colors. Furthermore, different densitometers may read the same color differently because of the lack of universal color response specifications.

Another diagram that has been used for representing the color of printed ink films is the color hexagon (really trilinear graph paper). This diagram displays only the hue and lightness color dimensions. The hexagon is normally used for comparing proof and press solid and overlap colors, or for investigating ink trap behavior.

**Other Measurement Methods**

The appearance factors that influence color perception are gloss, texture, and luster. Of these, gloss is the only property that can be measured satisfactorily. (The measurement of gloss is discussed in Chapter 2.)

The degree of fluorescence or metamerism related to any given color may be determined through spectrophotometric measurements. For fluorescence, it is possible to include or exclude the ultraviolet component from the measurements. If the readings differ under both conditions, the color will fluoresce. For metamerism, both colors must be measured with a spectrophotometer. If the curves are identical, then metamerism will not occur.

The other color appearance factors—surround effects, sharpness, brightness level, and viewing distance—are difficult to quantify. It has been suggested that a version of the Bartleson-Breneman brightness function for a complex field be substituted for L* in CIELUV in order to characterize pictorial color better.

**Visual Color Order Systems**

Numerical expressions of color do not convey any real sense of what the color actually looks like. Therefore, artists, designers, many workers in the printing industry, and the general public are likely to place low, if any, value on numbers that represent color appearance.

Most people are more comfortable describing color in terms of an existing sample. To facilitate this kind of specification and communication, many color order systems that consist of physical color samples have been devised. There are two basic types of color order systems: one is an **absolute** system, which is made up of permanent color chips and generally can be expanded up to the theoretical color limit whenever new

permanent colors are discovered; the other is a **relative system,** where the color gamut is fixed by a given set of colorants and does not allow or need expansion.

**Absolute References**

Examples of these systems include Munsell, Ostwald, Natural Colour System, Deutsche Industrie-Norm (DIN), Optical Society of America (OSA) Uniform Color Space, and the Imperial Chemical Industries (ICI) Colour Atlas. They are either *open-ended systems* that allow the continuous addition of new colors or are based on a regular *geometric solid.*

The open-ended systems are based on the color attributes of hue, saturation, and lightness. They include the Munsell Color System, the OSA Uniform Color Space (UCS), the DIN Color System, and the ICI Colour Atlas. These systems are generally based on polar coordinates. The notable exception is the OSA-UCS, which is based on a cubo-octahedral coordinate system.

The **Munsell System** has been chosen to illustrate the open-ended absolute reference system. Munsell is probably the most frequently used of all the color order systems.

Munsell uses the terms hue, chroma (saturation), and value (lightness) to describe the attributes of color. Five basic hues make up the notation system: red, yellow, green, blue, and purple. The transition from one color to another, e.g., blue to green, proceeds as follows: 10 B; 5 B; 10 BG; 5 BG; 10 G; 5 G. (B = Blue, BG = Blue-Green, G = Green.) Instead of each hue being divided into two, it can be divided into four, or as many as ten, discrete steps. Therefore, there may be as many as 100 hue steps in the Munsell circle. The perceptual spacing of hues is larger at high chroma than at low chroma.

The value scale ranges from 1 (black) to 10 (white) with perceptually equally spaced shades of gray. The chroma scale is open-ended, starting at zero in the center of the solid and increasing radially. From a practical viewpoint, chroma is limited by the availability of high-chroma samples.

The color identification scheme is given as hue-value/chroma. For example, 7 BG 4/3 indicates a bluish green color of hue 7 BG, value 4, and chroma 3. The colors of the gray scale are indicated by the letter N, so N5/ is a gray with the value of 5.

Munsell colors have been produced in both matte and glossy finishes. They were designed for daylight viewing, but only minimal distortion is likely under other light sources. The color spacing in the system was determined against a relatively light

Munsell hue spacing
(circumferentially)
and chroma (radially)

gray background. Because of these conditions, the spacing of
dark colors is somewhat distorted.

The geometric-solid types of absolute color reference are
based on mixtures of white, black, and chromaticity. They
include the Ostwald Color System and the Swedish Natural
Colour System.

The **Ostwald Color System** is based on an equilateral
triangle. White is located at one corner of the triangle, black at
the second, and a color at the third. The colors in the triangle
are regarded as an additive mixture of black (B), white (W),
and the color (C), so that B + W + C = 1.

The colors located on lines that are parallel to WC are colors
with fixed amounts of black content. They are called **isotones.**
The amount of white content along one of these lines is varied
to provide uniform spacing of the colors. Lines parallel to BC
represent colors that have a constant proportion of white
content and are known as **isotints.** Those colors along lines
parallel to BW are those of equal full-color content and are
called **isochromes.** The Ostwald color solid is produced by
rotating the triangle around the WB axis, thus producing a

Munsell Color Space

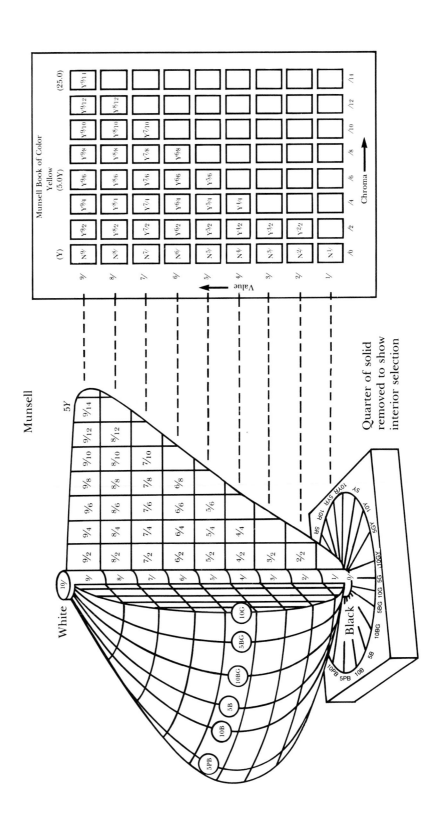

solid that looks like two cones placed base to base. Some colors within this solid may have constant white, black, and color contents but differing hues. These colors are known as **isovalent** colors.

The coordinates of the Ostwald System for a given hue plane

White

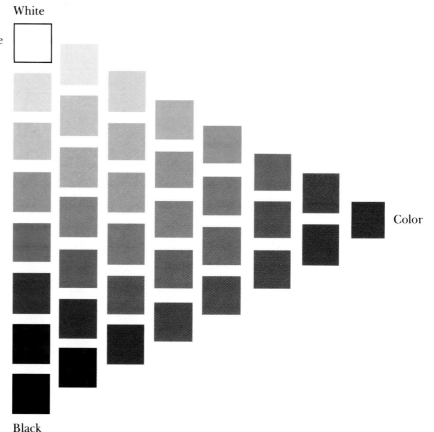

Color

Black

The Ostwald System has proved to be of practical value when it is necessary to mix a chromatic pigment with either black or white. In printing, the white paper and black ink can be thought of as adding to the chromatic colors; therefore, this system can be of use in the printing industry.

The drawbacks of the system include a limited number of basic hues (yellow, orange, red, purple, blue, turquoise, sea green, and leaf green) and the possibility of the development of a brighter hue than the existing full-color pigment. In this case, the new pigment would have to be placed at C and a whole new distribution developed.

The Ostwald System, in the form of the *Color Harmony Manual,* consists of 30 hue slices, with 28 colors on each slice.

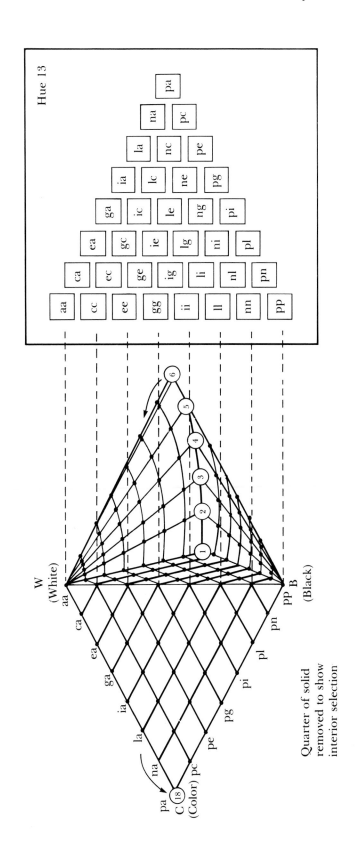

Ostwald Color Space

Hue 13

Quarter of solid
removed to show
interior selection

There are also eight gray steps for a total of 848 colors. Some extra colors have been added in cases where it was found that the basic colors did not extend far enough to include all of the available colors.

The notation of the Ostwald System indicates the percentage of white (W), black (B), and color (C) content; for example, C = 34, W = 22, B = 44.

The **Natural Colour System (NCS)** was developed in Sweden. It is called "natural" because it is based on Hering's psycho-physical classification of color according to the six elementary color sensations: red, yellow, green, blue, white, and black.

The NCS color solid is similar to the Ostwald color solid. The four unique hues—yellow, red, blue, and green—are placed 90° apart on the circle. There are a total of 40 equal hue triangles, each containing 66 color locations, a total of 2,640. In practice 1,412 of these colors have been realized in the form of actual color samples.

The notation is somewhat similar to Ostwald, except that the color page identification is part of the notation. For example, an orange may consist of 30 yellow, 30 red, 25 white, and 15 black, with the sum always being 100. The numbers indicate the degree of similarity to the fundamental sensations of that name.

The Natural Colour System has the advantage of being conceptually useful to artists and designers while retaining room for expansion. Its major drawback is that differences between neighboring unique colors are not the same. For example, if we go from unique yellow to unique red in ten equal hue steps, keeping lightness and saturation constant, we would require between twenty and fifty steps of the same size to go from unique red to unique blue. The *cubo-octahedral coordinate system* of the OSA Uniform Color Space System overcomes this problem along with the problem of high-frequency color sampling near the central axis of polar coordinate systems.

## Relative References

Relative references are usually confined to the printing industry and take one of two forms. The first type is the **halftone** reference, where varying percentages of yellow, magenta, cyan, and black are printed in many combinations on a variety of substrates. The intent is to characterize the gamut of a given ink-substrate-press combination and to facilitate color prediction and color communication. The second type is the **ink-mixing** reference, where solid colors, which are mixed

The Natural Color
System (NCS) show-
ing *(top)* the color
triangle representing
a hue slice, and *(bot-
tom)* the color circle
based on yellow-blue,
red-green division

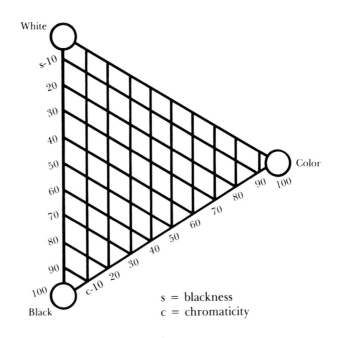

s = blackness
c = chromaticity

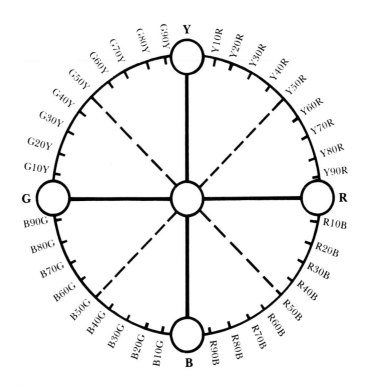

from a standard set of basic colors, are printed on coated and uncoated substrates. The intent is to record the ink-mixing formula for a given special color. A color selected by a customer may easily be matched by mixing the basic inks in the proportions listed for the color in question.

It is probable that many hundreds of halftone color charts have been devised over the years. They usually consist of grid patterns, initially containing two colors, each ranging from 0% to 100%. The next page of the chart duplicates the first, except that it adds a uniform percentage of the third color. Each page adds an increasing percentage of the third color until it reaches 100%.

Typical color chart configuration

Each individual page may now be overprinted with varying degrees of black in order to complete the range of available colors. An example of a commercially available preprinted chart of this type is the *Color Atlas* by Harald Küppers.

Master film sets for halftone color charts tend to be both difficult and very expensive to produce. Moreover, the printed charts are usually inconvenient to use because of the number of pages and the distance between similar hues.

A logical and convenient screen tint color chart is the **Foss Color Order System,** which is based on a cubic color solid. The eight corners of the cube represent the white, black, cyan, blue, magenta, red, yellow, and green gamut limits of a given ink and substrate combination.

In order to form a two-dimensional color chart from a color solid, it is necessary to sample sections of the solid, develop them, and lay them in order on a sheet.

Representation of the black printer on typical color charts

**ROW C — 1/8 BLACK** ⟶

**ROW D — 1/4 BLACK** ⟶

**ROW E — 1/2 BLACK** ⟶

The sampling procedure selected for the Foss Color Order System was to dissect each of the three uppermost surfaces from one corner to the opposite corner diagonally through the cube. This treatment produced six solids called *quadrirectangular tetrahedras.*

The development of the outer surface of these solids produced parallelograms. These were shifted into square order to make the chart more compact. The inner planes of the cube were similarly sampled and developed.

A cubic color solid

The resulting color chart consists of six color pages: blue to magenta; magenta to red; red to yellow; yellow to green; green to cyan; and cyan to blue.

The black in the system is incorporated by overprinting each of the tricolor areas with discrete steps of black. In order to keep the number of overprintings to a minimum, special black images are used that divide each color square into four. Two black plates will give eight black levels. The complete system contains 5,381 colors.

The nine tone values in the Foss Color Order System were selected to give approximately equal visual increments between each of the nine tone steps. The values are $0 = 0\%$, $1 = 4\%$, $2 = 13\%$, $3 = 23\%$, $4 = 33\%$, $5 = 53\%$, $6 = 74\%$, $8 = 87\%$, $9 = 100\%$.

The trichromatic form of the Foss Color Order System

The most important feature of the Foss Color Order System is that it was produced in the form of master films rather than as a printed chart. (Printers make plates from the films and print their own charts with their inks, papers, and presses.) The films were made in both sheetfed and webfed versions.

Another color chart available in master film form is the Rochester Institute of Technology Process Ink Gamut chart. This chart contains only the gamut colors.

Relative color order systems cannot be used as universal reference systems because the printed colors vary from one manufacturing system to another. However, they completely and uniquely describe the color space that is available for a given manufacturing system. Absolute color order systems are not flexible enough to give the desired color discrimination for a specific colorant system. Also, many printed colors may lie outside the color space of an absolute system, which uses only permanent color samples in its collection. Finally, unlike a relative system, an absolute system does not indicate how to match a given color with printing inks.

The GATF and other color surveys have revealed substantial differences between process-color printing conditions.[3] For this reason, a relative color order system that is generated under the printer's own conditions is the best color reference system that is available to the industry. Absolute color order systems can sometimes be used for color specification, but "off-the-shelf" printed color charts sold as dot percentage color guides should not be used for accurate color specification or control.

The ink-mixing reference type of relative color order system has existed in many forms. Almost every ink manufacturer and probably most printers have developed color drawdown samples that have resulted from combinations of two or more inks. These samples, plus the corresponding mixture records, serve as a guide for selecting and mixing future colors. The colors so selected are printed as solid special colors, such as the second color in a duotone job or a special background color for a label or a carton.

The black printer in the Foss Color Order System

The black images are shown in **A** and the effect of black No. 2 in **B**.

**A**

**B**

Various companies have developed color systems that consist of a series of colors plus white and black. Each page of their printed color reference contains up to seven solid colors. One central color

is made up of one or more of the basic colors. The other colors have either white or black added to the central color formula. The sample charts are printed on both coated and uncoated substrates.

The PANTONE®* MATCHING SYSTEM (formerly called PMS), which was introduced in 1963, is probably the most commonly

The Rochester Institute of Technology Process Ink Gamut Chart
*Courtesy Rochester Institute of Technology Technical and Education Center of the Graphic Arts*

used of all the ink-mixing color systems.[4] The basic ink colors in this system are identified by Pantone as PANTONE Yellow, PANTONE Warm Red, PANTONE Rubine Red, PANTONE Rhodamine Red, PANTONE Purple, PANTONE Reflex Blue,

*Pantone, Inc.'s check-standard trademark for color reproduction and color reproduction materials.

PANTONE Process Blue, PANTONE Green, PANTONE Violet, PANTONE Black, and PANTONE Transparent White. There are seven colors on each page and a total of 1,012 colors in the whole system. Each page in the system usually consists of a PANTONE Basic Color of one or more of the chromatic colors in the central position. The three lighter colors have the same proportions of the basic color components plus specific amounts of white. The darker colors again have the same proportions of the basic color components plus specific amounts of black. PANTONE Color Formula Guides are distributed by ink companies licensed to use the system and are also available for purchase from Pantone, Inc. or your local art supply store.

Some of the popular PANTONE MATCHING SYSTEM Colors have been matched by other products such as proofing film, artist's pens, and other art preparation materials.

The PANTONE MATCHING SYSTEM has been linked to a computerized color analysis system, the PANTONE Color Data System, where a spectrophotometer measures the desired color and then calculates what combinations of the basic colors will produce simulations.

The PANTONE MATCHING SYSTEM and other similar systems can be likened to the Ostwald Color System, where the gamut colors are obtained by mixing either white or black with a chromatic color. Colors that require additions of both black and white or that contain more than two chromatic colors make up only 13% of the available colors. Therefore, as a color order system, the PANTONE MATCHING SYSTEM is limited primarily to gamut colors. However, for the ink-mixing demands of this type of system, the color availability is probably satisfactory: selections of second or special colors would most likely be the more saturated colors shown in the guides. Of course, the system can be expanded to include more combinations of the basic colors if desired.

Some of the ink-mixing color order systems go beyond producing samples of solid colors. Halftone tint values of the individual colors and overprint solids or tints of other colors are sometimes incorporated into some guides. Because of trapping and dot gain variability, these latter guides are not as reliable as the basic solid guides. Solid fluorescent or metallic colors also appear in selected PANTONE Publications.

## Verbal Color Description

Numerical descriptors of color are usually too abstract for most people. Color sample descriptors are sometimes inconvenient to

obtain, locate, and use. Verbal descriptors, by contrast, are used extensively in all fields of human endeavor. The key problem with verbal descriptors is that they don't have universal meanings, therefore making specification and communication somewhat imprecise.

There are several aspects to the problem of using words to convey color descriptions. The first is the language itself. Some cultures have only two words, black and white, to describe all colors. The maximum number of basic color terms that are included in a language is eleven. They are added in this approximate order: white, black, red, green, yellow, blue, brown, purple, pink, orange, and gray.

The range of descriptors for colors within a given basic term varies according to environment. For example, desert dwellers have a large range of words to describe yellows and browns, while Eskimos have a similarly wide range of words to describe the colors of snow and ice. Their language does not contain a word for brown.

Another problem with verbal descriptors of color is that they keep changing. For example, a paint company once changed the name of its "Ivory" paint to "Oriental Silk," and as a result realized a substantial increase in sales. The power of a name to sell a color is substantial; therefore, we can expect the names of colors to change along with fashions.

A final problem with verbal description is the lack of universally accepted terms for describing changes in color. Terms such as lightness and darkness, vividness, brilliance, paleness, and deepness are used to modify color names or to indicate the direction of a desired change.

The problem of color naming was addressed by the Inter-Society Color Council (ISCC) in 1931. Work by the ISCC and the National Bureau of Standards (NBS) led to the 1955 NBS publication *The ISCC-NBS Method of Designating Colors and a Dictionary of Color Names* by Kenneth L. Kelly and Deane B. Judd. This landmark work (which is periodically updated) classifies thousands of color names under only 267 designations. These designations are identified by Munsell notation, therefore making it possible to determine the approximate appearance corresponding to any given color name.

The hue names selected by Kelly and Judd are listed in the accompanying table. The accompanying illustration shows the qualifying adjectives and adverbs used to describe the blocks in the purple segment of the color solid. Each hue segment does

not necessarily have a regular shape. Also, the qualifying terms and areas vary slightly from hue segment to hue segment.

It will be noted that the adjectives *light* and *dark* are used only for the colors near the black-white axis. Likewise, the terms whiteness, grayness, and blackness are confined to colors of low saturation. The terms vividness, depth, strength, and brilliance are applied to the more saturated colors.

ISCC-NBS hue descriptors

### ISCC-NBS Hue Descriptors

| | |
|---|---|
| Red | Yellow Green |
| Pink | Olive Green |
| Yellowish Pink | Yellowish Green |
| Reddish Orange | Bluish Green |
| Orange | Greenish Blue |
| Brown | Blue |
| Orange Yellow | Purplish Blue |
| Yellowish Brown | Violet |
| Yellow | Purple |
| Olive Brown | Reddish Purple |
| Greenish Yellow | Purplish Pink |
| Olive | Purplish Red |

The use of the ISCC-NBS color name system would reduce much of the ambiguity in color identification. However, with twenty-six hue terms and approximately nineteen hue descriptors for each, a convenient system of specifying color change is not easy to achieve. In the printing industry it is common for a print buyer to mark up a color proof with specified color changes. These changes are often rather cryptic or vague; thus there is a strong need for a satisfactory method of verbal communication of color requirements and alterations for the printing industry.

## Summary

The color attributes of hue, saturation, and lightness can be measured instrumentally, located in a collection of color samples, or described verbally. Some other attributes of color appearance—for example, gloss—can also be characterized by these methods. No one system satisfies the requirements of precision, convenience, and familiarity; consequently two or three of the methods may be used in a given situation.

For the printing and related industries the following usage is suggested: spectrophotometric measurements for ink color quality control; colorimetric measurements for paper color determination and possible monitoring of solid and tint colors on press; densitometric measurement for analyzing certain

Three-dimensional
nature of the
ISCC-NBS color
designators for one
hue

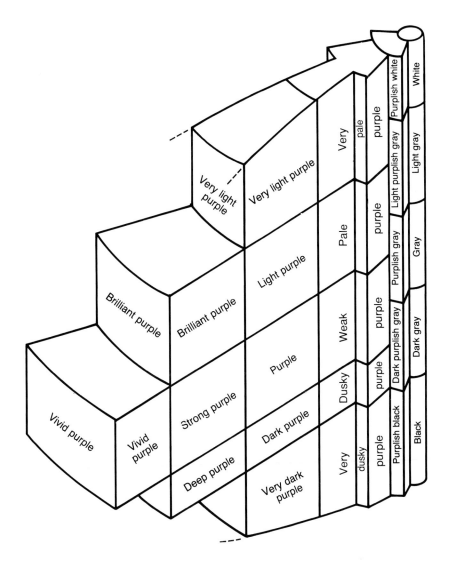

color printing problems and monitoring change in ink film
thickness; the Munsell Color System for explaining the
attributes of color; the Ostwald and/or the Natural Colour
System for explaining color mixing; the Foss Color Order
System for specifying halftone color values; the Pantone or a
similar system for determining ink-mixing formulas for
matching special colors; and the ISCC-NBS System for naming
colors.

A trained observer can distinguish about ten million distinct
colors. Verbal systems can only describe a few hundred,
physical sample systems a few thousand, and instrumental
systems, hundreds of thousands. Hence, the precision

requirements of a given situation will tend to dictate the specification system that should be used.

**Notes**

1. Ralph M. Evans, "Accuracy in Color Photography and Color Television," *ISCC* 1971 (Rochester, N.Y.: RIT Graphic Arts Research Center), pp. 47–48.

2. Robert P. Mason, "Specification and Control of Process Color Images by Direct Colorimetric Measurement," *TAGA Proceedings* 1985 (Rochester, N.Y.: TAGA), pp. 526–545.

3. Gary G. Field, "The 1970–72 GATF Color Survey," *Research Progress Report* No. 98 (Pittsburgh, Pa.: Graphic Arts Technical Foundation, 1973); A. R. Muirhead et al., "North American Print Survey," *TAGA Proceedings* 1985 (Rochester, N.Y.: TAGA), pp. 585–601.

4. Terry Scarlett and Nelson R. Eldred, *What the Printer Should Know about Ink* (Pittsburgh, Pa.: Graphic Arts Technical Foundation, 1984), p. 16.

# 4  Paper and Ink

Ultimately, the perception of the printed sheet depends largely on the optical properties of both the substrate and the printed ink film. Physical properties, such as paper smoothness and ink tack, also contribute to appearance factors, e.g., resolution and ink transfer. Therefore, it is appropriate to discuss some of the more important substrate and ink properties that affect color reproduction.

## Paper and Other Substrates

Because the vast majority of color printing is done on paper or paperboard substrates, this section focuses on their characteristics. However, other substrates—namely, films, foils, and metals used in the packaging industry—are discussed briefly at the end of the section.

## Reflectance

The optical properties of *whiteness* and *brightness* can be best understood by reference to spectrophotometric curves. The curves in the accompanying illustration are derived from measurements of white paper samples collected during the 1970–72 GATF Color Survey. These curves show the reflectance of visible light as measured at every 10 nm relative to a barium sulfate standard.

Spectrophotometric curves of paper samples collected as part of a GATF color survey

The *peak* of 440 nm for one paper is due to the optical brighteners added during the paper-making process.

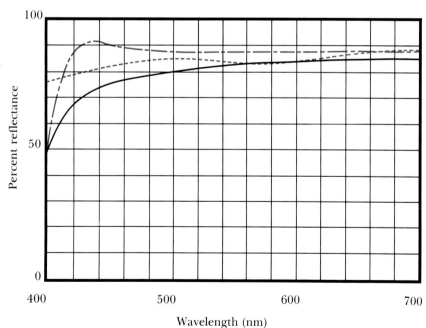

## Whiteness

The **whiteness** of a substrate can be defined as the absence of a color cast or the ability to reflect equal amounts of red, green, and blue light. That is, a *white* sheet is a *neutral* sheet. In

practice, most white papers have a slight yellow cast. Although a neutral sheet may be desirable strictly from a color reproduction standpoint, independent studies indicate that more image/nonimage contrast is perceived with paper having a blue-white cast. This is particularly noticeable when using black text and halftones.

The illustration above shows papers with consistently higher red- and green-light reflection than blue-light reflection. The yellowish cast is due to the natural color of the pulp used in papermaking. This yellow color can be neutralized by the addition of blue dye or fluorescing agents during pulp preparation or coating formulation.

In order to avoid printed color distortion, it would seem logical that the substrate be as neutral as possible. For most printing substrates, however, the observer mentally adjusts to a slight color cast, takes it as a reference white, and perceives all other colors relative to that reference. This works well when viewing a sheet in isolation, but when comparing it to a proof or previously printed job, shifts in the color of the substrate become more apparent.

The best way to determine whether paper color will be a problem in color reproduction is through a visual comparison. Simply compare samples of the unprinted substrates side by side and don't use those that look significantly different. Several thicknesses of lightweight papers should be used to avoid poor opacity, which causes a false color bias. Standard viewing conditions must be used for the evaluation. Densitometer readings of the unprinted substrates are not particularly useful because of poor discrimination ability in light tonal or color areas. If numerical results are required, colorimetric measurements can be made. The illustration shows colorimetric plots of a sampling of papers in the 1970–72 GATF Color Survey.

**Brightness**

The **brightness** of a substrate, from a color reproduction viewpoint, can be defined as the total reflectance of light from that substrate. By contrast, the papermaking industry defines brightness as the 45° diffuse reflectance at 457 nm. This measure is used to control the brightening agents added during the papermaking process.

Generally, the more light reflected from a sheet the better, from a color reproduction viewpoint. A substrate that reflects 90% of the red, green, and blue light that falls on it produces a better reproduction than a substrate that reflects only 75% of

An enlarged section of a chromaticity diagram showing a selection of average printing substrates

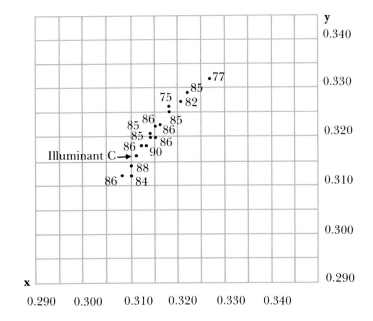

The points lie along a blue-yellow axis. The numbers beside each point represent the lightness values that extend vertically from the page.

the red, green, and blue light. The lower-brightness paper produces reproductions with lower contrast and sharpness.

The evaluation of brightness is best done through the visual ranking of unprinted samples of substrates. Colorimetric measurements also can give useful results, especially when whiteness is a factor in paper evaluation. The above illustration indicates paper color in the x-y coordinates (the points follow a yellow-blue orientation) and lightness. The numbers beside each point indicate the lightness values.

**Fluorescence**

Fluorescence in paper can prove potentially troublesome when one is trying to achieve exact color matches of light, pastel colors. A reflection original, a proof, and a printed sheet with different fluorescing characteristics can contribute to the problem of metamerism. The adoption of a standard 5,000 K viewing source has helped to minimize this problem.

Fluorescence can be best detected by illuminating the samples in question with a **black light** (a source rich in ultraviolet and low-frequency blue radiation) in a darkened room. A simple visual ranking of the substrates could then be made. Spectrophotometric and colorimetric measurements also can be used to characterize the fluorescing properties of the substrate. It is very important that the light source be specified when making such measurements because fluorescence is highly dependent on the illuminant.

**Gloss**

While it can be stated that high gloss improves the reproduction of photographic originals, there are other cases where gloss can be a detriment. An artist's watercolor or drawing that was prepared on a matte surface should be printed on a matte surface in order to retain the integrity of the original. Also, there are some photographic originals with a particular mood and texture that would be disturbed if high-gloss substrates and inks were used. Finally, it is common for text and illustrations to appear side by side in such printed matter as magazines, newspapers, some books, annual reports, and advertising brochures. High gloss contributes to eye fatigue when reading text; therefore, what may be good for pictorial reproduction is poor for text printing. Packages, book covers, posters, postcards, and record album covers have no text to speak of and are often finished with a high gloss.

Gloss can be detected by illuminating the surface with a focused light beam and positioning the eye so the angle of incidence and the angle of reflection are equal. A glossmeter is used to make accurate measurements of gloss. For most papers, the standard method is to make measurements 75° from the perpendicular. Because paper is a nonuniform substrate, readings are usually taken in both the grain and cross-grain directions. High-gloss papers (cast-coated, extrusion-coated, film-laminated, etc.) and high-gloss inks, varnishes, and coatings often are measured at 60° or 20°, which produces lower percent gloss readings but enables better objective analysis of samples.

**Internal Light Scattering**

Some substrates, especially paper, are not perfectly dense, opaque materials. Thus, when light strikes the paper surface, or when it passes through the printed ink film, there is scattering of light among the fibers and other materials that make up the substrate. Some of the light that passes through the ink film eventually emerges from the paper in an unprinted area, shifting the color of that area toward the color of the ink film. This phenomenon makes halftone values appear darker than would be predicted by physical measurement. The darkening of halftone values is called *optical dot gain*. Another effect of internal light scattering is to make light-tint color tones appear *cleaner* (less gray or more saturated) than the same tint printed on a substrate having less internal light scatter.

The degree of internal light scattering largely depends on the amount and type of coating applied to the substrate.

Uncoated papers exhibit the highest scattering, followed by clay-coated paper, and finally white ink or enamel coated on metal, which exhibits very little scattering. Internal light scattering is related to opacity—the more opacity *per unit thickness*, the less internal light scattering. Opacity can be measured with an **opacimeter,** which, when divided by the caliper, is a measure of unit opacity. For all but very thick papers, this measure gives some indication of the propensity for internal light scattering.

It is difficult to determine whether internal light scattering is good or bad. Light color tints tend to be cleaner with light scattering, but the image loses sharpness and tonal values appear darker. Compensation can be made for the darkening of tonal values; thus, the issue is reduced to a trade-off between sharper images and improved color rendition of light tones. In practice, it is impossible to consider the internal light-scattering properties of paper in isolation. High scattering is associated with uncoated paper, which in turn is associated with low gloss, higher absorbency, and lower resolution. Therefore, some originals, such as low-resolution artist's watercolors containing many pale colors, will probably reproduce very well on papers with high internal light scatter. For most other types of reproduction, a coated paper with moderate internal light scattering is probably better than uncoated papers having high internal light scatter.

**Absorbency**

Although a physical and not an optical property, the absorbency of paper has been shown to cause shifts in the color of the printed ink film. Frank Preucil of GATF was able to integrate absorbency and gloss measurements into a measure called *Paper Surface Efficiency* (PSE). High gloss and low absorbency produced a high paper surface efficiency; that is, the minimum distortion of the printed ink film color by the substrate. Metals and plastics had high PSEs. Low gloss and high absorbency produced a low PSE with significantly higher shift of the printed ink film color. Cyans became grayer and magentas became redder. Uncoated paper had low PSEs.

Absorbency can be measured by the use of **K and N testing ink,** a special gray ink. The K and N ink is applied to the papers under test for two minutes. The ink is then wiped off, and the density of the resulting stain on the paper is measured with a densitometer. Some paper companies measure the brightness of the K and N stain or calculate percent retained brightness. Note that a single stain produces different values of

Printed samples of
the same cyan ink on
different papers

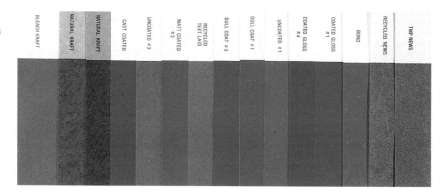

reflection density, percent reflection, brightness, and percent retained brightness; thus, the same measuring method must be used for proper communication. Croda Ink Company also has a similar red absorption test ink. In addition to the objective measurements, the ink stain should be ranked for absorption uniformity or the tendency to mottle. Darker stains indicate high absorbency.

From the color reproduction viewpoint, it is desirable to have substrates with low absorbency, hence resulting in minimal degradation of the printed ink film color. However, other printability concerns such as drying and ink transfer ultimately impose the minimum absorbency requirements.

**Smoothness**

The other physical substrate property that influences color printing (of halftones) is smoothness. The smoother the paper, the higher the resolution that can be achieved. For special effects, textured papers are sometimes used for color reproduction. Image resolution is always lower when such papers are used. Lightweight embossed papers also should be avoided for high-quality process-color printing, as these papers often lack adequate dimensional stability needed to obtain tight color-to-color register. A range of optical and air-leak smoothness testing devices is available. High-gloss papers always have high smoothness, but some high-smoothness papers do not have high gloss.

**Nonpaper Substrates**

Plastics, foils, metal, and glass fall into the category of **nonpaper substrates** and are commonly used in the packaging industry. Generally, these materials are selected more for their barrier and strength properties than for their optical or color reproduction properties.

The nonpaper substrates usually can be thought of as having low absorbency and lacking a white, bright surface. Some

surfaces are metallic, others transparent, e.g., plastic. However, these substrates also are very smooth and usually have high gloss. In practice these substrates are often coated with an opaque white ink or enamel that acts as the printing surface. (In the case of flexible packaging films, the white "base" is applied after the colors and the web is turned over for use). Sometimes the natural metallic base or the clear plastic film is used as part of the design.

The net effect of the opaque white coating is to produce a neutral surface with low internal light scattering, high gloss, and low absorbency.

## Ink

The formulation of ink largely depends on the requirements of the particular printing process. Concerns such as drying, picking, chemical ghosting, and mottle, while important to overall print quality, do not pertain directly to color reproduction and therefore will not be considered. The discussion is limited to the color properties of inks.

The process-color inks—yellow, magenta, cyan, and black—are commonly abbreviated as Y, M, C, and K. The letter K is used for black rather than B to avoid any confusion with the word "blue." In some cases the cyan ink is called "blue" or "process blue." In addition, the term "red" or "process red" is sometimes used to describe magenta inks. These alternate terms are incorrect.

The use of "red" and "blue" for magenta and cyan can cause confusion. For example, it is correct to refer to red-, green-, and blue-*filter* color separations; also, it is correct to use the terms red, green, and blue *overlaps* when discussing ink trap. If the terms red and blue are used to describe the magenta and cyan *inks*, they are likely to cause misunderstandings. The color reproduction process is complex enough already without the use of terms that will make the process even less clear.

## Color Gamut

The **gamut,** or color range, of an ink set is largely determined by the selection of the pigments used in the ink. The objective, from the viewpoint of color reproduction, is to use pigments that give the widest possible color gamut, thus allowing the more accurate reproduction of original colors. In practice, other concerns also must be considered when selecting a set of process pigments: resistance to light, moisture and chemicals; cost; fineness of pigment particle; ability to be dispersed in the vehicle to give good flow properties; low toxicity; and the ability to produce minimal environmental concerns.

Process-ink pigments most commonly used include carbon black for the black ink, phthalocyanine for the cyan ink, diarylide yellow for the yellow ink, and either lithol rubine or rhodamine Y (or a combination thereof) for the magenta ink. Toners also are often added to inks to achieve the desired spectral qualities.

The gamut of a good commercial process ink set plotted on a CIE chromaticity diagram

Also shown are the ranges of colors discerned by the eye and the camera.

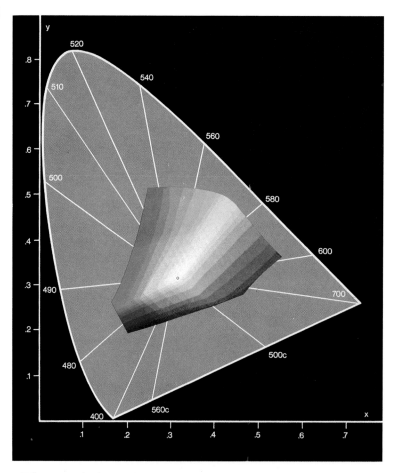

The restrictive color gamut in the illustration above suggests that it is impossible to reproduce certain colors. However, while some colors are difficult to reproduce, it is obvious that high-quality color reproductions are regularly produced using common pigments. Thus, it seems that the pigments listed above are quite satisfactory for the great bulk of color reproduction work.

Occasionally, special fifth or sixth colors are used to help extend the color gamut of the process ink colors. Blues, violets, and reds seem to be the most common colors used in this respect. Pinks and light grays also are used occasionally as supplementary colors. Sometimes extra colors are used to get around particular press problems, such as trapping or the lightness/dot gain trade-off, rather than for gamut expansion.

More commonly, fifth or sixth colors are used, not to expand the process color gamut, but rather to produce background solid colors or to match a trademark color on a label or carton. These special colors are often used as second colors for letterheads, brochures, and books. Typically, the special colors are mixed from a set of eight base colors (plus black and white) according to the proportions specified in a color swatch book. These formulas must be followed carefully in order to avoid the problems of metamerism.

Color gamut is best characterized by printing a color chart such as the Foss Color Order System or the Rochester Institute of Technology's Process Ink Gamut Chart. Gamut is best evaluated visually, but colorimetric or densitometric measurements can be used to help quantify color gamut. A particularly simple way of characterizing color gamut is to measure the yellow, magenta, and cyan solids through red, green, and blue filters, plot the resulting points on the GATF Color Triangle (Chapter 3), and connect the points. The enclosed area represents the approximate color gamut.

**Transparency and Opacity**

In an idealized system, the process inks reflect no light, with the exception of minor first-surface reflections. Rather, the printed ink film should function as a filter, with the substrate having the role of reflecting the light, as modified by the ink film, back to the viewer. In other words, the printed ink film should be transparent. In practice, all inks are slightly opaque, which means that some rays of light that strike the ink film are reflected by the pigment particles in the ink film rather than by the substrate under the ink film. This means that the resulting color, when two or more ink films are overprinted, will be skewed towards the hue of the top-down color. This problem is most noticeable with yellow pigments.

In some cases, opacity is a desirable property for pigments to have. In cases where it is necessary for a color to obscure the surface or color underneath completely, an opaque pigment is a necessity. Such requirements exist for some screen-printed

The use of the
GATF Color
Triangle for color
gamut determination

Lines drawn between
the plots of the
primary colors will
show the approxi-
mate hue-saturation
components of color
gamut.

posters, metallic colors, and the "backup" white used as a base for metal or flexible packaging printing.

Opacity can best be detected by making a drawdown across a black bar printed on white paper. If the black bar appears unchanged, the ink is quite transparent. If the black bar has shifted towards the hue of the ink under test, the ink is partially opaque.

A drawdown of two inks showing that the one on the right has the higher opacity

**Tinctorial Strength**

The **tinctorial strength** of an ink is a measure of the amount of ink per unit area required to produce a given strength of color. The lower the amount of ink, the higher the tinctorial strength. Tinctorial strength is influenced by pigment selection and quantity of pigment used in the formulation.

In general, high-tinctorial-strength inks are preferred over low-tinctorial-strength inks. With high-strength inks, thin ink films can be run, thus minimizing dot gain and resolution problems, and probably reducing trapping problems. Less ink will be consumed, resulting in the likelihood of lower costs. However, high-tinctorial-strength inks generally cost more than the lower-strength inks, so unit cost and total volume must be considered together in order to determine total cost. Possible drawbacks to high-tinctorial-strength inks include lower gloss, higher viscosity, and the increased forces required to split thin ink films, which, in turn, can lead to picking of the substrate.

The main problems concerning tinctorial strength are those encountered when trying to match a press proof to press runs.

If the proofing inks have high tinctorial strengths while the printing inks have lower strengths, a satisfactory match between proof and press sheet may be impossible to achieve. When color saturation in solids is correct, dot gain will be too high. When dot gain is satisfactory, solid colors will be desaturated.

The **bleach out** test is used for comparing tinctorial strengths of inks. One part of the test ink is mixed with fifty parts of a white bleaching compound (for example, titanium dioxide dispersed in a vehicle compatible with the ink under test). In practice, an opaque white ink is often used as the white bleach. One part of the standard ink also is mixed with fifty parts of the white bleaching compound. Samples of each of these mixtures are then simultaneously drawn down on white bond paper so that the drawdowns contact each other. A visual comparison is made. By adding white bleach to the darker of the two mixtures until both mixtures match, it is possible to calculate the tinctorial strength of one ink relative to the other. For example, another fifty parts of white may have to be added to the standard ink to get a drawdown match. If this were the case, the test ink would have one-half the tinctorial strength of the standard ink. The test is difficult to control, but it does indicate gross tinctorial-strength differences.

**Gloss**

The comments on the gloss of printed ink films are similar to those on the gloss of paper. For most pictorial reproduction, high gloss is desirable because it improves contrast and saturation. For artist's watercolor or poster color originals, high gloss is not desirable.

Gloss is dependent on the type and amount of vehicle, relative to pigment, in the ink. Gloss is measured with a glossmeter from a rollout of the ink under test on the paper that will ultimately be used for printing.

**Other Characteristics of Ink**

Other perceptual attributes of ink include color fastness, fluorescence, and metallic appearance.

Printed ink films can fade, bleed, or change color in the presence of light, water, heat, alkalis, acids, soap, detergent, oils and fats, waxes, or various foodstuffs. Fading of color due to exposure to light is a common problem for virtually all inks. Some pigments are much worse than others; the organic yellows, in particular, are not very lightfast. Type of vehicle and pigment concentration have also been shown to affect the color permanence.

Fluorescent inks are readily available. They are usually used for solid type and background colors on packages, as well as for some screen-printed posters. Some inks exhibit unwanted fluorescence, which can cause problems in color matching— a fact that stresses the importance of using a standard light source for color viewing. As noted earlier in the chapter, fluorescence can be detected by illuminating printed ink film samples with black light in a darkened room or viewing booth.

Metallic finishes can be either undesirable or desirable. The undesirable type results from the migration of toners to the surface of a printed ink film. Reflections from the surface of the ink film mix with light reflected from the substrate through the ink film, thus distorting the intended color. Black and blue colors are usually the ones most affected. This problem is sometimes called bronzing, and changing color sequence can help to hide it. On the other hand, desirable metallic finishes are produced by making inks with aluminum or bronze particles suspended within the vehicle. They are usually quite opaque.

## Printed Ink Films

The evaluation of inks and substrates can be partially conducted by evaluating the materials independently. However, many color properties cannot be measured until there is an interaction between ink and substrate. This requires that samples be produced that simulate the ink-on-substrate appearance of normal printing. The ultimate way to produce such samples is by running a special test form on the actual press to be used in practice. The on-press test captures information that is not normally revealed by simple bench tests. For example, with lithographic printing, the effects of plate type, fountain solution, blanket type, and press settings all combine to produce information on the final print that would not be captured by a simple drawdown of ink on the substrate. Of course, the big drawbacks with press testing are time and cost. Press tests should be run on an occasional basis, but for routine sample generation, other methods must be considered.

## Producing Samples

Combination ink-and-substrate samples can be generated by a number of methods. The most simple, and probably the most common, is the tap-out test. Wet ink is simply tapped out with the finger until the ink film density is the same as normal printed density. Obviously, this method has drawbacks: ink film thickness is unknown, the tapped-out area is small and

generally uneven, and moisture and dirt from the finger may influence the color of the ink film.

Another common method of producing ink-substrate samples is the drawdown. A drawdown ink knife spreads a small sample of ink over the substrate. Two inks may be drawn down side by side, thus making the test useful for comparing two inks at the same time. Again, the big drawback is that ink film thickness is unknown. Also, it is particularly difficult to get a good drawdown on low-absorbency glossy papers.

The other off-press methods of producing samples involve the use of precision ink-metering devices and the transference under precise conditions of a known quantity of ink to paper. These range from the *Quickpeek* rollout test through the printability testers to the flatbed proof presses. As might be expected, the time, cost, and space requirements of these pieces of equipment increase along with their ability to produce a sample that most accurately predicts actual press performance. For most routine work, a rollout tester like the Quickpeek is satisfactory. The biggest problem with this method is controlling roller pressure when making ink transfers. With practice, a single operator is able to obtain reasonable consistency. It is best not to use just one method of producing test samples. Different or many methods should be used depending on the circumstances.

**Optical Evaluations**

The sample dimensions for optical evaluation vary according to the measuring instrument. Densitometers can successfully measure areas as small as $\frac{1}{4} \times \frac{1}{4}$ in. ($6 \times 6$ mm). On the other hand, some spectrophotometers and colorimeters require samples up to $1 \times 1$ in. ($25 \times 25$ mm). Glossmeters also require samples about $1 \times 1$ in. ($25 \times 25$ mm).

When using the densitometer to evaluate printed samples, calibrate it to the supplied reference or zero it to the substrate. If the densitometer is calibrated to the reference, measure the printed ink film, measure the unprinted substrate, and subtract the substrate density from the printed ink film density in order to eliminate the effect of the substrate.

Spectrophotometers and colorimeters are usually calibrated to a reference white, such as barium sulfate. Unlike densitometers, colorimeters and spectrophotometers often offer a choice of measurement conditions: specular component included or excluded, fluorescence included or excluded, and, for colorimeters, the choice between CIE illuminant A, C, or D65. For printed ink films the 0/45° geometry most closely approximates

normal viewing conditions, and illuminant C or D65 comes closest to the 5,000 K industry standard viewing source. To simulate normal viewing conditions more closely, the fluorescent component should be included in measurements.

Glossmeters are available in a variety of different geometries, or in some cases, adjustable geometry. For measuring coated papers, the geometry where incident and reflected beams are 75° from normal is preferred. For cast-coated papers, the 20° geometry should be used, and for printed ink films, the 75° geometry is the most common.

Readings should be made both with the paper grain and against it when measuring either unprinted paper or printed ink films. This is particularly important when directional geometry (such as 0/45°) rather than diffuse geometry is used. When comparing readings from wet and dry samples, it must be realized that wet readings will be higher than dry readings. As the ink dries, the gloss decreases, thus increasing the first surface reflections and lowering the density. Ideally, all readings should be taken dry. Alternatively, for density readings, a correction factor can be used to convert wet to dry readings. This factor varies according to the ink and paper in use. To compute it, measure the printed ink film wet, measure the same spot when it is dry, and record the difference between the two readings as the correction factor. Polarized densitometers read wet and dry densities alike.

**Physical and Chemical Evaluations**

Tests for physical and chemical evaluations are often run under the actual conditions that the product is expected to withstand. For fading tests, prints are placed 1 ft. (0.3 m) from a south (in the northern hemisphere) window for thirty, sixty, or ninety days. Fadeometers and other special laboratory testing machines are available for testing light exposure as well as other outdoor exposure conditions. For evaluation of resistance to various chemical or animal products, the printed sample is either dipped in or wrapped around the substance under test. Changes in the printed ink color can be characterized by the previously discussed optical measuring instruments.

**Standard Materials**

There are very few standard inks or papers in the printing industry. For most printing, there is little need for such standards: the printing industry produces many kinds of products, such as magazines, books, folding cartons, greeting cards, labels, flexible packaging, catalogs, annual reports,

advertising brochures, and more. Establishing a common standard for these products would unnecessarily restrict variety and creativity and ignore the economics of the individual products.

However, there is one branch of the printing industry in which standards are imperative—publications that contain advertising. Color separations and proofs for the advertisements are often made by many different color separators. These separations are printed in-line in the same magazine. If the inks, papers, and other manufacturing conditions were not compatible in the proofs, then it would be virtually impossible for the printer to get all the printed advertisements to appear the same as their proofs. In the U.S., specifications for web offset magazine proofing have been established by the SWOP committee, while those for gravure have been set by the Gravure Technical Association. In Europe the ISO 2846 standard addresses the same problem.

Many people would like to see proofing conditions standardized to simplify the color separation process. However, as long as there is a need for variety in the industry's printed products, a goal for a standard substrate and process ink set is both unnecessary and ill-advised.

## Summary

The ink and substrate *are* the printed product; therefore, their characteristics make a very large contribution to the ultimate appearance of the end product.

Purchasing agents, estimators, the sales force, production management, press operators, and anyone else likely to make decisions about paper and ink selection should be aware that what may seem to be subtle distinctions between different inks or papers may produce serious color-matching problems. The nature of these problems usually becomes apparent only when the job is on press. To lift the job from the press at this stage not only wastes money but also loses time.

An important point to remember is that cheaper inks or papers usually correlate with lower-quality printing. For example, inks with low-tinctorial strength are cheaper than those with high strength. But, in order to get satisfactory solid densities, thicker films of the low-tinctorial-strength ink must be used (hence increasing total cost), which in turn can create dot gain problems. The use of low-tinctorial-strength inks on press compared to high-tinctorial-strength inks when proofing is a major reason for the classic "why-won't-the-print-match-the-proof" problem.

The testing of ink and substrates for various optical and physical properties can become a full-time activity. However, for the average printing plant, such testing will not only be quite expensive, but, in many cases, unnecessary. Routine visual comparisons of paper whiteness, brightness, and gloss should satisfy most needs. Occasional K and N absorbency tests of paper, and rollouts of ink for visual or instrumental color and gloss comparisons will generally take care of most optical testing needs. Tinctorial strength is important, but it is not a convenient test to run. However, such tests should be run whenever changing ink manufacturers, using new ink batches, or checking the quality of ink from current suppliers. For more elaborate, but occasional, testing needs, samples can be sent to the laboratories of GATF or similar organizations.

# 5 Color Printing

After the selection of the ink and substrate, the printing process is the other factor that determines the characteristics of the end product. The machine that transfers ink to paper can control printed ink film thickness, ink transfer—both to paper and to previously printed ink films—dot gain, register, and resolution.

Of course, the reproduction also depends on the image on the plate, which is modified to suit the printing process by adjusting the preceding film images. The characteristics and performance of the printing press dictate the aimpoints and objectives of the previous stages. The printing press produces the ultimate product of the color reproduction process and usually is by far the highest production cost center.

The most important color printing processes are lithography, gravure, and flexography. Screen process printing is restricted to low-volume work. Letterpress, once a dominant color printing process, has declined in popularity.

## Methods

### Lithography

The **lithographic printing process** was developed in 1798 by Alois Senefelder in Germany. The original process consisted of crayon drawings on a special stone. These stones were dampened with water and then rolled up with ink. The ink adhered to the greasy crayon image and was repelled by the dampened stone area. The inked image was then transferred to paper on a flatbed press.

Lithography started to become a major printing process when the rotary press, offset cylinder, and the wraparound metal plate were introduced. It took until the 1950s before lithographic platemaking technology and lithographic inks and papers were refined to the point where consistently high-quality lithography became a possibility. With the refinement of webfed presses and the rapid spread of four-color presses, lithography became the dominant color printing process.

The primary advantages of offset lithography include low-cost platemaking, high-speed production, economical production for short or long runs, the ability to print on a wide variety of surfaces (smooth and rough), and higher resolution than any other printing process. The biggest problem with lithography is the control of ink-water balance.

### Gravure

The modern **rotogravure process** was developed from the *intaglio process* in 1890 by Karl Klietsch in England following his earlier work in Austria. The gravure image areas consist of cells recessed in the surface of a cylinder. The cells are about

0.005 × 0.005 in. (0.127 × 0.127 mm) in area and vary up to 0.002 in. (0.05 mm) in depth. Conventional gravure has cells of common size and varying depth. Other gravure cell systems include varying area and common depth, and varying area and varying depth. The cells are filled with ink; a blade scrapes the excess ink from the cylinder surface, and the ink is transferred, under pressure, to the substrate. Transfer is aided by the capillary action of the paper fibers or coating and electrostatic assist systems.

The primary advantages of the gravure process include consistent print quality, high-speed production, long-lasting cylinders, and good color saturation and strength. The major disadvantages include high cylinder cost and the necessity to use smooth substrates. Gravure is generally restricted to printing long-run magazines, catalogs, folding cartons, flexible packaging, and specialty items.

**Flexography**

The **flexographic printing process** dates from about 1905, when the first aniline press was built by C. A. Holweg of France. The process used a relief rubber plate, web feeding, and rapid-drying inks, which consisted of dyestuffs dissolved in spirits. The early plates were duplicates made from letterpress engravings; today most flexo plates are made directly from negatives on soft photopolymers. The *inking system* is one feature that sets flexography apart from letterpress. Flexography uses a fluid petroleum solvent- or water-based ink that is distributed to the plate by a single engraved cylinder called an **anilox roll.** A nip roller or a doctor blade removes the excess ink from the anilox roll before it inks the plate.

The primary advantages of flexography include high speed, variable image cut-off length, the ability to print on virtually any surface, and relatively inexpensive and simple printing presses. The disadvantages are those associated with relief image carriers. They include lower resolution than lithography, difficulties with pressure differentials, and image distortion on uneven substrates.

**Screen Printing**

The use of a stencil to form an image is probably the oldest method of producing duplicate images. The modern **screen printing process,** however, derives from the silk screen printing patent of Samuel Simon in 1907 in England, in which a hand-cut stencil was applied to a silk mesh that was stretched tightly across a wooden frame. Ink was forced through the stencil and mesh onto the substrate by a brush. Today's screen

Principles of the
offset lithographic
printing process

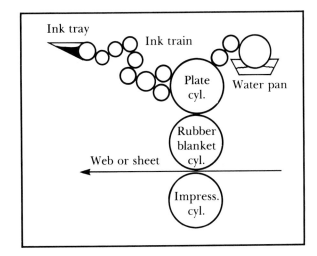

Principles of the
gravure printing
process

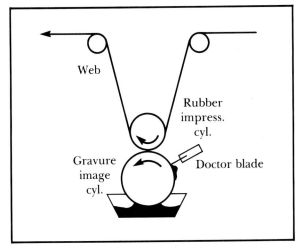

Principles of the
flexographic printing
process

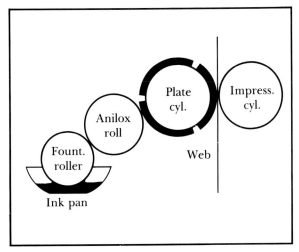

printing process is virtually identical. Now, mesh screens of nylon or polyester and photographically produced stencils are used together with a squeegee instead of a brush.

The advantages of the screen printing process are that it can print on any substrate (curved or flat), it can lay down an extremely thick ink film, and it doesn't even require a printing machine, although they are commonly used for high-quality work. The big drawbacks with screen printing are that it is extremely slow, has limited resolution, and requires the use of drying racks or tunnels. The process is well suited for short-run, high color-saturation work printed in any size on any substrate. Large posters and showcards are often printed by the screen printing process.

**Letterpress**

**Letterpress** is the oldest of the printing processes, dating back to the use of relief woodblock printing by the Chinese in 593. Johann Gutenberg, in Germany during 1455, developed the process further by linking typecasting, ink manufacture, composing, a press, and paper into a single workable printing system. The process uses a relief image carrier and a paste ink. The ink is broken down to a thin film by a series of rollers, then transferred from the image carrier to the substrate by direct impression.

The major advantages of the process as compared to lithography are high color strength and saturation, and consistent quality printing. The drawbacks include slow speed (for platen and cylinder presses), the necessity to use smooth papers, lower resolution than lithography, expensive plates, and the need for differential packing when printing halftones. The use of letterpress for process-color printing declined rapidly in the United States after long-run reliability was developed in the lithographic process. The lack of rotary letterpress presses capable of producing high-quality work left the expanding process-color market to lithography and other processes.

# Running Considerations

The following considerations apply to each of the printing processes, but the primary focus is on the most difficult process to control—lithography. Although the discussion assumes the use of multicolor printing—i.e., two or more printing plates, many of the considerations apply to single-color printing as well.

**Sequence**

When printing the four process-color inks, there are twenty-four possible color sequences. Most printers use one of three:

Principles of the
screen printing
process

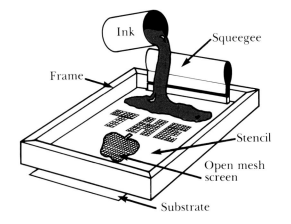

Screen-printed
image

Principles of the
letterpress printing
process

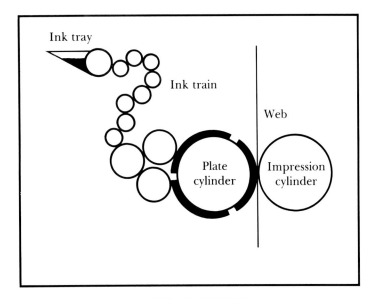

yellow, magenta, cyan, and black (YMCK); cyan, magenta, yellow, and black (CMYK); and black, cyan, magenta, and yellow (KCMY). There are many reasons why one sequence may be preferred over another.

**Optical factors.** These factors are established by the optical properties of the printed ink films.
● **Opacity.** The color of overprints shifts toward the color of the top-down ink if that ink is at all opaque. Also, the density of the four-color solid (and hence the contrast of the printing) will be reduced if nontransparent colors are printed over black, compared to printing black over those colors. This is especially noticeable when yellow is the last-down color. The KCMY

sequence may reduce the maximum density by about 0.40 in comparison to YMCK.

- **Gloss.** Some process colors (notably yellow) have a higher gloss than others. Running such colors last in the sequence can improve the gloss of the finished print.
- **Bronzing.** Certain inks (notably black but sometimes cyan and magenta) have toners as part of their formulation. Under some circumstances, these toners can migrate to the surface of the printed ink film and change its appearance. This problem can be minimized by printing that ink earlier in the sequence.

**Production problem factors.** These factors occur when press, ink, substrate, and plate are combined under production conditions. When the results are not satisfactory, a press operator may alter color sequence in order to minimize a given problem and thus improve the appearance of the final print. The problems that the operator seeks to minimize are listed below.

- **Trapping.** The ability to transfer one ink to a previously printed wet ink depends on a variety of factors. Sequence affects this transfer, as does trapping if the inks are not run in their correct tack sequence. The first-down ink should have the highest tack, with each succeeding ink having slightly lower tack.
- **Doubling.** Under some circumstances, a form of dot gain called doubling can cause printing problems. This is especially true when very heavy ink films are being run. To minimize the effect of this factor, the most critical color (for example, magenta in a catalog job containing many skin tones or black in a magazine with considerable textual matter) could be run on the last unit.
- **Mechanical problems.** A particular printing unit may be causing slur or misregister due to mechanical problems with that unit. Until repairs are made, the noticeability of the problem may be minimized by running yellow, the least visually discernible color, on the defective unit.
- **Printback.** On long runs with heavy ink films, the gradual contamination of one ink by the preceding ink is sometimes observed. This contamination could take the form of magenta contaminating yellow and turning it toward orange. The printback problem can be minimized by printing lighter colors before darker colors; for example, yellow before black will not result in any noticeable contamination, but the reverse could result in serious contamination.

● **Backtrap mottle.** A variety of factors can contribute to the phenomenon known as backtrap mottle. Large solids composed of approximately 100% cyan and 70% magenta seem most likely to show backtrap mottle. Changing color sequence so that the heavy form overprints the light form minimizes most mottle. Printing the offending color (usually cyan) last will eliminate backtrap mottle in that color and its overprints, but the problem may then occur in another color. Changing paper may be required.

● **Ink coverage.** Inks with heavy coverage can often cause distortion of thin substrates. Consequently, to facilitate register, it may be desirable to print this ink last in a four-color sequence. This argument is frequently advanced for printing yellow last, since it often is the heaviest-coverage color. Other related arguments for printing yellow last include reducing moiré patterns, minimizing noticeable setoff, and improving rub resistance. Yellow-last arguments such as covering an ink that has a tendency to bronze and improving gloss have already been mentioned.

Some claim that yellow is printed at a heavier film thickness than the other process colors and consequently causes trapping and dot gain problems under normal printing conditions. Some also claim that yellow is more difficult to trap on and thus should be printed last. With proper ink tack differentials, there does not seem to be any reason why good trapping on yellow cannot be achieved.

● **Gray balance.** The U.S. Specifications for Web Offset Publications (SWOP) guidelines suggest selecting color sequence to achieve gray balance (and to achieve maximum trapping). However, to maximize trapping for two given colors (e.g., yellow and cyan) does not mean that trapping for other overprints (yellow and magenta, and cyan and magenta) is also maximized; consequently, the recommendation is quite vague.

Gray balance should be established in a set of separation films for a given set of printing/proofing conditions that would include color sequence. If a number of color separators produce films (and proofs) gray balanced for different color sequences, it will be impossible for a printer, using one color sequence, to match all proofs.

**Other factors.** Other reasons advanced for the use of one sequence over another are usually related to printing four colors on a one-color press. They include ease of washup (print

light colors before darker colors), running the critical color last, and habit.

It is strongly recommended that black follow yellow in the sequence. The loss of maximum density ($D_{max}$) in printing yellow over black aggravates the problem of print contrast and tone reproduction. Also, the yellow cast over neutrals (when yellow is last down) is objectionable and cannot be corrected by adjustments to any of the other colors. The long-time industry practice of yellow, magenta, cyan, and black is a good choice as a standard sequence. Regardless of what sequence a given plant chooses, the important factor is that it be kept constant for all but the rarest circumstances.

**Ink Film Thickness (IFT)**

The *ink film thickness* that is run on press influences a number of print factors other than the color properties. Films that are too thick cause drying and setoff problems. Those that are too thin (in lithography and letterpress) may cause picking problems. Thin ink films also result in mottled or uneven solids.

The image quality factors that are influenced by ink film thickness (IFT) are listed below. The dot gain and trapping factors due to IFT change are separately listed.

**Color saturation and strength.** Increasing the ink film thickness naturally produces a darker color (i.e., lower lightness values). However, the other dimensions of color—hue and saturation—may shift because of the higher IFT. For example, higher magenta IFTs shift the hue toward red. Higher cyan IFTs cause the color to lose saturation, to become grayer. The hue and saturation of relatively pure colors like yellow show little change with variations in IFT.

The reason for the hue shift can be explained by reference to the *masstone* and *undertone* of the ink. **Masstone** is the color of a mass of ink film thick enough to be completely opaque. **Undertone** is the color of an ink film that is thin enough to be quite transparent. The color of a normal printed ink film is a combination of masstone and undertone. The effect of masstone becomes greater if more than a normal ink film is run. The undertone becomes predominant if the ink film is less than normal. For example, a magenta with a bluish undertone may print as a warm red if run heavy and as a cold pink if run light.

A further example of color shift due to ink film thickness may be illustrated by considering the percentage reflectances of

a magenta ink. A normal ink film thickness of magenta reflects about 90% of the red light that falls on it and 30% of the blue light. The ratio of red to blue is 3 to 1. If the ink film thickness is doubled, reflectance in the red area is 90% of the previous value (i.e., the normal thickness); the net reflectance of the incident red light is 90% times 90%, or 81%. Reflection in the blue region is reduced to 30% times 30%, or to 9% of the incident blue light. The ratio of red to blue is now 9 to 1.

**Gloss.** Higher ink film thicknesses produce higher gloss.

**Color tint distortion.** The shifts in halftone color tints due to changes in IFT may be different from the shifts in the solids of the same color. Proportionality failure occurs when the hue or the saturation of a tint is different from the solid. The tints tend to be dirtier than the solids. This effect is more noticeable with coarser screen rulings. Proportionality failure is discussed in more detail in Chapter 10.

**Sharpness.** Increasing the ink film thickness increases the print contrast and hence the image sharpness. The ink film thickness can be increased or decreased in lithography or letterpress by opening the ink fountain blade, increasing the fountain roller sweep, or increasing the ductor roller oscillation frequency.

For gravure, ink film thickness can be increased on press by lowering the angle of contact of the doctor blade or by using a thicker or duller doctor blade. Deeper cells in the cylinder will also enable higher ink film thicknesses to be achieved.

In flexography, the anilox roll screen coarseness, doctor blade adjustments (the same as gravure), ink viscosity, plate composition, printing pressure, and the softness of the inking roller all influence the attainable ink film thickness.

Greater IFTs may be obtained in screen printing by using a thicker stencil, a higher caliper mesh, a coarser weave mesh, increased squeegee pressure, a softer squeegee blade, a lower squeegee angle, lower screen tension, lower squeegee speed, and lower squeegee sharpness.

**Ideal IFT**

The ideal ink film thickness for any given ink is difficult to determine. Some have suggested using the solid density and the density of a 75% tint to derive a *Print Contrast Ratio* (PCR). The following equation is used:

$$\text{Print Contrast Ratio} = \frac{D_s - D_t}{D_s} \times 100\%$$

where $D_s$ = the density of the solid, and $D_t$ = the density of the 75% tint. The PCR range for good printing has been reported as ranging from 28% to 30%. This equation may help to balance ink film thicknesses from color to color and press to press, but it will not necessarily lead to the ideal ink film thickness.

Preucil suggests that the peak of visual color efficiency for a given ink be considered when selecting ink film thickness. This factor is determined by first measuring a printed ink film through the red, green, and blue filters of a densitometer. The lowest of these readings is divided by the highest in order to calculate Preucil's grayness factor. Finally, the accompanying chart is used to locate the peak color efficiency for the ink in question. The curve for the calculated grayness value is selected and followed until a peak is reached. The optimal density is read from the horizontal axis.

Optimal printed densities according to the concept of visual color efficiency

The "ideal" density is where the curve for a particular grayness value reaches a peak. In practice, higher densities than indicated must be used.

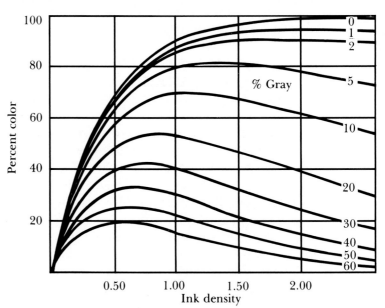

The visual color efficiency method suggests that magentas and cyans be run at considerably lower densities than yellows. But to produce good reds and greens, yellows are actually run at lower densities than the other colors. Therefore, this method also does not satisfactorily answer the optimal density question.

A final method of solid density determination was advanced by F. L. Cox of GATF. His method was based on earlier work by Preucil and made the assumption that the overprint red, green, and blue solids should absorb certain ratios of their *wanted absorptions*. The wanted absorptions for green are red

and blue; that is, the overprint green should have a high density through each of these filters. The individual ink films should be adjusted until the ratios are close to ideal.

The ideal ratio of green- to blue-light absorption for the red (i.e., yellow plus magneta) overlap is 0.80; the ideal ratio of red- to blue-light absorption for the green (i.e., yellow plus cyan) overlap is 1.00, and the ideal ratio of red- to green-light absorption for the blue (i.e., magenta plus cyan) is 1.00.

The accuracy of this method will be influenced by trapping and other additivity failure factors. Also, different densitometers will tend to give different results.

In practice, the preceding guidelines are often not particularly useful. Because ink film thickness influences so many print quality factors, a change to benefit one factor acts as a detriment to another factor. Even if only the color factors are considered, this holds true. This explains the press operator's practice of adjusting IFT and color sequence in order to improve the appearance of a given job.

Although the optimal density of printed solids cannot be specified because the optimal IFT is not known, this does not mean that a plant should not try to establish an internal reference standard. At the least, an internal standard is desirable in order to provide an objective for the production of color separation films.

House standard densities will depend on the substrate smoothness and the pigment concentration of the ink. The higher both properties are, the higher the density that can be achieved. The major appearance trade-offs that are at the control of the press operator are the density of solids, hue and saturation of solids and tints, gloss, dot gain, sharpness, and trapping. All of these factors can be influenced by changes in ink film thickness.

The best ink film thickness to run avoids problems like setoff or picking and is easy to run consistently. That is, it will probably be a midrange ink feed setting, for which the ink is not at one extreme of thickness or thinness. The objective is to produce running conditions that are most reproducible. The press operator may deviate from this level in order to optimize a given job, but the objective should be to make ready to the midrange settings. If the separation films have been produced for the midrange press conditions, then the resulting print should be close to the desired appearance. The appearance may be refined by slight adjustments in the press inking levels. The press should not be adjusted, however, in order to

compensate for poor separations. Such attempts are usually doomed to failure.

**Ink Trap**

**Ink trap,** or trapping, refers to the transfer of one ink film over a previously printed ink film. Ink trap percentage refers to how well a printed ink film covers a previously printed ink film relative to its coverage of unprinted paper. For example, an 80% ink trap means that the ink film thickness of the second-down ink over the first-down ink is 80% of the thickness of the second ink on an unprinted substrate. The terms **wet trap** and **dry trap** refer to whether the first-down ink was wet or dry just prior to being overprinted by the second ink.

It is possible to achieve perfect trapping, undertrapping, or overtrapping, with the most common condition being undertrapping. The factors that influence trapping, together with the direction of influence, are presented below.

**Tack of inks.** In order to facilitate the transfer of one ink to a previously printed ink or inks that are still wet, the tack of the ink being printed should be lower than that of those already printed. If the tack of the second ink is higher than the first, *back trapping* may result; some of the first-down ink may be pulled off the paper by the second-down ink.

**Ink film thickness.** If the first-down ink film thickness is substantially higher than the second-down ink film thickness, *undertrapping* may result. Given that a tack-graded set of inks is being used, the ink film thicknesses of all the colors should be approximately equal. For the best trap, the IFT should increase slightly from unit 1 to unit 4, while the tack of the inks should correspondingly decrease.

**Ink temperature.** An increase in temperature lowers the tack of an ink and therefore affects its trapping performance. All inks should be maintained at about the same temperature.

**Time between impressions.** The longer the time delay between the first impression and the second, the more time there is for the first ink film to start to set. The tack of the printed ink film will start to increase when it starts setting. This tack increase eases the trapping of subsequent colors. Drying or partially drying the first ink film between impressions can also help to improve trap. If too long a time elapses between impressions

(for example, when a four-color job is being printed on a one-color press), dry trap problems may result. Various additives in the first ink, such as waxes, may migrate to the surface and act as a barrier to the second ink.

**Ink-water balance.** In lithography, the water feed rate can influence ink tack and, consequently, trapping. If too much water is fed, the ink tack usually will go down. If not enough water is fed, the ink tack normally will increase. The reason for this behavior is that lithographic inks take up to about 40% by volume of water. The water take-up normally reduces the viscosity of the ink and lowers the tack. This influence usually outweighs the corresponding tendency for the tack to increase because of the lower temperature of the water. Maintaining correct ink-water balance for all of the colors is crucial for all aspects of lithographic printing quality. Correct balance avoids snowflakiness and scum or catch-up.

**Paper absorbency.** The more absorbent the substrate, the quicker the penetration of the ink vehicle into the substrate. This action causes an increase in the tack of the surface ink, which eases the trapping of the next ink.

**Coverage.** All other factors being constant, a light-coverage form, rather than a heavy-coverage form, will tend to cause the ink tack to increase. The reason for this is that the ink for the light form stays on the ink roller train with slower replenishment than that for the high-coverage form. The longer the ink is on the rollers, the more the evaporation or polymerization of the vehicle, and thus, the higher the tack when the ink finally reaches the plate. To avoid this problem, light-coverage forms should use low-tack inks.

On the other hand, large-area coverage forms require greater forces to separate them from the paper than do light-coverage forms. In practice, especially when GCR is used in making the separation films, there is not a large difference in coverage between the colors.

**Trap measurement.** The most convenient method of measuring ink trap is to take densitometer readings of the first-down ink, the second-down ink, and the overprint. Readings are taken through the filter complementary to the color of the second-down ink. For example, if magenta is the second-down ink, the readings are taken through the green filter. The

densitometer is zeroed to the substrate before taking readings. Percent trap is calculated with the Preucil equation:

$$\text{Percent Apparent Trap} = \frac{D_{op} - D_1}{D_2} \times 100\%$$

where $D_1$ is the density of the first-down ink, $D_2$ is the density of the second-down ink, and $D_{op}$ is the density of the overprint.

The densitometric method of trap evaluation does not give precise measurements of the actual ink film thickness percentage. This occurs because of the influence of the following factors: first-surface reflection and gloss, multiple internal reflection, opacity of the second-down ink, back transfer, and the spectral response of the densitometer. In particular, the use of narrow-band versus wide-band filters in the densitometers will influence the apparent trap calculations. An actual trap of 100% may normally have an apparent densitometric trap anywhere between 95% and 105%, or, in some cases, even beyond those limits.

As with ink film thickness, the optimal trap may depend on a given job. In practice, it is normal to aim for 100% trap, but commercially acceptable values of 75 to 95% are more the norm for wet-on-wet printing. Again, consistency of trap is more important than achieving a given absolute value.

The GATF Color Hexagon is a good diagram for documenting changes in ink trap. The appearance of the overprint color, as opposed to the actual percent trap value, is plotted on the diagram. Proof and press sheets are often compared on this type of diagram.

Another way of evaluating trap is simply to look through a filter complementary to the color of the second-down ink. The second-down solid and the overprint solid should appear about equal for 100% trap.

The usual recommendation for achieving good trapping is to use tack-graded inks. That is, the first-down ink has the highest tack possible without picking the paper. Each subsequent ink has a tack about two points lower. For example, the first-down ink may have a tack of 18, and the following inks may have values of 16, 14, and 12. Tack-graded inks are more important on common impression cylinder presses than on unit construction presses. The time between the first and second impressions on a common impression cylinder press is 0.12 seconds at 7,600 impressions per hour. The corresponding time for a unit-construction press is 1.00 second. The longer time on

the unit press allows the printed ink film to dry partly, thus increasing tack.

**Dot Gain and Related Factors**

In order to transfer ink to a substrate, it is necessary to use pressure. Because ink is a fluid substance, this pressure not only forces the ink into the substrate but also causes it to spread sideways. Therefore, because some pressure is necessary to transfer ink, some ink spread is also necessary. Hence, **dot**

Change in dot size from film to plate to blanket to paper in offset lithography
*Courtesy Heidelberger Druckmaschinen AG*

Two halftone dots on film (enlarged approximately 150 times)

The same noninked halftone dots on the plate (plate has been washed; traces of magenta coating still visible)

Halftone dots on the plate after inking

Halftone dots on the rubber blanket

Printed halftone dots on paper

Halftone dot
distortion: doubling

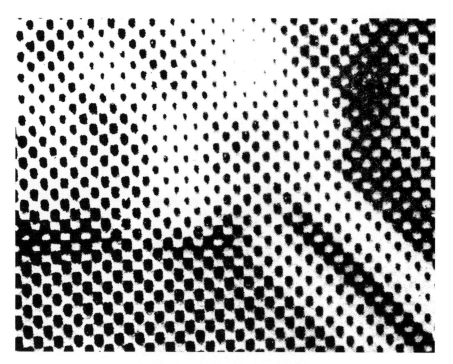

**gain** (which is caused by ink spreading) should be thought of more as a characteristic of a given process rather than as a fault of the process.

Dot gain is one aspect of halftone dot distortion. The other aspects are slur and doubling. **Slur** is a directional form of dot distortion; a round dot on the plate prints with a shape close to an ellipse.

**Doubling** is the double printing of a dot so that the two images are slightly out of register. One of the images is generally much lighter than the other.

Although it is possible to eliminate slur and doubling, dot gain to some degree is always present. The following list shows how various factors influence dot distortion.

● **Ink film thickness.** The thicker the ink film is, the greater the dot gain.

● **Impression pressure.** The greater the pressure is, the greater the dot gain. Pressure can be adjusted by plate and blanket packing.

● **Offset blanket.** Compressible blankets distort less than conventional blankets and thus produce less dot gain.

● **Ink-water balance.** In lithography, too much water feed causes the ink to become waterlogged. This, in turn, causes greater dot gain.

- **Plate and blanket tension.** If the tension is not high enough, doubling may occur.
- **Press speed.** Increased speed tends to decrease dot gain, assuming the press is in good mechanical condition and is properly adjusted.
- **Paper factors.** Smoother papers and papers with more coating exhibit less dot gain.
- **Ink factors.** Higher-tack inks and inks with higher pigment concentration exhibit lower dot gain.

Many of the above factors apply to all of the printing processes, although some apply exclusively to lithography, the dominant color printing process. The factors pertinent to other processes are listed below.

**Gravure.** Dot distortion in gravure takes the form of dot spread. The spread is due mainly to the capillary action of the paper. The greater the volume of the cell and the lower the viscosity of the ink, the more likely is the occurrence of dot spread.

**Flexography.** Flexographic dot gain contains elements of both gravure and lithographic gain factors. In addition, the coarser the screen on the anilox roll, the greater the dot gain. Also, a lower angle of doctor blade contact increases dot gain. Other factors that increase gain include thicker doctor blades and softer rubber inking transfer rollers.

**Screen printing.** The screen printing dot gain factors are unique to that process. Thicker stencils, mesh, and increased squeegee pressure tend to increase dot gain. Also, softer squeegees, lower squeegee angles and speed, and lower ink viscosity increase dot gain. If the end of the squeegee is rounded instead of sharp and if the mesh or screen tension is low, dot gain increases.

**Letterpress.** Because letterpress and lithography use similar paste-type inks, many of the factors affecting one also affect the other. One exception is the differential pressure exerted in different tonal values for letterpress printing. If the packing is adjusted to print satisfactory solids and dark tones, the light tonal values show increased dot gain. To counter this problem, it is necessary to vary the packing depending on tonal value.

Dot distortion may be determined by visual or densitometric methods. The visual approach relies on the use of test images

that emphasize or magnify the distortion. All of these images use high-resolution patterns of dots or lines that are very sensitive to change in the factors that influence dot distortion. The images that GATF has developed for indicating changes in dot distortion are shown in the illustration.

One problem with many dot distortion indicators is that they do not identify the cause of the distortion that they indicate. The GATF Star Target clearly shows the cause of dot distortion as being either dot gain, slur, or doubling.

The Star Target amplifies dot gain to such a degree that it is possible to monitor changes in gain by examining the center of the Star Target. The density of this target also can be

Test images developed by GATF to monitor changes in dot size: (A) Star Target, (B) original Dot Gain Scale, and (C) Dot Gain Scale-II

**A**

**B**

Midtone Dot Gain Scale  120/in.  48/cm

Copyright © 1983 Graphic Arts Technical Foundation

**C**

The use of the Star Target to show normal (A), dot gain (B), slur (C), and doubling (D) conditions

**A**

**B**

**C**

**D**

measured. The illustration shows photomicrographs of tint and Star Target areas from two press sheets. The table presents the density measurements from these and the solid areas. Note that

Photomicrographs of halftone tints and Star Targets on two sample press sheets

The center of the Star Target serves as an extremely sensitive indicator to changes in the conditions that affect dot gain.

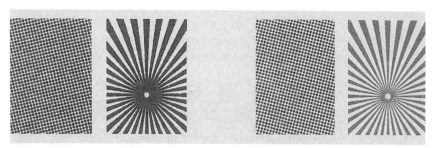

an 8% variation in solid density results in a 26% variation in tint density and a 60% variation in the density of the center of the Star Target. The high sensitivity to dot gain afforded by this target allows the press operator to detect changes before they develop into major problems.

Monitoring dot gain by density measurements

| Sample | Solid | Tint | Star Target | Dot Area |
|---|---|---|---|---|
| #1 | 1.36 | 0.38 | 0.64 | 54% |
| #2 | 1.26 | 0.30 | 0.40 | 48% |
| Difference | 8% | 26% | 60% | |

The other method of determining dot distortion is through the use of density measurements. Typically, density is measured from solid and tint values of a given print and dot area calculated using either the Murray-Davies equation or the Yule-Nielsen modification of the Murray-Davies equation (see Chapter 10 and Appendix D). Some densitometers are programmed with these equations for easy calculation of dot area.

The Murray-Davies equation produces results that incorporate both the physical and optical aspects of dot gain. The **physical** is the actual spreading of ink; the **optical** is the apparent increase in dot size due to light scattering within the substrate. The Yule-Nielsen modification removes the light-scattering effect, consequently giving the physical dot size measurement. The values for printed dot area can now be compared with the transmission dot values of the original films in order to determine the gain from film to print.

The Murray-Davies equation, and the modification, do not

distinguish among dot gain, slur, and doubling. Therefore, it is also important to use a visual target when examining dot distortion problems.

Graininess is another dot distortion problem that appears when dot gain is quite high. The uneven pattern, especially noticeable in smooth, even tones, is related more to the distortion of image detail rather than tonal value.

Photomicrographs showing, from left to right, increasing halftone graininess

In general, it is desirable to reduce dot distortion to a minimum. Unfortunately, some of the strategies used to reduce dot distortion may have unwanted consequences. For example, if ink film thickness is reduced, dot distortion will be reduced. The unwanted consequence is that the maximum color density is also lessened. If the ink has more pigment added to it to help compensate for the reduced density, the flow properties may be impaired to a degree that makes the ink impossible to use. One solution, for offset printing, is to use a compressible blanket rather than a conventional blanket. This substitution, however, may not be satisfactory when large solids, such as labels, are being printed. The slight distortion due to the conventional blanket helps to even out large solids, often covering marks or spots that would be obvious with a compressible blanket.

Impression pressure, ink feed level, and other factors should be adjusted to minimize or eliminate halftone graininess, slur, and doubling. The resultant dot gain should not be thought of as a fault needing correction, but rather as a characteristic of the ink, substrate, plate, blanket, and press that are being used. As long as dot gain is consistent, it is useful to characterize it and to build allowances into the color separation films. That is, if a printing system will print a 50% dot on the film as a 60% dot on the substrate, subsequent films can be adjusted so that they are 10% lower in dot value at that point. The GATF

Halftone Gray Wedge was devised to help characterize tonal distortion on press.

Dot gain is normally expressed as an additive quantity. That is, if a dot value on the film of 50% is printed as a 55% dot, that dot has gained 5%, even though, mathematically speaking, the dot is now 10% larger. Dot gain is also a function of the original film values. That is, a 0% dot and a 100% dot cannot gain. A 99% dot can only gain 1%, but a middle tone value has the potential for considerable gain. The nonlinear aspect of dot gain is shown in the graph. The area of peak gain is the tonal value that has the largest dot perimeter. For many cases this will be the 50% dot, but it could be higher or lower, depending upon the halftone dot shape.

An example of typical dot gain characteristics throughout the tone scale

The maximum gain occurs where the dot perimeter is the largest, i.e., around the middletone values.

Various industry surveys have found that overall dot gain (physical and optical combined) averages about 20% at the 50% film value. The film-to-print gain is different according to whether positive or negative plates are used. A positive plate loses about 4% at the 50% value, while a negative plate gains about 2%. When a plate or a printed sheet has a dot value that is less than that on the film, the dot is said to have sharpened.

**Undercolor Removal**

**Undercolor removal** (UCR) and its variant, **gray component replacement** (GCR), are used, in part, to compensate for some of the trapping and dot gain problems discussed in the preceding sections.

The argument for UCR is based on the fact that some printers have difficulty in printing four solid ink films on top of each other while the preceding film is still wet. Undercolor removal is incorporated into the color separations in order to reduce the yellow, magenta, and cyan dot values wherever black is going to print. In other words, color is removed from the neutral scale. If the 100% values of the four solid colors are reduced to 60% yellow, 60% magenta, 70% cyan, and 70%

black, the total coverage amounts to 260% compared to the previous 400%. These films are described as having 260% UCR.

The proponents of UCR claim that trapping is easier when UCR is used because of the reduced coverage. Trapping is only partly a function of area; rather, it is largely a function of ink film thickness. In the 260% UCR example from the last paragraph, it is obvious that there must be micro areas within the overlapped dots that consist of solid layers of all four colors. For the dots to lie side by side and not overlap each other, the values of each dot would have to be considerably less than 50%. Therefore, 400% coverage does occur for most values of UCR.

For a complete explanation of how UCR works, it is necessary to consider dot gain. Most of the proponents of UCR are involved in the publications printing industry. This process uses inks that must run at high speed on fairly lightweight paper. To prevent picking the paper, it is necessary to avoid thin ink films. The thicker ink films used in this industry result in higher levels of dot gain. For 100% dot values, no gain is possible; therefore, the ink that does not penetrate into the paper remains in a relatively thick film on top of the paper. Difficulties may arise when transferring the next ink film to the first film. For 60% dot values, the ink spreads sideways (i.e., we have dot gain) upon impression. Some of the ink, then, penetrates into the paper, and the remainder spreads across the paper to a degree that corresponds to the dot gain of the system. Consequently, the thickness of the printed ink film is lower than the no-UCR case, and it is easier for the second ink to trap on the first.

The major drawback with UCR is that as UCR is increased, the maximum density of the printed sheet decreases. Reduced $D_{max}$ means reduced contrast and reduced quality. Therefore, avoid using UCR whenever possible. When good-quality materials are available, and the press has been set to minimize dot gain and to maximize trapping, UCR should not be needed. For high-speed magazine production and similar types of work, some UCR may be desirable. The recommended UCR values range from 240% to 300%.

A variant of UCR is gray component replacement (GCR). This technique has gained popularity only quite recently. Most modern scanners now have the software capable of incorporating GCR into color separations.

Different scanner manufacturers use different terms to describe gray component replacement. The table lists the terms that apply to each manufacturer.

Alternate terms used to describe gray component replacement

| Company | Term |
|---------|------|
| Crosfield | Polychromatic Colour Removal |
| Dainippon Screen | Integrated Colour Removal |
| Hell Graphic Systems | Complementary Colour Reduction |

Other terms such as "achromatic reproduction" have also been used to describe the GCR process.

The theory behind GCR is that whenever dots of yellow, magenta, and cyan are present in the same color, there is a gray component to that color. That is, if the smallest of the three dot values were to be removed from the color, together with appropriate amounts of the other colors in order to produce a neutral gray tone, then that gray tone could be replaced by a dot of black. Following this reasoning, it is possible to achieve almost any given color by using two of the three colored inks plus black.

The primary advantage touted for GCR is that color variation on press is not as serious when GCR is used. For example, if the cyan dot in a brown color without GCR were to vary, the resultant color would shift toward either red or black. If GCR were used, and black were substituted for cyan, variations in the black dot would result in the brown getting lighter or darker, but not shifting in hue. Recent research, however, suggests that in a few cases, individual colors within a printed illustration may show more variability with GCR than with normal separations.[1] The other major GCR advantage is the reduced use of expensive colored inks.

The major problem with GCR, like UCR, is reduced density of darker colors. For many jobs this is not a major problem, but for others it may be. A coverage of 300% is noticeably lighter than 400% coverage; therefore, in cases where strong, dense blacks are required, the amount of GCR or UCR that is used should be limited. A related problem with excessive GCR is that the gloss of the reproduction will be reduced. To help correct for excessive color reduction, the process of undercolor addition is used on most color scanners. With this process, it is possible to add color somewhat selectively to dark tonal areas. The other GCR arguments, such as improved trapping, could be rationalized by the dot gain/trapping effects described earlier for UCR.

The three-color, black, and four-color prints for normal, undercolor removal (UCR), and gray component replacement (GCR) separations

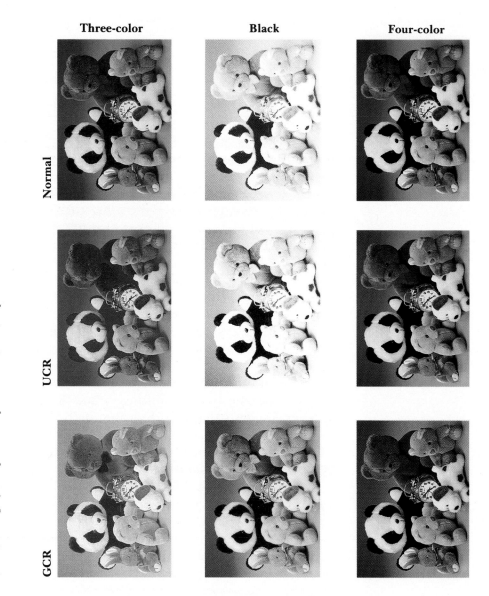

The amounts, and the starting points, for UCR and GCR can be continuously varied between 0 and 100 on most color scanners. Unfortunately, the method of designating GCR varies according to the scanner manufacturer. A 60% GCR set of separations made by one scanner will not necessarily appear the same as a 60% GCR set made by another scanner. The most popular levels of GCR seem to be between 40% and 60%. Photographic techniques can also be used to accomplish UCR but cannot be used for GCR.

**Register**

The *register* between individual color images influences the quality of the color reproduction. Register variations can result in loss of resolution and sharpness. Moiré patterns may also appear if there is angular misregister.

Resolution loss with out-of-register printing *(top)* compared to in-register printing *(bottom)*

The degree of misregister that can be tolerated largely depends on the screen ruling and the sharpness of image detail. Soft-focus pictures have more tolerance for register variation than do sharp-focus pictures. Coarse screen rulings do not show a given misregister as noticeably as fine screen rulings.

Image with sharp- and soft-edged detail

Misregister will be more apparent in the sharp-edged foreground detail.

Research has shown that register variation of up to one-half a row of dots ($\pm 0.002$ in. for 150-lines-per-inch-screen) would probably be acceptable for most printed images. The GATF Right Register Guide is a useful register indicator that is capable of detecting very small misregister.

Some color variations can be attributed to misregister. If two halftone dots print side by side, the resulting color will be the additive combination of the light reflectances from the white paper and the two colors of the inks used to print the dots. If a slight misregister causes the two dots to print on top of each other, the resultant color will be the integration of the white paper reflectances and the overprint dot reflectances. Because of additivity failure, the reflectances of the overprint differ from the combined reflectances of the individual inks. Register variations, therefore, produce color variations. The degree of color variation depends on the screen ruling, the percentage dot value of each of the colors, the actual register variation, and the additivity factors for the ink films in question. This color shift is one of the primary reasons why same-angle separations are not used. The same-angle separations give superior resolution to conventional four-angle separations, but only when precise register is maintained—an impossibility in most production printing plants.

The GATF Right Register Guide printed same size **(1)** and at $30\times$ enlargement **(2)**

When printing line color work, where one color type is printed against a background of another color, a slight misregister shows as a white line separating the two colors. In order to counter this problem, the type is **spread (enlarged slightly)** or the background is **choked (shrunk slightly)** to provide a very slight overlap between the two colors. The following illustration shows a regular and a spread image.

**Mechanical Ghosting and Other Problems**

**Mechanical ghosting,** or starvation, sometimes occurs in lithographic and letterpress printing. The illustration on page 127 shows this phenomenon, where ink is not uniformly distributed from front to back of the image. This occurs because, for large areas of coverage, the inking systems of lithography and letterpress cannot replenish ink at the same rate as it is consumed. For light coverage this is not a problem; therefore, when a *windowframe* pattern is printed, the bars

The effects of spreading *(top)* and not spreading *(bottom)* the cyan image

The spread image has more register latitude.

perpendicular to the direction of travel are higher in density than those parallel to the direction of travel.

Apart from the problems caused by windowframe designs, mechanical ghosting can contribute to color variation within a sheet of heavy ink coverage images, such as labels. In some

cases, the lead image is the darkest, with each succeeding image a little lighter. In other cases, the images may get lighter and then heavier. The exact pattern depends on the inking system design. Density variation from front to back could be as much as 0.15.

Starvation or mechanical ghosting problems can be minimized by avoiding windowframe designs, using opaque inks, laying out the form so that heavy coverage images do not print in line with each other, adding an oscillating rider roller above the last form roller, using a special oscillating last form roller, or using a minimum of water on an offset litho press.

Mechanical ghosting induced by the selection of a "windowframe" design that, in turn, will be printed by lithography or letterpress

The inking system also may cause density variation across the image. This problem may occur if the ink fountain contains a warped one-piece flexible steel ink fountain blade. Ink key adjustments at one point can sometimes cause unwanted distortion at another point along the blade. Segmented fountain blades that can be independently controlled eliminate this problem.

Other inking-system-induced color problems are due to the intermittent feed of ink from the fountain to the ink roller train. A surge of ink is transferred at a frequency that depends on mechanical timing of the ductor roller. This noncontinuous feed contributes to slight sheet-to-sheet variation in density. This problem can be minimized by setting the fountain blade to the near-minimum possible setting and the ink duct roller to the near-maximum possible swing.

## Press Makeready and Running

Once the printed color factors have been established, the press must be set up to achieve these objectives consistently. A detailed discussion of press makeready and running is beyond the scope of this book; therefore, the following guidelines are necessarily brief.

### Makeready Objectives

The basic color objectives in makeready are setting correct impression pressure, achieving perfect register, and establishing correct ink feed. For lithography, the correct water feed must also be established.

Impression pressure settings can be determined by using bench micrometers, high-quality packing materials, packing gauges, and press impression adjustments.

Register is adjusted by plate positioning and packing, side guide, gripper and transfer cylinder adjustments, or, in the case of web printing, cylinder position and web tension adjustments.

Ink fountain blade key settings across a sheet or web must correspond to the coverage on the plate. The most efficient method of achieving this objective is to use a plate scanner, which will automatically adjust the individual keys to correspond with the ink requirements of the image. Since very few of the scanners exist, the vast majority of presses rely on operator skill to set ink keys. The ink feed rate depends on the desired ink film thickness. As a general guide for lithography, GATF recommends 0.00015-in. to 0.0004-in. ink film thickness on the hard surface roller closest to the last ink form roller. For lithography, the water feed rate is balanced to the ink feed so that scumming and snowflakiness are avoided. For gravure and flexography, the doctor blade angle and pressure, cell volume, and ink viscosity influence ink feed.

### Monitoring Performance

The printed images can be monitored intermittently or continuously. Intermittent monitoring involves pulling seven to ten sheets or signatures at 5–10 min. intervals. Fanning the sheets in one pull detects any short-term inking system variation. Comparing a representative sheet from each pull to the OK sheet detects longer-term color variation. A color bar, such as the GATF Compact Color Test Strip, should be printed across the trailing edge of every job to facilitate rapid comparison of images. In order to construct control charts or to quantify the actual press performance, densitometer readings should be taken from the sample sheets.

Continuous monitoring of printed images is usually confined to web presses. Stroboscopes or rotating mirrors are used to stop the apparent motion of the web in order to check register. On-press density can be read with some densitometers while the press is running at high speed. These readings can either serve as a record of press performance or alert the operator to quality variations. Very few of these densitometers have been installed.

**Control Strategies**

Consistent printing depends on the environmental, materials, press, and human conditions existing at the time of makeready. If these conditions can be maintained throughout the run, then consistent quality is produced. Unfortunately, this is either difficult or expensive to achieve.

The environmental conditions are essentially temperature and humidity. These can be controlled with an air conditioning system and monitored with a chart recorder.

The press conditions consist of register adjustments, ink (and water) feed, and impression control. A sound maintenance program must be implemented to eliminate or minimize possible mechanical variations. To stabilize the ink feed rates for lithography and letterpress, maintain the ink level in the fountain at a constant level, such as three-quarters full. Use an ink agitator to maintain the thixotropic properties of the ink. For fluid ink systems, such as gravure, periodically check the ink viscosity either manually or automatically and add solvent as needed.

Little can be done on press to compensate for variations in the ink or substrate. If the variation is too wide, the press should be stopped, the materials replaced, and the suppliers contacted. If materials variation proves to be a serious problem, implement statistical sampling and testing before the materials are approved for printing.

Operator-related problems are concerned with either individual changes in color perception due to fatigue or to differences in color perception between an operator on one shift and one on another. Operators involved in color judgment should be tested for anomalous color vision with one of the tests described in Chapter 2. Other judgment problems can be countered by having an OK sheet available and using a reflection densitometer to make periodic measurements of solids, overlaps, and tint or Star Target areas. Use a $10 \times$ magnifier to check color register.

## Postpress Treatments

The postpress treatments that influence the optical properties of the print include varnishing, laminating, bronzing, foil stamping, foil embossing, and embossing.

Varnishing is employed to impart a high-gloss finish to a printed image. This gloss finish reduces first-surface reflections and thus improves print contrast and saturation. Such a finish usually improves the quality of reproductions of photographic originals. Glossy finishes, however, are usually not suitable for reproductions from pencil, water color, or pastel originals. A high gloss on text printing results in eye fatigue and therefore is not advisable. It is also possible to use low-gloss or matte varnishes where the design warrants. Varnishing also produces a scuff-resistant finish on the print. This is very important for label and package printing.

Laminating has the same objective as high-gloss varnishing; that is, to produce a high-gloss protective finish on a printed image. The development of nonyellowing varnishes that can be set by UV radiation has reduced the use of laminating as a finishing technique.

Bronzing is used when a metallic finish is required that looks more realistic than that which can be achieved with metallic inks. A metallic powder is dusted over a clear varnish that has been selectively printed on the sheet. The excess powder is removed with reciprocating brushes.

Foil stamping is used when the ultimate in metallic appearance is desired. It is also useful for creating solid, opaque color images. The process employs a letterpress printing machine, usually a platen, a relief stamping die, rolls of special foil, and a heating mechanism. The effective transfer of foil or color to the substrate depends on the foil, temperature, dwell time, pressure, and substrate.

Embossing can be done on a blank substrate (**blind embossing**), with foil, or in conjunction with a printed image. A letterpress platen press must be used for this process. An embossing die is mounted on the platen of the press. These dies are often made of brass and are *sculptured* to different levels. A counter die is formed, usually with an epoxy compound, on the platen of the press. The substrate is pressed between the heated die and the counter die to *iron* it to the shape of the die. The substrate type, die depth, temperature, dwell time, and pressure influence the quality of the embossing.

**Summary**

Color printing is the most important aspect of the color reproduction process. It is here that the ultimate product purchased by the consumer is produced. All of the production steps prior to printing should be executed with the sole intent of maximizing the quality of the printed image and minimizing any production problems. This is why it is so important to establish the ideal printing conditions first and then adjust the prepress activities to conform to the printed image characteristics.

Achieving ideal printing conditions involves setting the press up to run at its most consistent level. Extremes of adjustment should be avoided for normal procedures.

While consistency is the primary objective, the press should also be set to minimize dot gain, maximize trapping, achieve perfect register, and print a high-density neutral black. If tack-graded inks are used, impression pressures are properly adjusted, the press is in good mechanical order, and a printing sequence is selected where black is printed after yellow, the printer will have a reasonable chance of achieving these goals.

Once an ideal or OK sheet has been produced, the key objective becomes that of duplicating the conditions that prevailed at makeready in order to ensure consistent quality printing. Mechanical aids such as automatic ink agitators can help maintain production conditions, and stroboscopes and on-press densitometry can help monitor production. Standard viewing conditions and press operator testing must also be considered in a program designed to ensure printing consistency.

Postpress treatment of the print in order to enhance the appearance is fairly common outside the publications market. The designer and buyer of print should be alert to these techniques of adjusting the appearance of the printed product.

**Notes**

1. Gary G. Field, "Color Variability Associated with Printing GCR Color Separations," *TAGA Proceedings* 1986 (Rochester, N.Y.: TAGA), pp. 145–157.

# 6 Color Tolerances and Specifications

Printing, like any other manufacturing process, has a certain variability associated with the production technology that causes some inconsistencies in the printed product. These fluctuations are due to the total effects of variations in raw materials, environmental conditions, press mechanical factors, and operator judgments and actions.

How much variability is acceptable? The answer must take into account the costs of inspection, rejection, and reprinting or reworking the job. In practice, acceptable variation limits are dictated by how much the customer pays for the printing. The scrap or reworking frequency depends on how well the process is controlled.

Printing is evaluated by visual methods; therefore, it is difficult to establish quantitative control limits for production. The normal method of control is to select a sheet as an *OK sheet* and tell the press operator to match it as closely as possible. Some quantification of printed images and the use of control charts, however, have been undertaken by some printers.

## Color Tolerance

The specification of color tolerance must take into account the product requirements of the customer and the inherent variability that can be attributed to the materials and the production technology.

## Product Requirements

The degree of variability acceptable in a printed product depends on how much a consumer is willing to pay for it. For example, color register variation in a newspaper is rarely a reason for a consumer not to purchase that newspaper. On the other hand, color register variation in an expensive art reproduction book is a reason for consumers to reject the product.

Another aspect of printed product variability concerns the corporate quality image of the company that ordered the printing. For example, if shoppers in a supermarket see color variation among a row of what should be identical products, they may assume that the company doesn't pay much attention to the quality of its products. Alternatively, color variation in the labels of food products may mean that some are fresher than others and that the contents vary in age. The consumers may decide to stop buying that brand and switch to a competitor's product.

A further aspect of customer quality acceptability limits concerns the buyer of printing rather than the ultimate consumer of the printed product. Examples of print buyers or

critics include art directors, publishers, advertisers, corporate purchasing officers, and catalog merchandisers. In most of these cases, the ultimate consumer does not directly purchase the printed product. Examples of these "free" products are mail order catalogs, advertising brochures, billboard posters, and advertising in magazines. These products are purchased by a company or an agency in order to promote its corporation or product. A buyer from such an organization has a vested interest in promoting a quality image of the company in order to avoid negative connotations about its products.

Few print buyers admit wanting to buy anything but top-quality printing. Even so, some buyers mistakenly think that high-quality printing merely demands a little extra care and really does not cost any more than lower-quality printing. Of course, higher-quality printing, like any other product of high quality, costs more. The extra costs are due to higher quality and consistency of the raw materials, increased equipment maintenance, more highly skilled operators, inspection and testing, higher reject levels, and higher-precision equipment. Generally speaking, these costs apply equally to requirements for high *absolute* levels of quality and to high levels of *consistency*.

Two of the largest purchasers of printing in the world are the United States and the Canadian Government Printing Offices (USGPO and CGPO). They have each realized that different printing jobs have different quality requirements and correspondingly different prices. Independently, the two printing offices developed five different levels of print quality. They are presented in the following table.

| Levels of printing at the United States and Canadian Government Printing Offices | Quality | CGPO Classification | USGPO Classification |
|---|---|---|---|
| | I | Prestige | Best Quality |
| | II | Library | Better Quality |
| | III | Informational | Good Quality |
| | IV | Office | Basic Quality |
| | V | Utility | Duplicating Quality |

In actuality, it would be difficult for a plant to attempt to produce five distinct levels of quality. In fact, the USGPO recently reduced their five levels to three. Indeed, most plants are probably efficient at only one level. For color printing, two levels of quality can probably be established. The accompanying table is a suggested list of consistency requirements for color printing.

Consistency
requirements for
color printing

**High-Consistency Requirements**
 High-priced bound books
 Annual reports
 Maps
 Limited series lithographs
 Art calendars, catalogs, or posters
 Four-color catalogs
 Cosmetics, pharmaceuticals
 Food and beverage packaging and labels
 Checks, securities
 Currency, stamps
 Prestige magazines

**Medium-Consistency Requirements**
 Two-color catalogs
 Magazines
 Advertising literature
 Textbooks
 Paper products, hardware, clothing, toys and games packaging
 Record album covers
 Four-color newspapers
 Greeting cards
 Promotional calendars
 Industrial product packaging

The absolute level of print quality, as opposed to the consistency level, correlates to some degree with the products listed in the table. For example, cosmetic packaging is likely to make use of overprint varnishes, foil embossing, extra colors, and top-quality substrates to impart feelings of prestige and luxury to the product. On the other hand, a breakfast cereal package does not need the high absolute quality level of the cosmetic package but still requires the same high level of consistency. Greeting cards and advertising literature are likely to require high levels of absolute quality but not the same consistency as fine art prints or four-color catalogs.

An interesting sidelight to customer acceptance of color printing is the sensitivity of the human visual system to changes in color. A person with excellent vision under ideal viewing conditions can distinguish about ten million distinct colors when side-by-side comparisons are made. The smallest difference between two adjacent colors is called a **Just Noticeable Difference,** or a JND. When a judgment is made of a printed color from memory of that color rather than from a sample, the matches made by critics are much less accurate—the printed color will be about 23 JNDs away from the color they thought they were matching. When the printed sheet is compared side by side to the OK sheet, only a 10 JND

difference may be expected. In comparing color bars from the OK sheet to the printed sheet, a variation of only 3 JNDs can be expected, while the use of a densitometer reduces this range to 1–2 JNDs. A JND is equal to about 0.01 density at density levels above 1.40.[1]

**Materials and Process Characteristics**

There are inconsistencies in the quality of printed output due to variability in ink, substrate, and other materials; the printing machine settings and mechanical actions; and ambient temperature and humidity. The judgment, skill, and alertness of the printing machine operator can also contribute to inconsistencies or allow variability induced by other means to go unchecked.

The role of the printing press operator, once makeready has been completed, is to monitor the output of the press and to make any machine adjustments necessary to keep the print consistency within the specified limits.

There are some aspects of print quality that vary despite the best efforts undertaken by the operator. These factors are usually related to variability in the raw materials. For example, variations in paper smoothness, color, and absorptivity cannot be corrected by the operator. Likewise, for paste-type inks, variations in tack, pigment type and concentration, and viscosity are all factors beyond the control of the operator. The press operator can only reject the batch of materials and switch to another in attempting to solve the problem. If problems of this sort persist, management should implement raw materials testing or even change suppliers.

Other uncontrollable variations are printing press related. The gripper-to-tail density variation that should be expected for lithographic and letterpress printing is discussed in Chapter 5. Some chance or random sheet-to-sheet variation may also occur. This variation is due largely to the intermittent ink feed. For any given color, this variation in solid density could be ±0.02 or ±0.03.

Of all the printing processes, lithography is the one most subject to shifts in consistency. The water feed rate, fountain solution alcohol concentration, and the water temperature are somewhat difficult to control. The consistent transfer of a uniform thickness of ink to the plate, by means of the inking system, is also difficult to achieve. The key factor is balancing the quantities of ink and water on the plate. Some emulsification of water into the ink is necessary, but too much creates a plethora of printing problems.

Letterpress also has the ink feed problems of lithography, but without the water feed. It is an inherently more stable process.

Flexography and screen printing probably follow letterpress in inherent stability. Both have simple inking systems, and little can go wrong.

Gravure is probably the most inherently stable process. The image carrier is actually the inking system. If the viscosity of the ink remains consistent, then little can change to influence color density.

Printing press and auxiliary equipment manufacturers have been developing a range of control devices designed to reduce the variability of printed output. The availability of cheap microprocessors has spurred the introduction of these devices. Most of these efforts have focused on lithographic printing; therefore, it can be expected that the inherent variability in the lithographic process may decline and perhaps equal that of gravure.

**Establishing Acceptability Limits**

The acceptability limits for color printing are established either formally by the buyer of printing or informally by the printer. Large organizations and buyers of package printing often establish formal limits. The most extensive specifications are probably those published by the Canadian and U.S. Government Printing Offices. Following is an example of these specifications.

**Color match for a single spot color (CGPO).** This test is only for solid spot or background colors, not for tints or process color. Measurements are made using a CIE response, three-filter colorimeter with D65 illuminant. Measurements are taken on samples of the printed solid and on an approved color swatch. The measured results are expressed in CIELAB coordinates; L*, a*, b*. The total color difference between the printed and the specified color is calculated from the following formula:

$$\Delta E, \text{ or total color difference} = \sqrt{\Delta L^2 + \Delta a^2 + \Delta b^2}$$

where $\Delta L$, $\Delta a$, and $\Delta b$ are the measured differences betweed L*, a*, and b* values for the actual and specified color samples.[2]

The total color difference $\Delta(E)$ between the specified and the printed color must not exceed:

| Quality Level | Allowable Deviation |
|---|---|
| I | 2.0 |
| II | 3.0 |
| III | 4.0 |
| IV | N.A. |
| V | N.A. |

It is not suggested that either the United States or the Canadian Government purchasing specifications are necessarily similar to the requirements for nongovernment work. Nevertheless, these specifications are the result of lengthy investigations by very large buyers of printed matter, and therefore are likely to be useful starting points for any printer or print buyer wanting to establish a formal set of control specifications.

**Specification of Tolerances**

Quality acceptability levels are sometimes particularly difficult to specify. This is especially true for process-color printing. Variations in solid background colors are relatively easy to characterize by selecting press sheets that represent the lightest and darkest acceptable levels. For process-color printing, comparing the color bars offers the best chance of monitoring consistency. Visual comparison or densitometric measurements also can be used to evaluate the production run.

**Visual Comparison**

The technique of visual comparison is most frequently used when a job contains a large background solid, such as on a label or package. The upper and lower density limits are visually selected from a series of press sheets. Sections of the light and dark sheets are cut out and mounted on a piece of stiff card with a cutout hole in between them. The card is placed over the printed sheet to see whether the color falls between the limit values.

Visual comparisons must be made with the proper illumination. A color temperature of 5,000 K and an intensity of 2,000 lux with a neutral surround are recommended. The only problem with this technique concerns the comparison of wet and dry ink films. The samples on the card will be lower in gloss than the newly printed sheet. Therefore, it is necessary to adjust the angle of the samples to minimize surface glare.

For visual comparisons of process-color work, the best technique is to compare the color bar on the newly printed sheet to that on the OK sheet. Next, a visual scan can be made

across the sheet to check register, spots and patterns, and other defects that will not show up on the color bar.

A visual comparator, which can be used to make rapid evaluation of color variation when printing large solids such as labels or cartons

Side-by-side comparisons of the OK and pressrun images of a GATF color control bar

Visual comparisons are best for the quick evaluation of a range of print quality factors.

**Instrumental Measurements**

There are several advantages to expressing acceptability limits in numbers by the use of a densitometer or colorimeter: instrumental readings are not dependent on human judgment; numbers can be easily transmitted to multiple printing sites to be used as control objectives; numbers are subject to statistical analysis, which can help to signal the need for corrective

*(Text continued on page 146.)*

# Color Tolerances and Specification
# (U.S. Government Printing Office)

## Moiré

**Definitions:**   **1.** Moiré is defined as objectionable patterns that are created when halftone screens are printed over one another at incorrect screen angles. Moiré may also appear when rescreening a single-color halftone or screening an original halftone that contains patterned objects (e.g., fabrics).

**2.** Avoidable moiré is moiré that is due to poor production methods rather than the inherent limitations of the process (e.g., 15° yellow screen angle, rescreened halftones).

**Instruments:**   **1.** Visual evaluation

**2.** Screen angle gauge

**Procedures:**   **1.** Visually examine halftone under standard viewing conditions.

**2.** Determine the deviation of each color from the desired screen angle by means of a screen angle gauge.

### Demerit Table for Moiré

| Product Quality Levels | | Demerits | | |
|---|---|---|---|---|
| | | 4 | 20 | 100 |
| Level I | Any avoidable moiré | | | X |
| Level II | Avoidable moiré through and including 0.5° | | X | |
| | Greater than 0.5° | | | X |
| Level III | Avoidable moiré to but not including 0.5° | X | | |
| | 0.5° through and including 1.0° | | X | |
| | Greater than 1.0° | | | X |
| Level IV | 0.5° to but not including 1.0° | X | | |
| | 1.0° through and including 1.5° | | X | |
| | Greater than 1.5° | | | X |
| Level V | Not applicable to Level V | | | |

# Register

**Definition:**   Register is the alignment of two or more image components. The two categories of register are:

1. Multicolor halftone register (internal and/or border)

2. Linework register (solid colors)

**Instruments:**   1. Visual evaluation

2. Magnifier with scale graduated in increments of 0.1 mm or 0.005 in.

**Procedure:**   **1. Multicolor halftone register (internal and/or border):**
Establish the measuring base by determining two colors in register with 0.5 row. Sum the rows of misregister for all colors. Enter the sum on the demerit table to assign demerits. If three or more colors are used and no two colors register within 1 row, assign 100 demerits to that page. If more than one illustration appears on a page, assess demerits only on the most defective illustration. A maximum of 100 demerits will be assessed per page.

**2. Linework register (solid colors and specialty screens):**
Establish the measuring base by determining two colors in register within 0.10 mm. Using a magnifier with a graduated scale, measure in millimeters the misregister for each color. Sum the measurements of misregister for all colors. Enter sum on the demerit table to assign demerits. If no two colors are in register within 0.10 mm, select as the measuring base the color which will result in the smallest number of demerits.

**Demerit Table for Multicolor Halftone Register**

| Product Quality Levels | | Demerits | | |
|---|---|---|---|---|
| | | 4 | 20 | 100 |
| Level I | 0.5 to but not including 1 row | X | | |
| | 1 through and including 2 rows | | X | |
| | Greater than 2 rows | | | X |
| Level II | 1 to but not including 2 rows | X | | |
| | 2 through and including 3 rows | | X | |
| | Greater than 3 rows | | | X |
| Level III | 1 to but not including 2 rows | X | | |
| | 2 through and including 4 rows | | X | |
| | Greater than 4 rows | | | X |
| Level IV | Not applicable to Level IV | | | |
| Level V | Not applicable to Level V | | | |

## Solid or Screen Tints Color Match

**Definition:** Solid or screen tints color match is the density deviation between the reproduction and the specified standard. There are three solid and/or screen tint categories:

**1.** Single-color solids or tints

**2.** Multicolor solids or tints

**3.** Process-color solids or tints

**Instruments:** **1.** Visual evaluation

**2.** Reflection densitometer

**Procedure:** **1.** For single-color solids or tints, make a dry comparative densitometer reading using the filter that will indicate the highest density.

**2.** For multicolor solids or tints, make a dry comparative densitometer reading using the filter that will indicate the highest density.

**3.** For process-color solids or tints, use the scoring system for **Process-Color Match** to determine demerits.

**Exceptions:** If a visible density shift occurs within or between solids or tints (on a single page or on a two-page spread), 100 demerits at Levels I and II, and 20 demerits at Levels III and IV will be assessed for each page.

### Demerit Table for Solid and/or Screen Tints

| Product Quality Levels | | Demerits | | |
|---|---|---|---|---|
| | | 4 | 20 | 100 |
| Level I | ±0.05 to but not including ±0.10 density | X | | |
| | ±0.10 through and including ±0.15 density | | X | |
| | Greater than ±0.15 density | | | X |
| | Visible variation within a solid | | | X |
| Level II | ±0.07 to but not including ±0.12 density | X | | |
| | ±0.12 through and including ±0.17 density | | X | |
| | Greater than ±0.17 density | | | X |
| | Visible variation within a solid | X | | |

| | | | | |
|---|---|---|---|---|
| Level III | ±0.09 to but not including ±0.14 density | X | | |
| | ±0.14 through and including ±0.19 density | | X | |
| | Greater than ±0.19 density | | | X |
| | Visible variation within a solid | | X | |
| Level IV | ±0.12 to but not including ±0.17 density | X | | |
| | ±0.17 through and including ±0.22 density | | X | |
| | Greater than ±0.22 density | | | X |
| | Visible variation within a solid | | X | |
| Level V | Not applicable to Level V | | | |

## Process-Color Match

**Definitions:**

**1.** Process-color match is the fidelity of color match between the item being inspected and the specified standard.

**2.** A perceptible shift is a shift in color between the specified standard and the sample that is perceptible under standard viewing conditions but is not large enough to be classified as objectionable.

**3.** An objectionable shift is a shift between the specified standard and the sample causing a definite change of color. Examples are fleshtones shifting slightly towards a yellow or magenta hue, green grass taking on a yellow or cyan cast, browns turning slightly reddish or yellowish, and overall density change.

**4.** A serious shift is a shift between the specified standard and the sample causing a change of color approaching misrepresentation or loss of identity. Examples are fleshtones, browns, and grays turning green or purple, green grass turning brown or magenta, and plugged shadows or washed-out highlights.

**Instruments:**

**1.** Visual inspection

**2.** Densitometer

**Procedure:**

**1.** Compare sample with specified standard for shifts in hue, saturation, and lightness under standard viewing conditions.

**2.** Assess demerits in accordance with the table below (maximum 100 demerits per page).

**3.** When a sample of production run press sheets (fan) is required:

**a.** Assess demerits to each page.

**b.** Combine corresponding sample numbers from all fans to construct a set of "equivalent books."

**c.** Calculate an average demerit level for each equivalent book.

### Demerit Table for Process-Color Match

| Product Quality Levels | | Demerits | | |
|---|---|---|---|---|
| | | 4 | 20 | 100 |
| Level I | Perceptible shift | | X | |
| | Objectionable shift | | X | |
| | Serious shift: see finishing attribute F-18 | | | |
| Level II | Perceptible shift | X | | |
| | Objectionable shift | | X | |
| | Serious shift | | | X |
| Level III | Objectionable shift | | X | |
| | Serious shift | | | X |
| Level IV | Not applicable to Level IV | | | |
| Level V | Not applicable to Level V | | | |

## Printing Attributes

For each copy that is inspected, the Government will evaluate each applicable printing attribute by separately inspecting:

**1.** Outside covers (i.e., the spine and covers 1 & 4)

**2.** Text (i.e., pages and covers 2 & 3)

## Average Demerit Levels

Average demerit levels (ADLs) will be determined as follows:

**1.** Outside covers will be inspected and evaluated as one unit. The unit will be assessed demerits (i.e., 4, 20, 100) pursuant to the demerit table for each printing attribute that deviates from specifications. The demerits that are assessed constitute the ADL for outside covers for that printing attribute for that copy.

**2.** The text will be evaluated by inspecting pages (each page is an individual unit), cover 2, and cover 3 as individual units. Each unit will be assessed demerits (i.e., 4, 20, 100) pursuant to the demerit table for each printing attribute that deviates from specifications. The demerits which are assessed will be summed, and each sum will be divided by the number of individual units that were inspected for that printing attribute. The quotient constitutes the ADL for text for that printing attribute for that copy.

**3.** In each copy the ADLs for each printing attribute will be classified as follows:

### Tolerance Table for Printing Attributes

| Average Demerit Levels | Classification of Defect |
|---|---|
| 4 or less for both outside covers and text | None |
| More than 4 for either or both outside covers and text | Major |

After the USGPO Demerit values have been converted into defects, they are used to discount the price that will be paid for the printed job. The demerits are tallied from sheets that have been pulled from the production run according to Military Standard 105D "Sampling Procedures and Tables for Inspection by Attributes." A section of the discount table that would apply to color printing defects is presented in the accompanying table.

### USGPO Discount Table for Major Defects

| Number of Major Defects | Number of Copies in Sample | | | | | | | | | | | |
|---|---|---|---|---|---|---|---|---|---|---|---|---|
| | 2 | 3 | 5 | 8 | 13 | 20 | 32 | 50 | 80 | 125 | 200 | 315 |
| 1 | 5.0% | — | — | — | — | — | — | — | — | — | — | — |
| 2 | 5.0 | 5.0% | 5.0% | 5.0% | — | — | — | — | — | — | — | — |
| 3 | 9.8 | 5.9 | 5.0 | 5.0 | 5.0% | — | — | — | — | — | — | — |
| 4 | 17.7 | 11.2 | 5.9 | 5.0 | 5.0 | 5.0% | — | — | — | — | — | — |
| 5 | 25 | 16.9 | 9.4 | 5.2 | 5.0 | 5.0 | — | — | — | — | — | — |
| 6 | 25 | 23.0 | 13.1 | 7.5 | 5.0 | 5.0 | 5.0% | — | — | — | — | — |
| 7 | 25 | 25 | 16.9 | 9.9 | 5.4 | 5.0 | 5.0 | — | — | — | — | — |
| 8 | 25 | 25 | 20.9 | 12.4 | 6.9 | 5.0 | 5.0 | 5.0% | — | — | — | — |
| 9 | 25 | 25 | 25 | 14.9 | 8.5 | 5.0 | 5.0 | 5.0 | — | — | — | — |
| 10 | 25 | 25 | 25 | 17.5 | 10.1 | 5.9 | 5.0 | 5.0 | — | — | — | — |
| 11 | 25 | 25 | 25 | 20.2 | 11.7 | 7.0 | 5.0 | 5.0 | 5.0% | — | — | — |
| 12 | 25 | 25 | 25 | 22.9 | 13.4 | 8.0 | 5.0 | 5.0 | 5.0 | — | — | — |
| 13 | 25 | 25 | 25 | 25 | 15.0 | 9.1 | 5.0 | 5.0 | 5.0 | — | — | — |
| 14 | 25 | 25 | 25 | 25 | 16.7 | 10.2 | 5.7 | 5.0 | 5.0 | — | — | — |
| 15 | 25 | 25 | 25 | 25 | 18.5 | 11.4 | 6.4 | 5.0 | 5.0 | 5.0% | — | — |

measures; and, in some cases, color can be measured from a moving web or sheet. Of course, a visual inspection is required to detect spots and marks, but instrumental measurement can monitor most other printing qualities.

The disadvantages with instrumental measurement include the following: the problems of interinstrument agreement, particularly for densitometers; the time required to make the measurements before making press adjustments; and the extra costs involved in measuring and recording data.

The colorimeter is a relative newcomer to graphic arts quality control. The instrument comes with preestablished reference standards, illuminants, and optical geometry. The densitometer, by contrast, lacks universal reference standards and standardized spectral response. A recent standard (ANSI PH 2.18-1984) specifies spectral response and color references. Densitometers made to this standard are called status T instruments. Until all densitometers are made to a common standard, it will be necessary to calibrate all in-house densitometers to a common reference and to be especially careful when communicating density numbers outside the plant. If any doubt exists, an actual printed sample should be supplied with the density numbers written on it.

The densitometer can measure the image directly when large solids are being printed. Take care to measure the same spot exactly each time. For process-color work, measurements on the color control strip are best. Measure the solid density patches, the overprints, and the tint patches or the star targets. The color bar, which is always positioned perpendicular to the direction of printing, is also measured along its length to determine intrasheet consistency. Some press control systems are capable of semiautomatic measurement of the control strip, computation of appropriate factors such as trapping or dot size, and printing out the subsequent results.

The primary advantage of density measurements is that they can be plotted on a control chart. Monitoring the trend in control chart plots can alert the printer to necessary press adjustments.

To construct a control chart for a given press, it is first necessary to collect data on press variability. Samples are pulled from a normal press run at approximately every thousand sheets or signatures and measured. Solids, overprints, and tints or star targets should be measured. The mean, or average, of each of the data sets is calculated along with the standard deviation. The **standard deviation** is a measure of dispersion

around the mean. A sample standard deviation is calculated
with the following equation:

$$\sigma = \frac{\sqrt{\Sigma(x - \bar{x})^2}}{n - 1}$$

where x = the observed value; $\bar{x}$ = the arithmetic mean of the
samples; and n = the sample size. Control charts are now
constructed with a central horizontal line representing the
mean value ($\bar{x}$) for a given variable. Outer process limit lines
are placed above and below the mean line at distances
corresponding to plus and minus three standard deviations
(normally written as $\pm 3\sigma$). The $3\sigma$ limit lines are the process
limits for the variable in question. Almost 100% (actually
99.72%) of all similar printing should fall within these control
limits.

Control charts can be prepared for solid density, trapping,
and dot size for each color. If one factor does not seem to vary
much, or if it is strongly correlated with changes in one of the
other variables, it need not be measured.

Once a control chart has been established, it is possible to
make informed decisions about customer specifications. For
example, if the standard deviation of a process is 0.05 density,
but a customer specifies that the density should not vary by
more than $\pm 0.10$, the printer now faces a problem. Only about
95% of the prints fall within the customer's tolerance range.
This leaves the printer with the following choices: try to reduce
the standard deviation of the process, hand sort the printed
product to remove those outside of the tolerance limits, try to
convince the customer that the limits should be $\pm 0.15$, or
refuse to bid on the job.

The control charts also serve as a guide for making press
adjustments. The illustration shows a control chart with $\bar{x}$ at
1.20 density. The standard deviation is 0.05. The warning limit
lines are normally set at $\pm 2\sigma$ (1.10 and 1.30) and the action
lines are set at $\pm 3\sigma$ (1.05 and 1.35). If a series of density
measurements show movement toward the warning limit on the
high side of the mean, this is a signal to reduce the ink feed
rate or make other press adjustments to reverse this trend. If
measurements fall on or beyond the $3\sigma$ line, the process is out
of control, and immediate action should be taken to bring it
back into balance.

The normal variation for a given press-paper-ink combina-
tion cannot be predicted in advance. Process capability studies

A control chart that can be used to detect changes in process behavior

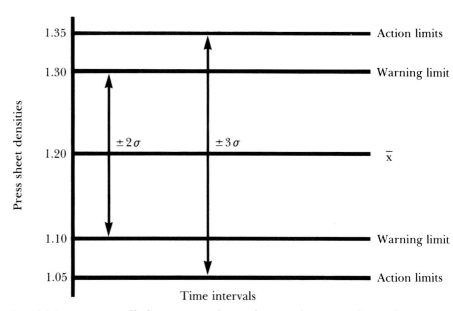

should be run on all the presses in a plant, using a variety of substrates and inks. The data collected over a long period gives a clear picture of plant capabilities. These data also help to identify particularly troublesome printing machines or raw materials sources.

## Summary

The requirements of either the print buyer or the ultimate consumer become the key factor in establishing color control limits. In general, the tightness of these requirements will be positively correlated with the cost of the job.

The variability limits that can normally be expected from the printing process constitute the other major consideration in color control. These limits will help determine if a printer can satisfy the consistency demands of a particular customer.

The American and Canadian Government Printing Offices have established quantitative measures for most print quality factors for five different product quality levels. These specifications may serve as useful starting points for establishing a set of print specifications. They should not be blindly accepted as they stand, however, because they may not represent the customer requirements of a given printer.

An indispensable way of monitoring consistency is by the use of visual inspection. To facilitate this inspection process, it always is necessary to use a color bar such as the GATF Compact Color Test Strip when printing process-color work. An inspection limit card can be made up to help monitor changes in solid densities. The high intensity level of the

# 7  The Objectives of Color Reproduction

The answer to the question, "What are the objectives of a color reproduction system?" is rather elusive. It depends upon the characteristics of the ink, the substrate, the printing process and conditions, the type of original, the color separation process, and, most importantly, the requirements of the print buyer and the expectations of the end user or consumer of the printed piece. The *set point* of the systems diagram introduced in Chapter 1 represents the setting required for optimal reproduction.

## Exact Color Reproduction

Although it may be thought that the objective of all color reproduction is exact reproduction, this is not the case. Deliberate distortions in color rendering are more the rule than the exception. In some cases, however, exact reproduction can be specified.

## Artwork and Artist's Originals

Original oil paintings and watercolors that are painted as ends in their own right are occasionally reproduced in catalogs or books, on posters, postcards, or calendars. The objective here can truly be said to be exact reproduction. The person purchasing an art book wants the reproduction to convey the color and tonal properties of the original as closely as possible. It may only be possible to achieve this objective by using more than the normal process inks.

Artwork prepared by a graphic designer is produced for the sole purpose of being reproduced. Exact reproduction can be clearly stated as the objective. In many cases the designer will specify the ink and paper to be used for the design. In other cases, he or she will be aware of the materials being used. For example, a designer preparing artwork for reproduction in a magazine should be aware of the appropriate standard proofing conditions and choose colors that are within the available gamut. If the artwork cannot be reproduced by the specified manufacturing conditions, then the artwork is at fault. Unlike fine art, which itself is the finished product and is only incidentally reproduced, commercial art serves as the starting point in the reproduction process. If the artwork is impossible to reproduce under the specified conditions, it has failed as commercial art and should be redone. In cases where the designer does not know the intended manufacturing conditions, he or she should try to ascertain whether coated or uncoated paper will be used and then choose available colors from an appropriate color chart.

**Product Colors**    Clothing, paint chips, floor tiles, automobile colors, and furniture fabrics are all examples of products that are illustrated in catalogs or brochures. The consumer often orders products based on their appearance in a catalog and consequently expects the product, when delivered, to be a close match to the catalog representation. To ensure close reproduction, actual samples of fabrics or paint are often supplied as guides for the color separator. In some cases, the separations must be made directly from the samples themselves.

The objective for product colors is exact reproduction, but this must be qualified. To achieve an exact match of a flat paint chip is one thing, but to achieve an exact match of the paint color on a product—e.g., a car—is something quite different. In the latter case, the color has been distorted by the color film used to capture the scene. Also, the shading, reflections, surround colors, lighting contrast, and color temperature of the light illuminating the scene all influence the perception of the paint color in the supplied photograph. Other factors, such as texture, gloss, sharpness, resolution, and tone reproduction must be considered in addition to color exactness. The whole picture is judged, rather than just the color in isolation.

The reproduction of a flat color, if it is within the gamut of the ink-paper combination, is fairly straightforward. If the supplied color lies outside the normal gamut, then it is not uncommon to use five or more colors to achieve a match.

The accurate reproduction of a particular color within a complex scene is not so easily achieved. For reasons to be explained in the next section, compromises must be made when reproducing photographs. The product colors in such reproductions can convey only a general sense of the original color.

## Optimum Color Reproduction

The term **optimum color reproduction** refers to the quality of a reproduction. In the printing industry, it means the quality of a printed reproduction as compared to the original artwork (which is usually a photograph). The term **optimum** in this context means the best reproduction under the circumstances.

The factors that influence optimum color reproduction include the substrate, the ink, the printing process, the color separation and correction system, and the characteristics of the original. The **best** reproduction is the one that most people would choose from a sampling of reproductions made from a given original.

Printed reproductions are made from photographs of an original scene. Because the photographs are *not* accurate reproductions of reality, it may be irrelevant whether or not the printed reproduction matches the supplied photograph. Judgments of quality are best made by the same method used by the final consumer—that is, by evaluating the printed reproduction on its own merits, not by comparing it to an intermediate reproduction (the photograph used for reproduction). Of course, there are some cases in which the photograph supplied for reproduction has exactly the same distortion from the original as is desired by the customer. In these cases, exact reproduction may be an objective, but the printing process will determine whether this can be a reality.

**Limitations of the Processes and Materials**

The selection of ink, substrate, and printing process imposes certain limitations on color reproduction quality. The colorimetric properties of the inks and substrates influence color gamut. The printing process and paper smoothness influence resolution. Contrast is affected by paper gloss, pigment concentration, ink trap, and ink film thickness. A sampling of these influences is summarized in the following illustration and table.

The illustration shows the color gamut differences due to the use of a rhodamine magenta instead of a rubine magenta. The more expensive rhodamine magenta allows an expanded color gamut in blues and purples.

The table shows the average densities on both coated and uncoated paper for solid process colors and their four-color overlap.[1] The four-color density indicates the maximum contrast that can be achieved by a given ink-substrate combination. These figures were derived from samples collected during the 1970–72 GATF Color Survey.

| Average ink densities on coated and uncoated paper | Uncoated Paper | Coated Paper |
|---|---|---|
| **Yellow** | 0.75 | 0.95 |
| **Magenta** | 0.95 | 1.20 |
| **Cyan** | 0.95 | 1.10 |
| **Four-Color** | 1.50 | 2.00 |

The screen rulings generally used for given processes and substrates are summarized in the following table. In practice, a 250-line-per-inch screen ruling is about the limit that can be resolved by the human eye at normal reading distances.[2] The process of screenless lithography is capable of achieving higher

Color gamut
differences between
lithol rubine ($M_1$)
and rhodamine Y
($M_2$) magenta inks

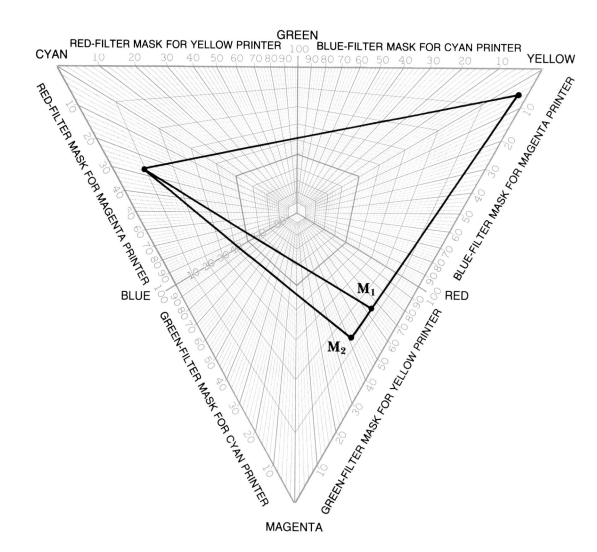

resolution. The smallest dot size that can be resolved in lithography is about 8 microns (0.00032 inches).[3] This is far smaller than with any other printing process, which means that lithography produces higher resolution than the other processes.

<table>
<tr><td><em>Screen rulings generally used for given processes and substrates</em></td><td><strong>Process and/or Substrate</strong></td><td><strong>Ruling (lines per inch)</strong></td></tr>
</table>

| Process and/or Substrate | Ruling (lines per inch) |
|---|---|
| Screen printing—textiles | 50 |
| Letterpress—newsprint | 65–85 |
| Screen printing—smooth substrates | 85–110 |
| Flexography | 85–120 |
| Letterpress—machine finished | 100 |
| Lithography—machine finished | 120–133 |
| Letterpress—coated | 133–150 |
| Gravure—all substrates | 150–200 |
| Lithography—coated | 150–250 |

Coarser screens (as low as 20 or 30 lines per inch) may be used for billboard posters. This is possible because it is the viewing distance—more than the process or substrate—that affects image quality in such cases.

The process and materials limitations are generally dictated by the economics of the end product. For example, an illustration printed on a machine-finished magazine stock does not look as good as the same illustration printed on a high-quality cast-coated paper. Likewise, a reproduction printed with more colors than the standard process inks is likely to look closer to the original than the same illustration printed with just the four process colors. A **duotone black,** for which two black plates are used to create higher shadow contrast in black-and-white halftone reproductions, is another example of materials and process selection that can influence the quality limits of the reproduction. In other words, the more expensive materials and procedures generally produce higher-quality results. In some cases—for example, a weekly magazine that uses a standard ink set and substrate—it is not possible to specify more expensive materials and procedures. In this case, the limits of quality are fixed. The separation films must be produced to achieve maximum quality within these limits.

Buyers of printing and designers should realize that there are finite quality limits established by the ink-substrate-process combination. These quality limits can often be expanded by using extra colors or higher-quality substrates, but only at higher cost. Attempts to achieve the same quality with

machine-finished paper and standard process inks as with the best coated paper and five or six inks are unproductive.

**Color Distortions of Photographs**   A color photograph (print or transparency) is a reproduction of an original scene or object. The accuracy of this reproduction depends on the brand and type of color film, the illumination of the original object or scene, the exposure of the film, and the processing of the film. The optical system of the camera may also introduce distortions.

The types of distortion inherent in photographic color reproductions include hue, lightness, and saturation shifts of colors; image defects caused by loss of resolution, the presence of grain, and poor sharpness; and tonal distortions caused by the emulsion characteristics.

The perception of distortions is influenced by several viewing conditions: the degree of magnification, the color temperature and intensity of the viewing light source, and the surround conditions.

The viewing conditions for photographs have been standardized by various national standards organizations. The kind of color film that is used by photographers, however, can never be standardized. From the creative viewpoint, such standardization would be unnecessarily restrictive.

Unfortunately, many color photographs are not intended as originals for photomechanical reproduction. For example, 35-mm color transparencies are designed for projection in darkened rooms; consequently, the gamma and contrast of the emulsions are designed for that purpose rather than as originals for photomechanical reproduction.

The illustrations on pages 158–160 show a selection of 35-mm films that have been exposed under identical conditions. Certain films reproduce some colors more accurately than others, but no film accurately reproduces all colors. The illustrations on pages 164–165 show a grain size comparison of the test 35-mm films. In general, the slower the film, the finer the grain. Kodachrome 25 ASA film is usually the best by this criterion, but its slow speed limits the conditions under which it may be used.

The key point concerning color photographs is that they are distortions of reality. Because different kinds of photographic material distort reality in different ways, the same brand and kind of color film should be used when a series of photographs are all going to be reproduced together, as in a catalog or a book. The optimum reproduction generally differs from the photograph. The reproduction may need to be closer to the

original scene or object colors; it may have to be even further distorted to be considered optimum. The photograph submitted for reproduction is merely a starting point, not an end in its own right.

**Optimum Color Research**

A major conference on optimum reproduction of color for photography, television, and printing was held by the Inter-Society Color Council in Williamsburg, Virginia, in 1971.[4] A follow-up conference was held in 1978.

The findings of these conferences included the observation that excellent color reproductions are produced on occasion, but not consistently, by the photography, television, and printing industries. Some points of general agreement were reached at the conferences. Since then, other research work has shed more light on the requirements for optimum color reproduction. The findings can be summarized under the headings of tone reproduction, color accuracy, and other objectives.

**Tone Reproduction**

Virtually all researchers in this field agree that reproducing good tone is the first and foremost objective in achieving good color reproduction. Of primary importance is the compression of the tone scale in order to achieve the best results. The brightness range of an original scene is often greater than the corresponding density range of a photograph, which, in turn, is greater than the photomechanical reproduction that can be made from it.

Some of the many tone reproduction curves that are possible when the density range of a transparency is compressed by the printing process

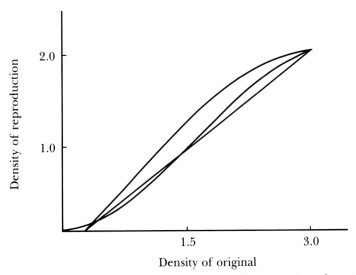

(Text continued on page 161.)

A selection of 35-mm color transparency films (pages 158-160) that have been exposed under identical conditions

Certain films reproduce colors more accurately than others, but no film accurately reproduces all colors.

**Note:** These illustrations do not all convey the correct impression of image quality because of exposure differences and limitations of photomechanical reproduction.

A selection of 35-mm color transparency films (pages 158-160) that have been exposed under identical conditions

Certain films reproduce colors more accurately than others, but no film accurately reproduces all colors.

**Note:** These illustrations do not all convey the correct impression of image quality because of exposure differences and limitations of photomechanical reproduction.

A selection of 35-mm color transparency films (pages 158-160) that have been exposed under identical conditions

Certain films reproduce colors more accurately than others, but no film accurately reproduces all colors.

**Note:** These illustrations do not all convey the correct impression of image quality because of exposure differences and limitations of photomechanical reproduction.

The printer has to work from original transparencies often having a contrast range greater than 3.0. The contrast range of printed matter rarely exceeds 2.0; therefore, a density of 1.0 must be sacrificed.

Some graphic arts film manufacturers suggested using three-point gray scales and photographing them alongside the originals to a standard set of contrast ranges or aimpoints. These recommendations usually resulted in higher contrast in the highlight-to-middletone region than in the middletone-to-shadow region. As a first step towards the control of tone reproduction, these recommendations served a useful purpose, but it was found that they did not produce optimum results for every job.

Other researchers suggested using a uniform visual compression of the tone scale. Such a compression could be made according to the Munsell tonal spacing. Again, such a compression did not produce consistently high-quality results. The method produced advances over the results obtained through a fixed three-point system, in that a different compression could be used for different contrast ranges. However, such an approach would call for identical tonal compressions for a photograph of mostly light subjects (high key) and one of mostly dark subjects (low key) as long as their density ranges were identical.

C. J. Bartleson and E. J. Breneman introduced the concept of brightness into the perception of tone reproduction.[5] George Jorgensen of GATF applied their work to the photomechanical reproduction of black-and-white photographs and found that the optimal tone reproduction curves depended on the classification of the photographs as high key or medium key.[6] He concluded that the reproductions should be made to a gamma of approximately 1.0 in the *interest area* of the subject. This normally means emphasizing the highlights of a high-key original and the middletones of a medium-key original.

Although Jorgensen's work has not been extended to color reproduction, the likelihood of the interest-area concept applying to color reproduction has been generally adopted. For example, one company that manufactures a scanner programming aid supplies sets of high-, normal-, and low-key transparencies to assist the operator in the classification of originals. A series of tone reproduction curves is available to optimize the reproduction of these originals.

*(Text continued on page 166.)*

Image structure
characteristics of a
variety of 35-mm
color transparency
films, enlarged
approximately 240×
(pages 162-163)

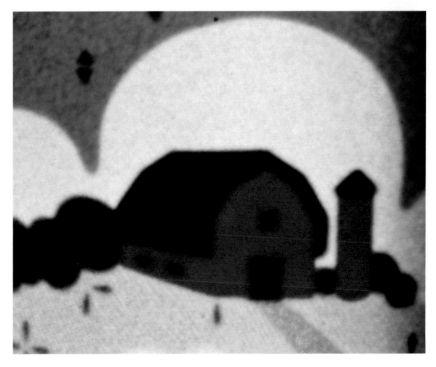

**Note:** These illustrations do not all convey the correct impression of image
quality because of exposure differences and limitations of photomechanical
reproduction.

Image structure characteristics of a variety of 35-mm color transparency films, enlarged approximately 240× (pages 162-163)

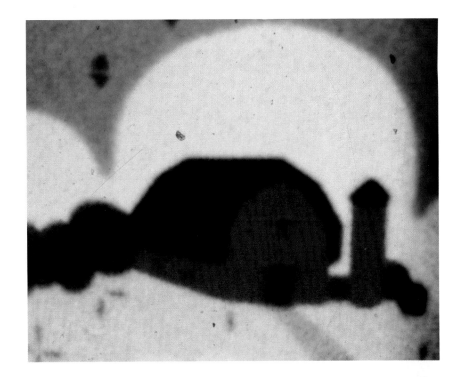

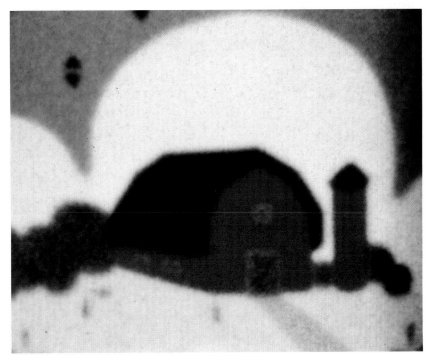

**Note:** These illustrations do not all convey the correct impression of image quality because of exposure differences and limitations of photomechanical reproduction.

Grain size
comparison for a
variety of 35-mm
color transparency
films, enlarged
approximately 240×
(pages 164-165)

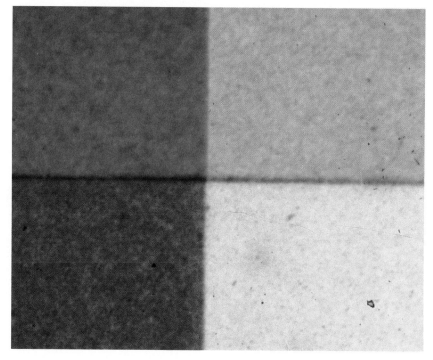

**Note:** These illustrations do not all convey the correct impression of image
quality because of exposure differences and limitations of photomechanical
reproduction.

Grain size comparison for a variety of 35-mm color transparency films, enlarged approximately 240× (pages 164-165)

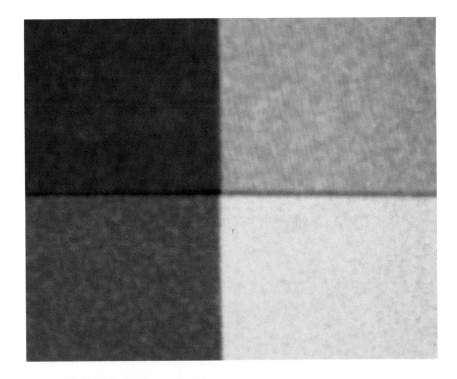

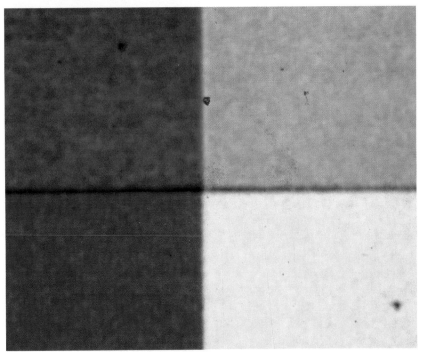

**Note:** These illustrations do not all convey the correct impression of image quality because of exposure differences and limitations of photomechanical reproduction.

Tony Johnson, in work at Pira and Crosfield Electronics Ltd., concluded that different tone reproduction curves would be necessary for different brightness originals.[7] His studies focused on whether a bright or dark surround was used when evaluating color transparencies for tone reproduction.

Thus, the thinking in tone reproduction research has gone from fixed three-point control to uniform tone scale compression to compression dependent on the main interest area in the picture. The exact tone curves for high-, medium-, and low-key color reproductions are not known. Indeed, the optimal curve for a normal photograph may shift according to what is perceived as the interest area.

"High-score" tone reproduction curves for black-and-white high-key and normal prints

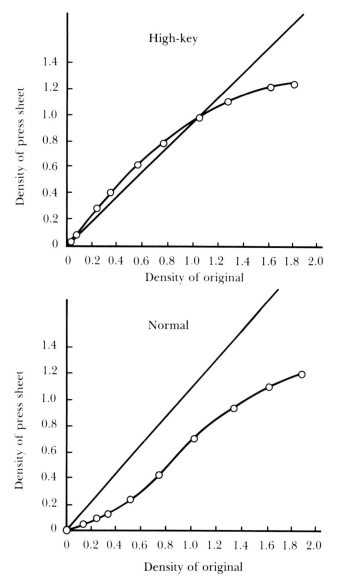

The same photo-
graph reproduced
using the tone
reproduction curves
in the preceding
illustration

The preceding discussion applies to determining the desired tone reproduction at a 100% reproduction scale. If the original is going to be greatly reduced, the middletones may appear too dark if the 100% tone curve is used. Likewise, if the original is greatly enlarged, the middletones may appear too light.

To counter the scale change effect, it is necessary to reduce the middletone values when making reductions and to increase the middletone values when making enlargements. The Dr.-Ing. Rudolf Hell Company recommends the adjustments shown in the following table.[8]

Middletone
corrections for
enlargement and
reduction

| Scale of Reproduction | Midtone Dot Change | Scale of Reproduction | Midtone Dot Change |
|---|---|---|---|
| 20% | Reduce by 15% | 600% | Increase by 5% |
| 40% | Reduce by 10% | 1000% | Increase by 7% |
| 60% | Reduce by 5% | 1500% | Increase by 9% |
| 80% | Reduce by 3% | 2000% | Increase by 10% |
| 100% | No change | | |

For cases in which the density range of the original exceeds the achievable range of a given ink-paper-press combination, we must emphasize certain parts of the tone scale at the expense of others. The sales personnel in printing or color separation plants have a special responsibility to find out from the customer the main interest area in the photograph and communicate this information to the person making the color separations.

**Color
Accuracy**

The term **accuracy** in this context relates to how closely a printed color agrees with that desired by the customer. There are two aspects to consider: how closely some colors match the original scene or object, and how closely a color matches the desired distortion from the original scene or object. The terms *color balance* and *preferred color* apply to these two cases.

**Color Balance**

Research has supported the importance of reproducing a good gray scale. That is, neutrals in the original scene must be reproduced as neutrals on the printed page.[9] If the neutrals are correctly reproduced, many of the colors will also be satisfactorily reproduced.

The two reasons for poor reproduction of neutrals are incorrect gray balance and poor neutrals in the original. Gray balance is dependent on the colorimetric properties of the printing inks and substrate and the subsequent image distortion caused in the printing process. Gray balance can be determined for any given press-substrate-ink combination by printing a test gray balance chart and analyzing it to determine the optimal yellow, magenta, and cyan dot values that produce a neutral scale. Once this objective is achieved, the press aspects of color balance are satisfied.

Problems with the color balance of originals are usually related to using a color film under the wrong lighting conditions. For example, if a film intended for daylight use is used indoors with tungsten illumination, the subsequent photographs will appear too warm. Poor color balance in photographs is corrected by using Kodak Wratten color correcting (CC) filters.[10] These filters are available in a variety of values in yellow, magenta, cyan, red, green, and blue. CC filtration is added to a transparency until balance is restored. For example, a greenish transparency is balanced by the addition of CC magenta filters. Color negatives are usually balanced by adding CC filtration at the color print-making stage. Therefore the print, which is then submitted for reproduction, should not have any color balance problems. Some viewers are now available that allow continuous variation in CC filtration between 0 and 100. The transparency is visually balanced; then the corresponding CC values are transferred to the scanner settings, or appropriate filters are used for nonscanner separation systems.

**Preferred Color**

The question of preferred color is more difficult with few concrete recommendations emerging from the research.

**Corrected**                                    **Uncorrected**

Tungsten illumination (3200 K)                   Tungsten illumination (3200 K)
Kodak Wratten 80A filter                         No filter

Fluorescent illumination (cool white)            Fluorescent illumination (cool white)
Kodak Wratten CC30M filter                       No filter

Conversion filters change the color quality of various light sources so that these illuminants can be used with color film that is balanced for a different light source. The illustrations above show the same color transparency film corrected and uncorrected for two light sources.

CC filters for the visual correction of out-of-balance color originals

The appropriate adjustments are incorporated at the color separation stage.

The Colortune Viewer, an adjustable viewer for the visual correction of out-of-balance color transparencies
*Courtesy Colortune Corporation*

The appropriate adjustments are incorporated at color separation stage.

Of course, the exact color reproduction discussed at the beginning of this chapter also could be considered preferred reproduction. That is, a product color must be exactly reproduced in a catalog. However, it is advisable to reserve the term **preferred** for colors that are intentionally distorted from the original scene or object.

One preferred color distortion is Caucasian skin tone. Research has shown that people prefer to have this color reproduced slightly tanner than its actual color. Also, water and sky colors are often preferred bluer than their actual appearance in nature. For example, postcards are usually reproduced with saturated blues (sky or water) and greens (grass) that don't match reality. Colors are sometimes altered to create a particular mood or atmosphere in a picture. In most cases, the color films used to take the photographs already have some of the desired distortions built in, such as tanner skin tones and bluer skies. Thus, the objective of the reproduction process is to reproduce the distorted colors in the photograph as closely as possible. This is reasonable if the desired colors lie within the gamut available from the given printing conditions.

The reproduction of nongamut colors has received some attention from research workers. The major difficulties with nongamut colors concern saturation and lightness. Hue can always be matched. To some degree, lightness can be satisfactorily adjusted when modifying tone reproduction to emphasize an interest area. Little agreement exists on how saturation should be modified. Some researchers suggest a uniform compression of all saturations. Others argue that this treatment sometimes sacrifices the saturation of important colors.[11] We must conclude that the optimal saturation compression is not known.

There is some evidence suggesting that excellent reproductions do not necessarily contain colors that are all reproduced equally well. Therefore, as long as good tone reproduction, color balance, and the satisfactory reproduction of the important picture areas are achieved, a loss of saturation in some areas is probably not significant. Of course, improved color saturation is possible if extra printing inks are used. The desaturation of light tones is primarily due to the halftone process (the coarser the screen ruling, the greater the desaturation). The use of light pastel ink colors (usually pale blue or pink) can help solve this problem. Desaturation of dark colors is generally related to the process ink pigments and the ink film thicknesses of these inks. Extra printings of colors such as red, blue, or purple are sometimes used to help improve the saturation of dark colors.

## Other Objectives

For flat-color areas, the colorimetric aspects of optimal color reproduction—hue, saturation, and lightness—are the significant properties. For pictorial subjects, though, the quality of the

image is also important. Resolution, sharpness, graininess, and moiré patterns may override colorimetric considerations in the judgment of overall quality. Likewise, other appearance factors, such as gloss and texture, influence perceived color quality.

**Image Quality Factors**

A designer will sometimes specify the use of a particularly coarse screen ruling or a special-effect mezzotint screen when reproducing a given original. The purpose of such a treatment is to attract the viewer rather than to reproduce the picture accurately. The following discussion assumes, however, that the objective is to reproduce the picture as naturally as possible.

The resolution of a reproduction is largely influenced by the chosen screen ruling. A 175-lines-per-inch screen produces a higher resolution reproduction than a 100-lines-per-inch screen, given the same viewing distance. Resolution is also influenced by the grain of the original, the subsequent photographic stages, and the plate. The finer the grain, the higher the resolution. In addition, printing conditions—such as ink film thickness, misregister, and paper smoothness—have an effect on resolution. All other things being equal, it is safe to say that the higher the resolution of a reproduction, the better. As a practical measure, it is difficult for the eye to perceive improvement in resolution beyond that achieved with 250-lines-per-inch screen rulings.

**Sharpness** refers to contrast at the edges of tonal values. If adjacent black-and-white tones contain a narrow band of higher density black and a narrow band of lower density white at the boundary, then the division between the two tones appears sharper than black-and-white areas of uniform density gradients. Color scanners use this *overshoot* principle to enhance the sharpness of color separations electronically. The problem with sharpness adjustment is in knowing how far to sharpen a picture. More sharpness is not necessarily better. For example, a soft-focus portrait is made that way by the photographer to create a particular mood. The mood would be destroyed by enhancing the sharpness. Occasionally, one observes unnaturally sharp reproductions in magazines or other printed matter. Such results are typically caused by incorrect adjustment of scanner sharpness controls or incorrect scanning aperture selection.

Sharpness selection seems to be a trial-and-error proposition. In the absence of research findings on sharpness, the following guidelines are offered as recommended starting points: photographs of natural subjects, such as landscapes or portraits,

Changes in image
resolution due to
different halftone
screen rulings: 133
lines per inch *(top)*
and 85 lines per inch
*(bottom)*

Increase in apparent
sharpness *(top)*
due to image
enhancement with an
electronic color
scanner

should not have any sharpness enhancement; photographs of industrial or consumer products, such as machinery or jewelry, may be improved by increasing the sharpness; and soft-focus *mood* photographs may be improved by reducing the sharpness.

Graininess generally refers to the nonuniform distribution of silver grains in photographs. The effect of such a phenomenon is to cause unevenness or mottle in what should be a smooth, even tone. Graininess also influences resolution. Apart from the original photograph, graininess is affected by the subsequent photographic stages, the plate, and the printing conditions. It is

not a major problem in complex scenes containing fine detail but becomes more obvious in large even areas, such as a blue sky.

For optimal reproduction, graininess should be as low as possible. Unfortunately, nothing can be done to reduce graininess in the original, but some techniques can be used in the reproduction stages to minimize its increase. Photographic stages should be kept to an absolute minimum—direct-screen color separation is best from this perspective. If the indirect process is used, the continuous-tone separations and masks should be made as large as possible. Using elliptical dot screens can help minimize the graininess of the original. Smooth grain plates and low ink film thicknesses also help keep grain to a minimum.

Interference patterns are the final image quality factor that should be considered. These patterns may include moiré, gear streaks, wash marks, and spots. From the color reproduction perspective, **moiré** is the most important of these factors. Moiré is caused by the overlap of halftone screens on different angles. In other words, all halftone color reproductions have moiré patterns. In some cases these are more objectionable than others. Objectionable moiré patterns are most likely to show up in browns, greens, or skin tones. This is due to the use of conventional screen angles (yellow 90°, magenta 75°, and cyan 105°) in conjunction with some press problem such as doubling.

The objective is to reduce moiré patterns to an absolute minimum—the *rosette* pattern. Some techniques for achieving this objective include switching the yellow and black angles (possible if a *skeleton* black is used) or placing the yellow on a finer screen than the other colors; for example, 175 lines per inch versus 150 lines per inch for the other colors. Also, magenta and black angles are often switched to help reduce moiré in skin tones.

A closing comment about image quality concerns *screenless,* or *continuous-tone,* lithography that seems to create periodic bursts of interest. This process is capable of remarkable resolution that certainly adds a dimension of quality to a color reproduction. Unfortunately, screenless lithography often enhances the graininess of the illustration, partly negating the improvement in resolution and the elimination of moiré patterns.

**Surface Effect Factors**

Surface effects, such as gloss and texture, influence the perceived quality of the reproduction. These factors are largely

related to the substrate selection, but can also be influenced by the inks.

The correct gloss or texture depends on the nature of the original and the end use requirements of the reproduction. For example, an artist's watercolor drawing does not reproduce well on a high-gloss substrate. The paper selected for such a reproduction should probably be uncoated and have a gloss and texture similar to the original paper that served as a substrate for the drawing.

For the optimal reproduction of photographic originals, high-gloss substrates (and inks) are desirable. The high gloss minimizes surface light reflections (scatter), thus leading to higher saturation and lightness (contrast) of printed colors. Image sharpness also appears higher on glossy substrates. A varnish is sometimes applied to printed matter to enhance this effect.

The substrate should also be as smooth as possible for optimal reproduction. Smoother papers make possible finer screen rulings, and thus, higher resolution.

## Summary

The question of what defines optimal color reproduction is most difficult to answer.

Optimal color reproduction was not a major concern in the past because the problems in producing any reasonable reproduction were so great that little effort was devoted to achieving optimal quality. In recent years the problems of consistency and control in color reproduction have been considerably reduced. Color scanners, automatic film processors, presensitized plates, continuous-flow dampening systems (lithography), ink agitators and pumps, and press control consoles have all reduced the variability in color reproduction.

With the color reproduction process now under reasonable control, the question of optimal color reproduction becomes valid. At present, excellent color reproductions are sometimes produced. We need to develop the knowledge of what produces this excellence so that high-quality photomechanical reproduction will become an expected outcome rather than a chance outcome.

To date, our knowledge suggests that optimal reproductions have the following qualities: a tone reproduction curve that favors the interest area in the photograph; color balance to achieve good neutrals; preferred skin and sky colors that are deliberately distorted from the original scene; correct saturation

of important color areas; high resolution; low graininess; minimal moiré; appropriate sharpness; high gloss; and perfect smoothness. It is anticipated that further research in the coming years will expand our knowledge of optimal color reproduction.

**Notes**

**1.** Gary G. Field, "The 1970–72 GATF Color Survey," *Research Progress Report* No. 98 (Pittsburgh, Pa.: Graphic Arts Technical Foundation, 1973).

**2.** George W. Jorgensen, "Lithographic Image Definition," *Research Progress* No. 62 (Pittsburgh, Pa.: Graphic Arts Technical Foundation, 1963).

**3.** George W. Jorgensen, "The Rendition of Fine Detail in Lithography," *Research Progress Report* No. 73 (Pittsburgh, Pa.: Graphic Arts Technical Foundation, 1967).

**4.** Milton Pearson, ed., *ISCC Proceedings* 1971 (Rochester, N.Y.: RIT Graphic Arts Research Center).

**5.** C. J. Bartleson and E. J. Breneman, "Brightness Perception in Complex Fields," *Journal of the Optical Society of America* 57 (1967): 953–957.

**6.** George W. Jorgensen, "Improved B & W Halftones," *Research Project Report* No. 105 (Pittsburgh, Pa.: Graphic Arts Technical Foundation, 1976).

**7.** Tony Johnson, "Designing Scanner Software to Meet the Press Requirements," *TAGA Proceedings* 1985 (Rochester, N.Y.: TAGA), pp. 135–151.

**8.** Ralph Girod, "Change of Contrast in Great Enlargements and Reductions," *Hell Topics* No. 1 (1984), p. 3.

**9.** W. D. Wright, "Informal Summary and Impressions of the Conference," *ISCC Proceedings* 1971 (Rochester, N.Y.: RIT Graphic Arts Center), p. 220.

**10.** *Silver Masking of Transparencies with Three-Aimpoint Control Q-7a* (Eastman Kodak, 1980).

**11.** W. L. Rhodes, "Review of the Aims of Color Reproduction in Printing," *ISCC Proceedings* 1971 (Rochester, N.Y.: RIT Graphic Arts Center), p. 129.

# 8 Systems Control in Color Reproduction

A systems approach to color reproduction is the only way to achieve high-quality results consistently. With a stabilized printing process and an established relationship between the original and the reproduction, the production of color separations can proceed in a systematic manner. Information from the printing process is fed *back* to the color separation department. Information concerning the compromises to be made in reproducing the original are fed *forward* to the color separation department.[1]

**Characterizing the Printing Process**

Systematic color reproduction is possible if the printing conditions are stable. If conditions are unstable, the color separation department is trying to hit a moving target.

Stable printing conditions include the use of plant standard inks, paper, plate type, and other materials. These materials are used consistently in order to achieve standard solid densities, overprint colors, dot reproduction, gloss, register, and other print quality factors.

In practice, it is very difficult to standardize on one set of printing conditions. A general commercial printer must respond to many different customer specifications. On the other hand, there are some printers, such as publications printers, for whom standardization is quite feasible.

Various procedures can result in a significant reduction of variables in commercial printing. They include the use of a plant standard ink set, color sequence, color bars, and densitometers, together with systematic press maintenance and control. Paper becomes the biggest variable, but it is probably possible to establish sets of specifications based on an average coated paper and an average uncoated paper.

We can now reexamine the systems concept introduced in Chapter 1. The **process** aspect of the color reproduction system includes every step from the contacting stage through platemaking, ink, paper, and other materials selection to the final act of printing. A particular tonal value on the color separation films is reproduced as a certain color in the printing process. The color reflects all the distortions inherent in the process, from contacting to printing. To produce color separations having the desired tonal values, we must identify the distortion and then attempt to compensate for it in the color separation stage. There are limits to the adjustment of color separation film characteristics.

The **feedback signal** aspect of the color reproduction system uses special charts representative of the printing process.[2]

These charts are available as master film sets from organizations such as GATF. The films are contacted to plates; the plates are mounted on press to print (using house standard inks and papers) feedback control charts. If a sheetfed printing plant uses a variety of papers, it would be normal to print the charts on a selection of papers. The charts are printed as closely as possible to the average or standard printing quality for that set of conditions.

**Color Charts**

The most comprehensive feedback chart is the color chart. This chart usually consists of a grid pattern of colored tint areas. Either through a code system or direct marking, it is possible to identify the dot areas (of yellow, magenta, cyan, and black) needed to reproduce a particular color square in the chart.

The dot values on the chart represent the values on the original films. A transmission densitometer provides a more accurate description of these values.

One chart that offers a good compromise between ease of production and number of colors is the Foss Color Order System, which was designed for both sheetfed and webfed lithographic printing.[3] There are 5,712 colors in the system. This large number is practical with only five printing plates because of the two black plates shown in the illustration. Three levels of black are reproduced on one plate and four levels on the other.

Color charts have two basic uses. The most common is for color specification. A customer chooses a color, usually for background or type, from those on the chart. The image assembly department positions screen tints corresponding to those values that were used to generate the color chosen by the customer. The other major use of color charts is for color matching. Color separators and dot etchers refer to the chart when adjusting dot values in color separation films.

**Gray Balance Charts**

The second major feedback control chart is the gray balance chart. The GATF Gray Balance Chart is typical of this test image. The primary purpose of the gray balance chart is to determine the amounts of yellow, magenta, and cyan inks needed to produce a visual neutral gray for the printing conditions under test. The other use of the chart is to identify dot gain from film to print. A more precise means of determining dot gain is through the use of the GATF Halftone Gray Wedge.[4] This image can be printed in any color. Chapter 10

presents a more detailed description of the use of this wedge and the gray balance chart.

**Color Separation and Correction Guides**

The GATF Color Reproduction Guide represents the final major feedback control device. This guide is used to establish the color correction requirements for the ink-paper combination as "seen" by the color separation system. Separation and masking color correction are adjusted to satisfy the **rule of three**.[5] That is, three of the colors on the guide must separate like black (the **wanted** colors), and three must separate like white (the **unwanted** colors). For example, for the yellow separation the green, yellow, and red colors must appear like black; the magenta, blue, and cyan colors must appear like white. Note that the use of the Color Reproduction Guide (or a similar device) cannot determine the color corrections, which are related to the characteristics of the copy. These requirements are more subjective.

# Controlling Color Reproduction

The successful operation of a color reproduction system depends on the consistency of the various steps that make up the system. The consistency of each stage is best monitored by using standard independent test images and instruments. Visual monitoring of the actual job image is also important from the viewpoint of defect detection, such as checking for spots and patterns. Because every job is different, however, and the human visual system is poor at memory-based judgments, visual monitoring should not be used exclusively for consistency evaluation. Test images and instruments are best suited for this type of application.

**The Camera and Scanner Department**

The primary test images for monitoring color separations are gray scales, which can be either stepped or continuous.

The images can be either silver or dye. The dye image gray scales should be used when transmission originals are being separated by an optical system such as an enlarger or scanner. Silver images may be used for contact separations or reflection separations. Five (scanners) or three (cameras) points on the gray scales are monitored on the separations. Densities or percent dot areas are checked with a transmission densitometer.

The previously described Color Reproduction Guide constitutes the other major image used for checking color separations. To use this guide, photograph it and the gray scale, alongside the original. The rule-of-three judgment can be

# The GATF Color Reproduction Guide

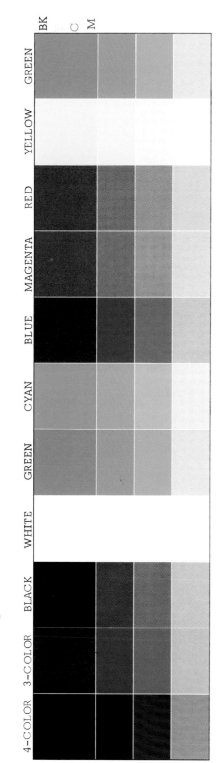

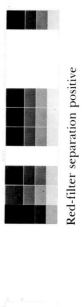

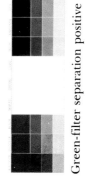

Green-filter separation positive

Red-filter separation positive

Blue-filter separation positive

Continuous or wedge gray scale *(left)* and stepped gray scale *(right)* for monitoring color separation tonal properties

made by measuring the densities of the color patches on the separations. Because the color reproduction guide only indicates correction of the ink-paper combination and does not consider the spectral properties of the original, its usefulness is somewhat limited. It is excellent for setting the ink-paper correction circuits on a color scanner but is lacking somewhat in judging separation and correction effectiveness of separations made on a camera from reflection copy. This is because the filters used for color separation do not match the spectral sensitivities of the human eye. They are said to have a low *colorimetric quality* (or q) factor. Scanners circumvent this problem because they can generally be set for independent correction of both the copy and the inks. Camera, or photographic, correction includes both copy and inks.

Resolution and squareness tests are also made of color separations, although not on a routine basis. They are only conducted when new equipment, materials, or systems are implemented and need to be checked alongside previous standards. Including a resolution target in all separations is advisable, however. Visual examination of these targets results in the detection of focusing errors or vibration encountered while the separation was being exposed. The USAF resolution target or the GATF Star Target are common targets for monitoring resolution.

Variables to control in color separation—apart from scanner programming, or camera masking and separation—include the exposure and processing of film. These variables can be controlled by using light integrators and automatic processors. If the appropriate light wavelengths are monitored by the integrator, and the activity of the developer in the processor is maintained, consistently accurate separations should be produced. The only remaining variable is the film. Photosensitive material can vary from batch to batch in such properties as speed, color sensitivity, and contrast. Aging of film causes changes in these properties. Generally, these variations are not troublesome if they can be anticipated. It is then possible to make compensations by altering exposure time and/or developing time. To identify emulsion properties, use the actual exposure system to produce two films, one from the old batch and the other from the new batch, having identical exposures. Process the films under identical conditions and then evaluate. Any differences between the films are due to the emulsion differences.

RIT Three-Bar Target for evaluating the resoluton of color separation systems
*Courtesy Rochester Institute of Technology Technical and Education Center of the Graphic Arts*

**RESOLUTION TEST OBJECT RT-3-72**

*Produced by:*
Graphic Arts Research Center
Rochester Institute of Technology
Rochester, New York  14623

*With the assistance of:*
Naval Ordinance Laboratory
Photographic Engineering and Services Division
Silver Spring, Maryland

GATF Star Target
(enlarged 3×) for
evaluating the
resolution of color
separation systems

## Image Assembly and Contacting Department

The image assembly stage can include the dot etching or retouching of color separations as well as the assembly of pictorial, text, tint, or line elements. All of these functions normally use at least one contacting operation. At this stage, possible tonal variations can influence the stability of the color separation system.

Like color separation, the contacting system involves the exposure and processing of film. Therefore, the use of light integrators, automatic processors, and control strips is necessary to ensure consistency of contact results. Unlike the color separation stage, contacting is significantly influenced by the vacuum frame in which the film is exposed.

In order to achieve perfect contact across the entire film area (especially in the center), it is often necessary to let the vacuum draw for 2 or more min. after the gauge reads that maximum vacuum has been achieved. Some vacuum frames have roller systems or inflatable bladders to ensure that air is evacuated from the center of the frame. Unless perfect contact is achieved, considerably greater dot distortion will be recorded in the center of the contact as compared to the edges.

Another major concern in producing quality contacts is the evenness of exposure. A point light source centered over a vacuum frame is closer to the center of the frame than it is to the corners. Hence, the center of the contact receives more exposure than the corners. If, for example, the light is placed at a distance equivalent to the diagonal measure of the film being exposed, the center will receive about 20% more exposure than the corners. To minimize this difference, the light should be positioned at a distance of twice the length of the film diagonal away from the frame. To achieve greatest dot fidelity, a point light source, rather than a diffuse light source, should be used for exposing contacts.

Contact consistency and quality can be monitored by using resolution-type contacting targets. Some of these targets are illustrated below. Evenness of contact (including vacuum and exposure variables) can be judged by placing five identical contact targets at the corners and in the center of a sheet of film. After exposure and processing, the target images should appear identical.

The contacting process usually distorts the image by a fixed amount. Contacts made from negatives typically gain in dot size. Those made from positives normally lose in dot size. This distortion is used to advantage in the process of dry dot etching; dot sizes are modified by photographic rather than chemical means. The *normal* distortion for contacts should not exceed one step on the GATF Dot Gain Scale. This is equivalent to 3% at the 50% dot.

Dot distortion in contacting is not linear throughout the tonal scale. It is at a maximum in the middletones, declining to zero at the 0% and 100% tones. Therefore, a gray scale, such as the GATF Halftone Gray Wedge, should be used to describe the distortion. Testing with a transmission densitometer quantifies the relationship between the original film and the contact. The construction of a graph serves as a reference when calculating allowances for contacting.

Contacting consistency can be monitored by the visual examination of a contacting target image. One such target should be included when making contacts from color separations. In addition, key dot values should be checked with a transmission densitometer. Density values may be converted to percent dot area values using logarithmic tables.

The other color reproduction checks employed at the image assembly stage concern screen ruling and screen angle. Objectionable moiré patterns may result if either of these two measurements is wrong. Screen angle and screen ruling can be easily checked by using indicators similar to those shown in the illustration on page 190.

**The Platemaking Department**

Platemaking control is similar to contacting control in that exposure time, light distance, vacuum drawdown, and processing all influence dot fidelity. Thus, to ensure minimum distortion and maximum consistency of plates, these factors must be controlled in the same manner as contacts. Adequate drawdown time, light at the distance of twice the plate diagonal, light integrators, and automatic plate processors all

GATF (A), Du Pont (B), and Eastman Kodak (C) contact targets

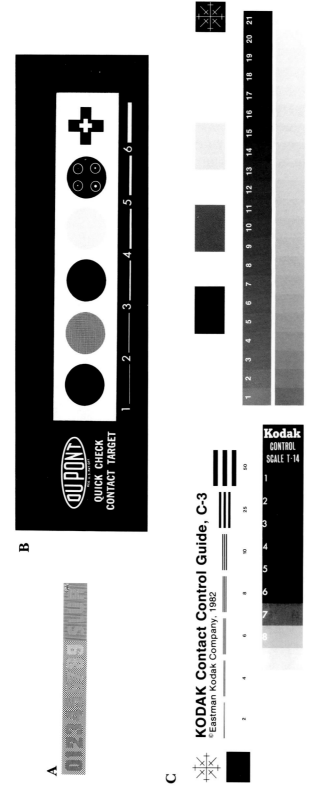

The GATF Halftone Gray Wedge

Graphic Arts Technical Foundation; Pittsburgh, Pennsylvania 15213

help to ensure fidelity and consistency of this aspect of the color reproduction process.

The properties of the plate coating should be monitored in the same manner as photographic emulsions. The common method of conducting this evaluation is to expose a sensitivity guide to the plate for the standard time. After processing, the sensitivity guide image is compared to that on previously made plates. The solid step value should be the same. The ideal value is specified by the plate manufacturer.

Plate consistency is best monitored by using sensitivity guides (for exposure and processing) and contacting targets for vacuum and contact efficiency. Because of the metallic properties of the plate, it is difficult to use a reflection densitometer to monitor dot size on the plate. Moreover, the

The Stouffer Sensitivity Guide **(A)** and the guide image on the plate **(B)**

A                    B

The GATF Screen
Angle Guide

use of a reflection densitometer on the plate may scratch or damage the surface. An electronic planimeter may be used to determine actual dot area on plates.

Although this discussion focuses on the lithographic process, all the procedures, recommendations, and targets can also be used for other dot image processes; namely, flexography, letterpress, screen printing, and (in some cases) halftone gravure. Coarser screen targets are usually necessary for screen printing and probably flexography.

If continuous-tone images are used for exposing the plate, such as in conventional gravure or screenless lithography, some modifications in control procedure are necessary. Resolution-type targets are still useful for determining the adequacy of contact efficiency and evenness. For judging tonal quality, however, a continuous-tone gray scale must be used. For gravure, a depth gauge is necessary to monitor tonal values of individual cells. In screenless lithography, reflection density measurements are made of the gray scale image. Three- or five-aimpoint control, similar to that suggested for color separations, can be used to monitor cylinder or plate quality.

The use of an electronic planimeter to determine dot area on the plate

**The Printing Department**

The control of the ink-on-paper image is the most difficult to maintain. The major color reproduction qualities that must be controlled include solid color density, overprint color (or trap), dot gain (or resolution), and register. Other important qualities include gloss, evenness, moiré patterns, and scumming. Some

print quality factors—such as picking and ink setoff—while important, are not directly related to the control of color reproduction.

A printing test image that allows for evaluation and measurement of key print quality factors facilitates the best control of printing conditions. Such a test image is the GATF Compact Color Test Strip, shown in the illustration. A test strip that is printed on every job enables a catalog of press performance data to be assembled systematically. Every job will be different (except for reprints), but the test image should be the same, regardless of the job (assuming the same ink and paper are used). Test images are designed to magnify the effect of printing variations. Also, their form makes visual comparison or instrumental evaluation quick and easy.

**The GATF Compact Color Test Strip**

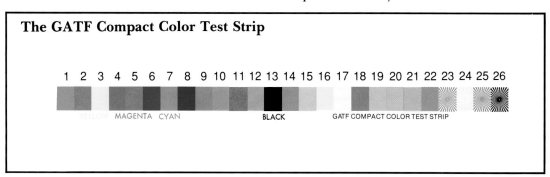

The GATF Compact Color Test Strip has several blocks useful for monitoring variations in solid density. They are numbered 1, 3, 5, 7, 13, 14, 16, and 18 in the illustration. Blocks 2, 4, 6, and 8 are used to monitor the overprint of solids. Blocks 11, 15, 17, and 19 are used to monitor single halftone tint values. Blocks 9, 10, 12, 20, 21, and 22 are used to monitor overprint halftone tint values. Blocks 23, 24, 25, and 26 are GATF Star Targets. These images can be used to indicate dot growth, slurring, or doubling.

Color register influences image sharpness and resolution. The best way to monitor register in production runs is to use a 10-power magnifier and examine dot placement within the live job area. For 150-line-screen halftones, a variation equivalent to one-half a row of dots or less is generally acceptable. Acceptable variation is influenced by the nature of the printed images. Sharp images have tighter tolerances than soft-focus images. The GATF Vernier Target provides a more quantitative measure of register. This device is not intended for routine monitoring but rather for studying process capability. It should

be included with feedback control charts when initially characterizing a press-paper-ink system.

Test strips, or color bars, should be mounted across the cylinder at either the tail or gripper edges (for sheetfed printing). A bar with tail placement tends to be more sensitive to image distortion than one with gripper placement. The tail bar is more apt to be influenced by mechanical ghosting (ink starvation) patterns than one placed at the gripper edge, however. The important point is that the bar placement must be consistent. Also, if more than one set of master bars is used, it is important that halftone dot values and Star Target resolution be identical on each set.

The test image can be evaluated by visual or densitometric methods. The common visual evaluation is to make side-by-side comparisons of OK and press sheet images of the color bar. Choose a group of seven to ten sheets at 5- to 10-min. intervals. Fan out the sheets so the color bars are displayed. The OK color bar can be compared to the freshly printed color bars. Allow for gloss and color changes in dry ink films of the OK color bar.

Density of test images is best measured at the makeready stage or as part of a statistical sampling study. It is not practical to pull sheets or signatures from a high speed press and measure density for solids, overprints, and tints (across the whole sheet) and then attempt to relate this analysis to the immediate control of the press. Too many sheets would have been printed in the intervening time for the analysis to still be valid. On-press densitometry, however, does seem to offer on-line monitoring of some print quality variables and could be a useful aid to process control. Also, densitometric measurement of small "live" image areas are now practical and may provide useful control information[6].

The makeready or quality control department analysis of the test image (color bar) should include density measurements of the solids, overprints, and tint areas. Take readings through all three filters and plot the subsequent data on a GATF Color Hexagon. Calculate the trap for the overprint colors by using the Preucil formula discussed in Chapter 5. The dot area for each color may be calculated by the Murray-Davies formula, also described in Chapter 5. Some densitometers have a built-in program for solving these equations. The unitary values for solid density, percent trap, and dot area can be plotted on control charts. Such charts are useful for process capability

studies. They may also be used as an indicator that a particular job is within the customer's *acceptable quality limits* (AQL). The AQL for a given job depends largely on the level of quality that the job demands.

The ideal density, trap, and dot values to be achieved when generating feedback control charts are those most easily reproducible. That is, they are average values obtained from a process capability study over a period of months. A color chart, for example, is produced at these average values and used as a guide for color separation production. When the separations are printed, the press initially should be made ready to the same values. In practice, the ideal density, trap, and dot size values for a particular job may differ from those of the color chart. Such deviations are often desirable to improve the quality of the printed image. This is a positive shift, as opposed to a negative one that entails making press adjustments in an attempt to compensate for a poor set of color separations. These latter adjustments are rarely successful. On the other hand, while good separations can sometimes be made better by press adjustments, they can often be made worse by inappropriate adjustments. Therefore, significant deviations from ideal (or average) density, trap, and dot values should be made only with extreme caution.

Because the printing press factors that influence the printed image are many, a detailed discussion of press control is beyond the scope of this book. Although controlling impression pressure and ink feed rate achieves control of the printed image, each individual printing process often has additional factors that must be monitored. For example, in lithography the water feed rate must be controlled, and in gravure the ink viscosity must be maintained.

A variety of devices is available to help achieve ideal press setup and running conditions. These include ink agitators or viscosity controllers, ink film thickness gauges, bench micrometers to establish correct impression pressure, durometers to monitor inking roller or impression roll hardness, and pH meters for checking fountain solution acidity.

**Paper and Ink**  The raw materials, specifically paper and ink, can significantly contribute to process variability. The tests for specific paper and ink properties have been well documented in GATF's paper and ink books and the Technical Association of the Pulp and Paper Industry (TAPPI) and National Printing Ink Research Institute (NPIRI) standards. The most important of

these tests for color reproduction control include paper absorbency, gloss, color, brightness, and smoothness. The ink tests of importance are color, pigment concentration, transparency, gloss, viscosity, and tack. The tests are relatively easy to perform—the difficulty comes when trying to establish realistic control limits. For example, how much can pigment concentration vary from the norm and still be acceptable?

Control limits for raw materials tests must ultimately relate to quality or production time factors for the printed product. Pigment concentration, for example, can vary to the point at which it causes a shift outside of previously established quality limits for the printed product. The effects on print quality of some of these ink or paper properties, however, may be cumulative. Therefore, if any one property varies to the limit, only a very slight change in another property would be required to tip the process outside the control limits.

The control limits for raw materials, in terms of acceptable variation in the end product, are largely unknown. Such limits can be approximated by conducting the series of ink and paper tests detailed above on each new batch of materials. The results of such tests are recorded and accumulated to the time when print quality approaches the control limits. In making comparisons of print quality to individual properties of raw materials, the insight gained helps to establish limits for raw material tests.

Likewise, inks and papers may be changed from standard if the effects of such a change do not move the process outside of the acceptable print quality limits. Also, jobs could be shifted from one press to another with slightly different print characteristics, given that the net change in print quality was still within print quality limits.

**Practical Customized Color**

Clearly, the key to systems control is the establishment of print quality limits discussed in Chapter 6. Once these limits are chosen and the printing systems (press-ink-paper-plate-contacting) are characterized by feedback control charts, it is possible to decide how many color reproduction systems must be established. For example, a plant producing three different quality levels on both web and sheetfed presses, using coated and uncoated paper and two or more ink sets, could be forced to develop a number of color reproduction systems.

Multiple color reproduction systems can be unwieldy and unworkable. Thus, establishing two color reproduction systems is recommended—one for coated paper and the other for

uncoated paper. A two-system approach is workable if the other factors are held constant. Process inks must be standardized (within the plant), and press mechanical performance should be adjusted so all presses print with close to the same characteristics. Test forms, such as color charts, can help achieve this latter objective. Preventive maintenance, proper makeready, and process control are required if this goal is to be met.

The objective of a systems approach to color reproduction is to produce color separations suited to the characteristics of a controlled printing process. Uncontrolled conditions introduce a "lottery aspect" into the color reproduction system. Sometimes, excellent color reproduction results; other times, jobs are poor and often rejected.

## Summary

The achievement of consistent high-quality results in color reproduction, then, occurs only when the systems approach is followed. A color printing process is characterized by a feedback control chart, which is then used to help produce color separations to suit the individual printing characteristics of the process.

Such an approach to color reproduction works if the individual production stages are held under tight control. Color separations, contacts, plates, and printing must be produced within the control limits. Test images and densitometers can be useful aids in attempting to control the process.

Variations in the raw materials, especially paper and ink, can be tolerated to the point where they tip the process outside of the control limits. In practice, acceptable control limits for properties of raw materials are very difficult to establish.

The intention of a systems approach is not to customize color separations to suit every conceivable printing system. Such an approach would require vast amounts of setup or programming time. The establishment of two color separation systems—one for coated paper and one for uncoated paper—is recommended. Additional systems should be created only when the two do not serve the quality needs of the printer.

The measurement, analysis, and programming involved in a systems approach should be thought of as *tooling up*, or *setup*, costs. Once the system is established, it can be run indefinitely with the same procedures and control points. It is necessary to recalibrate only when a significant change is introduced into the printing process. Examples of such a change include a new

press, different plate system, or an ink with a higher pigment concentration.

Considerable time, energy, and money must be invested to develop a systems approach to color reproduction. People must be trained, equ_____ _____ _____ ___ in top condition, control devices _____ _____ _____ instruments must be used, and _____ _____ ____ st be undertaken. The payoff is _____ _____ ___ality color reproduction _____

**Notes**

**1.** Gary G. F_____ _____ o Color Reproductic_____ _____ngs 1984 (Rochester, N.Y.: TAG/_____

**2.** Gary G. _____ ___, *Test Images for Printing* (P_____ :hnical Foundation, 1984).

**3.** Carl E. _____ Offset Version of the Muns_____ *rogress Report* No. 96 (Pittsburg_____ :oundation, 1974).

**4.** George_____ W Halftones," *Research* _____ n, Pa.: Graphic Arts Technica_____

**5.** Zenon_____ New GATF Color Reprodu_____ *Report* No. 67 (Pittsbur_____ Foundation, 1964).

**6.** Jame_____ vice for Automatic Density _____ ;s 1985 (Rochester, N.Y.: T_____

# 9 Color Originals for Reproduction

The selection of the type of original to be used for color reproduction purposes is usually a creative act. Photographs and artist's sketches and drawings are created specifically for the purpose of being reproduced. Other originals for reproduction include fine art and merchandise samples. These latter originals often cause problems in the manufacturing process because their primary purpose is not to serve as originals for photomechanical reproduction. They are each an end in their own right.

Many problems in printing arise when a designer or a photographer produces an image without considering how well it will reproduce. This is a futile exercise, as it thwarts the best attempts of everyone in the reproduction process to produce a satisfactory reproduction. The end result is all-around dissatisfaction. The best originals are those that take into account the characteristics of the reproduction process so that the ultimate reproduction is the most pleasing and best that can be obtained with the ink, substrate, and printing process being used. The best commercial artists or graphic designers are those who can produce creative work within the constraints of the manufacturing process of which they are a part. In practice, it may be easier to indulge in the unconstrained creativity afforded by the field of fine art, where the discipline of the reproduction process can be ignored.

The graphic designer must keep the objectives of commercial art and fine art quite distinct. Sometimes frustrated fine artists turn their hand to commercial art without understanding the constraints of the reproduction process. At other times these constraints are deliberately ignored in order to produce gallery quality art masquerading as commercial art. Such actions may produce an impressive portfolio of original artwork for the designer, but it will not produce an impressive portfolio of printed samples. The intent of this chapter is to explore the factors that make an original suitable or unsuitable for reproduction purposes and to develop guidelines for the selection of the appropriate photographs or artwork for reproduction.

## Problems Due to the Original

There are a series of problems that arise in color reproduction that are due to the type of color original that was used. In some cases these problems cannot be corrected or overcome in the reproduction process. In other cases the problems can be overcome, but only at a substantially higher cost than that for satisfactory originals. In many cases the persons, equipment,

and materials used in the reproduction process get the blame for *failure to match the copy.* The true blame often lies with the designer, photographer, or art director for supplying unsatisfactory originals. Some blame must also be borne by the sales force who accepts unsatisfactory originals. The overzealous salesperson who says, "We can reproduce anything," may be causing untold grief for production personnel and low profits for the company through ignorance of the problems inherent in certain kinds of originals.

**Spectral Response of the Separation System**

One of the problems with originals concerns the way in which individual colors are "seen" by the color separation system. In Chapter 2 the problems of metamerism are discussed; that is, where colors appear different to the human eye under different illuminants. The problem of anomalous color vision, where two people perceive the same color differently, is also discussed. The way in which a color separation system sees a color compared to how the human visual system sees the same color can be likened to the phenomena of metamerism and anomalous color vision.

In a color scanner, the response equals the combined effect of the transmission properties of the lenses and condensers, the transmission and reflection properties of the mirrors, the absorption characteristics of the color separation filters, and the spectral response of the photomultipliers. For photographic color separations, the response is the combined effects of the transmission properties of the lens, the absorption characteristics of the color separation filters, and the spectral response of the color separation emulsion.

A further complicating factor in color separation is the fact that the standard viewing conditions are 5,000 K, whereas a color scanner uses a tungsten or xenon light source, and a camera is generally equipped with pulsed xenon lighting. The spectral emission of these sources is shown on page 203.

Although color separation systems have a response different from that of the human eye and use different illuminants, this is not the problem that it may seem to be at first. For example, a color scanner can be "tuned" to produce an excellent reproduction from a given color transparency. The color corrections for photomultiplier response, color filters, etc., are part of the overall process of color correction that is discussed in more detail in Chapter 10.

Response of the
human eye to color

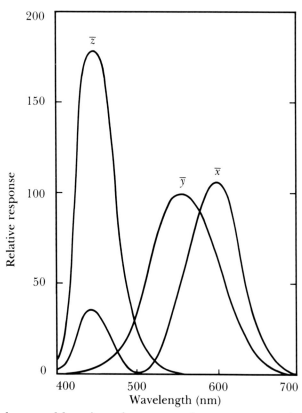

The key problem in color separation response arises when different types of color transparency films are used, or incompatible dyes or pigments are used for retouching photographs or creating artwork. In these cases it is possible for two colors that appear the same to photograph differently. The visual relationship between given colors also may be altered by the color separation system.

For color transparency films, the major disruptive effect is the cyan dye layer. The red spectral densities may vary considerably in two given films. Because of the poor eye response to near-infrared radiation, the eye may not detect the difference between the two colors, but a color separation will record the difference and hence distort the color reproduction.

The other effect caused by color transparency films concerns the ultraviolet absorbers in these color films. Given the UV sensitivity of the photomultipliers, a transparency with UV absorbers separates darker than one without. The magnitude of this particular problem may be illustrated by reference to the table where the visual density and the UV density of a series of Kodak films are compared. This problem may be corrected by removing the UV radiation from the illuminant before it

Response of color separation systems to color

This response is influenced by (**A**) the filter characteristic, (**B**) film response (for photographic color separation), and (**C**) the photomultiplier response (for electronic color separation).

Spectrograms

Incandescent light (3,000 K)
▬▬▬

Open arc light (5,000 K)
▬ ▬ ▬ ▬

Pulsed-xenon light (6,300 K)
▬▬ ▬▬ ▬▬

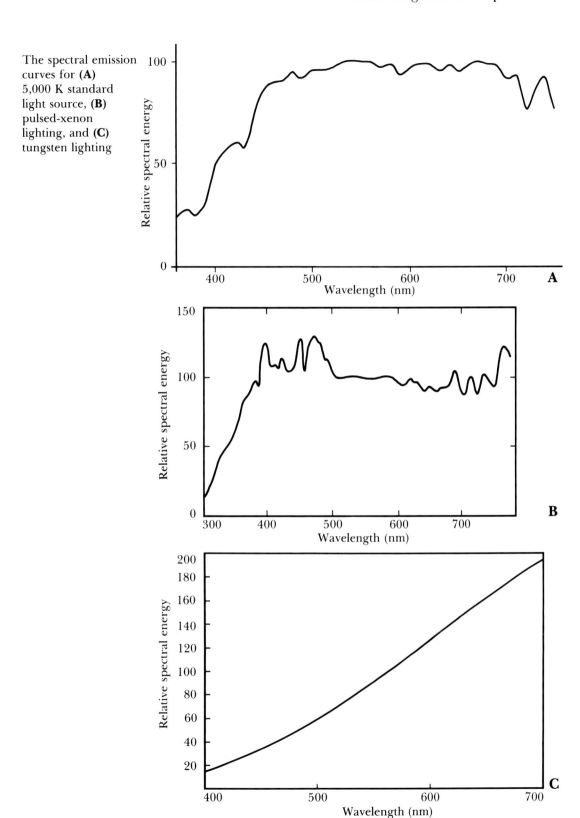

The spectral emission curves for **(A)** 5,000 K standard light source, **(B)** pulsed-xenon lighting, and **(C)** tungsten lighting

reaches the original. For color scanners, the use of a Wratten 2E filter over the light source is recommended. For camera or enlarger separations, a sheet of weatherable Mylar should be placed over the light sources. The filter and Mylar should be periodically replaced.

Comparison of visual and UV highlight densities in processed Kodak transparency films
*Reprinted from Kodak Q-500-4 (1980) with permission*

| | Optical Density | |
|---|---|---|
| **Process K-12 Films** | **Visual** | **UV** |
| Kodachrome II Film (Daylight) | 0.28 | 0.40 |
| **Process K-14 Films** | | |
| Kodachrome 25 Film (Daylight) | 0.24 | 0.86 |
| Kodachrome 64 Film (Daylight) | 0.25 | 0.96 |
| **Process E-4 Films** | | |
| Ektachrome-X Film | 0.27 | 0.43 |
| **Process E-3 Films** | | |
| Ektachrome Film 6116, Type B | 0.20 | 0.37 |
| **Process E-6 Films** | | |
| Ektachrome 64 Professional Film 6117 (Daylight) | 0.18 | 1.21 |
| Ektachrome Professional Film 6118 (Tungsten) | 0.21 | 0.37 |
| Ektachrome Duplicating Film 6121 | 0.28 | 1.03 |
| Ektachrome 64 Professional Film (Daylight) | 0.28 | 1.21 |
| Ektachrome 160 Professional Film 5037 (Tungsten) | 0.20 | 0.24 |
| Ektachrome 200 Film (Daylight) | 0.28 | 1.16 |
| Ektachrome 160 Film (Tungsten) | 0.22 | 0.36 |

It is possible to adjust individually for dye set differences on color scanners. Some adjustment may be possible with photographic color separation systems by placing CC filters over the light source. However, the best way to solve this problem is to use the same brand, type, and speed of color film for the entire job.

It is relatively straightforward to correct for the dye set differences of color transparency (and print) films. The reason for this is that all the colors within a transparency are made from the same dye set, which in turn separates colors the same relative to each other. Quite different problems arise when separating artist-drawn originals.

Often, an artist combines different media on the same piece of artwork. The resultant colors may appear visually correct, but because of the different dyes, pigments, and binders that are used to make up an individual piece of artwork, the separation system may "see" them quite differently. This same effect may be observed when a color transparency or print is

The spectral dye
densities *(left)* and
the emulsion spectral
response *(right)*

Normalized dyes to form a
visual density of 1.0 for a
viewing illuminant of 3,200 K

Kodachrome 25 film (daylight)

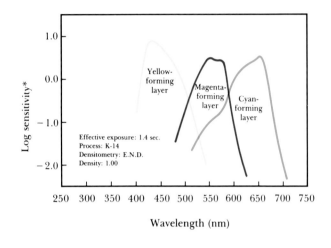

Kodak Ektachrome 64 professional film (daylight)

Normalized dyes to form a
visual density of 1.0 for a
viewing illumination of D$_{5000}$

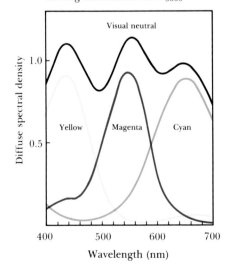

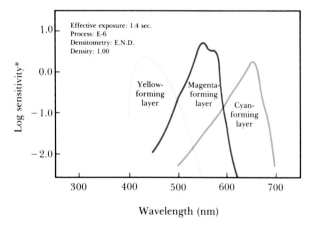

*Sensitivity equals the reciprocal of exposure required to produce specified density.

The absorption curve for a Wratten 2E ultraviolet-absorbing filter

retouched with dyes or pigments that are not compatible with the dyes in the photographs.

The problem of color distortion within a piece of artwork or a photograph becomes especially troublesome when materials that fluoresce are used. If the substrate used for artwork preparation, the photographic print, or the transparency material fluoresces, electronic or hand retouching is the only way to correct for this influence. This same solution applies when the retouching dyes or pigments fluoresce.

The influence of fluorescence is often noticed on watercolor or poster color originals where a number of near whites are included. If these near whites have been mixed by using fluorescent pigments, the color in question will record as *whiter than white* on the color separations. A fluorescent substrate could easily alter the photographic effects of one color relative to another.

One method of detecting fluorescence problems is to view the copy under a black light source. Retouching and other problems become apparent under this illumination if fluorescent compounds have been used. To keep manual correction to a minimum, UV absorbing materials should be placed over the light sources of color separation equipment.

**Reproduction Scale**

The preferred reproduction scale is same size, or 100%. The reasons for this preference are as follows:
● Too great an enlargement emphasizes defects in the original. A customer, on seeing the defect in the reproduction, may elect to believe that this is a fault of the reproduction process rather than an inherent defect of the original. Photographic grain is one such defect that becomes more noticeable with high enlargements.

- Too great a reduction loses detail from the original. The customer will be able to see detail in the original and may blame (justifiably, but unfairly) the reproduction process for losing this detail. This problem is especially acute with fine-pen-line artist's drawings.
- Tonal perception is different when comparisons are made between small originals and large reproductions or vice versa. This problem is discussed in Chapter 7. The middletone values have to be lightened or darkened in order to overcome the effects of great reductions or enlargements. This effect is somewhat complex, and if the viewing distances are varied, the tonal perception may change.

Normal illumination *(left)* and blacklight illumination *(right)* on the same piece of retouched artwork

The blacklight has detected the use of a fluorescing retouching material.

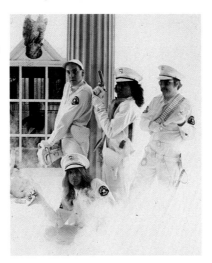

**Nongamut Colors**

The problem of nongamut colors, where colors in the original are outside the gamut or range of the ink-substrate combination, is discussed in Chapter 7. In the case of color photographs, and in particular, color transparencies, not much can be done about nongamut colors. Likewise, fine art and merchandise samples have to be accepted as they are. The only way to reproduce these colors accurately is to expand the color gamut of the process ink set. This can be done in many cases through the use of five, six, or even more colors. In the absence of the extra-colors option, the reproduction has lower saturation than the original.

Nongamut colors should not exist in commercial artwork. The graphic artist or designer should understand the gamut restrictions of average process inks on coated and uncoated papers. The colors that are selected for the artwork in question must fall within the range that is reproducible by the

A 640% enlargement
of a duplicate 35-mm
slide

Notice the changes in
detail, contrast, and
hue compared to
either of the
illustrations below.

A 640% enlargement
of an original 35-mm
slide

There is no
objectionable losses
of detail or hue shift
when compared to
the illustration below.

A 310% enlargement
of an original 35-mm
slide

production conditions. If some colors outside the gamut are chosen, these colors will be reproduced at lower saturation. Those other colors within the gamut will be reproduced correctly. Therefore, with some correct and some incorrect colors in the final reproduction, the designer's original intent becomes distorted.

Situations where the density range of the original exceeds that of the reproduction are also discussed in Chapter 7. This difference is largely unavoidable for transparency reproduction. For an artist's original, there is no good reason why the density range of the artwork cannot be made equal to or less than the range of the reproduction process. Likewise, it is often a reasonable objective to produce color photographic prints that have a density range similar to that of the reproduction.

**Transparency Originals**

In general, color transparencies are often preferred over other kinds of originals for color reproduction purposes. This is because they are a *first-generation* original and are usually sharper than a color print that has been enlarged from a color negative. Also, unlike many reflective originals, transparencies are flexible and therefore can be wrapped around the drum of a color scanner. Finally, color transparencies are much less likely to have color-incompatible retouching that sometimes is present on reflective color prints.

The major drawbacks with transparencies have to do with their size and their mode of viewing. Virtually all transparencies have to be enlarged in the reproduction process. Indeed, many transparencies are 35-mm format and consequently have to be enlarged quite substantially. The problems of comparing small originals to large reproductions are discussed earlier in this chapter. The color transparency, specifically the 35-mm format, was designed for projection by a tungsten light source in a darkened room. The lighting conditions for viewing printed color reproductions is quite different; therefore, the question arises as to how valid a comparison can be made between the two.

The viewing conditions for 35-mm to 2¼-in. (57-mm) square color transparencies and transparencies 4×5 in. (102×127 mm) and larger are covered by ANSI PH2.30-1985 (see Chapter 2).

Customers should be cautioned about holding transparencies up to desk lamps or windows or other unsuitable illuminants. Some sales personnel carry portable transparency viewers for

customers to use. Some companies even buy standard viewers for the use of their customers.

The apparent saturation of a transparency can be increased by surrounding it with an opaque border. Since color reproductions almost always have a white border, such a comparison between the original and the reproduction is invalid. A transparent gray surround must be provided for the transparency in order to create the correct *visual flare*. A comparison between the original and the reproduction can then be made under similar conditions.

## Types of Originals

The type of original used for a given purpose depends on the degree of realism or abstraction desired by the designer. Photographs are generally preferred when a high degree of realism is desired. The more abstract design usually employs hand-drawn artwork, although some photographs also can be used for this purpose. For the ultimate in realism, the actual object or piece of merchandise may be submitted for use as an original.

The creative demands of the job may determine the color transparency format. For example, large format $8 \times 10$-in. $(20 \times 25$-cm$)$ cameras cannot be used satisfactorily for high-speed action photography. The 35-mm camera with its light weight and motor drive is preferred in these situations. On the other hand, 35-mm cameras are not suitable for architectural photography. The swings and tilts of large-format cameras must be used to overcome the converging parallels common with 35-mm and other fixed-plane cameras.

### Photographic Originals

Photographic originals take the form of either *prints* or *transparencies*. Prints can be further subdivided into *dye transfer* prints and *integral tripack* prints.

**Dye transfer.** Dye transfer prints are made by transferring individual yellow, magenta, and cyan images from dyed matrices to a special substrate. The matrices are created from either color separation negatives made directly from an original scene, or, more usually, from a color transparency or a color negative. These prints make excellent originals for color separation. In particular, their highlights and light colors are bright and clean by comparison to tripack materials that have three emulsion layers coating the entire substrate. Dye transfer prints are expensive to make.

**Integral tripack.** The integral tripack type of color print is by far the most common for reflective color reproduction originals. This material consists of a paper base that is coated with red-, green-, and blue-sensitive layers that form, during processing, cyan, magenta, and yellow dye layers. This is known as the dye coupling process. Depending on the film type and the processing technique, tripack materials can be used to make prints from color negatives, color transparencies, or directly from the original scene in the case of "instant" photography. By contrast, the dye bleach process consists of predyed emulsion layers that are selectively removed in processing. The prints can be made only from transparencies in this process.

One possible problem that can be encountered when reproducing color prints is due to the fluorescence of the substrate, which can affect the reproduction of light tones. Substrate fluorescence can be countered by mounting UV absorbers over the illuminating light source.

The integral tripack type of color print is the most popular type of color print for reproduction. The quality is almost as good as dye transfer prints, while the cost is much less.

Color transparency films all have integral tripack types of emulsions coated onto film bases. Unlike photographic print materials, color transparency materials vary greatly in terms of resolution, sharpness, graininess, speed, and color rendition. In general, the lower the speed the higher the image quality.

Films that are designed for viewing by projection in a darkened room, such as 35-mm transparencies, tend to have a higher contrast range than sheet film transparencies. All transparency materials, however, have a range greater than 3.0. Each individual color film distorts the original colors in its own way. No one color film can be selected as the *best* for all photographic assignments, but wherever possible, the same film should be used throughout a given job.

A specialized type of color transparency film is duplicating film. This material is used for making duplicates of supplied transparencies or transparency conversions from reflection copy. Duplicates are usually made for image assembly purposes; that is, correctly scaled duplicates can be cut and assembled before they are color separated. Duplicates tend to be larger than the originals; thus it is easier (and safer) to retouch them. Transparency conversions are made from reflection copy when the original is too large or too inflexible to be wrapped around the drum of a color scanner. Duplicates

generally have lower density ranges than original transparencies.

Color negatives can also be used as photographic color originals. These materials have the advantage of being first-generation originals and are therefore likely to have better image quality than second-generation materials, such as color prints or duplicates. Color negatives generally have built-in orange photographic masking images in order to produce a satisfactory color print. The big drawback with color negatives is that they are extremely difficult to judge. They are not common originals for reproduction.

It may be desirable to use prints instead of transparencies when the photographer has no control over the lighting of the original scene. It is possible to make adjustments when making the color print in order to make it conform more closely to the desired appearance. Also, the print is a reflection original with a contrast range and gamut close to the photomechanical printing processes. Thus, such originals are generally easy to separate and match. Customer comparisons of original to reproduction are easy to make when color prints have been used.

Transparencies have several advantages over prints. The higher resolution and sharpness and the ability to wrap around a scanner drum constitute two of the most important factors. Color negatives may find application where high-speed color separation with modest color quality is desired. Newspaper editorial photographs are often examples of this type of work.

**Artist's Originals**

As stated earlier, artist's originals exist either as fine art, which is created with no thought of reproduction, or as commercial art, which is created specifically to be reproduced.

A wide variety of artist's mediums is available as a carrier and binder for the pigments. Some of these mediums are listed below:

- **Oil paint.** Refined linseed oil is used as the base for oil paints. They are available in a vast range of colors and can be applied by one of several techniques to a range of substrates.
- **Watercolors.** Available in liquid (tube) and solid (pan) forms, watercolors include glycerine to soften them. Most of these materials are transparent, but some are available as opaque gouaches. An airbrush can be used for applying these colors.
- **Poster paints.** Poster paints are gouaches that are available only in a small range of opaque primary colors. These materials are sometimes also referred to as tempera colors. (Tempera is

also used to describe the process of painting where pigment is combined with size, casein, or egg yolk.)

- **Pastels.** Pastels contain pure, high-quality pigments in a minimum of binder. They are available in about 200 hues and tints.
- **Drawing inks.** The colors in drawing inks are transparent. They can be applied with brush or pen.
- **Felt-tipped pens.** Felt-tipped pens are used to dispense colored inks. The colors are not particularly permanent.
- **Acrylics.** Acrylics are fast-drying plastic emulsions that may be used instead of oil or watercolor.
- **Chalk.** Wood charcoal falls into the category of chalk. It is still a very popular black for making sketches. Colored chalks are also used for sketches.
- **Colored pencils.** Art pencils are available with dense, smooth, and permanent colors.
- **Waxy watercolors.** Waxy watercolor pencils can be used on glossy surfaces, unlike conventional watercolors or wax material. Opaque pigments are suspended in this base material.

**Problems with artist's originals.** The medium chosen to produce a given piece of art depends upon the creative intent of the artist. Certain materials convey a particular mood, sensation, or color more successfully than other materials. Some problems may arise, however, when trying to reproduce artwork that has been prepared using these techniques. The kinds of problems that can be encountered include the following:

- **Nongamut colors.** The heavy intensities and saturations of oil paintings may be difficult to reproduce, especially if there is a lot of dark shadow detail. The clear, light colors of pastels may also cause problems in duplication, especially in the halftone processes. Extra colors may have to be used to achieve satisfactory reproductions.
- **Fluorescence.** Certain felt-tipped pens and markers and some substrates may fluoresce under camera lights, thus upsetting the visual color balance of the artwork. Ultraviolet absorbers over the camera lights eliminate the contribution of UV to fluorescence, but the visible radiation fluorescence will still be present.
- **Surface texture.** It is often desirable, especially for oil paintings, to capture the texture of the paint in the reproduction. This effect may be achieved by using unidirectional lighting when color-separating the painting.

Unfortunately, this technique produces uneven illumination; therefore it is necessary to shade the copy with a black sheet of board in order to attempt to equalize the illumination. The original should be placed on the copyboard so that the shadow of the texture appears natural. That is, the reproduction must look like it has been illuminated from above.

● **Specular reflections.** Oils and acrylics often have a high-gloss finish. If the camera lights are not properly adjusted, specular *hot spots* may result from this type of artwork.

● **Highlight dropout.** For watercolor, pastel, and crayon artwork, it is usually desirable to drop all halftone dots out of the bare base material. This is usually done by the use of *booster highlight masks,* or no-screen exposures. If very pale highlight colors or fluorescent colors are used, though, it may be very difficult to drop out the background white. In these cases, hand retouching of the negatives must be used.

● **Color permanence.** Felt-tipped-pen colors may fade on exposure to camera lights. In turn, this fading makes comparisons between original and reproduction particularly difficult. This type of artwork should be covered when not being used.

● **Physical damage.** Oil paintings should not be sandwiched under the camera copyboard glass because of the risk of damaging the artwork. Oils should be mounted on the front of the copyboard. Because pastels can be smudged through careless handling, they must be treated with extreme care. Other artwork, such as watercolors and poster colors, may be damaged by water; therefore, such work should be kept well away from running water where the danger of splashing exists. A clear, protective film should be placed over this type of artwork.

● **Unwanted transparency.** Sometimes an artist, especially when working with oil colors, paints over unwanted detail with another color. Although the detail underneath is invisible to the human eye, the camera may "see" it. Hand retouching of the separations is the only way to correct this problem.

● **Black line detail.** Some artwork is prepared with watercolor background colors and black ink lines. The objective is to print the black lines solid without any halftone screen breaking the lines and to have the adjacent white areas print free of any halftone dots. This effect is very difficult to achieve when the black ink lines and the watercolors are on the same piece of artwork. The lines require a line negative for best reproduction, whereas the colors need a halftone treatment.

These objectives can be realized if the line work is prepared on a separate overlay of clear film. The alternative involves lengthy hand retouching of the negatives.

**Merchandise Samples**

In those cases where a very accurate color match is required, an actual sample of the product is sometimes supplied for use as an original. Examples are paint chips, fabric swatches, linoleum squares, or upholstery samples.

There are several difficulties that are encountered when making reproductions from these originals.

- **Nongamut colors.** In addition to the normal problems encountered with nongamut colors, some samples may also contain metallic colors. One difficulty with the latter is adjusting the camera lights so that the sample is photographed as evenly as possible. Metallic inks must be used to make satisfactory reproductions from these originals.
- **Texture.** One advantage of using the merchandise sample as an original is that the original detail and texture are captured quite well by the reproduction process. Some adjustment of the camera lights may be necessary to create the ideal effect.
- **Fluorescence.** The pigments or dyes in the merchandise samples may fluoresce. The corrective measures outlined earlier in this chapter should be used to compensate for unwanted fluorescence.

**Electronic Artwork**

A number of fine artists and graphic designers have been experimenting in creating images with computer graphics systems. Images displayed on color monitors can be transferred to magnetic disks and then to color image processing systems for producing color separation films. In other words, the original artwork does not exist as a tangible object but only as a video display.

Other recent experiments have involved the use of video cameras to provide pictorial input to color separation and color image processing stations. This development promises to replace conventional photographic originals.

The electronic systems offer high speed, easy image erasability, image storage capability, and true interface between design and manufacturing. The major disadvantages at present are high cost and limited image portability. Nevertheless, it is expected that these systems will play a major future role in both the manipulation of conventional copy and the creation of completely new kinds of copy. One of the major advantages of

An artist creating
original artwork
using computer
graphics software

such systems is that the metamerism and other problems of
conventional artwork and photographs will be eliminated.

**Retouching**    In general, supplied artwork should never be retouched by
the color separator or printer. The dangers of ruining artwork
or an original photograph are too high. If the customer will
not accept the return of the artwork for the purposes of
retouching, the color separator or printer should, as the best
alternative, do all retouching work on the color separation
films.

　　If the artwork has been generated in-house, or if a duplicate
or conversion transparency has been made from the original,
retouching can be safely undertaken. The major color
reproduction problems that are created with retouching have to
do with the retouched area separating differently from the
nonretouched area. In cases where the retouching is not
visually apparent on the original but shows up on the
separations, the problem is similar to metamerism.

　　It is very difficult to tell if a given retouching dye will cause
color separation problems. Use of the Kodak Retouching

The Kodak
Retouching Target

Target affords one method of checking retouching dyes.
Retouch the target with the dyes in question so that the colors
match the target colors. Next, color-separate the target to see
what dyes pass the suitability test. Because different color
separation systems "see" color quite differently from each
other, the test may have to be repeated several times.

The Kodak Retouching Target is made on E-6 Ektachrome
duplicating film. To test dye compatibility on other films or
prints, make a copy photograph from the target on the
appropriate films. Apply the test retouching to the new films
and color-separate as before.

In some cases, the retouching dye that should be used is
quite obvious. For example, dye transfer prints should be
retouched with dye transfer dyes, and watercolor drawings
should be retouched with watercolors. Art mediums should not
be mixed when retouching.

Retouching marks is the other major problem encountered
with retouching: brush marks and other signs make it obvious
that this process has taken place. One way of getting around
this problem is to make the image about twice the reproduction
size. Imperfections and blemishes are more difficult to see
when the original is reduced to one-half size.

Electronic imaging systems are ideal for retouching. The
image in question can be enlarged many times, and the image

removed, changed, or created on a pixel-by-pixel basis if necessary. Because pigments or dyes are not involved, the color match between retouched and nonretouched areas is perfect.

An enlarged video image that can be retouched on a pixel-by-pixel basis if desired

## Ideal Originals

The technical requirements of ideal originals for photomechanical reproduction can be discussed under the headings of photographic transparencies, photographic prints, and artist's originals.

### Photographic Transparencies

Color transparencies for reproduction should generally be as large as practical. The exception occurs when they must be reduced for reproduction, as is often the case in label printing. Transparencies should be ultrasharp and free from objectionable graininess. Those that have been **push processed**—that is, rated at a higher speed and overdeveloped—will exhibit coarser grain than if they were handled under normal conditions.

Transparencies also should not be excessively contrasty. Where possible, lighting should be adjusted to produce transparencies with shadow densities under 3.0. On the other hand, transparencies should not be *washed out* or desaturated, which can be caused by overexposure. High- or normal-key originals generally are preferred to low-key originals.

Finally, there should not be any general objectionable color casts due to incorrect illumination, inappropriate filtration, poor processing conditions, or defective film; nor should there be any localized color casts due to unwanted reflections from

colored objects either within or outside the photograph.

In practice, it is not always possible to achieve all the requirements for ideal transparencies that are stated above. Even so, the objectives of high sharpness (especially for 35-mm transparencies) and the absence of color casts would seem to be minimal requirements that could be easily satisfied. Graininess increases with the speed of the film. High-speed film is required for poor lighting conditions, stopping movement, or both. Therefore, low graininess may not be possible for certain photographic assignments. In these cases, the color film format should be as large as possible.

From an image quality point of view, duplicate color transparencies should not be used. Because duplicates are one more step removed from the original scene, they are not as sharp as the first-generation original. Also, some duplicates compress highlight or shadow detail and may introduce color distortions. These objections are often outweighed by the image assembly economics, especially for catalog pages, that can be realized through the use of duplicate transparencies. The increased use of color electronic assembly devices, however, will certainly reduce or eliminate the use of color duplicates for image assembly purposes. In cases where a rigid reflection copy must be converted to a flexible transparency in order to allow separation on a scanner, a duplicate transparency is almost indispensable.

All of the color transparencies for a given job should be made on the same brand, type, speed, and batch of transparency film. Each particular film has its own particular way of reproducing color (see Chapter 7). Therefore, the use of different films does not cause differences only in the color renditions of the same objects but also in the color separations. Of course, it is possible to adjust color scanners to compensate for the dye sets of different films. Also, it is possible to retouch film or electronic images in order to correct for unwanted color distortion caused by the color sensitivity of the transparency films. Such adjustments and corrections can be expensive, though, and are unnecessary if the same transparency film can be used for all photographs within a given job.

**Photographic Prints**

Color prints should be made to the final reproduction size. Larger prints are also acceptable. Prints should be sharp and free from grain. These qualities depend (for non-"instant" prints) on the sharpness and graininess of the negative or

transparency used to make the print. The surface of the print should be smooth and flat; i.e., textured paper is not acceptable. The maximum density on the print should not be greater than about 2.0. The print should be free of color distortions that are due to problems with the negative or to incorrect filtration, exposure, or processing of the color print paper. The comments on color transparencies concerning color casts and saturation also apply to prints. Finally, the print should be unmounted so that it can be wrapped around the drum of a color scanner.

One advantage of prints over transparencies is that prints can be manipulated in order to eliminate some of the lighting and other defects inherent in the negative. Therefore, almost all of the above objectives should be readily achievable. Because prints are often made to final size, and then compared side by side to the reproduction, they have important advantages over transparencies. The major disadvantage with prints is the loss of image definition as compared to transparencies. This loss of definition is sufficient reason for many people to specify that transparencies rather than prints be used as originals for reproduction.

The best-quality photographic color print is the dye transfer print. Its highlights and light tones are generally cleaner and lighter than the tripack materials. The tripack color prints made from intermediate color negatives or transparencies, however, are the most practical type of print. They can be made much more quickly and cheaply than dye transfers. The "instant" color prints have the advantage of speed, but they are often available only in small sizes, they have semirigid bases in some cases, and their color and tonal rendition are usually inferior to other types of color prints.

**Artist's Originals** The key requirement for hand-drawn artwork is that it does not contain any colors that are outside the gamut of the reproduction process. All artists and designers should have a printed color chart, such as the Foss Color Order System, on both coated and uncoated substrates. The chart should be consulted before selecting the colors for the artwork.

Another major requirement for artwork is that it not contain fluorescent colors, either as a pigment or as the substrate. If a job is to be printed with fluorescent inks, it is usually better to prepare preseparated artwork in black and white and simply make line negatives for each color.

The artwork should be prepared to the final printed size and ideally should have a smooth surface. The normal physical requirements for artwork—namely, that the work is clean, the colors even, and a protective overlay attached—also apply. In order to facilitate separation by a color scanner, a flexible base should be used for the artwork.

In cases where the white base serves as a background that must be dropped out, it is desirable to make the light tones in the art slightly darker than wanted in the reproduction. This technique is especially useful when the separations are going to be made with a camera.

**Other Originals**

The other kinds of originals submitted for reproduction are very rare. Of these, color negatives can create problems for color-scanner operators because the negatives have built-in color correction masks and are negative images. Their requirements regarding grain, sharpness, etc., are the same as for color transparencies.

Merchandise samples and fine art are never prepared for reproduction; therefore, no specific guidelines can be established for this type of original. Merchandise samples should be clean and representative of the product.

## Summary

The creation or selection of artwork or photographs for reproduction is one of the most important stages in the color reproduction cycle. The quality of the final reproduction is very dependent on the quality of the original.

The most difficult aspect of originals to deal with or explain to customers is the metamerism-like effect of the camera or scanner "seeing" colors in the original differently from the human eye. The other source of customer disappointment concerns the loss of image detail when an original is reduced too much, or the emphasis of image defects such as grain when the image is enlarged too much.

In general, unretouched photographic prints or transparencies will reproduce well. Artist's originals can create difficulties in the reproduction process due to the use of mixed media, fluorescent materials, textured base or paint, nongamut colors, pale colors on a drop-out white background, or the mixing of line drawings with tonal copy.

An unresolved problem in color reproduction is how best to compare transparency originals with reflective reproductions. This problem is exacerbated when the transparency is much smaller than the reproduction. Transparencies should always be

viewed with a clear surround, and when possible, 35-mm and other small transparencies should be viewed with one of the standard graphic arts projection viewers.

Ideally, originals should be sharp, free from image defects, and the same size as the final reproduction. They should not contain any nongamut colors, should not be made of materials that will fluoresce, and should not have a longer density range than the reproduction process. In order to facilitate color separation with a scanner, originals should be flexible enough to wrap around the scanner drum, and the surface should be smooth and clean.

Customers will never supply ideal originals all of the time, but as long as defects in the original are pointed out before the color separations are made, the appearance of the color proofs will come as less of a surprise. Estimators should be aware of the problems that certain originals can cause in the reproduction process and submit a price that reflects the extra time needed to attempt to adjust the reproduction to correct these problems. If possible, samples of unsatisfactory artwork and the subsequent reproductions should be kept by the sales personnel to be used as examples of what can go wrong when poor originals are submitted.

# 10   Color Separation and Correction

The color separation process represents the only stage in the color reproduction system where it is possible to control the nature of the image that will be produced by the printing press. The original has fixed properties, and the press is capable of only broad changes in the ink feed.

Color separation equipment is adjusted to produce films that have been corrected for press conditions, such as ink color and dot gain, and also for the reproduction requirements of the original, such as expanded highlight tones or color cast correction.

The method of adjustment for color separations depends on the methods, equipment, and materials that are in use. For color scanners, all the changes are the result of the scanner programming decisions. The properties of the film have little to do with these decisions. For photographic color separation systems such as cameras, enlargers, and contact frames, the programming is related to the behavior of the photographic material. The operator must make use of the sensitometric properties of the film in order to achieve the desired color separation objectives. This is accomplished by selecting materials, filters, and methods in conjunction with the correct exposure and development of the film. A good set of color separations is one that produces the optimal reproduction from a given original when printed under specific ink-paper-press conditions.

The final information needed for producing good color separations are the analytical techniques for calculating the precise separation film requirements and the practical techniques for achieving those requirements. In addition to exploring these two areas, this chapter also addresses the topic of quality control for color separation.

## Color Separations: Theoretical Requirements

Good color separations are those that contain dot values which, when printed, will yield the desired colors. If the color separator can determine the colorimetric specifications of the desired colors and obtain the characteristics of the printed colors for a specific ink-paper-press combination, then the required halftone dot values may be computed.

Instead of computing all the colors in a reproduction on a point-by-point basis, it is possible to characterize the reproduction in terms of the tone reproduction, gray balance, and color correction requirements. If the ink-paper-press conditions are correct, then the film dot values for a given subject produce the desired printed colors.

The theoretical halftone dot values can be derived by individual computation for each color or by just correcting for the broad defects in the system. Although both approaches will theoretically produce exactly the same results, each does have particular advantages and disadvantages. These are discussed in detail in the following sections.

**Computation of Individual Dot Values**

The problem of computing the individual dot values that are required to reproduce a given color has been approached in several ways. Demichel made the first efforts in this area in 1924. His equations* were based on the premise that any halftone color area can be considered as combinations of the following: unprinted white paper; the individual process inks, yellow, magenta, and cyan; the two-color overlaps, red, green, and blue; and the three-color overlap, black.

Halftone color reproduction—the result of the additive combination of the eight (or fewer) colors that are formed by overlapping dot values of the subtractive primaries on a white substrate

---

*The mathematical details of all the computational approaches described in this chapter are presented in Appendix D.

A given area could contain any or all of the eight colors present in an additive combination. Of course, the red, green, blue, and black areas are formed by the subtractive principle, but from the visual viewpoint the eye must fuse together up to eight colors in order to gain an appreciation of the combination color. In some areas, particularly dark tones, the primary colors and white are not visible; in others, such as a three-color solid, only one of these additive colors is visible. This way of looking at halftone color reproduction is similar to the pointillist painting technique used by the Impressionist artist Georges Seurat in the nineteenth century.

The area covered by yellow, magenta, or cyan can be expressed as a fraction between 0.00 and 1.00. The fractions for each of the eight colors can be added to find the dot areas that must be in the three color separation films.

Hans Neugebauer extended these equations in 1937 by introducing the color properties of the process inks and incorporating the red, green, and blue tristimulus values of a colorimetric system.

In the late 1930s, A. C. Hardy and F. L. Wurzburg developed an experimental color scanner that solved the Neugebauer equations for dot area on a point-by-point basis. The inputs to the computer circuits were unmasked red-, green-, and blue-filter separation negatives. The usual applications for these equations today are in the generation of scanner lookup tables.

The equations in their original form are not accurate because of additivity failure and the effect of the penetration of light into paper upon halftone units.

John Yule suggested compensating for the light scattering effects by modifying the measured densities of the ink patches by a factor of $n$ (between 1.5 and 3.0 depending on the screen ruling and the type of paper) and similarly treating the calculated densities on the multicolor halftone pattern by $n$. Irving Pobboravsky and Milton Pearson developed modified Neugebauer equations based on this suggestion.

F. R. Clapper was the first to take an empirical approach to the quantification of color reproduction requirements. He first printed a test form that consisted of all possible combinations of 0%, 50%, and 100% values of yellow, magenta, and cyan (in other words, there were twenty-seven different areas). He measured the color patches through filters that had a high colorimetric quality. The density values thus obtained were

used to solve empirical equations that related the colorimeteric values of the original to the amounts of the individual inks. A second-degree least-squares solution produced very low residual standard errors.

Pobboravsky extended the approach of Clapper in the quantification of the relationship between the tristimulus values of a printed color and the dot values used to generate those colors.[1] He first generated a 310-color test form and made both densitometric and colorimetric measurements of each individual color patch. The density data were expressed in the form of Equivalent Neutral Density (END); that is, in terms of the density of a neutral a given colorant would produce if overprinted with sufficient values of the other colorants to achieve a neutral. A second-degree mathematical model was fitted to the data by regression analysis.

Pobboravsky found that this empirical approach gave him the tools needed to measure any given color in terms of colorimetric density, calculate the required dot areas, and achieve a very close color match between the original color and the printed color (for gamut colors). In a separate study, he also worked out a way of transforming the three-color system into a four-color system.

Richard Warner of GATF took a more theoretical approach to the problem of color reproduction quantification. He too started from the premise that factors such as additivity failure and proportionality failure would cause inaccuracies in the unmodified Neugebauer equations. His approach involved the generation of empirical correction factors to correct for problems caused by *interimage reflectance*. The model is still under development, but the results to date look very promising. A version of the Neugebauer equations is used as a basis for the Interimage Reflectance Model. A series of coefficients is generated to compensate for the effects of overprinting color halftone values.

A final area concerns the quantification of the relationship between a single tint color and the film dot area that was used to generate it. The normal method of characterizing this relationship is through the Murray-Davies equation, which incorporates the effects of both optical and physical dot gain in the results.

The Yule-Nielsen modification to the Murray-Davies equation uses an empirical factor, $n$, to correct for the optical effects on dot gain. In practice, the value for $n$ will vary

according to the substrate and the screen ruling. Milton Pearson has suggested using a standard value of 1.70 for $n$ in most situations.

The Murray-Davies/Yule-Nielsen equations have proved to be good predictors of black dot values. For monochrome halftone tints, these equations could be applied for each filter reading (blue, green, and red) of the ink in question. This approach, however, produces inaccuracies. J. A. S. Viggiano has suggested making spectrophotometer readings at 20-nm intervals, thus avoiding the errors inherent in wide-band density measurements.[2]

Once the relationship between the film dot values and the resulting printed colors has been expressed, it is now possible to characterize the tone reproduction relationship of original to reproduction. Thus, a given tone input is transformed to the desired tone value, which is used to compute the halftone dot values that are required to achieve the printed tone. The manipulation of individual color areas could also be achieved, but only if it were possible to specify physically the location of the color in question.

**Correction for System Characteristics**

The Neugebauer and other equations can be used to compute the required dot values for a given set of inks and paper. The other approach involves correcting for the system characteristics without concern for individual colors. If corrections are made for the overall system, then the individual colors should also be corrected. The system characteristics that are of concern are *tone reproduction, gray balance,* and *color correction.*

**Tone reproduction.** The two aspects of tone reproduction are the tonal compression for a given original and the tonal adjustments due to the platemaking and printing conditions. The preferred tonal compression of the reproduction should emphasize the interest area of the picture and deemphasize the other areas.

While the optimal reproduction tone curve may vary for given originals, the relationship between the halftone film values and the resultant printed color should be constant for a given printing system. The tonal distortion due to the printing conditions can be determined by the use of the GATF Halftone Gray Wedge.

The Jones diagram method of tone reproduction analysis

The desired appearance of the reproduction is tracked from Quadrant I, through the printing conditions in Quadrant II, to the specification of the color separation negative requirements in Quadrant IV.

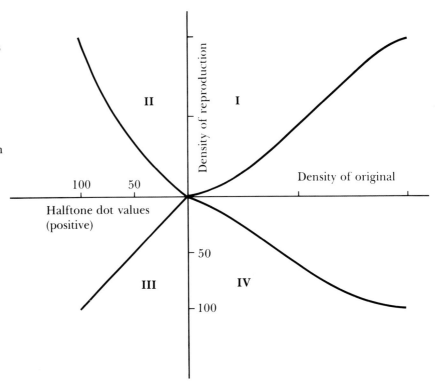

The halftone gray wedge does not require a special pressrun in order to generate the necessary data. To use this method, assemble the wedge into the trim area of a typical job. After printing, choose a representative sample for analysis. Make reflection density measurements along the printed scale at fixed intervals, e.g., 1 cm. Also make transmission density measurements of the original film wedge at exactly the same places that were measured on the printed wedge. Although it is possible to convert these density values into halftone dot values, it is not really necessary.

A Jones diagram (named after its inventor, Lloyd Jones) is typically used for tone reproduction analysis. The illustration shows how one of these diagrams is used. Quadrant I shows the desired relationship between the original and the reproduction. Quadrant IV shows the relationship between the halftone dot values on the film and the corresponding printed density values (i.e., the reproduction). Quadrant III may be used if there are additional images, such as halftone positives, in the reproduction system. In this case, let us assume that Quadrant III is blank; therefore, we can use a 45° line simply to transfer the halftone dot values from the *x* axis of Quadrant II to the *y* axis of Quadrant IV.

To determine the negative requirements, first select any point on the curve in Quadrant I. Extend a horizontal line from this point to the curve in Quadrant II. Next, drop a vertical line from this intersection until it touches the 45° line in Quadrant III. Extend a horizontal line from this point into Quadrant IV. Finally, drop a vertical line from the original point in Quadrant I until it intersects the horizontal line in Quadrant IV. This intersection represents the relationship between a density in the original and the halftone negative tone value that is needed to produce the desired reproduction of the original density.

The procedure outlined in the previous paragraph must be repeated for several points on the tone curve in order to characterize the tone shape of the negative. In practice, it may be necessary to use Quadrant III in the analysis if the operator is using soft-dot camera negatives that must be contacted before plates are made. Quadrant IV would be used for the camera film and Quadrant III for the contact film.

For process-color work, the procedure for tone reproduction analysis is only a little more complex than outlined above. Such an analysis is usually performed as part of gray balance determination.

**Gray balance.** A gray balance analysis is performed in order to determine the correct color balance of the yellow, magenta, and cyan tone scales. If equal dot values of each color are printed on each other, the resulting color will not be a neutral. This may be seen, if we assume that ink density measurements are additive, by adding the three-color densities of each color. The table presents the densities of typical process inks.

Densities of typical process inks

| | Filters | | |
| | B | G | R |
|---|---|---|---|
| Yellow | 1.00 | 0.05 | 0.02 |
| Magenta | 0.65 | 1.30 | 0.10 |
| Cyan | 0.12 | 0.34 | 1.20 |
| | 1.77 | 1.69 | 1.32 |

We can see from the table that more red and green light is reflected (i.e., lower densities) than blue light. Therefore, the appearance of the color will be a warm brown.

The color distortion discussed above is not limited to just the gray scale. If the gray scale is too warm (i.e., too much yellow and magenta relative to cyan), then the other colors in the

picture will also look too warm. It is more convenient to determine color balance through examination of the neutral scale rather than individual color areas because the color areas may have distortions due to color correction rather than color balance. It would be almost impossible to separate the two effects from a color area.

Several methods have been suggested for the computation of gray balance. The first of these was advanced by F. R. Clapper in 1959.[3] Clapper's method required that halftone scales (from 10% to 100%) for yellow, magenta, cyan, and their overlaps—red, green, blue, and three-color—first be produced under the printing conditions in question. Proportionality graphs were made of the primary color scales, and additivity curves were constructed for the overlap scales. Gray balance is determined by starting with an arbitrary amount of cyan and then, by trial and error, adding magenta and yellow until a neutral (equal red, green, and blue densities) is achieved. The proportionality curves are used to determine the red, green, and blue densities for given dot values, and the additivity curves are used to indicate how these individual values are distorted when printed over another ink.

Irving Pobboravsky was the first to apply mathematical approaches to gray balance determination.[4] He tested modified Neugebauer equations and a set of empirical equations. The empirical equations take the form of a second-degree mathematical model with nine terms. These equations were the same as those previously reported by Clapper and Pobboravsky in separate studies of the relationship between colorimetric values of printed colors and halftone dot values. In this case, a series of near-neutrals were printed and measured with a colorimeter. The data were used in the equations to develop a solution by the use of regression analysis. The empirical equations were found to predict accurately the ink amounts needed to produce a neutral. The Neugebauer equations were inaccurate.

Felix Pollak modified the Neugebauer equations in order to make them more useful for calculating masking characteristics. These modified equations are known as the Pollak factorization of the Neugebauer equations. John Yule further modified Pollak's equations to make them more useful for gray balance prediction.[5] Yule's modification produces six simultaneous equations that are solved a number of times by an iteration approach until a neutral is achieved. Pierre Chappuis modified the Yule modifications to reduce his six equations to only two.[6]

In 1981, H. B. Archer advanced a further modification of
the Neugebauer equations to improve gray balance calculation.[7]
It was Archer, in 1954, who introduced the first empirical
approach to gray balance determination. Archer's
computational approach reduced the Neugebauer equations to
two rather complicated equations, one for the magenta value
and the other for the yellow value. Density readings of solid
primary and overprint colors and of 50% printed halftone dot
values are required for computing the gray balance
requirements. Archer's subsequent calculations were found to
produce reasonably close visual neutrals.

The key problem with most computational approaches is the
method by which the neutral value is selected. Normally, the
assumption is made that equal red-, green-, and blue-filter
densitometer readings will produce a visual neutral. However,
when three-color neutrals are measured, this is usually not true.
The selection of visual three-color neutrals will depend on the
light source that is used for illumination. If a 5,000 K
illuminant is used for the visual selection of a neutral, then it is
not altogether surprising that a 2,850 K densitometer bulb
together with the fitted color filters and the corresponding
photocell response will produce a different neutral.

If a measuring instrument, such as a colorimeter, can be used
to specify a neutral that would agree with a visual neutral, then
the computational methods will offer promise. Their big
advantage is that they don't require the printing of a relatively
large special test object. The necessary computations can be
made from measurements of color bar solids and tints.

The most common way to determine gray balance is first to
print a gray balance chart under the actual printing production
conditions. After printing, analyze the chart in order to find
the overlapping values of yellow, magenta, and cyan that will
produce a neutral gray. Select the neutrals with the aid of a
gray scale (such as the GATF Halftone Gray Wedge) that has
holes punched in the center of each step. The tone step in the
gray scale that is closest in density to the gray balance grid
being analyzed is used to scan the grid to spot the three-color
neutral. The gray scale that provides the reference gray should
be a printed scale that uses the same black ink and substrate
that will be used for the printed job. The reason for this
requirement is that the eye adapts to off-color whites and
blacks and actually perceives them as reference neutrals.
Therefore, if a magazine is printed with a given black ink on a
white paper, the eye will accept these as natural references, and

judge all color reproductions in the magazine within that framework.

Once the neutral areas have been located in each of the grids, the percentage dot values of each area are noted, along with the reflection density as measured through the *visual* filter. These data are now used to construct Quadrant IV of a Jones diagram.

The procedures used to determine the negative requirements in Quadrant II are the same as were previously described for one color, except that each of the curves in Quadrant IV is used to help construct corresponding curves in Quadrant II. The negatives described by the curves in Quadrant II are corrected for tone reproduction and gray balance. If these films are printed under the conditions used to generate the data for Quadrant IV, the resulting gray scale will be neutral and have tonal separation corresponding to the interest area that dictates the selection of the curve in Quadrant I. If a pictorial subject is included with the gray scale, it will also appear correct for tone reproduction and gray balance. Many colors may appear to be distorted, though, because the films have not been color corrected.

Incorporation of
gray balance data
into a Jones diagram

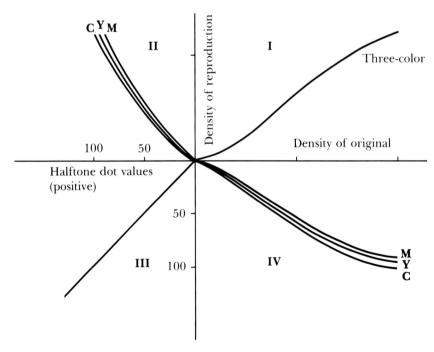

**Color correction.** While tone reproduction and gray balance are the two most important aspects of color reproduction, color correction usually must also be incorporated into a set of color separation films in order to get the best results.

Color correction is used when making color separations in order to compensate for the unwanted absorptions of the printing inks. The term **color correction** is also used to describe corrections that are made to compensate for deficiencies in the original. The following discussion applies only to the unwanted ink absorption aspect of color correction.

The first aspect of color correction concerns the unwanted absorptions of the solid cyan, magenta, and yellow inks. Ideally, a cyan ink should reflect all blue and green light and absorb red; a magenta ink should reflect all blue and red light and absorb green; and a yellow ink should reflect all red and green light and absorb blue. Therefore, if any given ink were to be measured through the three filters of a densitometer, two of the readings should be 0.00 (i.e., 100% reflection), and the other reading should be a high density (for example, a 2.00 density is equivalent to 99% absorption).

The inks used for color reproduction are not ideal. The table shows the reflection density values for a typical set of process inks. The unwanted absorptions are the key concerns.

Reflection density values for a typical set of process inks

| | Filters | | |
| | **B** | **G** | **R** |
| Yellow | 0.95 | 0.04 | 0.02 |
| Magenta | 0.50 | 1.20 | 0.12 |
| Cyan | 0.15 | 0.30 | 1.25 |

The cyan ink, for example, has 0.15 blue-light density and 0.30 green-light density where, in fact, these values should equal zero. If these absorptions remain uncorrected, the reproductions will not reflect enough blue and green light. It is not possible to *increase* the blue- and green-light reflection of the cyan ink; therefore, it is necessary to *reduce* the blue- and green-light reflection of the yellow and the magenta inks wherever cyan prints.

Another way of thinking of the color correction process is to consider that the cyan ink has been contaminated with small amounts of yellow and magenta ink that are causing the unwanted blue- and green-light absorptions. The only way to remove this unwanted contamination is to reduce the yellow and magenta inks wherever cyan prints.

The unwanted absorptions of the yellow and magenta inks must be similarly corrected. Therefore, cyan and magenta must be reduced wherever yellow prints and yellow and cyan must be reduced wherever magenta prints.

The amount of correction that is needed for any of the unwanted absorptions can be calculated by expressing the unwanted absorption as a percentage of the ink where it is a wanted absorption. For example, the 0.30 green density of the cyan ink is an unwanted absorption, but the 1.20 green density of the magenta is a wanted absorption. Expressing 0.30 as a percentage of 1.20, we get 25%. This means that the magenta must be reduced by this amount wherever cyan prints in order to compensate for the unwanted green-light absorption of the cyan ink. Each of the unwanted absorptions must be corrected, thus resulting in six color correction requirements for the solid inks.

The color correction percentages may also be determined with the GATF Color Triangle by using a method suggested by F. R. Clapper in 1971.[8] Plot the yellow, magenta, and cyan colors on the color triangle. Next, draw a straight line from each color to the other two colors and continue so that the line intersects the edge of the triangle. The value indicated as the point of intersection is the percentage correction that must be applied to the original color separation. The percentage corrections correspond to solutions of the masking equations, a set of three linear equations that are used to calculate the color correction requirements of a given set of inks.

In order to use the above methods for determining color correction percentages for photographic separations, it is necessary to express the density values in the form of actinic density (see Appendix A). These values include the following properties: absorption characteristics of the inks; absorption characteristics of the color separation filters; spectral emission of the light source; spectral response of the emulsion; and the absorption characteristics of the lens or other optical elements.

In practice, the above method of mask percentage determination will hold only when the contaminants of the inks are considered in isolation from each other. That is, for example, if the magenta ink contamination of cyan is considered separately from the yellow ink contamination of cyan. This restriction is unrealistic. If a mask is made from the green-filter negative to correct the blue-filter negative, it will have the effect of reducing yellow wherever magenta prints as well as reducing yellow wherever cyan prints. This latter effect

results from the poor green-light reflection (magenta contamination) of cyan. The cyan records too light on the green-filter negative and therefore is recorded on the mask, which in turn reduces yellow where cyan is printing. If the masking requirements for correcting the cyan and magenta patches in the blue-filter negative are the same, the cyan and magenta inks are said to be balanced.

For photographic masking, no more than three masks are usually employed: one to correct for both the blue absorptions of the cyan and magenta inks, one to correct for the green absorption of the cyan ink, and one to correct for the red absorption of the magenta ink. If the inks are not balanced, a fourth mask may be needed to correct for the blue absorption of cyan ink. For electronic masking, the correction signals can be manipulated somewhat independently of each other.

The next aspect of color correction concerns the overlap colors: the solid red, green, and blue areas. In theory, the color corrections that were calculated for the unwanted absorptions of the yellow, magenta, and cyan should also correct for their overlaps. That is, if the densities of the overlaps are simply the sum of two primary colors, then a correction for the primary color is automatically a correction for the secondary, or overlap, color.

In practice, unfortunately, the density values of two primary colors cannot simply be added to obtain the actual density values of the secondary color. This is called **additivity failure.** The reasons for additivity failure include undertrapping or overtrapping of the second ink; the lack of perfect transparency of the second ink; first-surface reflections; multiple internal reflections; the spectral response of the densitometer (or color separation system); back-transfer of the first ink; and light scatter within the paper, which can contribute to the *nonadditivity* of halftone tints.

Both **superadditivity** (where the measured overlap density is greater than the sum of the individual densities) and a lack of additivity (additivity failure) can occur within a given set of color separations. These effects, in turn, result in overcorrection or undercorrection of the overprint colors.

After the corrections for the unwanted absorptions of the primary colors have been calculated, the same correction values are applied to the overprint in order to determine the degree of undercorrection or overcorrection that will result. The color correction objective now becomes that of matching the actinic densities of the primary colors and the secondary (overprint)

Use of the GATF
Color Triangle to
determine percentage
mask strengths

colors. For example, in the magenta color separation, the
actinic densities of the magenta (primary), red (secondary), and
blue (secondary) colors must match. These colors are called
wanted, or black, colors in the magenta separation. Also, for
the same separation, the yellow (primary), green (secondary),
and cyan (primary) must match. These colors are called the
unwanted, or white, colors in the magenta separation. The
table illustrates the nature of the additivity problem.

The color correction requirements discussed so far can be
summarized by the rule of three. That is, in any color
separation, the three wanted colors must separate so they

appear equal in density to each other and to black (or the three-color patch). Also, the three unwanted colors in the same separation must separate so they appear equal in density to each other and to white. The GATF Color Reproduction Guide should be used when making color separations in order to determine if these objectives have been achieved. The Color Reproduction Guide is useful for determining the color correction requirements of the inks, but it will not indicate the color correction requirements of the original. If a color

The nonadditivity of densities

| Printed Colors | Blue Filter | Green Filter | Red Filter |
|---|---|---|---|
| Yellow | 0.93 | 0.06 | 0.03 |
| Magenta | 0.54 | 1.25 | 0.07 |
| Cyan | 0.04 | 0.22 | 1.06 |
| Yellow + magenta | 1.47 | 1.31 | 0.10 |
| Red overlap | 1.62** | 1.31 | 0.10 |
| Yellow + cyan | 0.97 | 0.28 | 1.09 |
| Green overlap | 0.92* | 0.30** | 1.09 |
| Magenta + cyan | 0.58 | 1.47 | 1.13 |
| Blue overlap | 0.60** | 1.42* | 1.14** |

* = additivity failure     ** = superadditivity

transparency is made of the printed guide, then adjustments for both the correction requirements of the inks and the transparency can be made. In practice, however, this may not be desirable as the transparency, even though it is "distorted," may represent preferred color reproduction.

The final aspect of color correction concerns the color halftone tint values. Ideally, the color correction percentage needed for the solid value of an ink would also be the same for the lighter tint values of that ink. In practice this is not so. Halftone tint values require more color correction than solids of the same color. This problem is called **proportionality failure;** that is, the ratio of unwanted absorptions to wanted absorptions of the solid ink is not proportional throughout the tone scale. The graph shows typical proportionality failure data.

The correction requirements for tint values can be calculated in the same manner as those for solid colors. For very light tints, three-place density numbers may be needed for accurate results. Halftone printing requires proportionally more color correction in the lighter tones than in the solid colors.

First-surface reflections and multiple internal reflections influence proportionality failure, but the major cause is the halftone dot pattern. Because the light tones are not completely covered by ink, the perceived tone is a combination of the light reflected from the paper and that reflected from the halftone

Graphical representation of proportionality failure

Perfect proportionality is represented by the dotted lines between the maximum and minimum points.

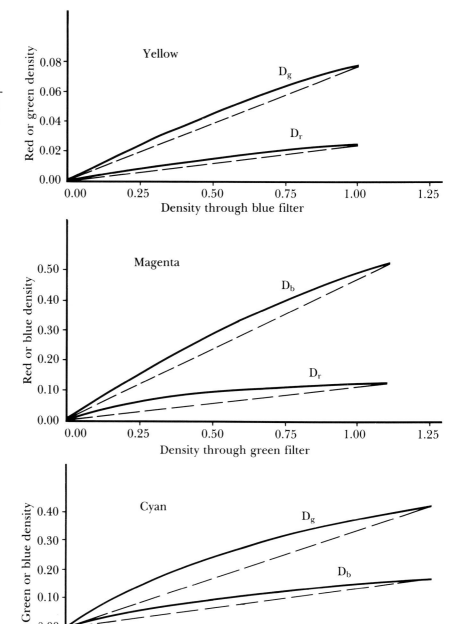

dot. The paper produces a graying effect on the tint. The effect is less for fine screens and uncoated paper because white light passes through the ink film, and some is scattered to such a degree that it emerges from the paper in an unprinted area. This colored light makes the paper appear colored around the halftone dot, thus making the paper and the halftone dot more alike in color. Finer halftone screens and uncoated paper result in proportionally more coloration of the unprinted paper and therefore less proportionality failure. Because of the almost continuous nature of a gravure ink film, the conventional version of this process rarely has any proportionality failure problems.

**The black printer.** The black can be used in four-color printing either to extend the density range of the reproduction, or, along with any two of the process colors, to reproduce a given color value. The black is also used, in some cases, to substitute for a portion of each of the process colors when they print together in a given color.

The primary use of black ink is to extend the contrast range of the reproduction. The illustration below shows the effect of adding a black printer to a three-color reproduction. In this case, the maximum density has increased from 1.60 to 2.10. The first printing dot of black occurs at the point where the densities in the preestablished optimum tone reproduction curve cannot be achieved by just the three colors alone. This point usually occurs around the middletone area.

The extension of the density range of a three-color reproduction by the addition of the black printer and the determination of the black printer tonal characteristics

The tonal range of the black separation should be made to correct the three-color curve shape to that desired in the four-color reproduction. In order to determine the black curve, it is necessary to know the additivity failure characteristics of three-color versus four-color systems. The table presents the densities of a three-color scale, a black scale, and the resulting four-color scale. Using this example, it is now possible to compute the required black separation characteristics, using the diagram above. The difference between the desired four-color curve and the three-color curve represents the density contribution of the black printer. In order to find the actual black values that created the differences in density between the three-color and four-color curves, it is necessary to consult the table. A graph similar to that shown in the illustration can be constructed from the table data.

| Additivity failure of the black printer | Density on Coated Paper | Density on Uncoated Paper |
|---|---|---|
| Three-color proof | 1.30 | 1.00 |
| Black proof | 1.15 | 0.90 |
| Additive density | 2.45 | 1.90 |
| Actual four-color proof | 2.00 | 1.30 |

In cases where undercolor removal (UCR) is required, the yellow, magenta, and cyan tone values are reduced in the neutral scale. The reduction of these values can be total or partial and can start anywhere from the lightest highlight to the dark tones. The value of black is increased to equal the three-color density that was removed.

Data similar to that in the table can be used to estimate the amount of black required to replace the three-color value. A better method, though, is to use overlapping three-color and black scales. This image can be used to construct additivity data for black overprinting any three-color value.

The use of black to substitute for one of the three process colors, called gray component replacement (GCR), is discussed in some detail in Chapter 5. Like UCR, the amount and starting point for GCR can be adjusted within wide limits. The theory behind GCR is that where three colors overlap, there is a component of equal densities of red, green, and blue (i.e., a gray tone) that may be replaced with an appropriate value of black. The value of black that is needed to replace one of the process colors may be determined by reference to a color chart,

such as the Foss Color Order System. A two-color-plus-black color is selected to equal a color made up of just the three process colors. The code numbers can be read from each patch to determine the relative dot percentages. In practice, it is not common to totally replace one of the process colors with black; rather, levels of about 45–50% GCR seem more popular.

The color correction requirements for the black printer are the same regardless of whether a short-range, long-range, or GCR black is required. No dot of black should print in the primary colors, overlaps, or tints of a GATF Color Reproduction Guide. Of course, for GCR, black will print in areas that would usually require three process colors. These values must be computed for each given ink-paper-press combination.

Gray component replacement (GCR)

GCR is the substitution of black for fractions of yellow, magenta, and cyan that, when combined, will produce a gray equal to the replacement black tint.

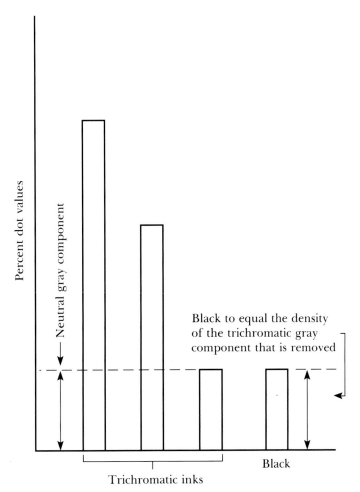

**Image Quality Requirements**

These factors are discussed, to some degree, in Chapter 7. The main aspects of image quality that are influenced by the color separation stage are sharpness, resolution, graininess, and moiré.

The sharpness enhancement aspect of image quality is difficult to specify. As stated earlier, it is believed that the optimal sharpness depends to some degree on the nature of the subject of the picture. One aspect of sharpness that is possible to specify is the focus of the separation films. A resolution target, such as a Star Target, should be provided as part of a color separation guide. This target should be examined for maximum sharpness at every stage of the photographic process. The focus aspect of sharpness can also influence resolution and graininess.

Resolution should be as high as possible; therefore, the finest screen ruling consistent with the substrate and the printing characteristics should be used whenever possible. A Star Target or other resolution target should be used to monitor the non-screen-ruling aspect of resolution.

The graininess of the reproduction should be no worse than in the original. The best way to evaluate graininess is to scan visually what should be flat, even tones.

Moiré patterns should be at the least objectionable level. The normal angles are yellow—90°, magenta—75°, cyan—105° (or 15°), and black—45°. These angles may occasionally create problems between the yellow and cyan or yellow and magenta. Sometimes, especially for a short-range black, it is advisable to switch the angles for the yellow and black. Alternatively, the black may be switched with either the magenta or cyan, depending on what colors are giving moiré problems. The angles may be checked with a screen angle indicator.

The screen angles for lithography, letterpress, flexography, and screen printing are the angles stated above. For gravure, the angles are as follows: yellow—60°, magenta—75°, cyan—105°, and black—45°.

For screen printing, it may sometimes be necessary to angle the halftone positives away from the perpendicular in order to avoid a moiré clash with the screen mesh. Unfortunately, this effect is often not predictable. Sometimes, the anilox roll pattern causes moiré patterns with the flexographic plate. The roll is usually badly worn when this effect becomes noticeable. An extra 8° angle for all of the colors will help to minimize this effect.

## Color Separations: Production Methods

Color separations may be produced by either electronic color scanning equipment or one of several kinds of photographic techniques. These separations may be made in two stages (the **indirect process**), where separating and screening are distinct operations. Separating and screening may also be accomplished in one step (the **direct process**).

Another aspect of color separation production is the individual color retouching that must be done by hand. Either electronic, chemical, or photographic dry etching techniques may be employed for this work.

### Electronic Color Scanning

Color scanning is the most important color separation technique. An estimated 80% of all color separations are produced on scanning equipment. Color scanners are generally based on either one of the approaches outlined in the theory section; namely, the computation of individual dot values or the correction for system characteristics. These theoretical approaches have their counterparts in the stored-color-data scanner (the digital scanner) and the real-time data-processing scanner (the analog scanner).

**The digital scanner.** The digital scanner has become more popular with the declining costs of digital computer equipment. The basic function of the digital scanner is to take the tristimulus values of the original, look them up in a stored color chart, and then print out the dot values that were used to generate the appropriate patch on the color chart. This method is often referred to as the *lookup table approach*.

Initially, the scanner is programmed with a series of color chart images that have been printed under normal printing conditions. This is accomplished by scanning the printed color chart. For a given square of the color chart, the red-, green-, and blue-filter tristimulus values derived from the input scan are stored along with the output dot values for yellow, magenta, cyan, and black. These output dot values represent the original film dot values.

When a transparency or print is scanned, a search is made of the lookup table to find the tristimulus values that correspond to each point on the original. The appropriate dot values are then output to film. When the original contains a color that is outside the gamut of the stored color chart (not an uncommon occurrence), an appropriate trade-off between saturation and lightness is made.

For tone scale compression, any shape may be selected by simply adjusting the tone curve control points. With some of these scanners, a color video monitor is provided so the operator may review the effect of tone scale manipulation. The gray balance is adjustable through a chrominance shift in either the red, green, blue, or yellow directions. This control is useful for correcting unwanted color casts in the original.

Selective color control may be achieved by focusing on a given color with the aid of cursors or light pens. The operator may alter the selected color independent of the other colors in the picture.

The digital scanner is simpler to operate than the analog scanner. The setup is largely accomplished through the use of computer graphics input devices like joysticks and light pens. The relationship between the input tristimulus values and the output dot percentage values has been precomputed by the Neugebauer or similar equations. The potential flexibility afforded by the digital scanner is limitless within the constraints of the lookup table.

**The analog scanner.** Today's analog scanners also use color video monitors to assist with the setup, but the principle of operation is quite different from that of digital equipment. The tristimulus values read from the original are each processed through the analog computer section for every point in the original. The output values are individually computed and exposed onto film. This computation happens as quickly as it takes the electrical signals to travel through the computer circuits, i.e., almost at the speed of light.

The analog computers work rapidly because the solution is worked out before any scan is made. That is, the individual potentiometer settings on the analog computer represent the solution to the color-masking equations that are often used to compute color correction on an analog scanner. Of course the solution is not specific to any color in the original; rather, it is general for the ink-paper-press combination. If the system is correct, then any color being processed through that system will also be correct.

Analog color correction circuits mimic the photographic two-stage masking process. Six masking signals are generated, which may be expressed as positive or negative signals. These are used to modify the white and black colors in the separation. The illustration shows the electronic color correction principle for one separation.

Color correction
using an analog color
scanner showing *(top)*
an uncorrected
separation and
*(bottom)* a corrected
separation

*White* and *black* colors
are adjusted by
individual scanner
controls.

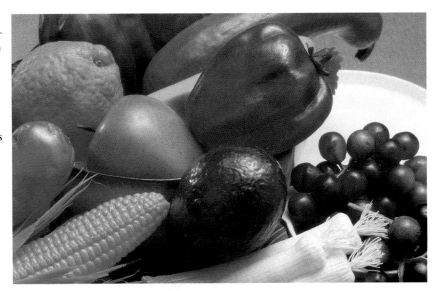

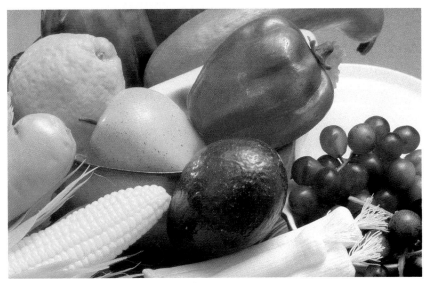

The masking equations will not give perfect color correction
of the inks where additivity failure is a serious problem. Also,
the spectral response of the scanner to a given original may
cause additional problems. The photomultiplier response, filter
absorptions, lens, and other optical element absorptions all add
up to produce a different response from what may seem to be
identical colors on two different types of color film. This
problem is discussed in Chapter 9. To compensate for these
problems, some analog scanners have up to thirty-two selective
color correction control knobs in addition to the six basic
controls. These selective controls can be used to add or subtract

yellow, magenta, cyan, and black to the three primary and three secondary colors plus other special colors such as browns or skin tones. The photographs show the selective color controls and gradation controls of an analog scanner.

The selective color correction controls of an analog scanner

The gradation controls of an analog scanner

Tone reproduction and gray balance adjustments on analog scanners are usually accomplished by setting each color channel to appropriate dot values at the points selected on a reference gray scale. The ideal tone reproduction and gray balance requirements must be selected in advance. The color correction guide can be placed on the scanner to aid in the setting of the

color correction controls. That is, they are adjusted until the rule of three is satisfied. The corrections for individual colors in the original, however, are largely derived by trial and error methods. One important color correction distinction between analog and digital scanners is the selective or individual color adjustment. A digital scanner can change any color within a specific area in the picture. An analog scanner can change any color, but this change will occur in that color throughout the entire picture without the use of special-area masking techniques.

Although analog scanners are much more complex to set up than digital scanners, the use of prescan devices and color video monitors has simplified the process somewhat.

**Image quality.** The image quality aspects of the color separations can be easily controlled on digital or analog color scanning systems.

Sharpness control is carried out by a process known as **peaking.** When the image is scanned, a large aperture and a small aperture traverse the picture. The large aperture senses the change in a tone at an edge sooner than the small aperture. The change in signal picked up by the large aperture is more gradual than the abrupt change at an edge that is generated by the small aperture. The difference between the two signals is added to the separation signal, which has the effect of exaggerating the contrast at the edge. The light tone and the adjacent dark tone are reproduced slightly lighter and slightly darker for a small boundary area. The net effect to the viewer is a sharper image. The starting point and the degree of sharpness can be selected on the scanner.

Resolution is largely controlled by screen-ruling selection. However, some scanners that use lasers for electronic halftone dot generation are capable of individually shaping the dot to conform to detail in the picture; for each screen ruling being used, this produces less detail distortion and, hence, higher resolution. The advantage here is that a coarse screen, which resists dot gain on press, actually has a higher resolution than one normally expected from that ruling.

Graininess in a conventional sense does not exist in scanning systems, although a kind of *electronic graininess* can be induced in some areas by too much peaking. Unless this problem occurs, the grain in the reproduction will be equal to the grain in the original.

Laser-generated dots, because of their irregular shapes, have the potential to cause moiré problems. The manufacturers have been able to restrict laser dot moiré so that it is no worse than conventional patterns. Screen ruling, screen angle, and dot shape are manipulated until the optimal settings are found. In some cases, it is possible for the user to select the screen angle, but for most scanners, the selection of a color circuit automatically activates the program for a preset screen angle.

The principles of sharpness control using an electronic color scanner: signal A (from normal scanning aperture), signal B (from unsharp-masking aperture), and signal C (a composite of signal A plus the voltage differential between signal A and signal B)
*Courtesy HCM Graphic Systems, Inc.*

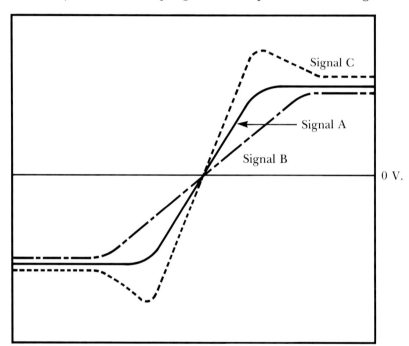

**Photographic Color Separation**

**Photographic color separation** is the term used to describe color separations that are not made on a scanner. These separations may be made on a camera, enlarger, or contact frame. In photographic color separation, the process of color separation and the process of color correction are distinct operations. They are interdependent, however, and because of this will be treated as they are in color scanning; that is, as one operation. The major distinctions in photographic color separation are more numerous than those in color scanning. The major points can be addressed under the headings of sensitometry, single-stage masking, two-stage masking, tone reproduction masking, halftone screening, and image quality.

**Sensitometry.** Unlike scanning, the sensitometric properties of the film exert a tremendous influence on the characteristics of

photographic separations. For example, the contrast characteristics of film may be manipulated by exposure and development control.

As the development time increases, so does the contrast. As the exposure time increases or decreases, the image's position on the toe, straight line, or shoulder portions of the characteristic curve change. These effects are an advantage when generating nonlinear masks.

Characteristic curves showing the effects of increasing development time

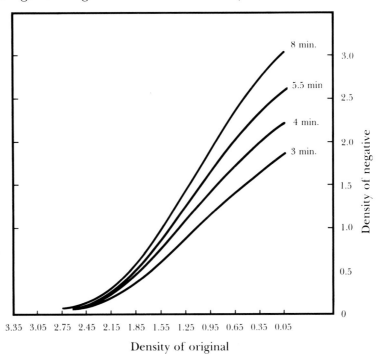

Density of original

The other important sensitometric property for a color separation is the spectral response of the film to a given light source. The manufacturer recommends a particular set of color filters when using a particular film with a given light source. In general, these recommendations should be followed.

The color patch densities produced on a given film are the combined effect of the ink absorptions, color filter absorptions, light source emission, film color sensitivity, exposure time, gamma of the film, and absorption properties of the lens and other optical elements. The densities of the colors from the original are influenced by all these factors (except ink) and the absorptions of the colors in the original.

Color separation negatives are made by exposing film through the appropriate filter for the correct time and then

The influence of changing the red filter when making color separations on a given emulsion

processing it at the right temperature and time. Usually, three density control points are used to monitor the tone reproduction and gray balance characteristics of these negatives. These three points are placed in the highlight, middletone, and shadow areas. The major film manufacturers publish their recommendations for separation negative aimpoints in terms of the three density control points. These recommendations must be used with caution. They have been established for a given type of original that will be reproduced under given printing conditions and therefore may not be suitable for other conditions. The approach to aimpoint determination outlined in the theory section of this chapter should be followed for best results.

The right exposure and developing times for a given negative can be determined only by consulting sensitometric tests for that film. A company should generate these tests for each new batch of film that arrives. Some film manufacturers supply dial calculators to help compute the right exposure and development time for a given film. These calculators are often very useful, but calculating the individual properties for a batch of film ultimately leads to more predictable results.

**Single-stage masking.** The color correction qualities of the separation negatives cannot be judged until the negatives have been masked. The masking stage can take place either before or after the separation negatives are made. In the former case, the separations that are made have the masking effect built into them. In the latter case, masks are taped in register to the uncorrected negatives.

The single-stage masking process is probably the most popular of the photographic masking processes. It can be used as either a premasking or a postmasking method. As a

postmasking method, it involves making positive continuous-tone masks from the continuous-tone separation negatives. These masks, which are made to a density range that corresponds to the percent correction requirements of the inks, are taped in register with the appropriate negatives in order to accomplish color correction.

Theoretically, six masks are needed to correct for the unmasked absorptions of the process inks, but this number actually can be reduced to two or three. The unwanted red and green absorptions of the yellow and the red absorption of the magenta are so small that they only require a 3–5% mask for correction. These corrections are often ignored. The unwanted blue absorption of the magenta ink and the unwanted blue absorption of the cyan ink can sometimes be corrected with just one mask. If the green absorptions of magenta and cyan are exactly proportional to the blue absorptions of magenta and cyan, then a correct-strength mask made from the green-filter separation will correct both the magenta and cyan areas in the blue-filter negative. Inks that behave in this way are called **balanced,** or compatible, inks. The final mask is made from the red-filter negative and placed over the green-filter negative. This mask corrects for the unwanted green absorption of cyan. The black separation is often left unmasked in single-stage masking. The red-, green-, and blue-filter exposures are adjusted to give the best balance between the color patches. Ideally, they descend in density in this order: white, yellow, magenta, red, cyan, green, and blue. The mask for the red-filter negative is a contrast reduction mask that is used to equalize approximately the density ranges of the red-, green-, and blue-filter negatives.

The major problem with the single-stage postmasking method is that it reduces the contrast of the separation negatives. Consequently, the separator must make increased-contrast separation negatives to compensate for this reduction. The combination of negative and mask requires long exposures for making the subsequent positives. If a short-range black is made, the remaining unwanted absorptions can be corrected by hand. A final disadvantage with the single-stage postmasking method is that it cannot be used with direct-screening separation.

The single-stage premasking system overcomes some of the problems of the postmasking system. In this system, the mask is made first and registered with the original; a corrected separation negative is then made from the combination. For

Flow diagram of the single-stage masking process

RFN = Red-filter negative
GFN = Green-filter negative
BFN = Blue-filter negative
SFN = Split-filter negative

example, the blue-filter separation is made by first making a green-filter mask from the original onto low-contrast masking film. The processed mask is registered with the original and exposed onto a separation film through the blue filter.

This premasking method can be used for transparencies or reflection copy. For reflection copy, the method is called camera-back masking. The mask is exposed on pins in the camera back; therefore, it is returned to the back to register with the image of the original rather than with the original itself. For transparencies, the mask is usually placed in contact with the transparency. However, in order to avoid unwanted graininess caused by the mask when enlarging the transparency, the camera-back or enlarger-easel method of exposure can also be used for transparencies.

One advantage of this premasking method is the ability to use split-filter exposures when making the masks. Combinations of red-, green-, and blue-filter exposures can create a mask that can be made equivalent to that produced by exposure through any given color filter. This technique results in more accurate color correction of the unwanted absorptions. Such an approach may be applied to the postmasking method by using register pins to facilitate the multiple exposure of masking film through two or more separation negatives. Alternatively, special split-filter negatives (usually two) can be prepared—in addition to the normal red-, green-, and blue-filter separations—from which the positive correction masks may be exposed.

A further advantage of the premasking method is that it can be used for the direct-screen separation process. Also, through split-filter and split-mask exposure, a well-corrected black separation may be obtained.

The major disadvantage with the single-stage premasking method is that it reduces the contrast of the original. Usually, it is necessary to reduce the contrast of transparency originals but not as essential to do the same for reflection originals. Consequently, high-contrast film must be used when making continuous-tone color separations from reflection originals. The usual method of making color correction masks on the shoulder of the material's characteristic curve minimizes the reduction effect on highlight contrast. Also, making special highlight masks compensates for any flattening of highlight contrast.

**Two-stage masking.** The two-stage masking method overcomes the contrast reduction problem of single-stage masking. This

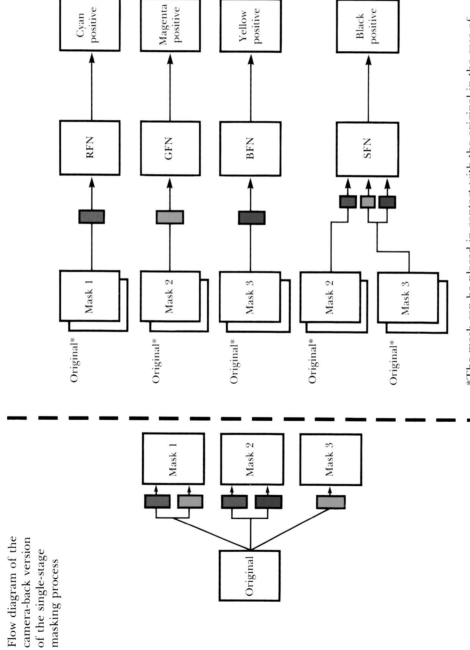

Flow diagram of the
camera-back version
of the single-stage
masking process

RFN = Red-filter negative
GFN = Green-filter negative
BFN = Blue-filter negative
SFN = Split-filter negative

*The mask can be placed in contact with the original in the case of
transparency separation, or in register with the image of the original
in the case of camera-back separation.

Mask 1 is a split red- and green-filter mask, mask 2 is a split red- and
blue-filter mask, and mask 3 is a green-filter mask.

method is also called the *double-overlay* method. Two-stage is a postmasking method (the negatives are made before the masks).

The first step in the two-stage masking process is to make contact positive masks from each of the three color separation negatives. These masks are made to the same contrast range as the negatives, that is, to a 1.00 gamma. These positive masks are called premasks. The final or principal masks are made by combining the separation negatives with the appropriate premasks and making an exposure onto masking film. For example, the blue-filter premask is combined with the green-filter negative in order to make the final mask for the blue-filter negative.

The primary advantage of the two-stage process is that color correction is accomplished without contrast reduction. When a negative and a positive image of the same contrast range are placed in contact, the gray scale is cancelled out. If the negative and positive images have been made through different filters, the color correction information is all that will be transmitted through the combination. With the color correction information isolated in this way, it is possible to use the toe and straight line portions of the masking film to produce nonlinear masks. The ideal corrections for the black colors and the white colors often require a nonlinear mask. When making the masks, exposure is adjusted to provide correction for the wanted colors and development is adjusted to correct the unwanted colors. Because the image contrast is not affected by the final mask, the contrast of this mask can be made much higher than would be possible with the single-stage method.

A good black-printer mask can be made with the two-stage system by using a split red-green filter negative with the blue-filter premask. The subsequent mask is combined with the red-green filter negative to form the black separation. Indeed, through the use of exposure and development adjustment and split negative mask exposure, it is possible to create color correction masks for almost any correction requirement. The two-stage masking method is by far the most flexible and versatile of all the masking methods.

The major drawback with the two-stage method is the increased film and time needed to make a set of separations. Also, it cannot be used for direct-screening separation.

**Tone reproduction masking.** Sometimes, especially with the indirect color separation system, it is necessary to make tone

Flow diagram of the
two-stage masking
process

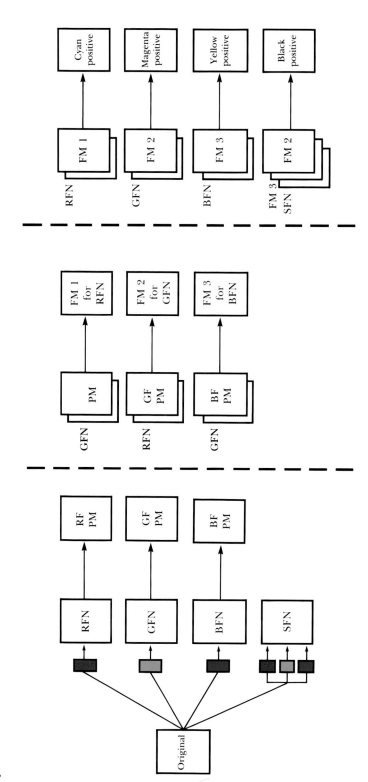

RFN = Red-filter negative
GFN = Green-filter negative
BFN = Blue-filter negative
SFN = Split-filter negative
PM = Premask
FM = Final mask

correction masks in order to achieve the desired tonal separation in the separation negatives.

The highlight mask is the most common of the tone correction masks. These masks are really underexposed and underdeveloped separation negatives. Their density and contrast are adjusted until the negative-plus-mask combination produces the right tonal separation in the highlights. If the highlight masks are not color corrected (which is often the case), there is a danger that color correction may suffer at the expense of tone reproduction. This potential problem can be overcome by making the color correction masks to compensate for the higher contrast that results with the use of a highlight mask. One other problem that is more difficult to correct is the increased color correction that is required in the highlight tones because of proportionality failure of halftone color images. The highlight mask emphasizes this problem, thus requiring some trade-off to be made between highlight tonal separation and the cleanliness of light colors.

A kind of premasking technique may also be used to perform highlight masking. This method is often used to emphasize specular highlights when color separations are made from transparencies employing the single-stage premasking technique. First, a short-range highlight premask is made on a high-contrast panchromatic film. No filter is used for this exposure. The mask is registered with the transparency, thus cancelling out or flattening the gray scale in the light highlight tones. Next, the normal color correction single-stage premasks are made from the combination of the transparency and the highlight premask. This color correction mask does not have any tonal separation in the highlights. Finally, the highlight premask is discarded and the color correction masks are registered, in turn, to the transparency in order to make the separation negatives. The highlight tones on the negatives are the result of combining the densities of the transparency with the flat, uniform (for the first few steps) density of the mask. Consequently, the tonal separation in the highlights is greater than the normal case where densities of the negative mask partly cancel out the densities of the positive transparency. The graph shows the effects of highlight masking.

Highlight masks may be made without a filter and used for all colors if the intent is to drop out only whites or to improve the highlight contrast of neutral tones. On the other hand, if it is necessary to improve the tonal separation of nonneutral light colors (such as pastels or skin colors), then highlight masks

Influence of a highlight mask in increasing highlight contrast in a color separation negative

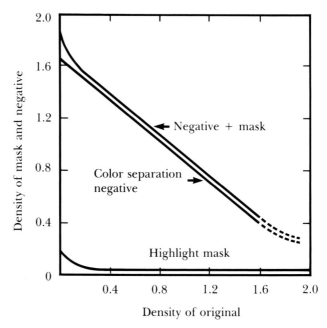

must be made for each color by using the normal color separation filters.

In order to achieve gray balance, it is usually necessary to print more cyan throughout the tone scale than either yellow or magenta. Therefore, a red-filter highlight mask is often made to increase the contrast of the red-filter separation relative to the blue- and green-filter separations. Shadow masks are more uncommon than highlight masks. Where necessary, they can be made by combining short-range positive masks, which have been made from a color separation negative, with full-range positives that have been made from the same negative. This process works when continuous-tone positives are made from the separation negatives. In halftone work, the same effect may be achieved by the use of a screenless *bump* exposure. Tonal manipulation by screen selection and exposure technique will be discussed later in this chapter.

An undercolor removal (UCR) mask is made by exposing a color-corrected black separation negative onto masking film. The exposure and development can be manipulated to select the desired extent (i.e., the starting point on the tone scale) and amount of UCR. The mask is registered, in turn, with each of the color separation negatives when making screen or continuous-tone positives. In cases where it is necessary to have more UCR in some colors than others, separate UCR masks must be made. The process of GCR cannot be successfully accomplished by photographic masking.

**Halftone screening.** The primary color reproduction concern involved in halftone screening is tone reproduction. Dot shape, screen ruling, and screen angle are also important concerns, but these will be discussed under the image quality heading.

Halftone contact screens are available as either negative- or positive-working screens. The screen characteristics for a negative screen have been designed to give a good negative from a positive original. The screen generally has the equivalent of a 4–5% bump exposure built into it. This bump increases the tonal separation of the highlight tones in the negative. A positive screen, by contrast, is designed to produce a good positive from a negative original (such as a color separation negative). If a negative-working screen is used to make a positive from a negative, the screen will flatten the highlights and expand the shadow tones. This effect may be desirable when making the black separation positive. If a positive screen is used to make a negative, the highlight tones will be flattened and the shadow tone contrast expanded. This effect may be desirable for low-key originals with important shadow detail. The illustration shows the screen characteristic curves for negative and positive screens.

Tonal characteristics of negative and positive halftone screens

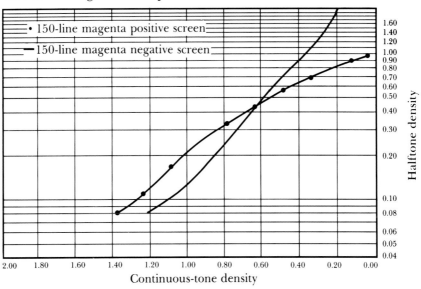

Apart from halftone screen selection, it is possible (indeed, usual) to modify the tonal characteristics of halftone negatives or positives through exposure techniques. The main exposure is given to the original with the screen over the film. The bump, or screenless, exposure is given for a short time (5-10% of the main exposure) to the copy without the screen. The flash

exposure is given using a white light with the screen. The bump exposure expands the highlight contrast of a negative or the shadow contrast of a positive. Therefore, a bump exposure may be used as a substitute for highlight or shadow masking. Apart from extending the range of the screen, the flash exposure flattens shadow detail in a negative and highlight detail in a positive. The illustration shows the effect of exposure manipulation on the basic screen characteristic curve.

Contact screens are available in either gray or magenta colors. Color filters can be used to adjust the screen curves that can be produced with magenta screens. A yellow filter reduces the contrast, while a magenta filter increases it. Magenta screens cannot be used for direct-screen separation. Gray screens (and magenta screens, if desired) use the main, flash, and bump techniques outlined above to adjust the screening curves. Gray screens can be used for both the direct and indirect color separation processes.

Use of exposure techniques to modify the tonal characteristics of a halftone screen

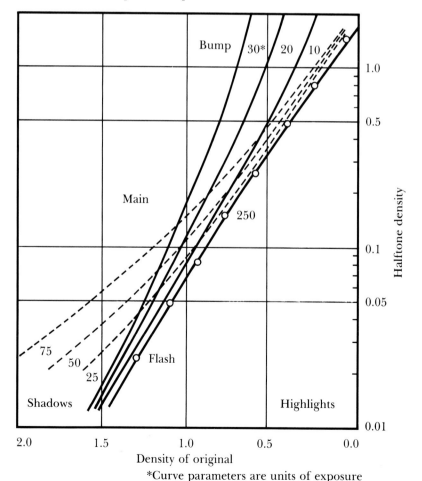

*Curve parameters are units of exposure

**Image quality.** The image quality aspects of photographic color separation are subject to a wide range of influences. Indeed, it is often because of poor image quality that scanner separations are sometimes preferred over photographic separations. In practice, it is possible to achieve photographic separations that are indistinguishable in image quality from scanned separations.

The two aspects of image sharpness are focus and enhancement. To achieve good focus it is necessary to use good optical equipment. This means a vibration-free camera or enlarger that has parallel film, lens, and copy planes. The lens must be free of chromatic aberration and have zero or very low levels of spherical aberration, astigmatism, curvature of field, distortion, diffraction, and spherochromatism. Apochromatic lenses must be used for quality color separation work. The lens must be used at the optimum aperture for maximum sharpness. This is usually equivalent to two stops down from maximum aperture, for example, f/22 for an f/11 lens. A quality magnifying glass should be used by the camera operator to check image sharpness on the ground glass. The camera should be locked into position as soon as the operator is satisfied that the image is sharp.

The image enhancement aspect of sharpness employs the technique of unsharp masking. If a sharp negative mask is placed in contact with a sharp positive transparency, the combined image sharpness will drop due to the sharpness of the mask, partially cancelling out the sharpness of the transparency. On the other hand, if the negative mask is unsharp, the sharpness of the transparency will not be cancelled and therefore will record on the separation negative. The mask can be made unsharp by a variety of techniques, which include the following: using a diffusion sheet between the transparency and the masking film when making the mask exposure; using a clear spacer film between the transparency and masking film and exposing with a broad source or diffusing light; using a masking film with no antihalation backing and exposing the film through the base; and, for the maximum unsharp masking effect, using a spacer between the transparency and masking film and rotating the contact frame off-center to the exposing light source. The undercutting that results from the latter method diffuses the mask image.

The resolution aspect of image quality is largely influenced by register between images, such as separations and masks. Stable base films, accurate register punches and pins, and

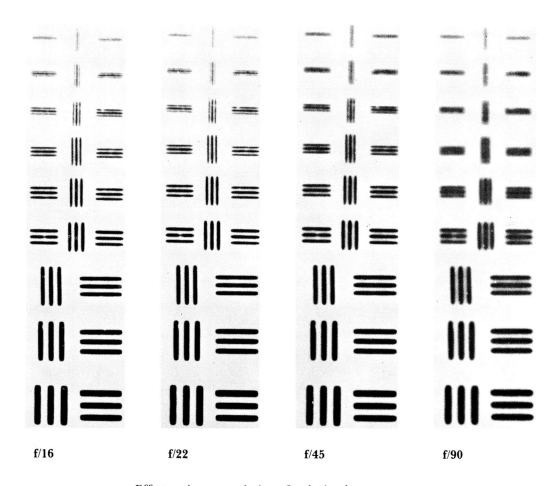

| f/16 | f/22 | f/45 | f/90 |

Effect on image resolution of reducing lens aperture
The optimal aperture is usually two stops down from maximum.

careful visual alignment are all required to achieve good register between images. A good lens, fine-grain film, and a fine-grain developer are other factors that can help to maximize image resolution. Of course, a finer halftone screen ruling also improves resolution, but this may not be allowable because of the printing conditions.

Graininess may be minimized by avoiding, as much as is practical, the enlargement of color separation masks or negatives. Therefore, instead of making contact masks for a 35-mm color transparency that has to be enlarged ten times, it would be preferable to enlarge the transparency to final size and make the masks on register pins that are positioned on the

Increasing image
sharpness by the use
of photographic
unsharp masks

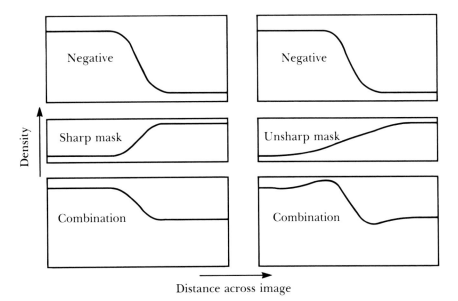

camera back or enlarger easel. The subsequent color separation
negatives are now made from the contact image of the mask in
combination with the projected image of the transparency. If a
condenser enlarger is used, this approach will also avoid the
problems of light scattering from silver images in this equip-
ment. The scattering will increase the apparent contrast of the
mask.

Graininess that is in the original may be minimized by using
an elliptical-dot screen instead of the normal square/round-dot
type. The elliptical screen smooths the middletone break and

Elliptical dot *(left)*
and square dot *(right)*
reproductions of the
same original

thus makes the grain less obvious, but it may lessen the apparent sharpness of the image and cause objectionable moiré patterns if doubling occurs on press. The screen should be used as a problem-solving screen rather than a general-purpose screen. The illustration shows the same image screened with elliptical- and square-dot screens.

Moiré patterns may be influenced by both screen selection and screen angle. The moiré problems that are caused by the 15° angle separation between yellow and magenta and yellow and cyan may be minimized by using a screen ruling for the yellow that is one step finer than the other colors. For example, if the normal ruling is 150 lines per inch, use 175 lines per inch for the yellow. The finer screen ruling may contribute to yellow dot gain problems on press; therefore, the tone curve of the separation must make allowances for this. To ensure correct angles, the preangled screens must be carefully checked with a screen angle indicator before use. If the screens are punched for location on pins in the camera back, the punch holes should be periodically examined for signs of wear that would change the angles.

The image quality of photographic color separations may also be affected by flare or stray light. Flare causes flattening of the tonal separation in the shadow tones of negatives and may also contribute to a loss of sharpness. Flare is usually caused by scratches, dust, fingerprints on the lens, and extraneous light from windows, pinholes in the bellows, room lights, or white walls or ceilings. Image flare causes problems in exposure calculation. A high-key original causes more flare than a low-key original, therefore necessitating exposure time adjustments, even though the high and low densities of both originals may be exactly the same.

A final aspect of image quality concerns the number of generations an image goes through from the original to the plate. Regardless of how good the lens is or how fine the grain of the emulsion is, some image quality is lost at every step. To minimize this loss, the image should be photographed through a lens no more than once. This might mean making contact separations and enlarged screen positives, or enlarged separations and contact screen positives. Of course, there are times when this objective cannot be achieved, but there are many cases where it can be.

To reduce the number of image generations, it is advisable to use direct-screening color separation techniques rather than the indirect methods. This improves image quality, but at the

expense of flexibility of tone reproduction adjustments and color correction control. For example, it is not possible to use shadow masking or two-stage masking techniques with direct screening.

Therefore, the selection of the appropriate photographic color separation technique involves making judgments concerning the important quality factors for a given job. A quality plant does not use the same technique for every job. Thus, when in doubt, the sales and estimating staff should check with the color separation department concerning the separation and correction techniques that will be used for out-of-the-ordinary types of work.

**Manual Color Correction and Retouching**

Manual color correction is sometimes needed when the customer wants a special change in one area of the picture. Special color inks or unusual printing conditions sometimes necessitate the use of manual retouching. Manual correction retouching can be accomplished by either electronic, chemical, or photographic means.

The ability to change one color electronically in a picture while keeping the others constant is discussed in the section dealing with digital color scanners. With many analog scanners, the signal is converted into digital form for display on a video display terminal. When the image is in this form, the operator may adjust individual colors independently of the rest of the picture. The advantages of electronic retouching over the other methods are as follows: the ability to retouch or change the color of very small images by enlarging the image with the zoom control; the ability to adjust the image before final films are made, thus avoiding the necessity of making contact images from wet-etched films in order to produce *hard dot* final films; and the ability to store the original, unretouched image so that it is possible to retrieve the original and start over again if a mistake is made in retouching.

The other methods of retouching are called wet etching and dry dot etching. The wet method involves the staging or protecting of the photographic image with a water-resistant material such as a varnish or lacquer. The exposed area is then treated with an etching solution to reduce dot size or tone density, or an intensifying solution to increase the dot size or tone density.

The dry-etching method involves preparing an opaque mask that covers the areas not to be changed. This mask may be prepared by cutting through peel-coat-type masking material,

or by painting the protected area on a sheet of clear film. The negative or positive is given a normal exposure onto contact film. The protective overlay mask is then placed over the negative or positive, and an additional exposure is made just for the area where the change is desired. When making the supplemental exposure, film spacers may be used for an even greater effect. The second exposure effectively increases the printing dot values when contacting from negative to positive and reduces them when contacting from positive to negative.

The problem with the wet- and dry-etching methods is that it is difficult to paint accurately around small details. Also, for wet etching, it is possible to ruin the image by overetching.

Wet etching may be carried out on continuous-tone negatives, positives, or masks, as well as halftone negatives or positives. Dry etching can only be used for halftone images. The only real advantage that wet and dry methods have over the electronic method is that they don't require expensive equipment.

## Color Separation Control

Controlling the consistency of color separations involves obtaining consistent emulsions, controlling exposure, and controlling development. In addition, a regular servicing schedule must be followed for the electronic and mechanical parts of scanners, cameras, and other equipment.

The major characteristics that should be checked for color separation emulsions are speed, gamma, $D_{max}$ and $D_{min}$, color sensitivity, and contrast. Film from each new batch should be tested for these properties by either exposing a standard gray scale onto the film through the use of a sensitometer, or by exposing the film under normal camera or scanner conditions. A sheet of the old batch should be similarly exposed; then both films should be processed under identical conditions. The gray scale images on each test film should be measured with a densitometer and compared. Slight shifts in speed or contrast can be adjusted in future exposure or development. Major sensitivity shifts may signal that the new film has something wrong with it. In these cases, the film should be returned to the manufacturer for further testing.

The storage conditions for sensitized materials are important if consistency is desired. Film should be stored under cool and dry conditions. Even in the best storage environment, the sensitivity of an emulsion will shift as a result of time. Old stock should not be used without running preliminary tests.

Exposure is controlled on photographic equipment through

the use of light-integrating systems. The integrator photocell aperture should be periodically cleaned. Development is controlled by the use of an automatic film processor. Temperature, replenishment rate, agitation, and processor speed should be monitored for consistency. The usual way of checking processor conditions is to run preexposed control strips through at regular intervals. The densities on the control strips are measured to ensure that they are within acceptable limits.

New contact screens have to be periodically checked by making test exposures under normal operating conditions. Color separation filters should be replaced when they get scratched or dirty or change color.

Finally, a dust-free, controlled-temperature and humidity environment must be provided for scanner and camera equipment. This environment helps to reduce extraneous spots, electrical malfunctions, register problems, and operator error.

The control devices outlined for color separation control in Chapter 8 should be used to monitor color separation production. If the color separation system is programmed with the correct aimpoints, and the precautions outlined above are followed, consistently high-quality separations should be the result.

## Summary

The color separation stage is the key step in the color reproduction process. Unless the separations are made correctly, the entire printed job will be incorrect. Correct separations are those that successfully integrate the press-paper-ink characteristics with the requirements of the original.

The most important parts of the color separation process are the analysis of the press and copy characteristics and the programming of the color separation equipment. For photographic color separation, the testing and analysis of the photographic emulsions are also a major part of the color separation process. The actual making of color separations, especially on a scanner, is a trivial operation by comparison.

Programming for color separation must deal with tone reproduction, gray balance, color correction, and image quality. This is the decision-making aspect of color separation and can be likened to the programming of a computer.

If the programming is done correctly, if the appropriate techniques are employed, and if the process is under control, it is possible to get results from scanner and photographic color separation systems that are virtually indistinguishable from each

other. The major difference between the two systems is that the camera operator needs higher levels of knowledge and skill than the scanner operator. Digital scanners, in particular, are quite easy to operate. The introduction of color video monitors has considerably simplified the color separation operation. It is now possible, for the first time, to produce quality separations without knowing very much about what determines quality. Of course, it is also possible to produce photographic color separations without much knowledge of what is required, but these films will be of lower quality than those produced on a scanner under similar conditions.

The scanner has many of the requirements for successful color separation built into the circuits or programs. On the other hand, a scanner in the hands of a person who turns too many knobs too far will produce a much worse result than could ever be achieved by photographic methods. Nevertheless, scanners are increasingly preferred over photographic methods because of the lower skill and knowledge required to get excellent results. The higher speed of operation is also a factor, but this is offset somewhat by the high initial investment.

The all-digital scanner is a comparatively recent development that was made possible by the availability of low-cost, high-speed digital computers. This type of scanner is easier to operate and is more flexible than the analog scanners. Future scanners will undoubtedly make extensive use of digital technology. At the very least, the use of color video terminals as an aid to scanner setup will become commonplace.

Photographic color separation will continue to be used for low-volume color separation plants and in cases where large, inflexible reflection copy must be separated. Of the photographic color correction systems, the two-stage method is the most flexible. Of the color separation systems, the direct-screening method will produce the best image quality. The ideal selection of separation and masking techniques will largely depend on the separation objectives for a given job.

Regardless of the color separation and correction techniques, manual retouching and color correction will always be with us. The electronic method of retouching digital images is so superior to manual methods that this factor alone may be enough to tip the balance in color separation system decision making.

The introduction of the automatic film processor and the laser screening device has done much to increase the

predictability and consistency of color separations. This, in turn, has been a major reason for the growth in color printing in recent years.

**Notes**

**1.** Irving Pobboravsky, "A Proposed Engineering Approach to Color Reproduction," *TAGA Proceedings* 1962 (Rochester, N.Y.: TAGA), pp. 127–165.

**2.** J. A. Stephen Viggiano, "The Color of Halftone Tints," *TAGA Proceedings* 1985 (Rochester, N.Y.: TAGA), pp. 647–661.

**3.** F. R. Clapper, "Balanced Halftone Separations for Process Color," *TAGA Proceedings* 1959 (Rochester, N.Y.: TAGA), pp. 177–189.

**4.** Irving Pobboravsky, "Methods of Computing Ink Amounts to Produce a Scale of Neutrals for Photomechanical Reproduction," *TAGA Procdings* 1966 (Rochester, N.Y.: TAGA), pp. 10–34.

**5.** John A. C. Yule, *The Principles of Color Reproduction* (New York: Wiley, 1967), pp. 371–374, 379–380.

**6.** Pierre H. Chappuis, "A Modified Factorization of the Neugebauer Equations to Compute Accurate Mask Characteristics for Neutral Balance," *TAGA Proceedings* 1977 (Rochester, N.Y.: TAGA), pp. 256–281.

**7.** H. B. Archer, "An Inverse Solution of the Neugebauer Equations for the Calculation of Gray Balance Requirements," *16th IARIGAI Proceedings* 1981 (Plymouth, Devon: Pentech Press Limited), pp. 154–168.

**8.** F. R. Clapper, "Modified Use of the Subtractive Color Triangle to Obtain Mask Percentages," *TAGA Proceedings* 1971 (Rochester, N.Y.: TAGA), pp. 503–512.

# 11   Color Proofing

The basic purpose of color proofing* is to ensure that the four black-and-white color separation films produce the desired result when they are printed in color. Theoretically, if the separations have been made correctly, there is no need for a proof. In practice, however, customers sometimes change their mind about the desired color in particular areas. Also, simple but important mistakes sometimes occur when the separations are made or assembled. Because of these and other factors, virtually every set of color separations is proofed before it reaches a production press. The cost and time required for the proofing step is considered a good investment. The risk of waiting to discover a problem until the job is being made ready at the printing stage is too great. The cost of making proofs is easily outweighed by the cost of having to pull jobs off the press.

**Purpose of the Proof**

Even if the separation films satisfy all the tone, color, and image quality requirements that are discussed in the preceding chapter, it will still be difficult to visualize the printed appearance without a proof. This is especially true if image assembly has taken place and there is a juxtaposition of pictures, tint panels, type, and logos. When these elements are combined, they create a new image of unknown impact and appeal. The proof provides the assurance of visual confirmation of the design decisions. Graphs, numbers, and control charts are sadly lacking when it comes to providing the feel, texture, color, size, and even the exhilaration of a well-made proof.

Of course, in order for the proof to be effective, it must accurately simulate the future printing conditions. The proof that "looks good" but does not show how the actual printed job will appear is useless. The proof is actually the *prototype* for the main production run, and as such has similar requirements to prototypes for any other manufactured product. This means that the perfect proof actually would be printed on the same press with the same plates, inks, and substrate as that used on the final job. There may be some instances where this happens, but in general it is not practical to go to this extreme to produce satisfactory proofs.

---

*Proof is a noun of which prove is the verb form; therefore, this activity should be called color proving rather than color proofing. However, the term "proofing" has acheived widespread usage in the printing industry.

Another use for proofs is to provide a guide for the printing of the job. If the proofs have been made to match the standard printing conditions for a given plant, there is theoretically no need for the proofs. All the printer must do to get a good result is make ready and print at the standard conditions. In practice, a job may be color-separated by a trade house that does not know what printer will actually print the job. In these cases (which are fairly common) the proof provides, at the very least, a reasonable guide for the printer.

The proof also serves as an internal guide for the color separator. In particular, proofs provide helpful feedback to scanner operators concerning the actual effect of the supplementary color correction controls. It is difficult to predict the influence of these controls on the whole picture. Another use of the proof in the color separation department is as a guide for the dot etcher or retoucher. Some plants produce a proof as soon as the films come off the camera or scanner. In these cases, the retoucher is better able to judge the effects of image detail, surround colors, and area on the actual color that needs to be adjusted.

The final use of a proof is as a legal document or contract. The customer's OK on a proof is an approval of the appearance of the proof. The related question of whether this OK also constitutes approval of the separation negatives that made the proof is less clear. The customer, in approving the proof, makes the implicit assumption that he or she will expect the actual printed job to appear the same as the proof. This can happen only if the color separations have been made to suit the printing conditions, or if the printing conditions are selected to suit those that the separations were made to match.

At the center of this circular reasoning stands the proof. If the proof has been made to match the production conditions, then all is well. Problems arise when the production conditions have to be selected or adjusted to match the proof. If the price of the printing has been quoted based on the use of paper and inks inferior to those used for the proof, nothing the printer can do will make the printed job match the proof. The customer, who has a certain responsibility in this tangled web, must either (a) inform the color separator of the printing production conditions for the job and specify that the proofs be a reasonable facsimile of the results obtainable from these conditions; or (b) allow the printer to use the same materials that were used to produce the proof, or, if cheaper materials are specified, not expect the printer to achieve the same quality

as the proof. If the printer knowingly submits a bid for printing that uses lower quality ink and paper than that used for the proof, then the printer has the responsibility of informing the customer that the printed product may not match the proof. If the printer sees the proof before submitting a bid that specifies the same ink and paper as the proof, then there is an implicit understanding that the printer can match the production run to the proof. For their own protection, printers should insist that color bars, such as the GATF Standard Offset Proofing Bar, be included on the proof.

If the printer is asked to submit a bid before the proofs are made, and if the color separators are not told what materials or conditions they should use to make the proof, then all the printer can do is give a "best-faith" effort. The customer should not be surprised if the printed results are not exactly what was expected.

In cases where it is impossible for the proofing conditions to match the printing conditions (a heatset web offset press, for example), the expectation is that the proof will represent only a reasonable approximation of the printed job. There is one thing a proof is not: it is not a record of *what is on the film*. The only conditions for which this can be considered a reasonable objective is for position, spots, and other mechanical characteristics of the image. This attitude should not be applied to tone or color appearance.

Some separators have the *mistaken* belief that the *color separation films are an end in their own right* and that the proof must capture the tonal values of the separations as precisely as possible. The objective on the part of the printer now becomes that of matching the proof, which the separator says is "not my problem." Some proofs that are produced by separators are almost handcrafted, a far cry from the mass production printing technology that must be used to produce the job economically and quickly.

The separation films are, of course, merely a means to an end. The color printing industry can prosper only if the final printed product is produced within the time, cost, and quality requirements of the customer. The printed product is what is ultimately purchased by the general public; therefore, all of the preceding steps should be executed with the sole intent of maximizing the quality and minimizing the cost of the end product. The *proofs-must-match-the-film* mentality is misguided. The correct attitude is, the *proofs must simulate the final printed result*.

## Proof Types and Characteristics

Many different kinds of color proofing systems have been developed over the last thirty years or so. Those that are in use today may be grouped under the headings of press proofs, overlay proofs, transfer or surprint proofs, electronic proofs, and digital image proofs.

The important characteristics of proofing systems include rendition of solid and tint colors, surface characteristics, image quality (collectively, press simulation), the time needed to make a proof, the cost of proofing materials and equipment, and the ability of the system to produce consistent results.

### Press Proofs

Press proofs are those made with ink and paper using a proof press or production press. Presses that are designed specifically for proofing are generally flatbed single-color machines. Some of them are hand-operated. These machines are more common in Europe, Japan, and Australia than in the United States and Canada. Rotary presses have been designed specifically for proofing purposes, some of which are webfed. Production presses in one-, two-, or four-color configurations are often used for making proofs. These presses are often especially modified to cope with the stop/start nature of proofing, rather than the long runs of production.

Rotogravure proof press
*Courtesy George Moulton Successors Ltd.*

The major argument for using press proofs has been that they are more likely to be an accurate simulation of the press result than other proofing methods. This argument will probably be quite valid if, say, a litho sheetfed job is proofed on

a four-color press that is similar to that used for the production run. For other situations, the argument for press proofs is less compelling.

Probably better than 90% of four-color process printing is printed on at least a four-color press. Five- and six-color presses are increasingly being used for color printing. This means that proofs produced on flatbed proof presses, or one- or two-color production presses, will probably not match the ultimate four-color press result. The key problem here is the better trapping that is obtained when the sheets are allowed to dry between impressions.

Problems also occur when trying to simulate the performance of a four-color web offset press with a four-color sheetfed press. For example, the inks and papers used for heatset web printing cannot be used on a sheetfed press. Therefore, sheetfed inks and papers that have similar appearance properties to the web offset counterparts must be used. Another problem is the difference in gloss between heatset inks and sheetfed inks. The major problems arise, though, when trying to match the performance of the sheetfed press to the web press. The key problem is to match the dot gain of the proof to that of the production press.

Dot gain may be increased on a sheetfed press by using lower pigment concentration inks, overpacking the press, and employing conventional as opposed to compressible offset blankets. However, the high speeds of web offset printing, the blanket-to-blanket printing configuration, and the particular properties of the web paper and inks may all contribute to a different dot gain function than that which can be produced on a sheetfed press. Indeed, because the printing process—and in particular the lithographic printing process—is so complex, it is often very difficult to match two four-color sheetfed results.

Apart from producing a proof with the look and feel of the production job, there are other advantages suggested for the press proof. One valid reason for producing press proofs applies when a large number of proofs are required. For example, a proof for an advertisement that is going to appear in many magazines that are each printed at many sites could probably be produced more cheaply and quickly as a press proof. Another reason advanced for preferring press proofs is that progressive proofs can be produced easily by this method. Progressive proofs may have been useful when one-color presses were used to print four-color jobs, but they have little

value to a four-color press operator.

The major drawbacks to press proofs are their cost and the time it takes to produce a proof. The cost of a four-color sheetfed press can be very high and is in no way offset by the inexpensive paper and ink that are used to produce the proof.

**Overlay Proofs**

**Overlay** proofs, or *multilayer* proofs, are made by directly exposing the color separation films to individual transparent colored films. Each colored film is registered to the others and backed by a sheet of white paper. The resulting proof is viewed by reflected light.

The color of the overlay material is preestablished by the manufacturer. The colors closely match most commercially available process inks.

An overlay prepress proof

These proofs have several advantages. They don't require any special equipment to make them other than that normally found in a plant's platemaking department. They are also quick to make; 15–20 minutes are all that is required. Their major advantage possibly is that, if necessary, one of the four individual layers could be remade without remaking the others. This condition could arise if a dot etcher retouches one film and wants to see the effect of the change. The old and new films can be alternatively flapped over the other colors in order to judge the effect of the change. Not surprisingly, one of the major uses of overlay films is for internal checking of color separations and color image assembly.

The major drawback to using overlay films is their difference in feel and appearance to the printed result. The surface finish

is high gloss, the overlap colors are often quite different from press results, and the dot gain is much less. This dot gain, however, is perceived as being much higher than it actually is because of the major appearance characteristic of overlay films; that is, the interimage light scatter between the four transparent films darkens the lighter tones of the proof.

Experienced users of overlay proof materials are adept at "reading" the proof; that is, they are able to make mental transformations on how they expect the job to appear when it is actually printed. Overlay proofs should not normally be submitted to those who are novices at buying or judging color printing.

**Transfer, or Surprint, Proofs**

The **transfer,** or *surprint,* proof is a development of the overlay proof technology. Like overlay proofs, transfer proofs often consist of photosensitive transparent colored films. Unlike the overlay films, these materials have a release layer between the colored layer and the clear base. The color images are sequentially transferred to a white base material during the processing stage. In one process, a sticky, clear image is transferred to the base. The color is obtained by wiping toners across the sticky image. The advantage with this latter process is that it can be customized to the printing ink color by blending toners and by varying the number of wipe strokes until the correct hue and density have been achieved.

In some cases, the base support for this kind of proof can be the same substrate that will be used for the press run. Another advantage is that the feel and look of this kind of proof is much closer to the printed image than overlay proofs. The darkening of highlights is virtually eliminated. Also, a reasonable simulation of press dot gain can be achieved by laminating a clear spacer sheet to the substrate before laminating the actual images. A key advantage of transfer and overlay proofs is their consistency. Exposure is the major variable; therefore, if good vacuum is obtained and light time and intensity are controlled, consistency is almost assured. The toner application system for some transfer proofs can be applied by machine, thus rendering this process more consistent.

The disadvantages with the transfer proofs include the rather lengthy time (about 30 min.) to make the proof, the cost of laminating and toning machines, and in some cases, the unrealistically high gloss of the proof. Using a matte finish final lamination on the proof overcomes the high-gloss problem.

Laminating one of the layers to a transfer or surprint prepress proof

The cost of materials used for transfer proofing, like those used for overlay proofing, tends to be high. Another disadvantage for some systems is that a white plastic material must be used as the base support. A final drawback is that these materials cannot simulate four-color press trapping.

In general, transfer proofs offer a reasonable alternative to press proofs. If they are made with the proper colorants, substrate, dot gain simulation, and surface finish, they are fair guides for the printer and the customer to judge the expected appearance of the future printed sheet. Their relatively low cost and high levels of consistency will continue to convince more and more people that these proofs are sensible alternatives to press proofs. Unusual or extreme printing conditions, however, will continue to require the flexibility afforded by press proofing.

**Electronic Proofs**    **Electronic** proofs are sometimes called *soft* proofs. They exist as images on color video monitors. These images can be generated from completed color separation films or directly from the stored digital image of the original. They are called soft because they do not exist as a tangible object like all the other kinds of proof. Other proofs can be referred to as *hard* proofs. Electronic proofs are also referred to as *real time* proofs

because they can be formed almost at the same instant that the original image is scanned.

Electronic proofing devices exist either as a stand-alone unit—the video display of a scanner—or as the display terminal of a color page makeup system . These display a color image that simulates the final printed sheet from the perspective of color. Obviously, the image quality and the surface characteristics cannot be displayed. Also, it is doubtful that this kind of image would ever be acceptable as a legal contract.

The image on the video display of the Hell Chromacom page makeup system

The major advantages and disadvantages of this kind of proof are very distinct. On the advantage side, the ability to generate a color display before separations are exposed is significant. This ability to modify the proof interactively as an aid to color correction, tone reproduction, and retouching has untold implications for operator selection, film usage, and separation costs. Most intriguing of all, the process poses the question of whether color separation trade houses, printers, or even publishers, advertising agencies, or other buyers of print actually will be the future producers of color separations. The key disadvantages of electronic color proofing concern the nature of a soft proof image and the high cost of the equipment.

Although the electronic proof is unsurpassed as a color separation production aid, it is system dependent, not permanent, and not portable. An unresolved problem of this kind of image is that it is formed by transmitted light and displayed under ill-defined room light conditions. Electronic proofs are formed by the additive process, whereas the printed image is subtractive. Therefore, it is difficult to adjust the lighting for the satisfactory comparison of both images. The growth and success of electronic color imaging systems, however, will ensure that electronic color proofing will be a common color imaging method in the future.

**Digital Image Proofs**

**Digital image** proofs also can be referred to as *photographic* proofs. They are generated from an electronic database onto photographic color print material. These proofs represent an optional hard-copy output that can be obtained from an electronic imaging system.

The major advantage of the digital proof is its color accuracy. From the digital database, it is possible to form an image that, when exposed onto color print material, simulates the printed sheet. In other words, two images are ultimately generated from the database. One is for the films used to make the plates, and the other is for making the proof that simulates the printed image produced from the films.

It is feasible to program the proof recording unit to simulate the dot gain, trapping, and paper and ink color of the final print. This method generates a high-resolution continuous-tone image in place of halftone dot values. It is not necessary to see the actual halftone dots in the proof as long as the tone that is produced accurately simulates what the halftone image will look like. The image quality and the surface effects of this kind of proof will not be the same as actual ink on paper, but the color accuracy probably outweighs these drawbacks.

The photographic imaging material used in these systems can range from instant color print material to conventional color print emulsions to the new electrophotography and toner systems. The image is exposed at high speed through red, green, and blue filters. The time required to make one of these proofs can be as low as 12–15 min. Digital image proofs can be made to simulate any printing process.

The disadvantages with digital image proofing, apart from those discussed earlier, include the high cost of the proof recording unit and the relatively small proof size that is available.

It is difficult to evaluate digital image proofing, or electronic proofing for that matter, without also considering the color separation and image assembly processes. The major decision is not whether digital proofing and electronic proofing are useful proofing systems, but rather, whether electronic imaging and assembly systems are justifiable investments. Electronic and digital proofs should almost be considered as accessories to what will probably prove to be the dominant graphic imaging technology of the future.

A digital hard-copy proof
*Courtesy HELL Graphic Systems*

## Matching the Proof to the Press Sheet

In Chapter 4 the results of GATF color surveys are presented. These studies make it obvious that different printing companies use different inks, substrates, and printing techniques. Given that the purpose of a proof is to simulate printing production conditions, we now need to know how to evaluate the available proofing systems so that they may be either selected or adapted to suit the printing conditions of a given plant. In other cases, such as where standards exist for a particular type of printed product, we need to know how to match that standard with the proofing system or systems that are available. The key to this problem is the development of appropriate analytical techniques and control devices or images.

## Analytical Techniques for Proofing

The first step in selecting or adapting a proofing system to match production printing is to select press sheets that represent normal production conditions. Chapter 8 discusses the selection of representative sheets for systems programming

purposes. These are the same sheets that must also be used for proof matching.

The representative press sheet should contain some standardized test images. These images facilitate the analysis needed to characterize the system. A color bar with solids and overlaps provides solid-area color data, while an analysis of the dot gain characteristics of the system gives the most important data. The best image for gathering this information is the GATF Halftone Gray Wedge that is described in Chapters 8 and 10. Alternatively, one image that gathers data on the color solids and abridged halftone information is the GATF Color Reproduction Guide.

Of course, the key objective in matching proof to press is that the images of the job match each other. Because a process-color reproduction is almost completely made up of halftone dots, it is imperative to match the dot gain characteristics of the printed sheet. The other important but related point is that the colors in the picture must match as closely as possible. An analysis of most pictures reveals that the majority of *picture colors* are the reds, greens, and blues. Therefore, the important color matches are strongly influenced by the color of the overlap colors in process-color printing. Consequently, it is more important that the red, green, and blue overlaps on proof and press sheet match each other than do the solids of the primary yellow, magenta, and cyan colors.

The proofs that can be made from a digital database, the electronic and photographic types, can be excluded from this discussion. They can be individually programmed to match virtually any printing condition. The major area of interest is the matching of press proofs, overlay proofs, and transfer proofs to the production printed sheet. The analysis of this process can be grouped under the headings of *overlap solids* and *dot gain in halftone tints*.

**Overlap solids.** The objective for the solid colors is to create matches of the red, green, and blue solids at the expense of the yellow, magenta, and cyan solids. The desired solid colors are characterized ideally by colorimetric measurements. In the absence of a colorimeter, a densitometer may be used. The three-filter densitometer readings are plotted on a GATF Color Hexagon.

The color of the proof overlaps may be shifted by a variety of techniques. For press proofs, the densities of the individual primary colors may be varied. For example, the color of an

overprint green may be made yellower by increasing the yellow ink feed. Trapping may also be varied by ink film thickness adjustments, ink tack adjustments, and press speed. The color sequence influences the overprint, with the resulting color showing a shift towards the color of the last-down ink. The selection of the process-ink pigments also influences the overprint color.

In the case of transfer and overlay proofs, color sequence and the initial colorant selection are the only methods of influencing the overprint colors. Because many manufacturers have a reasonable variety of proof colors available, a wide range of overprints is possible. The light absorption properties of the primary colorants and their opacities are the key variables in determining the overprint colors.

The proof overlap colors that are possible from the available systems are also measured through the three filters of a densitometer. The objective is to discover a combination that will produce equal three-color densitometer readings for each of the three overlap colors between the proof system and the press sheet. Densitometric data may be plotted on the Color Hexagon or other color diagrams in order to provide a graphical comparison of the systems.

**Dot gain.** The objective for proofing dot gain is to simulate press dot gain visually. This doesn't mean that the proof must be physically the same; it should just look the same. That is, a proof may use a combination of optical and physical gain to match the optical and physical gain of the press sheet. Overlay proofs, for example, have very little physical dot gain but have quite considerable optical gain. The reverse tends to be true for press sheets, especially those printed on coated paper.

For press proofs, a variety of techniques may be used to manipulate dot gain. One of the most effective is to use inks that have low pigment concentrations. To achieve the required solid density, it is necessary to print a high ink film thickness, which in turn causes higher levels of dot gain. This technique does have drawbacks; namely, setoff and drying problems, scuffing and marking, possible trapping problems, higher gloss, and, for lithography, possible ink-water balance problems. The other major gain alteration technique is the printing pressure. Increasing pressure increases gain. This can be done by using extra cylinder packing, moving bearerless cylinders closer together, or, for offset printing, using rubber blankets that tend to distort the dot.

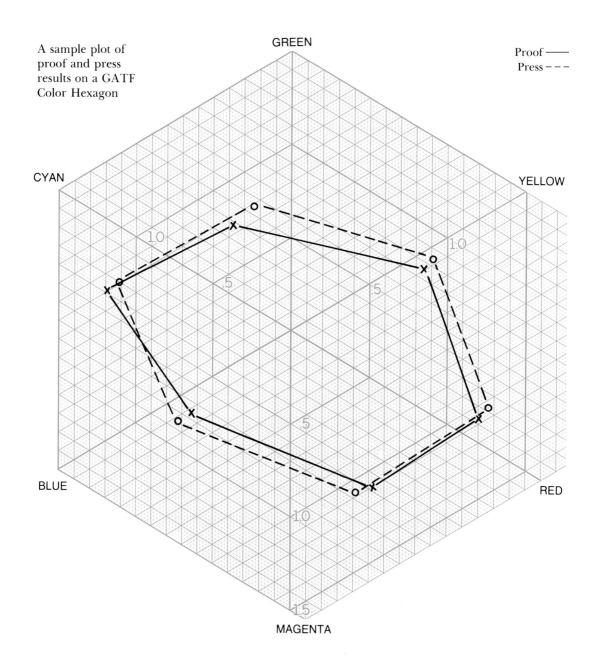

A sample plot of
proof and press
results on a GATF
Color Hexagon

Proof ———
Press – – –

For overlay and transfer proofs, physical dot gain can be influenced by either exposure or spacer sheets. For negative-working proof materials, overexposure produces dot gain. For positive-working proof materials, overexposure produces dot loss. These same effects may be observed if a spacer sheet or sheets are placed between the proofing material and the negative or positive when giving a normal exposure time.

Spacer sheets also may be used to enhance optical dot gain. The overlay proof, through its series of four transparent layers, has a built-in optical gain effect. This effect may be modified by the position of individual films within the stack. The opacity of the colors will also exert a strong effect if the film order is changed from what the manufacturer recommends. Therefore, this practice is not recommended as a standard procedure. Some transfer proofs use a clear laminate over the base as a support for the colored images. The subsequent separation between the surface of the base and the colored halftone images produces an optical gain.

Dot gain can be measured by making a series of density measurements of the proof tone scale and the printed tone scale. These density measurements may be used in the Murray-Davies equation to compute overall dot gain. Alternatively, a simple side-by-side comparison of the proof and print densities is perfectly satisfactory. The objective is to get the tonal densities of proof and print as close to each other as possible. This is a reasonable goal for press proofs, but for overlay and transfer proofs, the highlight and lighter tones will be darker than the print because of the interimage light loss.

The final aspect of proof and print match that can, to some degree, be controlled is the surface appearance, specifically the gloss. Some transfer-type proofs were available only with a very high-gloss finish. This type of surface reduced the first-surface light scatter and consequently improved the saturation and density of the colors in the proof. Many of these proofs proved to be unmatchable. The manufacturers responded by marketing matte finish sheets that could be laminated to the top of the finished proof. Therefore, the finish of the transfer proofs should be selected to correspond with the finish of the final print. Press proofs can be varnished if necessary, but overlay proofs are available only in a glossy finish.

The overlap solids and the dot gain characteristics of proofs are sometimes difficult to achieve in the same proof. The adjustments described above should be manipulated until the

overall appearance of the proof seems to be the best possible compromise match to the press sheet.

**Specifications for Proofing**

In order to reduce the problems of advertising reproduction in publications printing, it is necessary to establish industry-wide specifications for the proofing of advertising pages. A series of specifications have been established to serve this goal. Some are: SWOP, Specifications for Web Offset Publications; EUROSWOP, the European version of SWOP; SNAP, Specifications for Nonheatset Advertising Printing; and the Gravure Technical Association (GTA) Series I and V Specifications. GTA Group VI inks have recently been introduced for offset/gravure conversions.

All of these specifications seek the standardization of the inks and paper that are used for proofing advertising work for a particular publication printing method. The rationale is that if the proofs are all produced to the same specifications, then they should all reproduce equally well when printed. In the absence of specifications, some pages may reproduce well while others may be quite unsatisfactory. Apart from common inks and substrates, the other factors that should be specified include screen ruling, proof densities, color sequence, dot gain, undercolor removal, color bar, viewing conditions, and various miscellaneous items such as register marks and lettering specifications. These specifications are periodically updated by committees that represent the interests of those involved in advertising reproduction. An appendix includes the names and addresses of the various standards-issuing organizations. They should be contacted directly for the most current copies of their specifications.

Proofing for advertising is a special case. The average printed job does not require the printing of separations from as many as fifty or sixty companies. However, there are occasions—for example, catalog or book production—when a printer must have color separations produced by more than one company. To ensure that the films from these companies are compatible, the printer should supply sample press sheets that contain a normal color bar image. The separators should use (if press proofs are specified) the same ink and paper for proofing their separations. The objective is to match the printer's color bar characteristics.

Any attempt to standardize the proofing conditions across the entire printing industry are certain to fail. The range of

printed products is great and requires the use of an unconstrained range of substrates and inks. The creative constraints imposed by standardized conditions are only justifiable to solve problems like that of advertising reproduction in periodicals.

**The Impossible Proof**

On occasion, a printer may receive a press proof that proves impossible to match. There are some legitimate and understandable reasons why it may be difficult to match the proof. Apart from the obvious reasons of using different papers and inks from those used to make the proof, there are other explanations for this difficulty.

The type of plate used for the proof can contribute to the problem of the impossible proof. If, for example, the proof was made from a positive-working plate and the print is made from a negative-working plate, there can be as much as 5% or 6% difference in the midtone values on the plates.

Another common problem occurs when the films used to make the proof plate are different from those used to make the press plate. It is not an unusual situation when a color separator has to supply ten or twelve duplicate sets of advertising separations to printers all around the country. The way to overcome the problem of matching the proof is to make sure that the same generation of film is used for the proof as for the printed image. That is, the *final* color separation films should not be used to make the proof plate. Rather, *duplicates* of these films should be used to make the plates. After proof approval, the final films should be used to generate more duplicates that are in turn distributed to the printers.

A final problem for printers concerns corrections that have been marked on the original proof. Rather than reproof the job, a duplicate of the original proof and the corrected separation films may be submitted. If the printer was not informed that the proofs are not really supposed to match the final printed image, then a lot of wasted time and energy will be spent in trying to achieve a match.

Whenever possible, a printer should insist that color bars be included on the proof sheet. This provision makes it relatively easy to check the proof for ink color, density, dot gain, trapping, and other problems.

Some printers, on receiving suspect separations, will reproof the job on a transfer-type proofing system. Some use electronic proofing systems to enable rapid checking of incoming separation films.

Apart from the legitimate problems outlined above, which are caused mainly by a lack of communication, the printer may occasionally encounter the **dishonest** proof. This is a proof that has been "doctored" by persons whose only interest is selling separations and proofs without any concern for the problems the printer may encounter. There are several techniques that can be used to produce suspect proofs. The best way of detecting this type of proof is through the careful examination of proofs of the individual colors. The use of a high-powered microscope to inspect the image and the insistence on the use of color bars also can help to detect or deter the dishonest proof. A reflection densitometer is another useful device for the objective characterization of the proof.

## Selecting a Proofing System

There is no proofing system that is perfect for everyone. A company may use two or more systems in order to satisfy the many demands expressed in the need for proof images. Listed below are important selection criteria.

### Consistency

Consistency is probably the single most important feature of a proofing system. The need to be able to make proofs that have the same properties day after day is the reason many people prefer overlay or transfer proofs over press proofs.

### Accuracy

The requirement for accuracy also rates very high. A proofing system that is incapable of providing a reasonably close simulation of the printing conditions is not very useful.

### Cost

The cost of materials, the time taken to make the proof, and the investment in the proofing equipment must all be considered. Press proofs require expensive equipment; however, this may be partially offset if a large number of jobs can be ganged on the same plates.

### Speed

The time required to make a transfer proof may be almost 30 min. This is considerably longer than the time needed to expose and process a set of scanned separations. If the proof is being made to check the scanned films, then a lot of expensive scanner time will be spent waiting for the proof to be produced.

### Customer Acceptability

Some customers, especially advertising agencies, insist on progressive press proofs. Other customers refuse to accept overlay proofs.

**Familiarity**

Some people prefer a given type of proof (usually overlay or transfer) because they know how to read the proof. That is, after years of use they are adept at mentally adjusting the proof image to the ultimate printed image.

Proofing, more than most other stages of color reproduction, requires the blend of technical, financial, and psychological or human factors into the selection of a given system.

**Summary**

The color proof represents the major crossroads in color reproduction. It is here that the customer, color separator, and printer are drawn together to make judgments on the desired and expected appearance of the job. The proof is the major communications tool available to help make these judgments and decisions.

In order to be legitimate, the proof must be a reasonable simulation of the appearance of the final printed job. The conditions for "perfect" proofing are almost never realized in practice. Therefore, proofs representing the final print with varying degrees of accuracy generally are used in place of an unattainable ideal. These proofs usually are quite satisfactory for color decision making.

The problem of failure to match the proof is largely one of communication. If the color separator is aware of the nature of the printer's press conditions, it is possible to make proofs that are very close to press results. To facilitate the matching process, test images must be incorporated into the layout of both proof and press sheets. The test images represent a standard from job to job, therefore making it rather easy to spot the proof that is not compatible.

The selection of a proofing system or systems is mainly a technical decision, but the financial and human factors also must be kept in mind. Above all, a proofing system must be capable of producing consistent results.

In the future, the proof is more likely to be an integral part of the color separation process, rather than a distinct process. Electronic color separation, image assembly, and proofing seem to be gaining considerable popularity. The real-time proof is now a reality. The role of proofing is changing from an after-the-fact method of checking color separation quality to the means of facilitating direct human interaction with the color separation equipment.

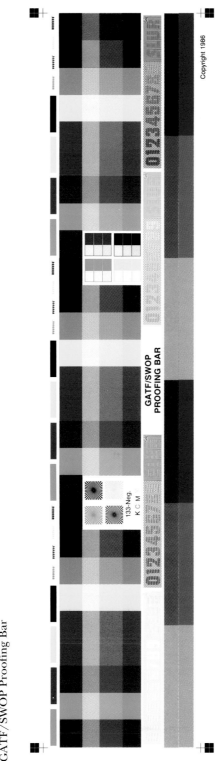

GATF/SWOP Proofing Bar

# 12  Color Communication

Color is one of the most difficult physical phenomena to specify, describe, or purchase. One reason for this is technical—that is, the object and the light source—but the major causes are human—physiological and psychological. The color communication problem becomes more difficult when pictorial color images are the object in question. Realistic color, as opposed to functional color, then becomes the issue.

The bulk of this book deals with what can be described as the technical aspects of color: the printed image and the light source. While Chapter 2 explores the physiological aspects of color, this chapter focuses on the psychological factors of color as they apply to color communication problems in printing.

Color communication can be accomplished, to some degree, through the use of numbers, a physical sample, or words. Specifications forms, charts, color atlases, symbols, nonverbal behavior, and perhaps other unknown methods are also used to help transfer color information from one person to another. To some degree, this process will always remain somewhat mysterious; but in order to solve many of the color problems in the printing industry, it is necessary to bring some sense of order to the color communication system.

## Networks

A color reproduction system typically employs two color communication networks. One involves creative process decision making, while the other concerns the documentation of ultimate manufacturing conditions. The two overlap to some degree when the print buyer has to make the initial decision concerning production materials and processes that suit the cost constraints, while still affording sufficient creative flexibility and print quality.

## The Creative Process Network

In many cases, the ideal design for a given color reproduction is subject to constant modification and refinement throughout the color reproduction process. This happens because an infinite variety of original subjects has to be reproduced by a potentially large number of printing systems. Under these conditions, it is very difficult to visualize the printed reproduction. Therefore, frequent communication about color is necessary at almost all stages of the manufacturing system. Creative decisions concerning color are made at almost all of these stages.

• **Originator of the concept.** An art director, for example, may conceive a certain color relationship designed to satisfy the end-use requirements. In some cases, this individual will make all

color approvals at each stage of the color reproduction communication process. In other cases, two or more people will make these decisions.

- **Artist or photographer.** The original concept is translated into the first tangible image by an artist or photographer. The appearance of the concept is based on the verbal comments of the art director together with the opinions of the creator of this first color image. The characteristics of the films and art materials used, as well as other factors, strongly influence the appearance.
- **Color preparation.** Apart from the mechanical transformations that are possible at this stage, color can be modified through photographic and manual techniques. Color decisions usually are made in conjunction with the art director.
- **Color separation.** A camera or scanner operator makes color decisions based on the original and the type of printing system through which the job will pass.
- **Color retouching.** A dot etcher or retoucher modifies films or plates—either manually or electronically—to refine decisions made in color separation and to make corrections not possible by other methods. A color proof (or proofs) usually is employed at this stage as a guide for subsequent corrections. Usually the art director or sometimes the color retoucher makes the decisions regarding these corrections.
- **Color printing.** The objective at this stage of the process is, in many cases, to *match the proof;* hence, this color decision is theoretically a color-matching decision. There are times, also, when on-press decisions affecting the existing appearance of the job are deliberately made. The final printed sheets are then evaluated by the customer, who may or may not be the same person who originated the concept of the job. Subsequently, the product is evaluated, unconsciously or consciously, by the ultimate consumers—the public.

The steps for creative decision making are diagrammed in the accompanying illustration. The key decision image is usually the color proof. This image, which is made from the separation films, should incorporate both the customer requirements concerning the original and the feedback information from the press. The proof is the prototype for the mass-produced printing job. Consequently, the prototype will be refined to the point where it represents the ultimate quality within the qualities of the raw materials and printing process and the constraints of time and cost.

Creative factor color
communication
system

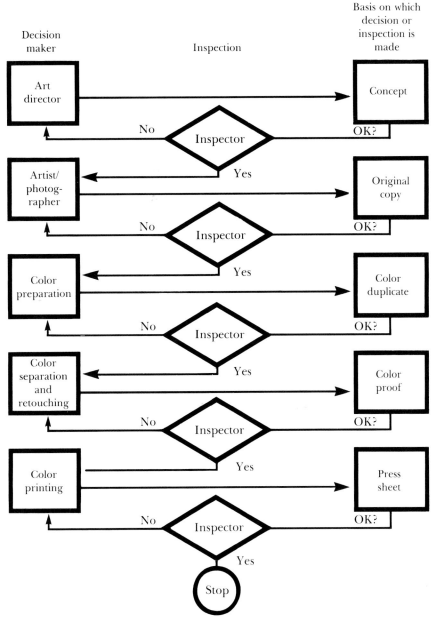

**Inspector.** This person may be the one making the immediate color decision, or anyone else at a previous step of the process, back to and including the customer originally requesting the job.

**Basis for decisions and inpections.** Some of the elements, such as color duplicates or color proofs, may not exist in some systems. Conversely, more elements, such as additional proofs, may be used in other systems.

**Communication example.** Referring to the diagram, a color duplicate is approved by the inspector—e.g., the art director. The duplicate (decision input) is then submitted for color separation. Films and plates are produced and retouched as necessary before producing the proof (decision output), which represents the decisions made in color separation and retouching. The proof is then sent to an inspector (e.g., the art director) for approval. If it is not approved, the proofs are returned to the color separation/retouching step for the production of new films and/or plates and, consequently, a new proof for submission to the inspector. If the proof is approved, the job passes to the color printing stage.

**The Manufacturing Conditions Network**

The information that is required from the manufacturing system is more objective and easier to characterize than the requirements for the creative decisions. Basically, information about the kind of original, the customer's objectives, and the printing conditions must all be supplied to the color separation system so that it is possible to produce color separation films that will satisfy these requirements.

Manufacturing system

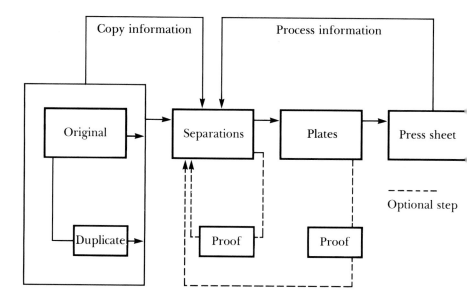

Because the proof images are intended for use in making creative judgments about the color reproduction, they are not really a part of the manufacturing conditions network. The individual stages of this system are detailed below:

● **Original copy.** This can take the form of an artist's impression or a photographic reproduction. The original takes many forms with respect to color, texture, gloss, and resolution. It may or may not represent the "ideal" of the concept on which it was based. Information concerning items such as the color film brand name and the objectives of the customer ("the highlight detail is the most important aspect of this job") must be conveyed from this stage to the color separation stage.

● **Intermediate original.** Color-duplicating techniques are sometimes used in the color reproduction system. They are used either to facilitate the subsequent manufacturing steps (i.e., scale to common focus or convert reflective originals to transparent) or to correct defects in the original copy (i.e., to correct color balance or to make use of color-retouching techniques).

● **Color separation.** This is accomplished through a series of steps that includes masking, color separation, halftone screening, and contacting techniques. Either electronic scanning or photographic procedures may be used to achieve these films. Also, hand retouching of the films can be employed at this stage. Color separation is the flexible pivot point in the color reproduction process. The information collected at this stage is incorporated into the color separation films.

● **Platemaking.** The film images are converted into a printing surface composed of image and nonimage areas. In letterpress and gravure, additional *color etching* is possible at this stage where the image is mechanically or chemically modified.

● **Proofing.** This is an optional step where the inked image on the plate is transferred to a substrate to predict the final appearance of the production run. In some cases a prepress proof is made from the separation films as an intermediate guide to color appearance.

● **Printing.** The inked image is transferred to the appropriate substrate using a particular printing press and process. Information concerning the production printing conditions should be fed back to the color separation stage, ideally by the use of a feedback control chart such as the Foss Color Order System.

The creative process network and the manufacturing conditions network are linked to each other by two communication channels.

**Technical factors communication.** Technical factors communication concerns the communication of the capabilities and requirements of the manufacturing system to those who are the ultimate decision makers (customers). Such communication conveys an appreciation of the techno-economic factors that constrain the creative process.

**Aesthetic factors communication.** Aesthetic factors communication concerns the communication of the aesthetic factors or the creative decisions from people such as art directors or designers to the people in the manufacturing system. The objective is to express the creative objectives in such a way that the persons in manufacturing, particularly color separation and correction, can convert these objectives into tangible form.

The accompanying illustration shows this general two-way model for Technical-Aesthetic communication. The noise in the

illustration represents barriers to communication that are
discussed in more detail later in this chapter.

Technical-Aesthetic
communication
model

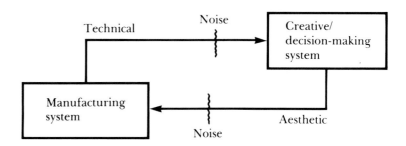

To summarize, the manufacturing conditions network is used
to supply information to the color separation stage in order to
produce films that are compatible with the original and
printing requirements. Printed test images or data collection
forms may be used for this purpose.

The creative process network is used to help refine the initial
creative decisions. In most cases, it is not possible to make just
one creative decision at the start of the process. Each stage of
the manufacturing process offers some creative possibilities;
therefore, creative decisions can be made at each stage.
Tangible color images, such as photographs or proofs, must be
used as guides for these decisions. The objective now becomes
the communication of these color decisions to persons in the
manufacturing system.

## Objective Aspects of Communication

There are certain barriers to color communication that can be
defined as objective factors. That is, they are physical, tangible,
or undebatable. If these factors can be identified as problems in
a given situation, then they can be swiftly solved. The color
communication factors that can be classified as objective are
listed below.

### Light Source

The matter of light source is discussed in earlier chapters. If
the original and the reproduction are illuminated by different
light sources and then compared with each other, the resulting
comparison will be invalid from the viewpoint of industry
standards. The recommended 5,000 K color temperature
source should be used for illuminating both the original and
the reproduction.

Another related problem is the situation where two colors (or
an original and a reproduction) match under one illuminant
but not under another. This problem of metameric match also

can be solved by ensuring that standard illumination is used when making color judgments.

**Proof or Other Color Reference**

Sometimes, where multiple proofs of the same image exist, it is possible to mix them up and unknowingly try to match the wrong one. Proofings should be clearly marked as *first proof, second proof,* etc. In addition, a rubber OK stamp with provisions for signatures and dates of approval helps to identify the correct proof or makeready sheet.

Color originals also can be confused. If more than one image or object is submitted for reproduction, each should be clearly marked for correct color reference. This problem sometimes occurs when an original and a duplicate transparency are submitted. Also, an original photograph and a merchandise sample can cause potential confusion.

The major problems of color communication due to differences in the physical object are encountered when using color charts or other similar color guides. A designer may select a color from a printed color chart and then transcribe the corresponding percentage dot values onto the layout. Image assembly personnel may lay the correct screen values, but the printed color may not appear the same as that selected by the designer. *Printed color charts are not universal color references.* They should be used *only* if they were produced under conditions similar to those that will be used for the printed job. Solid-color ink guides such as the Pantone books also can cause color communication problems if they are old, damaged, or faded. Ink guide books should be replaced on a regular basis.

Standard reference systems such as Munsell can be used for color specification, but care must be taken to ensure that the color will lie within the available printed color gamut and that the sample is identified as gloss or matte.

A final concern about communication problems caused by the proof or press sheet is that the inks and substrate are actually those specified for the job. Drawdown or similar tests should be conducted if there is any suspicion that these materials do not meet specifications.

**Anomalous Color Vision**

As may well be imagined, color communication between people who have markedly different color vision is likely to be difficult. The major problem arises when the person is unaware of having anomalous color vision. Indeed, it is possible for someone to go through life without realizing that his or her

color vision is not the same as that of most of the population. It is unlikely that anyone in the printing industry would not know of an existing color vision defect. However, it is possible that corporate buyers who purchase only a few printing jobs a year may be unaware of any color vision anomalies they may have.

Unfortunately, it is usually not possible to administer a color vision test to a customer, but proof markup behavior can sometimes provide clues. Confusion between light green, orange, turquoise, and pink colors often indicates anomalous color vision.

Color separators and printers should administer color vision tests to their production, sales, and other personnel who are likely to make color judgments or be involved in color communication. Persons found to have anomalous color vision should be restricted in terms of the color decisions they are allowed to make.

**Surround and Environmental Effects**

The discussion on lighting conditions in Chapter 2 points out the importance of excluding extraneous light and reflections from the viewing area. Walls and ceilings should be a flat neutral gray, and other strongly colored objects should be kept clear of areas where color judgments are being made.

The immediate surround of a given color in a picture influences the perception of that color. Therefore, the practice of using gray cards with holes punched in them to "spot" colors on a color chart for comparison with colors in the original may give false correlations if the color in the original is surrounded by high saturation colors. This effect becomes particularly noticeable when the surround color has a large area by comparison with the surrounded color. The white surround on a pictorial original is also important. The size of this surround influences the perceived contrast of the original, particularly if the original is a transparency. The effect of the picture surrounds should be equal on the original and the reproduction.

**Subjective Aspects of Communication**

The objective aspects of color communication are those that can be explained by logical analysis. Once the source of the problem has been discovered, it can be rectified. The subjective aspects of color communication, by contrast, do not have a strong scientific foundation. They are more emotional than rational and therefore are more difficult to identify and correct.

**Personality Factors**

The insistence that a particular color be reproduced at a stated level of precision varies from person to person. For some, it is enough that the color is in the general area of the specifications. For others, nothing less than absolute precision will do. This varying tolerance for inaccuracy exists in other fields of human endeavor. In the use of language, for example, some people insist on searching for the exact word or phrase for a particular circumstance, while others use more familiar words, or even slang expressions, to convey their thoughts on the same matter.

The reasons for these differences between people are not clear. They appear to be influenced by age, gender, education, social class, nationality, and other more or less objective factors. Still other factors have to do with the personality of the individual. Carl Jung classifies psychological functions as intuition, sensation, thinking, and feeling. These functions interact with two attitudes, introversion and extroversion, to form the dynamics of personality. Presumably, all possible personality types are involved, somewhere, in the business of buying, selling, or producing color printing. The interactions between these types have little to do with color per se; rather, they are expressions of different ways of looking at the world.

Some insight into the ways that individual perception differs may be gleaned from the black-and-white tone reproduction research of Jorgensen (Chapter 8). His findings include:

● Individual perception of quality varies, but for high-quality reproductions and low-quality reproductions, there tends to be good agreement among observers.

● If the same person evaluates a given reproduction at different times, the rating or evaluation will be different. This variation will not be large for high- and low-quality reproductions.

● To some degree, the evaluation of the reproduction depends on the observer's bias for or against the subject matter of the photograph.

It is not known whether these findings also apply to color reproductions, but it is probably reasonable to assume that they do. For example, several persons watching a color television often disagree on the exact setting for the color and tint controls, particularly for favorite programs.

**Verbal Communication**

The verbal communication of color information entails both the initial specification of color and the desired appearance of color.

For color specification, terms such as sky blue, Mandarin red, eggshell green, electric blue, crimson, buff, and Lincoln green are sometimes used. Many of these names will change over time as the color consultants decide that a new name for an old color will help increase sales for the product in question. Unfortunately, in the absence of a reference color, these terms will not mean the same to everyone.

A more common use of verbal descriptors for color is in the process of proof markup. The markups specify the color changes that are required by the print buyer and may consist of terms such as brighter, glossier, redder reds; cooler; more metallic; more luminosity; too dull; too muddy; and the more exotic phrases—"Make the reds talk to me," "Flesh needs weight and color," "It's got to be livelier," "I want more drama in this color," and "Make it sing." Again, the use of words to convey information about color does not seem to be particularly satisfactory.

**Other Forms of Communication**

Proof markup doesn't rely entirely on words. Sometimes numbers are used to indicate color changes. For example, "+10% yellow" usually means that an extra 10% yellow should be added to the area in question, rather than 10% of the tone value. That is, a 50% tone should be increased to 60%, not 55%. This terminology is not only ambiguous but also may result in the incorrect color. To specify color by percentage dot value requires either the use of a color chart or many years of color experience.

Sometimes symbols are used on proofs to indicate the desired changes. Attempts have been made to create a universal set of *proofreaders' marks* for color as a kind of verbal shorthand. Informal symbols such as arrows or circles also are used to identify direction of change (up or down) or the area that needs to be changed. Symbol meaning needs to be standardized and understood before universal usage is likely.

Nonverbal (or symbol) communications sometimes convey an overall impression about the proof. Even so, it is unlikely that this method of communication will convey any particular information about a given color.

**Buying Color**

Color communication is the key to "buying color" in the printing industry. The customer buys color photographs, artwork, proofs, and printing. The printer buys ink, paper, and sometimes color separations and proofs. The key to each of these transactions is the ability to specify the exact color that is

required. The communication technique that should be used depends on what is being purchased.

**Color Communication Techniques**

A measuring instrument affords the most objective method of color specification and communication. Spectrophotometers, colorimeters, densitometers, and glossmeters all can be used to quantify color and appearance.

Spectrophotometers find their primary application in the measurement of ink and pigment colors. Ink manufacturers use these instruments to assist with color mixing, color matching, and pigment evaluation. Matching spectro-photometric curves is the ultimate form of color matching.

Colorimeters are used for the color measurement of paper, ink, and printing. The printing uses have been largely confined to packaging, particularly large solid color control; most colorimeters required a relatively large sample because their viewing ports ranged from ½ in. (13 mm) to 1½ in. (38 mm) in diameter. Some colorimeters now can measure areas as small as ¼ in. (6 mm) in diameter. Some experimental work has been done concerning the use of colorimeters in measuring small spot halftone colors on press sheets. This method shows promise as a future color control system.

Densitometers are normally used to measure originals, proofs, and printed sheets. Measuring originals helps in the programming of color separation equipment. Proofs and printed sheets are measured to ensure that they are within manufacturing tolerances. Density numbers are often com-municated between color separation and printing concerning proof specifications. The responses of the densitometers must be the same for this communication to be successful. To facilitate proof density standardization, a central source issues publication industry density specifications for proofs.

Physical samples are an extremely important method of color communication. Indeed, for color selection, nothing can replace a selection of samples. Special solid ink colors are routinely selected from references such as the Pantone System. A code number from this system has an unambiguous meaning to all other holders of the sample books. Color tints of process colors are also selected from printed color charts such as the Foss Color Order System. Color charts depend on the particular process inks and the printing conditions used to generate the chart. In other words, these charts are a precise tool for a given color system but are not a universal reference method. Permanent, standardized color order systems such as Munsell

or Ostwald may be used as a universal reference but are not based on the use of printing inks or processes.

Color change may be specified by using any of the systems outlined above. The most common form of color change concerns color adjustments on process-color proofs. Hence, the process color chart is the most effective communication technique to use for this purpose. The difficulty with many process-color charts is that they often don't precisely match the proofing conditions. One chart, designed to overcome this problem, was the Du Pont Color Communicator, a miniature color chart to be printed on every proof. The desired color in the proof could be indicated by reference to the color chart. The drawback with this system was the handling of the black printer. Black was not printed as part of the chart but existed as an overlay positive film.

Another excellent device for the specification of color is the GATF Color Communicator. This device consists of sliding wedges of yellow, magneta, cyan, and black. Each of these colors can be continuously varied from 0% to 100%. The only problem with this system is that the color scales are made from overlay color proofing material (Chapter 11) and therefore will not necessarily match the final printed image. Nevertheless, the device is unsurpassed in its ability to show quickly the effect of increasing or reducing the dot values of a given color.

The GATF Color Communicator

Sliding color scales are used to simulate the effect of reducing or increasing dot values of any of the process inks.

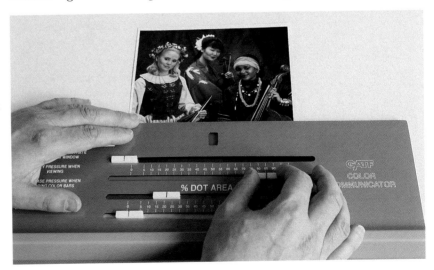

Verbal terminology is the most imprecise of the communication methods but, especially for color proof evaluation, is probably the most common method. The use of verbal terminology for the initial specification of color is

acceptable if one uses a color reference manual to identify the color in question. The Maerz and Paul *Dictionary of Color*, for example, lists about 3,800 color names that are each referenced to printed color patches.

The ISCC-NBS color name system described in Chapter 3 is also a satisfactory, but less precise, reference than Maerz and Paul. ISCC-NBS is more up to date; but broad, general colors are used as references, rather than the narrow, precise colors of Maerz and Paul. ISCC-NBS uses Munsell Colors as references in place of printed colors.

The ISCC-NBS method of verbal color description is very comprehensive. It probably could form the basis of a useful system for proof markup. Unfortunately, it is too complex for many people to master; therefore, use of its terms may result in misinterpretation. In place of a rich system like ISCC-NBS, it is suggested that a simple system be used when describing adjustments in proof color. The following terminology is reasonably unambiguous.

● **Hue.** When specifying hue shifts, use only four terms: bluer, greener, yellower, redder. For example, an orange that looks too much like a lemon needs a hue shift toward red (achieved by adding magenta, or reducing yellow).

● **Saturation.** Use two terms for saturation shifts: cleaner or grayer. For example, a gray-green that should be emerald green needs to be cleaner (achieved by removing the ink closest to the complementary of the color in question). In this case, magenta would be removed. The term **grayer** means making the color more like a neutral (gray, black, or white). **Cleaner** means making a color less like a neutral.

● **Lightness.** Use two terms for lightness shifts: lighter or darker. For example, a pale blue sky that does not provide sufficient contrast with the clouds needs to be made darker (achieved by increasing all the dot values in the sky, or by increasing black).

Color corrections often have to be made where it is necessary to move through at least two color space dimensions. For example, a blue sky may have to be made cleaner and darker (achieved by reducing yellow and increasing the other colors).

The use of symbols as a kind of verbal shorthand for proof corrections has its roots in the proofreader's symbols for the correction of text printing. One British publisher, the Hamlyn Group, developed a set of color correction symbols that they claimed helped simplify communication between color separators and printers in Europe. Where different languages

are involved, a set of symbols would seem to be quite useful. The use of international traffic signs is an example of the successful application of this concept.

The Hamlyn symbols for marking color adjustments on proofs

|   |   |
|---|---|
| 1. Reduce dot size ○ | 9. Too soft, sharpen △ |
| 2. Increase dot size ● | 10. Uneven tint ◑ |
| 3. Reduce ink density ▽ | 11. Make good broken line ✕ |
| 4. Increase ink density ▲ | 12. Improve register ⊡ |
| 5. Decrease contrast ☐ | 13. Correct slur ✗ |
| 6. Increase contrast ■ | 14. Passed for press ✓ |
| 7. Improve detail/modeling ☐■ | 15. Reproof △2 |
| 8. Too hard, soften ◡ | |

**Proof Markup**

The most crucial application of color communication techniques is the specification of color changes on a proof. This stage is the "fine tuning" aspect of color specification and represents the last opportunity to achieve the correct color before the printing begins.

The proof marking process can be divided into markups for color and other markups. As stated earlier, color marking ideally should be keyed to a printed color chart that matches the production conditions of the proof. In cases where a prepress proof—for example, a transfer proof—is used, the following strategy can be employed. Two color charts are made, one on press under the final production conditions, and the other on the transfer proof material. Next, the critical color area in the transfer proof of the job is located on the transfer proof color chart. The corresponding color patch in the printed color chart represents the final appearance of the critical color in the transfer proof. The desired color now can be selected from the printed chart, and the corresponding halftone dot values can be used to specify the correction on the proof.

The specification of percentage dots of the process colors should be done in conjunction with the appropriate printed

color chart. If a chart isn't available, the print buyer or judge should not act as an "amateur dot etcher" and try to guess what dot percentage changes are needed to correct a given color. There is a good chance that such judgments will be wrong in terms of the desired result. Also, if the specification is too precise, the retoucher may become overly dogmatic when carrying out corrections. The color dot etcher or retoucher has to make the final decision; therefore, it is advisable to allow this person the flexibility to exercise some judgment.

The color correction terminology referred to under "Communication Methods" should be used to indicate the general direction of desired color shifts.

These guidelines work well for specifying the direction of a change. Problems arise when trying to specify the amount of change. When using the dot percentage scale to specify lightness changes, we encounter the nonlinear response problem. That is, a 5% dot change at the 10% level is much more noticeable than a 5% change at the 90% level. A 5% dot size change near the 10% level is visually equivalent (approximately) to a 12% change near the 90% level.

Again, the best way of dealing with this problem is by use of a color chart. In the absence of such a guide, one is reduced to talking about *slight, moderate,* or *substantial* color shifts. These words mean different things to different people, but they are probably the best we can do. Thus, color proof markups would read something like this: "Make sky slightly cleaner and moderately darker," or, "Change skin to be slightly redder and moderately cleaner," or "make shadows substantially lighter and slightly dirtier."

Although the terms described here are open-ended, the degree of change that can be achieved is not. For example, a color that consists of solid yellow, magenta, cyan, and black cannot be made any darker, only lighter. A red consisting only of equal amounts of yellow and magenta cannot be made any cleaner, only dirtier. Because the hue dimension is circular, colors can be altered to any degree in this direction. The limits on saturation and lightness are fixed by the ink-paper-press characteristics.

In practice, matters are often more complex than outlined above. For example, reducing cyan in green has the main effect of shifting hue toward yellow but also results in a slight increase in saturation and a slight decrease in lightness.

In many cases a color correction may be specified that is impossible to achieve. For example, a red may bear the

correction "more saturation" but contain no cyan or black. The solid magenta and yellow overlap on the color bar represents a limiting value. This patch should be examined to see if this saturation value is high enough. If not, then the printing/proofing conditions will have to be altered. No change in the halftone dot values on the film can achieve the desired color.

The other aspects of proof markup include those for spots and patterns and those for image definition. Physical spots and patterns can be circled with the indication that the offending mark be removed. Image definition instructions are sometimes confusing. The markup "more detail" conceivably could refer to greater tonal separation, higher resolution, or more sharpness. The distinction between these qualities should be maintained in proof markup. Tonal separation can be adjusted, to some degree, in the retouching process, but resolution and sharpness cannot be changed by retouching or dot-etching. If the offending quality was caused by poor color separation work, the original will have to be reseparated. More often, sharpness and resolution disappointments are due to poor originals. Chapter 9 discusses the implications of enlarging unsharp and grainy originals too far or reducing fine line copy too far. These defects cannot be adjusted in the color separation or correction stages. New originals must be created if these problems are to be solved.

**The Psychology of Color Approval**

Proof markup is not merely a problem of how to communicate color in the most precise manner. The same proof can be marked up differently by different people and by the same person at different times. In other words, there is no one objective goal that will produce the "correct" result. Personality and other differences between individuals account for these inconsistencies. Some variability, therefore, is the norm. Given this fact, the question now becomes, "Who is right?" The normal answer is, "The customer is right." However, given that almost infinite variations are possible within color space, and that any two people probably will not agree on the preferred color for each area within the reproduction, the real question is,"What is reasonable?" The answer to this question is influenced by a number of situational factors.

Some of these situational factors might include the following differences between the print buyer and the sales representative: age, i.e., whether they are both young, both older, or different in age; sex, i.e., whether both are male, both female, or one is male and one female; relative social classes,

which include how they speak and dress; individual status or rank within their respective organizations; and years of experience in the areas of buying, selling, or producing color. The exact effects of the above factors are not known, but they probably do influence, to some degree, the sometimes emotional and occasionally irrational process of color approval.

The personality types of the buyer and seller may set the stage for a personal conflict where the proof becomes the battlefield. If personality differences cannot be kept separate from color judgments, one or both people may need to be reassigned. The personality type of the buyer influences the kind of proof markups that are made. The intuitive-feeling type may work in broad terms, whereas the sensing-thinking type may get very particular. The differences between the extrovert and the introvert are more likely to be ones of style than substance. The key balance is that between intuitive-feeling and sensing-thinking. (Intuitive-Feeling: "It doesn't do anything for me." Sensing-Thinking: "Increase the magenta exactly three percent.") Either extreme is not ideal for expressing proof corrections Comments that are too general don't give enough guidance, while those that are too specific may result in excessive retouching, which only produces the required color at the expense of the natural photographic effect of the picture.

Other factors that might play a role in the proof approval process include: the location where the inspection process occurs—in the buyer's company, the seller's company, or some third place; the time of day, in particular, whether the proof is inspected before or after lunch; and the presence or absence of others when the buyer and seller are discussing the proof. The positioning of the proof relative to the original—i.e., to the left or the right—may also influence the inspector's perception of the quality of the proof. The suggestion also has been made that the buyer will make fewer corrections on the proof if the white paper area around the job is kept as small as possible. This tactic will fail, as the buyer will simply write smaller.

A major situational factor that influences markup is that of the role of buyer and seller. The role of the buyer is sometimes defined as that of color critic. Art directors or designers sometimes play the part of decision maker, if not the actual buyer. The role of a critic is to criticize. This is sometimes reduced to finding trivial faults or perceived faults that have little or no influence on the quality of the reproduction. Many critics believe that, unless they find a fault, they have not done

their job. One can be critical, however, without finding fault. A series of proofs with the OK stamp indicating no corrections does not necessarily mean that the critic or buyer has been easy or lax. Rather, it usually means that the proof is reasonable, and to mark up corrections would only result in delays and increased costs without producing any significant discernible effect on the reproduction.

Reasonableness is often the result of dialogue between the buyer and seller. The sales representative has a major role to play in this process. A person involved in the activity of selling color proofs or color printing must not only be aware of how much color correction or adjustment is possible within the manufacturing process but also should be able to convey this information to the buyer. The give-and-take between the buyer and seller results in the reasonable balance between the desire to make another slight change and the possibility or practicality of making this change.

The question of color approval is also influenced by who pays the cost of "fine tuning" the reproduction. If the print buyer demands a change that departs from the original instructions, this is like an "author's alteration" and is payable by the person requesting the change. For "bargain" separations, the price does not include any corrections; therefore, none should be expected. Where the customer agrees to pay the cost of all specified corrections, unlimited fine tuning is possible.

The in-between cases, where an estimate has been submitted for the production of color separations and proofs, are less clear cut. If the color separator submits a *reasonable* proof to the customer, minor corrections are included in the price of the job; but re-proofs are paid by the customer. If the color separator submits an *unreasonable* proof, the corrections and the re-proof are paid for by the separator. Of course, individual contractual arrangements may differ from this convention.

The key question of reasonableness and unreasonableness and how well it is resolved depends largely on whether the buyer and seller consider it worthwhile to continue doing business with each other. The question of reasonableness must also depend upon the relative price. The higher the price, the higher the expectations. Another concern is the time available for corrections. If insufficient time is allowed to perform the requested adjustments, it is not reasonable to expect both the delivery deadline and the specified changes. If the delivery objective is realized, then the corrections must be accepted as reasonable. The final aspect of reasonableness concerns the

precision of the requested change. Comments such as "increase yellow 2½%" are a waste of time for two reasons. First, it is impossible to measure 2½% with any degree of precision. Second, a change of 2% or 3% will not be very noticeable in the final reproduction. This is especially true for changes in dark colors or changes in the yellow separation.

Color proofs should be marked up by the use of the terminology discussed under "Color Proof Markup." This terminology is specific enough to convey the buyer's desires but not too particular to exclude the judgment of the retoucher. The retoucher is not merely a mechanical extension of the buyer's brain. The skilled retoucher assesses the requested changes in light of the influence on other aspects of the reproduction and then makes adjustments designed to achieve the buyer's wishes while maintaining the integrity of the picture. A buyer who insists on some very particular dot size changes may "win the battle but lose the war," or *achieve the color but lose the reproduction.*

## Color Communication Improvement

Color reproduction is a complex process that requires the accurate communication of color information between a number of persons and organizations. In practice, considerable time, energy, materials, and money are wasted in the color reproduction process because of unclear or poor communication. Apart from the recommendations discussed so far—that is, standard lighting and viewing conditions, the use of color charts, testing for anomalous color vision, and the use of objective terms when describing the desired color corrections—there are a number of steps that can be taken to improve the communication process.

## Specifications Forms

Color communication can be made less ambiguous by the use of specification forms. These forms can help to establish both the objective and some of the subjective aspects of color reproduction. Two forms may have to be used in order to avoid confusion.

One form should be used to convey information concerning the original from the customer to the color separator. This form, one of which should be completed for each original, should contain the following information: required size; crop area; transparency brand and type; important tonal information area: highlight, middletone, shadow (check no more than two); areas of color change (indicate); and retouching requirements (indicate).

The specification form that should be used by a printer to convey the printing information to the color separator should contain the following information: printing process, ink brand and type, substrate brand and type, color sequence, amount of UCR or GCR, screen ruling, dot shape, negatives or positives, right- or wrong-reading, plate type, printing densities, and dot gain at the 50% level. A sample printed color bar should be attached to the form.

A color separator uses the information on the two forms to help program the color separation system and produce the color proofs. The use of these forms helps to ensure that the proof will be close to the customer's requirements and that the subsequent color separation films will print properly.

**Color Printing Samples**

It is very difficult to describe the effect of using a particular paper on the appearance of the future color printing. Sales representatives should carry samples of previously printed jobs on more than one paper stock. These samples can be generated easily by running the test stocks through the press at the end of the production run. The reproduction won't be optimal on the test stocks, but they will at least convey the general idea of the appearance shifts that are likely when a given substrate is used.

The sales representatives should carry a portfolio of other printed samples that indicate the effects of varnishing, five- or six-color printing, fine screen rulings, and any other appearance factors. Color communication is much more successful when actual samples are used to help describe the expected outcomes. Customers' expectations will be realistic if they see in advance some samples of work using the ink-paper-press combination of the printer in question. Of course, printed color charts should also be produced and distributed to potential customers.

The appearance difference between prepress proofs and the printed job can be conveyed by including proof and corresponding press sheets in the sales representative's portfolio. The customer, upon observing the difference between the proof and printed sheet, can now decide if it is worthwhile to produce a more expensive press proof or to use a prepress proof.

**Color Education**

The process of color reproduction in general and color communication in particular are complex and difficult concepts to understand fully. To help overcome this lack of understanding, some companies conduct special seminars for

their own employees, particularly their sales staff. Others even run special seminars for their customers with the belief that an informed customer is a better customer. Some plants use their own personnel to conduct these seminars, while others hire outside consultants for this purpose. Books, videotapes, and other aids also can be used to help spread an understanding of color reproduction and communication.

Some buyers of printing already have an excellent color education. A number of graphic design programs at various colleges and universities provide courses in printing and related technologies so that the student will understand the interaction of the design and manufacturing processes. Other institutions shortsightedly ignore printing as "not relevant" to the education of future art directors.

Some printing and color separation companies hire the "born salesman" type who might not know anything about color reproduction but has an impressive sales record. Other companies recruit their sales representatives from their own staff who have had either the advantage of a formal color education or extensive color production experience.

Color seminars and similar educational endeavors are useful for production people who might know their own field very well but are unaware of the other stages in the color reproduction process. Exposure to the *total system* should promote overall awareness, improve communication, reduce costs, and improve quality.

Thus, many benefits can be derived from a color education program, particularly if high-quality work is the objective. Reasonable-quality work can be produced with a rudimentary understanding of the process, but consistent excellence demands higher levels of knowledge and skills.

## Summary

The process of color communication is critical to the success of the color reproduction system. The two aspects of this communication are (1) the manufacturing system information that must be supplied to the color separation process and (2) the creative information that represents the buyer's print appearance objectives. That is, some information is conveyed that is primarily technical in nature ("compensate for 15% dot gain on press when the separations are made"), while the other information is largely subjective ("it is important that the fruit looks appealing").

The technical information can be communicated by the use of forms or printed test images. The creative decision has to be

made by judging a tangible image, such as a proof. The key problem now becomes how to communicate the results of the creative decision to the person or persons who will put that decision into effect.

The objective barriers to color communication, such as the use of nonstandard viewing conditions, are fairly easy to identify and change. In contrast, the subjective barriers to color communication, such as personality differences between the buyer and seller, are not only difficult to identify but are also almost impossible to correct.

The major communication techniques—instrumental measurements, physical samples, or verbal description—each have their strengths and weaknesses. The verbal technique, in particular, is very convenient to use but suffers from the lack of precision. This lack of precision can be partly overcome by the use of a few specific color terms. If the print buyer accurately specifies the direction of the desired color change, the color retoucher should be trusted to produce the appropriate degree of change.

The question of how close is good enough for a given color area on the proof is difficult to answer. It is related to the concept of reasonableness. That is, a color area is reasonable if, within the time, cost, visual limit, and manufacturing conditions constraints, it meets the customer's expectations. A skilled sales representative is needed in order to educate the customer in the concept of reasonableness.

A complex process of new technology and new materials, color reproduction contains many unknown nuances. It is a major undertaking to master the knowledge and skills that are required to understand the process and to communicate effectively the color requirements for creative and manufacturing concerns. Therefore, the continuing color education of all those involved in color reproduction is necessary. The creation and manufacturing of fine color printing is the result of a team effort. That it can be done at all, especially under the constraints of time or money, must be very satisfying to all those who are involved in the color reproduction process. The satisfaction, and even pleasure, that color printing provides to the ultimate consumer must also produce a sense of pride and purpose to those involved in the art and science of color reproduction.

# Appendix A
# Actinic Density

One use of hue error and grayness, as plotted on a color diagram, is to provide a basis for color masking calculations. The mask characteristics are usually determined by the photographic response of a GATF Color Reproduction Guide that is photographed alongside the copy. Because of different light sources, color filters, optical systems, and photographic emulsions, a given color will record differently under different photographic systems. Therefore, the hue error and grayness plot should be representative of how the color will record under the particular production conditions that are in use. To achieve this, the densitometer must measure color the same way as the emulsion records it (actinic density).

Determination of actinic density

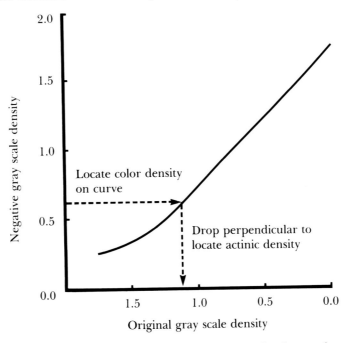

It is a relatively simple matter to check whether a densitometer is recording color as actinic density. First, a GATF Color Reproduction Guide (printed under standard plant conditions) and a reflection gray scale are positioned beside the reflection color copy to be reproduced. Unmasked red-, green-, and blue-filter separation negatives are made. The transmission densities of the gray scale on each negative are plotted against the reflection densities of the original gray scale as represented in the illustration. A curve for each separation negative will be produced. The transmission densities of the Color Reproduction Guide on each negative are then measured. These values are located on the transmission density ordinate

(vertical axis) of the appropriate graph. The densities are extended to the curve and perpendiculars are dropped to intersect the reflection density abscissa (horizontal axis). These values are the actinic densities of the colors as recorded by that particular photographic system. The final step in the checking procedure is to measure the previously photographed Color Reproduction Guide through the red, green, and blue filters of a reflection densitometer. These readings are compared to the calculated actinic densities. If they are significantly different, it means the masking calculations based on the densitometer readings alone will most likely be inaccurate.

# Appendix B
# Symbols and Abbreviations

| | |
|---|---|
| **AAAA** | American Association of Advertising Agencies |
| **ABP** | American Business Press |
| **ANSI** | American National Standards Institute |
| **ASTM** | American Society of Testing and Materials |
| **B** | Blue filter or tristimulus value |
| **BS** | British Standard |
| **C** | Cyan separation or printer |
| **CIE** | Commission Internationale de l'Éclairage |
| **D** | Optical Density; Three CIE standard illuminants |
| **DIN** | Deutsche Industrie Normen (German Standard Specification) |
| **END** | Equivalent neutral density |
| **FTA** | Flexographic Technical Association |
| **G** | Green filter or tristimulus value |
| **GATF** | Graphic Arts Technical Foundation |
| **GCR** | Gray component replacement |
| **GRI** | Gravure Research Institute |
| **GTA** | Gravure Technical Association |
| **IFT** | Ink film thickness |
| **IOP** | Institute of Printing |
| **IR** | Infrared |
| **ISCC** | Inter-Society Color Council |
| **ISO** | International Standards Organization |
| **j.n.d.** | Just noticeable difference |
| **K** | Black separation or printer; degrees Kelvin, a measure of color temperature |
| **lx** | Lux—unit of illumination (one lumen per square meter per second) |
| **M** | Magenta separation or printer |
| **MPA** | Magazine Publishers Association |
| **NBS** | National Bureau of Standards |
| **nm** | Nanometer = 1/1,000,000 mm |
| **NPIRI** | National Printing Ink Research Institute |
| **Pira** | Printing Industry Research Association |
| **PM** | Photomultiplier |
| **PSE** | Paper surface efficiency |
| **R** | Red filter or tristimulus value |
| **SNAP** | Specifications for Nonheatset Publications |
| **SWOP** | Specifications for Web Offset Publications |

| | |
|---|---|
| **TAGA** | Technical Association of the Graphic Arts |
| **TAPPI** | Technical Association of the Pulp and Paper Industry |
| **UCR** | Undercolor removal |
| **UV** | Ultraviolet (1 nm to 380 nm) |
| **V** | Value (Munsell System) |
| **Y** | Yellow separation or printer |

# Appendix C
# Names and Addresses
## (Primarily English-Speaking Countries)

**Research Associations**

Graphic Arts Technical Foundation
4615 Forbes Avenue
Pittsburgh, PA 15213, USA

Printing Industry Research Association
Randall's Road
Leatherhead
Surrey KT22 7RU, England

**Professional Associations**

Institute of Printing
8 Lonsdale Gardens
Tunbridge Wells
Kent TN1 1 NU, England

Inter-Society Color Council
c/o Miss Therese R. Commerford, Sec.
U.S. Army Natick RD&E Center
Attn. STRNC-ITC
Natick, MA 01760, USA

Society for Imaging Science and Technology
7003 Kilworth Lane
Springfield, VA 22151, USA

Royal Photographic Society
The Octagon
Milsom Street
Bath BA1 1DN, England

Technical Association of the Graphic Arts
c/o RIT T&E Center
1 Lomb Memorial Drive
P.O. Box 9887
Rochester, NY 14623, USA

**Official Standards Organizations**

American National Standards Institute
1430 Broadway
New York, NY 10018, USA

British Standards Institute
2 Park Street
London W1A 2BS, England

Commision Internationale de l'Éclairage
57 Rue Curier
Paris 5, France

International Standards Organization
1 Rue de Varembe
1 211 Geneva 20, Switzerland

**Standards
Setting
Organizations
and Other
Useful
Addresses**

American Association of Advertising Agencies
(SWOP Specifications)
666 Third Avenue
New York, NY 10017, USA

American Business Press
(SWOP Specifications)
675 Third Avenue, Suite 400
New York, NY 10017-5704, USA

American Society for Testing and Materials
1916 Race Street
Philadelphia, PA 19103, USA

Canadian Government Printing Office
Supply and Services Canada
Hull, PQ K1A 0S7, Canada

Flexographic Technical Association
900 Marconi Avenue
Ronkonkoma, NY 11779, USA

Gravure Association of America
1200 A Scottsville Road
Rochester, NY 14624, USA

International Federation of the Periodical Press Ltd.
(Specifications for European Offset Printing)
Suite 19, Grosvenor Gardens House
35-37 Grosvenor Gardens
London, SW1W OBS, England

International Prepress Association
(SWOP Color References)
7200 France Avenue S., Suite 327
Edina, MN 55435, USA

Magazine Publishers of America
(SWOP Specifications)
575 Lexington Avenue
New York, NY 10022, USA

National Printing Ink Research Institute
(Ink Testing Standards)
777 Terrace Avenue
Hasbrouck Heights, NJ 07604, USA

Printing Industries of America
(SNAP Recommendations)
Nonheatset Web Unit
100 Daingerfield Road
Alexandria, VA 22314, USA

Screen Printing Association International
10015 Main Street
Fairfax, VA 22031, USA

Technical Association of the Pulp and Paper Industry
(Paper Testing Standards)
15 Technology Parkway S.
Norcross, GA 30092, USA

United States Government Printing Office
Washington, DC 20401, USA

# Appendix D
# Equations for Color Reproduction

The computational approaches to color reproduction and color separation are described in chapter 10. This appendix lists the equations.

**Demichel Equations**

Demichel's equations are based on the following assumptions:

let:
  Fractional dot area of yellow = y
  Fractional dot area of magenta = m
  Fractional dot area of cyan = c

therefore:
  Area not covered by yellow = $1 - y$
  Area not covered by magenta = $1 - m$
  Area not covered by cyan = $1 - c$

and:
  Area not covered by yellow or magenta = $(1-y)(1-m)$
  Area not covered by cyan or yellow = $(1-c)(1-y)$
  Area not covered by magenta or cyan = $(1-m)(1-c)$
  Area not covered by yellow, magenta, or cyan
  = $(1-y)(1-m)(1-c)$ = white

similarly:
  Area covered by yellow and magenta, but not cyan
  = $ym(1-c)$ = red
  Area covered by cyan and yellow, but not magenta
  = $cy(1-m)$ = green
  Area covered by magenta and cyan, but not by yellow
  = $mc(1-y)$ = blue
  Area covered by yellow, magenta, and cyan = $ymc$ = black

and:
  Area that is solely yellow (i.e., not magenta and not cyan)
  = $y(1-m)(1-c)$ = yellow
  Area that is solely magenta (i.e., not yellow and not cyan)
  = $m(1-y)(1-c)$ = magenta
  Area that is solely cyan (i.e., not yellow and not magenta)
  = $c(1-y)(1-m)$ = cyan

Therefore, the following expression, $(1-y)(1-m)(1-c)$
$+ y(1-m)(1-c) + m(1-y)(1-c) + c(1-y)(1-m) + ym(1-c)$
$+ cy(1-m) + mc(1-y) + ymc$, is the mathematical

representation of the yellow, magenta, and cyan dot areas in a given color.

**Source:** Yule, *Principles of Color Reproduction*, 1967, p. 261.

**Neugebauer Equations**

The Neugebauer equations are based on the following conditions:

let:
$R_y$ = red-light reflectance of yellow ink
$R_m$ = red-light reflectance of magenta ink
$R_c$ = red-light reflectance of cyan ink
$R_{ym}$ = red-light reflectance of the overlap of yellow and magenta
$R_{cy}$ = red-light reflectance of the overlap of cyan and yellow
$R_{mc}$ = red-light reflectance of the overlap of magenta and cyan
$R_{ymc}$ = red-light reflectance of the overlap of yellow, magenta, and cyan

This equation works similarly for the green- and blue-light reflectances.

Assume red-light reflectance from white paper = 1; then, by incorporating the expressions for the reflectance properties of the inks into the Demichel equations that represent the halftone dot areas, we have:

$$R = (1-y)(1-m)(1-c) + y(1-m)(1-c)R_y$$
$$+ m(1-y)(1-c)R_m + c(1-y)(1-m)R_c + ym(1-c)R_{ym}$$
$$+ yc(1-m)R_{yc} + mc(1-y)R_{mc} + ymcR_{ymc}$$

$$G = (1-y)(1-m)(1-c) + y(1-m)(1-c)G_y$$
$$+ m(1-y)(1-c)G_m + c(1-y)(1-m)G_c + ym(1-c)G_{ym}$$
$$+ yc(1-m)G_{yc} + mc(1-y)G_{mc} + ymcG_{ymc}$$

$$B = (1-y)(1-m)(1-c) + y(1-m)(1-c)B_y$$
$$+ m(1-y)(1-c)B_m + c(1-y)(1-m)B_c + ym(1-c)B_{ym}$$
$$+ yc(1-m)B_{yc} + mc(1-y)B_{mc} + ymcB_{ymc}$$

where R = the total red-light reflectance, G = the total green-light reflectance, and B = the total blue-light reflectance.

The equations can be reformulated to determine the dot areas y, m, and c.

**Source:** Yule, *Principles of Color Reproduction*, pp. 260–266.

**Four-Color Version of the Neugebauer Equations**

The four-color version of the Neugebauer equations contain the following extra terms:

let:
　　Fractional dot area of black $= k$

then:
　　Area not covered by black $= 1 - k$

and let:
　　$R_k$ = red-light reflectance of black ink
　　$G_k$ = green-light reflectance of black ink
　　$B_k$ = blue-light reflectance of black ink

Assuming that $R_{yk} = R_{mk} = R_{ck} = R_{ymk} = R_{yck} = R_{mck} = R_{ymck} = R_k$, then the equation for red-light reflectance becomes:

$$\begin{aligned} R =\ & (1-y)(1-m)(1-c)(1-k) + y(1-m)(1-c)(1-k)R_y \\ & + m(1-y)(1-c)(1-k)R_m + c(1-y)(1-m)(1-k)R_c \\ & + ym(1-c)(1-k)R_{ym} + yc(1-m)(1-k)R_{yc} \\ & + mc(1-y)(1-k)R_{mc} + ymc(1-k)R_{ymc} + kR_k \end{aligned}$$

(and similarly for green and blue)

**Source:** Hardy and Dench, U.S. Patent 2,434,561 (January 13, 1948); and Hardy and Wurzburg, "Color Correction in Color Printing," *Journal of the Optical Society of America*, April 1948, pp. 300–307.

**Pobboravsky and Pearson Modification of the Neugebauer Equations**

Their equations took the form:

$$R^{1/2.05} = f_1 R_1^{1/2.05} + f_2 R_2^{1/2.05} + \ldots + f_8 R_8^{1/2.05}$$

$$G^{1/2.00} = f_1 G_1^{1/2.00} + f_2 G_2^{1/2.00} + \ldots + f_8 G_8^{1/2.00}$$

$$B^{1/1.80} = f_1 B_1^{1/1.80} + f_2 B_2^{1/1.80} + \ldots + f_8 B_8^{1/1.80}$$

where the values $f_1$ to $f_8$ represent the fractional dot areas of the eight additive colors, and $R_1$ to $R_8$ represent the corresponding red-light reflectances of the values $f_1$ to $f_8$, and similarly for $G_1$ to $G_8$ and $B_1$ to $B_8$. The values 2.05, 2.00, and 1.80 are their values of $n$ for the red, green, and blue reflectances. The $n$ values would change for other screen rulings, inks, and substrates.

**Source:** *TAGA Proceedings* 1972, pp. 65–77.

**Clapper Second-Degree Empirical Equations**

The model took this form:

$$c = a_{11}D_r + a_{12}D_g + a_{13}D_b + a_{14}D_r^2 + a_{15}D_g^2 + a_{16}D_b^2 \\ + a_{17}D_rD_g + a_{18}D_rD_b + a_{19}D_gD_b$$

(and similarly for m and y)

The values $D_r$, $D_b$, and $D_g$ are the colorimetric densities of the printed color patches and c, m, and y are ink amounts needed to match the original color. The $a_{11}$ to $a_{19}$ values are the unknown coefficients that are calculated by the regression analysis.

**Source:** *TAGA Proceedings* 1961, pp. 31–41.

**Pobboravsky Equations to Transform a Three-Color to a Four-Color System**

Pobboravsky used an empirical approach to convert a three-colorant to a four-colorant system. This work represented one of the earliest attempts at quantifying what is now known as GCR. The following example equation assumes 50% under-color removal and maximum removal from the smallest three-color component:

$$x_4 = \frac{(\text{Low E.N.D.})}{2}$$

where $x_4$ = the amount of yellow, magenta, or cyan (depending upon which is the smallest component in the color in question) that will print in the four-color system. The term **Low E.N.D.** is the smallest equivalent density component (i.e., yellow, cyan, or magenta) in the three-color system.

The amount of black, expressed in terms of density, is also calculated by taking half of the smallest three-color component:

$$\text{Black} = \frac{(\text{Low E.N.D.})}{2}$$

The correct amounts of the other two colors necessary to make the four-color system match the three-color system were established empirically. These values were least squares fitted to a linear equation that could then be used to compute the four-color amounts given the three-color amounts. For an example set of conditions, the equation was:

$$x_4 = 1.07\left[x_3 - \left(\frac{\text{Low E.N.D.}}{x_3} \cdot \frac{\text{Low E.N.D.}}{2}\right)\right] - 0.08$$

where $x_3$ = the amount of yellow, magenta, or cyan present in a three-color system that is to be transformed into the appropriate amount for a four-color system. For example, if the cyan present in a three-color system is to be transformed to the correspondingly smaller amount of cyan required in a four-color system, the $c_3$ and $c_4$ would be substituted, respectively, for $x_3$ and $x_4$.

The reason for proportionally taking more away from the smallest component and less from the largest amount was to boost the saturation of the colored inks for the four-color case above what they were in the three-color case.

**Source:** *Photographic Science and Engineering*, vol. 8, no. 3 (1964), pp. 141–148.

**Warner Interimage Reflectance Model**

Warner generates correction factors that correct Neugebauer equations for additivity failure and proportionality failure.

Warner calls the total correction factor **overcolor modification,** that is, the apparent modification to the first-down color caused by the second-down color. The general form of this equation is:

$$x.OCM.Az = x.FDA + (x.CDA - x.FDA)\left[\frac{z.A - z.D}{p.D - z.D}\right]^2$$

where:

$x.FDA$ = the film dot area of the first-down color
$x.CDA$ = the printed dot area of the first-down color
$x.OCM$ = the overcolor modification of the printed dot area of the first-down color due to the interimage effects of the second-down color
$A$ = minimum reflectance value of the first-down color
$x$ = first-down color

z = second-down color

D = minimum reflectance value of the second-down color

p = reflectance value of the substrate determined by the minimum reflectance value of the second-down color

The OCM term is used at appropriate points in the Neugebauer equation to correct for the interimage reflectance problems as shown:

$$
\begin{aligned}
R = {} & p.R(1-y.FDA)(1-m.FDA)(1-c.FDA) \\
& + y.R(y.FDA)(1-m.FDA)(1-c.CDA) \\
& + m.R(m.FDA)(1-yOCM.Rm)(1-c.CDA) \\
& + c.R(c.CDA)(1-yOCM.Rc)(1-mOCM.Rc) \\
& + r.R(yOCM.Rm)(m.FDA)(1-c.CDA) \\
& + g.R(yOCM.Rc)(c.CDA)(1-mOCM.Rc) \\
& + b.R(mOCM.Rc)(c.CDA)(1-yOCM.Rb) \\
& + t.R(yOCM.Rb)(mOCM.Rc)(c.CDA)
\end{aligned}
$$

$$
\begin{aligned}
G = {} & p.G(1-y.FDA)(1-m.CDA)(1-c.MDA) \\
& + y.G(y.FDA)(1-m.CDA)(1-c.MDA) \\
& + m.G(m.CDA)(1-yOCM.Gm)(1-c.MDA) \\
& + c.G(c.MDA)(1-yOCM.Gc)(1-mOCM.Gc) \\
& + r.G(yOCM.Gm)(m.MDA)(1-c.MDA) \\
& + g.G(yOCM.Gc)(c.MDA)(1-mOCM.Gc) \\
& + b.G(mOCM.Gc)(c.MDA)(1-yOCM.Gb) \\
& + t.G(yOCM.Gb)(mOCM.Gc)(c.MDA)
\end{aligned}
$$

$$
\begin{aligned}
B = {} & p.B(1-y.CDA)(1-m.MDA)(1-c.FDA) \\
& + y.B(y.CDA)(1-m.MDA)(1-c.FDA) \\
& + m.B(m.MDA)(1-yOCM.Bm)(1-c.FDA) \\
& + c.B(c.FDA)(1-yOCM.Bc)(1-mOCM.Bc) \\
& + r.B(yOCM.Bm)(m.MDA)(1-c.FDA) \\
& + g.B(yOCM.Bc)(c.FDA)(1-mOCM.Bc) \\
& + b.B(mOCM.Bc)(c.FDA)(1-yOCM.Bb) \\
& + t.B(yOCM.Bb)(mOCM.Bc)(c.FDA)
\end{aligned}
$$

where:

$r.R$ = red reflectance value of the overprint color red

$b.R$ = red reflectance value of the overprint color blue

$g.R$ = red reflectance value of the overprint color green

$t.R$ = red reflectance value of the three-color overprint

and:

yOCM.Rb = Overcolor modification of the yellow dot area [equivalent dot area red reflectance component due to the overprint colors of magenta and cyan (blue)].

The same notation as described above is used in the corrected equations for the green and blue reflectance values.

**Source:** GATF *Annual Research Department Report:* 1983–1984, pp. 3(1)–3(15).

**Murray-Davies Equation**

If:
  $a$ = dot area
  $D_t$ = density of tint
  $D_s$ = density of solid

then:
  $D_t = -\log[1 - a(1 - 10^{-D_s})]$

or, solving for a:
$$a = \frac{1 - 10^{-D_t}}{1 - 10^{-D_s}}$$

**Source:** *Journal of the Franklin Institute,* 1936, pp. 721–744.

**Yule-Nielsen Modification of the Murray-Davies Equation**

Let:
  $n$ = correction for internal light scatter

then:
$$a = \frac{1 - 10^{-D_t/n}}{1 - 10^{-D_s/n}}$$

**Source:** *TAGA Proceedings* 1951, pp. 65–76.

Using Pearson's suggested 1.70 value for *n:*

  $D_t = -1.7\log[1 - a(1 - 10^{-0.6D_s})]$

or:
$$a = \frac{1 - 10^{-0.6D_t}}{1 - 10^{-0.6D_s}}$$

**Source:** *TAGA Proceedings* 1980, pp. 415–425.

**Masking Equations**

Let:

$D_r$, $D_g$, $D_b$ represent the red, green, and blue densities of the three-color combination.

C, M, Y are principal densities of the individual inks.

$c_b$, $c_g$, for example, are the ratios of the blue and green densities of the cyan ink to its red density. The corresponding ratios for the magenta and yellow inks are $m_r$, $m_b$, $y_r$, and $y_g$.

Thus, according to the additivity rule, we have:

$$D_r = C + m_r M + y_r Y$$

$$D_g = c_g C + M + y_g Y$$

$$D_b = c_b C + m_b M + Y$$

The masking requirements can be expressed in this form:

$$C = a_{11}D_r + a_{12}D_g + a_{13}D_b$$

$$M = a_{21}D_r + a_{22}D_g + a_{23}D_b$$

$$Y = a_{31}D_r + a_{32}D_g + a_{33}D_b$$

These equations can be rearranged:

$$C = a_{11}\left(D_r + \frac{a_{12}}{a_{11}}D_g + \frac{a_{13}}{a_{11}}D_b\right)$$

$$M = a_{22}\left(\frac{a_{21}}{a_{22}}D_r + D_g + \frac{a_{23}}{a_{22}}D_b\right)$$

$$Y = a_{33}\left(\frac{a_{31}}{a_{33}}D_r + \frac{a_{32}}{a_{33}}D_g + D_b\right)$$

The complete solutions (the masking equations) are expressed in terms of density ratios:

$$C = \frac{1 - m_b y_g}{\Delta}\left(D_r + \frac{m_b y_r - m_r}{1 - m_b y_g}D_g + \frac{y_g m_r - y_r}{1 - m_b y_g}D_b\right)$$

$$M = \frac{1 - y_r c_b}{\Delta}\left(\frac{c_b y_g - c_g}{1 - y_r c_b}D_r + D_g + \frac{y_r c_g - y_g}{1 - y_r c_b}D_b\right)$$

$$Y = \frac{1 - c_g m_r}{\Delta}\left( \frac{c_g m_b - c_b}{1 - c_g m_r}D_r + \frac{m_r c_b - m_b}{1 - c_g m_r}D_g + D_b \right)$$

$$\Delta = 1 - m_b y_g - y_r c_b - c_g m_r + c_g m_b y_r + c_b m_r y_g$$

The coefficients inside the parentheses (multiplied by 100) represent the percent masks (six altogether) and the term outside the parentheses represents the overall contrast of the process.

For example, the red-filter mask for the blue-filter negative is $a_{31}/a_{33}$ term or $(c_g m_b - c_b)/(1 - c_g m_r)$.

**Source:** Yule, *Principles of Color Reproduction*, 1967, pp. 266–272.

# Glossary

**abnormal color vision**  Defective color vision ("color blindness"), which may take the form of protanopia (red and bluish green confusion); protanomalous (deficient in red response for certain color mixtures); deuteranopia (red and green confusion); deuteranomaly (deficient in green response for certain color mixtures); tritanopia (blue and yellow confusion); and monochromatism (no discrimination of hue and saturation).

**absorption**  The taking up of light energy by matter and its transformation into heat. Selective absorption of the range of wavelengths compromising white light produces colored light.

**achromatic**  The term used to refer to white, grays, and black—which have no hue.

**actinic**  Describes the ability of light to produce changes in materials exposed to it, such as photographic emulsions.

**actinic density**  The density of a color, relative to a positive gray scale, when recorded on a given photographic emulsion.

**additive color process**  A means of producing a color reproduction or image by combinations of blue, green, and red colored lights, such as in color television systems.

**additive primaries**  Blue, green, and red lights of high saturation, which when mixed together in varying combinations and intensities can produce any other color.

**additivity failure**  A common condition of printing ink on paper where the total density of the overprinted ink films is not equal to the sum of the individual ink densities.

**adjacent color effect**  The visual influence of a color area on an adjacent color. This effect is especially strong when the adjacent color area is relatively large and has high saturation.

**afterimage**  Sensation that occurs after the stimulus causing it has ceased. Because of cone fatigue, the colors of the afterimage may be complementary to those registered initially.

**airbrushing**  Retouching of prints or artwork by dyes or pigments sprayed on with high-pressure air from a small hand-held sprayer.

**analog**  Electrical signals of continuously variable frequency or intensity. These signals can be generated by photocells or photomultipliers and are related to the density of an original. Many color scanners use analog circuits.

**apochromat**  A lens used for color separation work. This lens will bring the red-, green-, and blue-light bands of the spectrum to the same point of focus.

**apparent trap**  See *trapping.*

**balanced process inks**  A set of process inks of which the ratios of the blue and green actinic densities of the cyan and magenta are equal, enabling the use of only one color correction mask for the yellow printer.

**benzidine yellow**  See *diarylide yellow.*

**black**  The absence of color; an ink that absorbs all wavelengths of light.

**black colors**  See *wanted colors.*

**black-light source**  A source rich in ultraviolet and low-frequency blue radiation.

**black printer**  The plate used with the cyan, magenta, and yellow plates for four-color process printing. Its purpose is to increase the overall contrast of the reproduction and, specifically, improve shadow contrast. Sometimes called the key plate. The letter $K$ is often used to designate this color. See *full-scale black and skeleton black.*

**blanket**  A fabric coated with natural or synthetic rubber that is wrapped around the blanket cylinder of an offset press. It transfers the inked image from the plate to the paper.

**brightness**  1. The amount of light reflected from a surface.
2. A paper property, defined as the percentage reflection of 457 nm radiation.
3. The intensity of a light source.
4. When used to describe color, this term means *highly saturated.*

**bronzing**
In process-color printing, the effect that appears when the toner in the last color (often black) migrates to the surface of the printed ink film, causing a change in the spectral aspect of surface light reflection.

**bump exposure**
A brief *no-screen* exposure that supplements the main exposure when making a halftone. The effect is to compress the screen's density range without flattening tonal detail. The technique produces a full range of halftone dots from short-density-range copy and can also be used to expand highlight or shadow tonal separation, depending on whether negatives or positives are being made.

**C print**
A term used by some to describe any reflective color print. The term was used to designate a particular Eastman Kodak integral tripack color print material.

**camera-back masking**
A single-stage color correction process where the processed masks are placed in turn over unexposed separation film in the camera back before producing the separation negatives.

**carbon black**
The pigment commonly used in black inks. Toners are usually combined with this pigment in the ink formulation to make the black ink more neutral.

**CC filter**
Color compensating filter, a high transmittance filter used to correct the color balance of transparencies. CC filters are available in six colors and several strengths.

**characteristic curve**
Graphical representation of the relationship between the exposures given to a sensitized material and the corresponding image densities produced under specified development conditions.

**chroma**
The degree of saturation of a surface color in the Munsell System.

**chromaticity diagram**
A graphical representation of two of the three dimensions of color. Intended for plotting light sources rather than surface colors. Often called the *CIE diagram*.

**chrome**
A term used to describe a color transparency. It is a contraction of brand names such as Kodachrome, Fujichrome, Ektachrome, or Agfachrome.

**chrome yellow**   An inorganic pigment that is primarily lead chromate, used for making opaque yellow inks.

**CIE**   Commission Internationale de l'Éclairage, a standards-setting organization for color measurement.

**CIE diagram**   See *chromaticity diagram*.

**cleanliness**   Synonym for high saturation.

**color balance**   The combination of yellow, magenta, and cyan needed to produce a neutral gray. Determined through a gray balance analysis.

**color bars**   See *color control strip*.

**color blindness**   See *abnormal color vision*.

**color cast**   The modification of a hue by the addition of a trace of another hue, such as yellowish green, pinkish blue, etc.

**color chart**   A printed chart containing overlapping halftone tint areas in combinations of the process colors. The chart is used as an aid to color communication and the production of color separation films. The charts should be produced by individual printers using their own production conditions. See *Foss Color Order System*.

**color circle**   A GATF color diagram used for plotting points as determined by the Preucil Ink Evaluation System. The dimensions are hue error (circumferentially) and grayness (radially). See *Preucil Ink Evaluation System, color triangle, hue error, grayness*.

**color control strip**   Small patches of color solids, overprints, tints, and resolution targets for the purpose of monitoring printing press performance. Sometimes called color bars.

**color conversion**   A color transparency made from a color reflection original. A conversion is made for the purpose of allowing a rigid reflection copy to be color-separated using a drum-type scanner, or for any of the other reasons listed under *color duplicating*.

**color correction**  1. A photographic, electronic, or manual process used to compensate for the deficiencies of the process inks and the color separation process.
2. Any color alteration requested by a customer.

**color duplicating**  The process of making a duplicate transparency from an original transparency for purposes of retouching, color cast adjustment, density range normalization, image assembly, or reproduction scale adjustment. Color duplicates are sometimes called *dupes.*

**color gamut**  The range of colors that can be formed by all possible combinations of the colorants of a color reproduction system.

**color hexagon**  A trilinear plotting system for printed ink films. Adapted for the printing industry by GATF, the method was originally developed by Eastman Kodak. A color is located by moving in three directions (at 120° angles) on the diagram by amounts corresponding to the densities of the printed ink film. The diagram is generally used as a color control chart, particularly for detecting changes in the hue of two-color overprints.

**colorimeter**  An optical measuring instrument designed to respond to color in a manner similar to the human eye.

**color proof**  A printed or simulated printed image of the color separation films. The colorants used are selected so that the proof will produce a close visual simulation of the final reproduction.

**color quality index**  See *color rendering index.*

**color references**  A given set of inks printed at specified densities or strengths on a given substrate, used for color control.

**color rendering index**  A measure of the degree to which a light source, especially a fluorescent light, under specified conditions, influences how the perceived colors of objects illuminated by the source conform to those of the same objects illuminated by a standard source, which is usually some aspect of daylight. Also called *color quality index.*

**color reproduction guide**    A printed image consisting of solid primary, secondary, three-, and four-color, and tint areas. It is primarily used as a guide for color correction of the defects of the printing ink pigments and the color separation system. The guide should be produced under normal plant printing conditions.

**color scanner**    See *scanner*.

**color separation**    The process of making film intermediates from the color original to record the red-, green-, and blue-light reflectances. These films are used to prepare the cyan, magenta, and yellow printing plates. A black separation is also made.

**color sequence**    The color order of printing the yellow, magenta, cyan, and black inks on a printing press. Sometimes called *rotation* or *color rotation*.

**color temperature**    The temperature, in degrees Kelvin, to which a black body would have to be heated to produce a certain color radiation. 5,000 K is the graphic arts viewing standard. The degree symbol is not used in the Kelvin scale. The higher the color temperature, the bluer the light.

**color transparency**    A positive color photographic image on a clear film base. It must be viewed by transmitted light. Sizes range from 35-mm color slides up to $8 \times 10$-in. ($203 \times 254$-mm) sheet film transparencies.

**color triangle**    A GATF color diagram based on the Maxwell Triangle for plotting points as determined by the Preucil Ink Evaluation System. The dimensions are hue error (circumferentially) and grayness (radially). Color masking, color gamut, and ink trapping may be determined from the diagram by using simple geometric techniques. See *Preucil Ink Evaluation System, color circle*.

**continuous tone**    Variation of density within a photographic or printed image, corresponding to the graduated range of lightness or darkness in the original copy or scene. Sometimes referred to as *contone*.

**contone**    See *continuous tone*.

**contrast**  Differences between light and dark tones, including the visual relationship of the tonal values within the picture in highlight, middletone, and/or shadow tones.

**copy**  Any material furnished for reproduction. For color printing it may be a color photograph (print or transparency), artist's drawing, or merchandise sample. Sometimes called *original copy*.

**cyan**  The subtractive transparent primary color that should reflect blue and green and absorb red light. One of the four process-color inks. Sometimes called *process blue*.

**densitometer**  An electronic instrument used to measure optical density. Reflection and transmission versions are available.

**density**  The ability of a material to absorb light. Expressed as the logarithm (base 10) of the opacity, which is the reciprocal of the transmission or reflection of a tone.

**desaturated color**  A color that appears faded, printed with too little ink, or as though white had been mixed with the colorant.

**diarylide yellow**  A strong organic pigment, frequently used in yellow process inks. Formerly *benzidine yellow*.

**diffuse highlight**  The lightest highlight area that carries important detail. Normally, these areas are reproduced with the smallest printed tone value.

**digital**  The use of discrete pulses or signals to represent data. In digital imaging systems, 256 steps are normally used to characterize the tone scale. Some color scanners use digital circuits.

**direct-screen color separation**  A system of producing color separation negatives or positives directly from the original. Each film is color separated and screened in one step.

**$D_{max}$**  Maximum density that can be achieved in a given photographic or photomechanical system.

**$D_{min}$**  Minimum density that can be achieved in a given photographic or photomechanical system.

**doctor blade**    A metal blade or knife (used in the gravure process) that removes ink from the surface of the gravure cylinder, leaving ink only in the recessed cells. A doctor blade is also used on some flexographic presses to remove ink from the surface of the anilox roll.

**dot area**    The proportion of a given area which is occupied by halftone dots. Usually expressed as a percentage.

**dot etching**    A manual technique for chemically changing the dot size on halftone films, for purposes of color correction or adjustment of individual areas. Similar techniques can be used for adjusting continuous-tone images on film or areas on metal relief or intaglio image carriers. Can be localized or general.

**dot gain**    The change in size of a printing dot from the film to the press sheet. Usually expressed as an additive percentage. For example, an increase in dot size from 50% to 60% is called a 10% gain. Dot gain has a physical component—the gain in the dot area—and an optical component—the darkening of the white paper around the dot caused by light scatter within the substrate.

**double overlay masking**    See *two-stage masking*.

**doubling**    A printing defect in halftone imaging processes that appears as a faint second image slightly out of register with the primary image.

**drum scanner**    A color scanner on which the original is wrapped around a rotary scanning drum. See *scanner*.

**dry back**    The change in density of a printed ink film from wet to dry caused by the penetration of ink into the substrate.

**dry etching**    A technique for creating selective or overall change in dot areas by manipulating contact printing exposures onto photographic material.

**ductor roller**    On an offset press, the transfer roller that carries the ink from the fountain to the roller train.

**dupe**    See *color duplicating*.

**duplicate transparency**

A transparency created by *color duplicating.*

**dye**

A soluble coloring material, normally used as the colorant in color photographs.

**dye transfer**

A method of producing color prints, first involving the making of red-, green-, and blue-filter separation negatives, and then the subsequent transfer of yellow, magenta, and cyan images from dyed matrices.

**editorial changes**

Modifications requested by the customer to change a particular color in the reproduction so it is unlike the original.

**electronic color correction**

The process of correcting color on a color scanner or similar electronic imaging system.

**electronic masking**

A simulation of photographic color correction masking by the circuits of a color scanner. Area drop-out masks are also made by electronic methods.

**electronic planimeter**

A device used for the visual and mathematical evaluation of dot area. The equipment includes a microscope, a television camera and receiver, and a small computer.

**elliptical dot screen**

Halftone screen with an elliptical dot structure. Designed to avoid the sudden jump between midtone densities where the corners of square dots join. Elliptical dot screens help to reduce image graininess.

**feedback control chart**

An image produced on a printing press that supplies information to the color separation department for producing color separation films. Gray balance charts, color charts, and color reproduction guides are examples of feedback control charts.

**filter**

A transparent material characterized by its selective absorption of light of certain wavelengths. Used to separate the red, green, and blue components of an original when making color separation films.

**first-surface reflection**

Light scattering from the surface of a printed ink film.

**five- and six-color printing**
A photomechanical variant of the subtractive color reproduction process that uses additional chromatic colors such as pink, light blue, or red in addition to colors similar to the process primaries. It expands the color gamut but is rarely used.

**flatbed scanner**
A color scanner on which the original is mounted on a flat scanning table. See *scanner*.

**flat color**
A solid or tint area devoid of tonal variation. The color may be achieved by the use of overlapping halftone tints, a special ink mixture, or a single halftone tint. See *screen tint*.

**flat etch**
A chemical technique to change the size of the dots over the entire halftone film image.

**fluorescence**
The emission of light following the absorption of light of a shorter wavelength. Added to the light reflected by the color in the normal way, fluorescence gives an extra brightness. Often occurs through the conversion of ultraviolet radiation into visible radiation. Can occur in printing inks, papers, or original photographs, artwork, or retouching dyes and pigments.

**Foss Color Order System**
A printed color chart that features color order, visually equal tone spacing, compact design, and full-range black treatment.

**fountain blade**
On an offset press, the strip of flexible steel that forms the bottom of the ink fountain. The fountain roller forms the other side of the ink trough. Moving the blade closer to or farther away from the fountain roller controls the thickness of the ink film across the roller.

**four-color printing**
A subtractive color reproduction process that uses yellow, magenta, cyan, and black colorants.

**full-scale black**
A black printer that will print in all tonal areas of the reproduction from the highlight to the shadow.

**gamma**
The ratio of the density range of a negative to the density range of the original. Also, the ratio of the density range of the reproduction to the density range of the original. A gamma of 1.0 means that the tones in the reproduction show the same separation as those in the original.

**gloss** Physical characteristic of a surface. A high gloss is suggestive of a polished surface that has the effect of reducing first-surface reflections and increasing the density range of the image.

**grain** Silver salts clumped together in differing amounts in different types of emulsions. Generally speaking, faster emulsions have larger grain sizes.

**graininess** Visual impression of the irregularly distributed silver grain clumps in a photographic image, or the ink film in a printed image.

**gray balance** The values for the yellow, magenta, and cyan that are needed to produce a neutral gray when printed at a normal density. When gray balance is achieved, the separations are said to have correct color balance. Gray balance is determined through the use of a gray balance chart. See *color balance*.

**gray balance chart** A printed image consisting of near neutral grid patterns of yellow, magenta, and cyan dot values. A halftone black gray scale is used as a reference to find the three-color neutral areas. The dot values making up these areas represent the gray balance requirements of the color separations. The gray balance chart should be produced under normal plant printing conditions. See *gray balance*.

**gray component replacement** The process of reducing the smallest halftone dot in areas where yellow, magenta, and cyan all print, together with quantities of the other two colors sufficient to produce a neutral gray, and replacing that neutral with black ink.

**gray scale** An image containing a series of tones stepped from white to black that is used for monitoring tone reproduction. A gray scale is a photographic image in either transparent or reflective form. Sometimes called a *step wedge* or *step tablet*.

**gray wedge** An image that varies continuously from white to black that is used for monitoring tone reproduction. It is a form of gray scale but does not have discrete tone steps. Often used for color scanner setup.

**grayness**  In the Preucil Ink Evaluation System, the lowest of the three (red, green, and blue) densities expressed as a percentage of the highest.

$$\text{Percentage grayness} = \frac{L}{H} \times 100.$$

**halftone**  Image in which the range of tones consists of dots of varying area but of uniform density. Creates the illusion of continuous tone when seen at a distance. The normal imaging technique for reproducing tones by lithography, letterpress, flexography, and screen printing.

**halftone tint**  An area covered with a uniform halftone dot size to produce an even tone or color. Also called *tint* or *screen tint*.

**hard copy**  A tangible image such as an original, a proof, or a printed sheet.

**Hering theory**  A theory of color vision proposed during the nineteenth century by the German physiologist and psychologist Ewald Hering. Hering regarded yellow and blue, red and green, and black and white as pairs of opponent colors, where one member of each pair is perceived at a time.

**high key**  A photographic or printed image in which the main interest area lies in the highlight end of the scale.

**highlight mask**  Generally, a light negative image that is registered with a normal density continuous-tone negative for the purpose of enhancing highlight tone contrast.

**highlights**  The lightest areas in a reproduction. See *diffuse highlight* and *specular highlight*.

**hue**  Quality or sensation according to which differences of wavelength of radiant energy, such as blue, green, yellow, and red, are visually perceived.

**hue error**  In the Preucil Ink Evaluation System, the amount of the largest unwanted absorption of a process ink, expressed as a percentage of the wanted absorption content. Red-, green-, and blue-filter densitometer readings are made of a given color and

used to compute the hue error with the following equation:

$$\text{Percentage hue error } = \frac{M - L}{H - L} \times 100$$

where H = the highest density reading, M = the middle, L = the lowest. The term is used to indicate departure from the ideal hue for a process ink.

**Hurvich-Jameson Theory**   See *opponent-process model.*

**indirect color separation**   The making of halftone screen negatives or positives from continuous-tone separation positives or negatives. Two steps are used, one for separation of color values, the other for the screening of tone values.

**ink film thickness**   Thickness of an ink film printed on a substrate. There is no simple relationship between this term and density, although the two are related.

**ink trap**   See *trapping.*

**integral tripack**   Photographic film or paper with three main emulsion layers coated on the same base. Each layer is sensitive to one primary color of light. During processing, a subtractive primary color dye image is formed in each layer.

**intensity**   Synonym for *color saturation.*

**interimage reflection**   The passage of light between layers of ink and the substrate. Can contribute to additivity failure and other printed image characteristics.

**Jones diagram**   A graph that presents steps in objective tone reproduction from the original to the separation negatives and the printed sheet. The relevant information at each stage is linked to the next by plotting the graphs on a quadrant in such a way that the influence of each successive step is displayed. Named after its inventor, Lloyd Jones.

**joystick**   An input device for an electronic color imaging system. The amount and direction of travel will alter the image qualities in some predetermined manner.

| | |
|---|---|
| **Kelvin (K)** | Unit of temperature measurement starting from absolute zero, which is equivalent to $-273°$ Celsius. Used to indicate the color balance of a light source. |
| **key** | **1.** In photography, the emphasis on lighter or darker tones in a print; high key indicates prevalence of light tones; low key, prevalence of dark tones. <br> **2.** See *black*. |
| **light pen** | An input device used in conjunction with a video display. The pen is touched to the display screen to identify the point to be processed. |
| **lightness** | Property that distinguishes white from gray or black, and light from dark color tones. |
| **lightness/dot gain trade-off** | The attempted balance of minimal dot gain and optimum image density by adjusting ink film thickness. Thin ink films will produce low dot gain along with light solids. Thick ink films will produce darker solids along with increased dot gain. |
| **lithol rubine** | A reddish pigment used for making magenta inks. This pigment has relatively poor blue-light reflection. |
| **look-up table** | A table, stored in computer memory, that contains the dot sizes needed to reproduce given colors. The processed input signals of certain color scanners are used to search the table to find the values that will produce the color represented by the signals. |
| **low key** | A photographic or printed image in which the main interest area lies in the shadow end of the scale. |
| **lux** | Metric unit of illumination. |
| **magenta** | The subtractive transparent primary color that should reflect blue and red and absorb green light. One of the four process-color inks. Sometimes called *process red*. |
| **masking** | The process of making light photographic images, called masks, from the original or a photographic image, for the purpose of color correction, contrast reduction, tonal adjustment, or detail enhancement. See *two-stage masking, single-stage masking, unsharp masking, highlight masking, electronic masking*. |

**masking equations**   A set of linear formulas used to determine the mask strength required for color correction. They are based on the unwanted absorptions of the colorants and assume perfect additivity and proportionality.

**masstone**   Color of ink in mass. Often differs from the printed color of the ink.

**matte**   A dull surface that scatters the specular component of light, thus causing the underlying tone to appear lighter. Lacking gloss or luster.

**Maxwell Triangle**   Equilateral color triangle devised by James Clerk Maxwell in 1851 to show the composition of the ranges of colors produced by additive mixtures of red, green, and blue light.

**mechanical dot gain**   See *dot gain*.

**metameric color**   A color that changes hue under different illumination. If two colors match under one illuminant but differ under another, their spectrophotometric curves are different.

**metamerism**   The process where a change in illuminant will cause visual shift in a metameric color.

**metamers**   Colors that are spectrally different but visually identical for a specified viewing condition.

**midtones or middletones**   The tonal range between highlights and shadows.

**modeling**   The apparent detail in a picture that shows an article has surface texture or relief, such as the surface of an orange.

**moiré**   An interference pattern caused by the out-of-register overlap of two or more regular patterns such as dots or lines. In process-color printing, screen angles are selected to minimize this pattern. If the angles are not correct, an objectionable effect may be produced.

**mottle**   Uneven color or tone.

**Munsell System**  A method of classifying surface color in a solid. The vertical dimension is called value, the circumferential dimension is called hue, and the radial dimension is called chroma. The colors in the collection are spaced at subjectively equal visual distances.

**Murray-Davies Equation**  A formula for calculating printed dot area based on densitometer measurements. The resulting calculations are for total dot area, including the optical and physical aspects. See *Yule-Nielsen Equation*.

**nanometer**  Unit of wavelength of electromagnetic radiation. Equivalent to $10^{-9}$ meters. Visible light wavelengths range from 400–700 nanometers.

**Neugebauer Equations**  A set of linear equations used for calculating tristimulus values of halftone color mixture combinations, when the dot areas of the contributing colors are known.

**neutral**  Any color that has no hue, such as white, gray, or black.

**nonreproducible colors**  Colors in an original scene or photograph that are impossible to reproduce using a given set of colorants, because they are outside the gamut of the system. See *color gamut*.

**normal key**  Photographic copy in which the main interest area is in the middletone range of the tone scale or distributed throughout the entire tone range.

**off-press proofing**  See *prepress proofing*.

**OK sheet**  An approved press sheet that is intended for use as a quality guide for the rest of the production run.

**opacity**  Describes a material's lack of transparency. In photography, it is defined as the reciprocal of the fraction of light transmitted through, or reflected from, a given tone. For printing ink, it is defined as the ink's ability to hide or cover up the image or tone over which it is applied.

**opponent-process model**  A theory of color vision that has been refined by Leo M. Hurvich and Dorothea Jameson. The theory assumes the

existence of long, medium, and short wavelength cone receivers linked to cells that process stimuli in an opponent manner. It contains elements of the Young-Helmholtz and Hering theories.

**optical density**  The light-stopping ability of a photographic or printed image expressed as the logarithm of its opacity, which in turn is the reciprocal of the reflection or transmission.

**optical dot gain**  See *dot gain.*

**optimum color reproduction**  A reproduction that represents the best compromise within the capabilities of a given printing system.

**original**  A photograph, artist's drawing, or merchandise sample submitted for reproduction by the photomechanical process. Sometimes called *original copy.*

**Ostwald System**  A system of arranging colors in a color solid. The colors are described in terms of color content, white content, and black content. The solid appears as two cones, base to base, with the hues around the base, and with white at one apex and black at the other.

**overprint color**  A color made by overprinting any two of the primary yellow, magenta, and cyan process inks to form red, green, and blue secondary colors.

**Pantone Matching System**  A system of solid ink color mixing, based on eight colors plus white and black. Not to be used for the specification of process dot percentage combinations. Mixed colors were referred to as PMS colors. The term PMS is no longer used by Pantone.

**pastel colors**  Soft or light colors usually in the highlight to midtone range.

**peaking**  An electronic edge enhancement effect that produces the appearance of increased image sharpness.

**photomultiplier**  Highly sensitive form of photocell for transforming variations in light into electric currents. Used in many color scanners for creating the input signals to the computing circuits.

**phthalocyanine**    A pigment available in a green shade or blue shade. A combination of the two is often used to create the cyan ink for process-color printing.

**pigment**    An insoluble coloring material in finely divided form. Usually the colorant in printing inks.

**pixel**    Picture element. The smallest tonal element in a digital imaging or display system.

**premask**    An auxiliary mask used in the two-stage masking system to obtain color-correcting masks without contrast-reducing aspects. See *two-stage masking*.

**prepress proof**    A color proof made directly from electronic data or film images.

**press proof**    A color proof produced on either a regular printing press or a special proof press.

**Preucil Ink Evaluation System**    A color evaluation system developed by Frank M. Preucil. A reflection densitometer is used to measure a printed ink film through Wratten #25, #58, and #47 filters relative to the substrate. These measurements are converted into hue error and grayness parameters for plotting on color diagrams. See *hue error, grayness, color circle, color triangle*.

**primary colors**    Colors that can be used to generate secondary colors. For the additive system, these colors are red, green, and blue. For the subtractive system, these colors are yellow, magenta, and cyan.

**process blue**    See *cyan*.

**process-color reproduction**    A printed color reproduction using the three process inks or the three process inks and black.

**process-ink gamut chart**    A color chart for comparing the gamut or color limits that can be produced from any given ink set and substrate combination.

**process inks**    A set of transparent yellow, magenta, and cyan inks used for full-color printing. A black ink is also included in a four-color process ink set.

**process red** See *magenta*.

**progressive proof** A set of press proofs that includes the individual colors, interspersed with overprints of the two-, three-, and four-color combinations in their order of printing. The proofs are used by printers on single-color presses as an aid when printing process-color work.

**proof** A prototype of the printed job that is made from plates (press proof), film, or electronic data (prepress proofs). It is generally used for customer inspection and approval before mass production begins. See *press proof, prepress proof, color proof.*

**proportionality failure** A common condition in halftone color printing where the ratio of red- to green- to blue-light reflectance in halftone tints is not the same as that in continuous ink solids.

**purity** A synonym for saturation.

**quality** When applied to printed images, it could mean: (1) the aesthetic aspect, influenced largely by the creativity and knowledge of the designer; (2) the technical aspect, the way the original is processed through the photomechanical system; (3) the consistency of the printed image.

**random proof** See *scatter proof.*

**real-time** Computing at a speed that can produce results without a noticeable delay.

**reflection copy** An opaque original, photographed using reflected light.

**reflex blue** Used as a toner in black inks to neutralize the brownish tinge of carbon black pigments.

**resolution** The ability to separate adjacent small details either visually, photographically, or photomechanically.

**retouching** The art of making selective manual or electronic corrections to images.

**rhodamine** A bluish red pigment used for making magenta ink. The Y or yellow shade of the pigment is normally selected. Has the best blue-light reflectance of the commonly used magenta pigments.

**rosettes**      The patterns formed when halftone color images are printed in register at the correct angles.

**rotation**      See *color sequence.*

**rubine magenta**      See *lithol rubine.*

**saturation**      The dimension of color that refers to a scale of perceptions representing a color's degree of departure from an achromatic color of the same brightness. The less gray a color contains, the more saturated it is.

**scanner**      A color separation device that electronically processes images point by point through circuits that color correct, manipulate tones, and enhance detail.

**scatter proof**      Generally a press proof, containing many images placed randomly on the substrate. Also called a *random proof.*

**screen angle**      The angle at which the rulings of a halftone screen are set when making screened images for halftone process-color printing.

**screen ruling**      The number of lines per inch, in each direction, on a halftone screen.

**screen tint**      A halftone screen pattern of all the same dot size that creates an even tone.

**secondary colors**      Colors that are produced by overprinting pairs of the primary subtractive colors. The subtractive secondary colors are red, green, and blue. Same as *overprint colors.*

**sensitivity guide**      A narrow, calibrated continuous-tone gray scale with each tone scale numbered.

**separation films**      Three photographic negative or positive images recording the red, green, and blue components of the colors of the original. A fourth image is usually produced through all three filters for the black printer.

**separation filters**      Red, green, and blue filters each transmitting about one-third of the spectrum and used when making color separations.

**setoff**            The undesirable transfer of wet ink to the following sheet in the delivery pile.

**shadow mask**       Generally a light positive image that is registered with a normal density continuous-tone positive for the purpose of enhancing shadow tone contrast.

**shadows**           The darkest areas in a reproduction.

**sharpness**         The subjective impression of the density difference between two tones at their boundary.

**shoulder**          The upper, convex end of the characteristic curve of a photographic emulsion where equal log exposure increases show decreasing density differences as its slope gradually diminishes to zero.

**single-stage masking**  A process where a light photographic image that has been produced through one filter is registered with an image that has been produced with a different filter for the purpose of correcting for the unwanted absorptions of the printing inks. The process also reduces contrast of the masked image.

**skeleton black**    A black printer that will print only the darker half of the gray scale from the middletones to the shadow areas.

**slur**              A directional dot distortion effect that can occur in halftone printing. A round dot would appear elliptical in shape.

**soft copy**         An image on a video display terminal.

**spectral response** The manner in which the eye responds to visible radiation. Often used to describe how the light-sensitive component (photomultiplier or film) in a color separation system responds to visible and invisible radiation.

**spectro-photometer** An instrument for measuring the relative intensity of radiation throughout the spectrum that is reflected or transmitted by a sample.

**spectro-photometric curve** A graph showing the reflectance or transmittance of a sample as a function of wavelength.

**specular highlight**    The lightest highlight area that does not carry any detail, such as reflections from glass or polished metal. Normally, these areas are reproduced as unprinted white paper.

**spot color**    Localized nonprocess ink color. May be printed as a supplemental color.

**staging**    The process of applying protective lacquer or varnish to a negative or positive image in preparation for selective dot etching. Can cause staging lines, especially when applied in areas of soft-focus detail.

**standard inks**    A set of process inks made to the color specifications of a standards-setting organization. Common in the publications industry for proofing advertising reproductions, but otherwise uncommon.

**standard viewing conditions**    A prescribed set of conditions under which the viewing of originals and reproductions are to take place, defining both the geometry of the illumination and the spectral power distribution of the illuminant. For the graphic arts, the standard specifies 5,000 K color temperature, 90 color-rendering index, transparent gray surround with transparencies, and viewing at an angle to reduce glare.

**star target**    A circular test image containing alternating light and dark wedge shapes that meet at a point in the center of the target. A common target for monitoring dot gain, slur, and doubling on press. Also used for evaluating resolution of a given photographic or photomechanical system.

**step wedge or step tablet**    See *gray scale*.

**straight line**    Region of constant slope of the characteristic curve of a photographic emulsion where density is directly proportional to the logarithm of exposure.

**substrate**    The paper or any other generally flat material upon which an image is printed.

**subtractive color process**   A means of producing a color reproduction or image by combinations of yellow, magenta, and cyan colorants on a white substrate.

**subtractive primaries**   Yellow, magenta, and cyan dyes or pigments, at least two of which must be transparent. When combined in various intensities or areas (dots), they can produce any other color.

**superadditivity**   The opposite of additivity failure. Occurs when the total density of overprinted ink films exceeds the sum of the ink densities.

**tack**   The resistance to splitting of an ink film between two separating surfaces, i.e., stickiness. To improve trapping in wet-on-wet printing, the ink being printed should have a lower tack than the ink that was printed before it.

**texture**   1. A property of the surface of the substrate.
2. Variation in tonal values to form image detail. See *modeling*.

**three-color patch**   The combination of solid yellow, magenta, and cyan areas on a color control strip. This color will normally appear slightly brown.

**tinctorial strength**   The concentration of colorant in a printing ink.

**tint**   1. A halftone area that contains dots of uniform size, that is, no modeling or texture.
2. The mixture of a color with white.

**toe**   The lower, concave end of the characteristic curve of a photographic emulsion where exposures are not recorded as proportional densities.

**tone**   Any variation in lightness or saturation while hue remains constant.

**tone reproduction**   A term that relates the density of every reproduced tone to the corresponding original density. This may be facilitated by the use of graphical techniques.

**toner**   Pigments that are added to printing inks as supplemental colors, used to get greater tinctorial strength.

**transmission copy**    An original that must be viewed by transmitted light.

**transparency**    See *transmission copy, chrome.*

**transparent ink**    An ink that contains a vehicle and a pigment with the same refractive index. Excluding the selective color absorption, these inks will allow light to be transmitted through them without loss. See *opacity.*

**trapping**    The ability of an ink to transfer equally to unprinted substrate and a previously printed ink film. Apparent trap is measured via the equation:

$$\frac{D_{op} - D_1}{D_2} \times 100$$

where $D_1$ = the density of the first-down color, $D_2$ = the density of the second-down color, and $D_{op}$ = the density of the overprint, all measured through the filter complementary to the second-down color.

**tristimulus colors**    Three color stimuli that, when used in appropriate proportions, will closely match any given color. In practice, red, green, and blue lights are used. Their composition may range from monochromatic spectral lines to bands of wavelengths, each of which comprises about one-third of the visible spectrum.

**two-stage masking**    A color correction process. A full-range positive premask is made from one separation negative and combined with another separation negative for the purposes of making a final mask that, when returned to the first negative, will correct for some of the unwanted ink absorptions without lowering contrast. A total of three premasks and three final masks are usually made. Usually called the *Double Overlay Method* in Australia and Britain.

**ultraviolet**    Invisible, electromagnetic radiation of a shorter wavelength (10–400 nm) than blue. Can create fluorescence effects with the appropriate materials.

**undercolor removal (UCR)**    A technique used to reduce the yellow, magenta, and cyan dot percentages in neutral tones and replacing them with increased amounts of black ink.

**undertone**      Color of ink printed in a thin film.

**unsharp masking**      A light transparent photographic image that is deliberately unsharp. The mask is combined with the sharp image from which it was made, thus enhancing the sharpness of subsequent images made from the combination.

**unwanted colors**      Colors that should not be in three of the patches of a Color Reproduction Guide; for example, yellow in cyan, blue, and magenta. Sometimes called *white colors.*

**value**      Term used in the Munsell System to describe lightness.

**viewing conditions**      See *standard viewing conditions.*

**wanted colors**      Colors that should be in three of the patches of a Color Reproduction Guide; for example, yellow in red, yellow, and green. Sometimes called *black colors.*

**wavelength**      Quantitative specification of kinds of radiant energy.

**white**      **1.** The presence of all colors.
**2.** The visual perception produced by light of relatively high overall intensity and having the same relative intensity of each wavelength in the visible range that sunlight has.

**white colors**      See *unwanted colors.*

**Wratten filters**      Comprehensive range of photographic filters manufactured by Eastman Kodak Company.

**xenon lamp**      A powerful light source used for camera illumination, color scanning, and in some optical radiation measuring instruments.

**yellow**      The subtractive transparent primary color that should reflect red and green, and absorb blue light. One of the four process-color inks.

**Young-Helmholtz Theory**      The theory of color vision proposed by Thomas Young in the early nineteenth century that our judgments of color are based on the functioning of three kinds of receptors in the eye, each

having peak sensitivities in the red, green, and blue parts of the spectrum, respectively. H. L. F. von Helmholtz elaborated on this theory.

**Yule-Nielsen Equation**     A modification of the Murray-Davies Equation to compensate for light scatter within a substrate when measuring printed dot area. This equation calculates the physical dot area.

**zone theory**     See *opponent-process model*.

**zooming**     The process of electronically enlarging an image on a video display terminal to facilitate electronic retouching.

# Bibliography

The general reading guide that follows is intended for the guidance of those persons wishing to undertake further studies of color and its reproduction. Where appropriate, a distinction is drawn between elementary and more advanced sources.

A listing of specific references that are related to the subject matter of each chapter are included under the chapter headings at the end of this section.

**History of Color Reproduction**

Sipley's book *A Half Century of Color* is the best general reference to the history of color reproduction. It is well illustrated, with many illustrations appearing in color. The early issues of *The Penrose Annual* (from 1895) present an interesting view of the year-to-year development in color reproduction. The progress in pigment technology becomes obvious when a comparison is made between the reproductions in the early *Penrose Annuals* and those of today.

**Color Theory— Introductory**

Elementary texts on color include *Light and Color* by Clarence Rainwater, Golden Press; *Color as Seen and Photographed* by Eastman Kodak Company; *Pocket Guide to Color Reproduction* by Miles Southworth, Graphic Arts Publishing Company; *Color Primer I* and *II* by Richard Zakia and Hollis Todd, Morgan and Morgan, Inc.

More advanced texts, but still introductory in nature, are *The Enjoyment and Use of Color* by Walter Sargent, Dover Publications; *Colour* by Hazel Rossotti, Penguin Books; *An Introduction to Color* by Ralph Evans, Wiley; *Color Observed* by Enid Verity, Van Nostrand Reinhold; *Color: Essence and Logic* by Rolf Kuehni, Van Nostrand Reinhold. A large-format, well-illustrated general reference on color is titled *Color,* edited by Helen Varley and published by the Knapp Press.

**Color and Color Reproduction— Theoretical Aspects**

The classic work on the theory of color reproduction is *The Principles of Color Reproduction* by John Yule, published by Wiley in 1967 but still the standard reference. *The Reproduction of Colour* by Robert Hunt was published in its third edition by Fountain Press in 1975. This latter text covers photography and television as well as printing, but much of the theory is relevant to all processes. The proceedings of the 1971 ISCC conference, *The Optimum Reproduction of Color,* remains the major reference source on this topic.

A more general reference on color theory is *Color in Business, Science, and Industry* by Deane Judd and Gunter Wyszecki, the third edition of which was published by Wiley in 1975. *The*

*Science of Color,* published by The Optical Society of America, is also an excellent general color theory reference that is quite technical. For theoretical discussion of color vision theory, *Color Vision* by Leo Hurvich, published in 1981 by Sinauer Associates, is the most up to date.

There are no general theoretical treatments of the printing processes. Most theoretical aspects of printing are published in professional journals such as the *Proceedings of the Technical Association of the Graphic Arts,* published annually by TAGA, and *Professional Printer,* published by the Institute of Printing. The reports of GATF, Pira, and other research institutes discuss advances in printing theory. Occasional papers on graphic arts color reproduction are also published in the journals of the Society of Photographic Scientists and Engineers, the Royal Photographic Society, and the Optical Society of America. The journal *Color Research and Application* is a major source of theoretical work on color. The biannual proceedings of the International Association of Research Institutes for the Graphic Arts Industry are also a major source of theoretical papers on the printing processes.

**Color Reproduction— Practical Aspects**

Good background references for the practical aspect of the printing processes and graphic arts color reproduction are *The Lithographers Manual,* edited by Raymond Blair and published by GATF; *The Printing Industry* by Victor Strauss, published (in 1967, hence a little dated) by the Printing Industries of America; *The Technical Guide for the Gravure Industry,* revised by Oscar Smiel for the Gravure Technical Association in 1975; and *Flexography Principles and Practices,* published in a third edition by the Flexographic Technical Association in 1980.

Particular publications on aspects of graphic arts color reproduction can be grouped under the headings of graphic arts photography, proofing, and printing. The photography references include two books published by GATF—*Graphic Arts Photography: Black and White* by John Cogoli, and *Graphic Arts Photography: Color* by Fred Wentzel, et al.; *Color Separation Photography* by Miles Southworth and published by the Graphic Arts Publishing Company; and many publications of the graphic arts film manufacturers, specifically those of Eastman Kodak Company, E. I. du Pont de Nemours and Co., Inc., and Agfa-Gevaert N.V. An excellent book on this subject is *Graphic Reproduction Photography* by J. W. Burden, published by Hastings House.

A text entitled *Principles of Color Proofing* has been published by GAMA Communications. It is written by Michael Bruno and should prove to be the major reference to this aspect of color reproduction. It was not available for review at this writing.

Good, practical references for the materials used in color printing are published by GATF: *What the Printer Should Know about Paper* by William Bureau, and *What the Printer Should Know about Ink* by Terry Scarlett and Nelson Eldred. A more detailed guide to printing ink pigments may be found in *The Printing Ink Manual* edited by D. E. Bisset, et al., and published by Northwood Books.

The actual printing processes have few practical guidebooks. The exception is lithography. Here GATF has published *Web Offset Press Operating* by David Crouse, et al.; *The Lithographic Pressman's Handbook* by George Jorgensen and Abrahim Lavi; and *Lithographic Presswork* by A. S. Porter. Many research and technical reports published by GATF also deal with litho press operating and control. The printing quality control series by George Jorgensen are worth particular attention. For the screen printing process, a lengthy series of practical guides have been published by the Screen Printing Association International. The gravure process is covered by the *Gravure Bulletin*, published by GTA, and the flexographic process by *Flexo*, published by FTA. The trade press magazines also publish articles of practical interest on all processes.

The summaries of current articles in professional journals and the trade press are published in *Graphic Arts Abstracts* (GATF), *Graphic Arts Literature Abstracts* (RIT), and *Printing Abstracts* (Pira).

The most detailed specifications that have been published on the question of print quality acceptability levels are those of the Canadian Government Printing Office and the United States Government Printing Office. Some of these specifications deal with color printing quality (basically consistency), but they don't address the more general question of color reproduction quality.

A good general reference for the equipment, materials, and techniques of art and design is *The Artist's Manual*, edited by Stan Smith and H. F. T. Hold and published by Mayflower Books. *The Art of Colour Photography* by John Hedgecoe, published by Mitchell Beazley Publishers, presents a comprehensive coverage of color photography. Both of these books are illustrated in full color. Another reference

concerning art preparation is *The Graphic Designer's Handbook* by Alistair Campbell, published by Running Press.

The subject of color communication has not been addressed in any detail for the printing industry. However, the subjects of the psychology of color, the use of color, and human response to color has been addressed in more than twenty books written by Faber Birren, color consultant.

Most of the titles listed in this section are still in print. The out-of-print books listed are excellent reference sources. They can probably be located in most major libraries.

**Chapter 1**   Burch, R. M. *Colour Printing and Colour Printers.* Baker and Taylor Co., 1910 (Reprinted by Garland Publishing, Inc., New York, 1981).

*Color as Seen and Photographed.* Eastman Kodak, 1966.

Hunt, R. W. G. *The Reproduction of Colour.* Fountain Press, 1975.

Sipley, L. W. *A Half Century of Color.* New York: Macmillan Company, 1951.

*The Focal Encyclopedia of Photography.* Focal Press, 1965.

**Chapter 2**   Burnham, R. W., R. M. Hanes, and C. James Bartleson. *Color: A Guide to Basic Facts and Concepts.* New York: Wiley, 1963.

Evans, R. M. *An Introduction to Color.* New York: Wiley, 1948.

Hurvich, L. M. *Color Vision.* Sunderland, Mass.: Sinauer Associates, 1981.

*The Science of Color.* Washington, D.C.: Optical Society of America, 1963.

**Chapter 3**   Grum, Franc, and C. James Bartleson, eds. *Optical Radiation Measurements Vol. 2: Color Measurement.* New York: Academic Press, 1980.

Hesselgren, S. "Why Colour Order Systems?" *Color Research and Application* 9, no. 4 (Winter 1984): 220–228.

Judd, Deane B., and Gunter Wyszecki. *Color in Business, Science, and Industry*. 3d ed. New York: Wiley, 1975.

Kelly, Kenneth L., and Deane B. Judd. "The ISCC-NBS Method of Designating Colors and a Dictionary of Color Names." *National Bureau of Standards Circular 553*, 1955.

Varley, Helen, ed. *Color*. Los Angeles: The Knapp Press, 1980.

Wright W. D. "The Basic Concepts and Attributes of Colour Order Systems." *Color Research and Application* 9, no. 4 (Winter 1984): 229–233.

**Chapter 4**

Bureau, W. H. *What the Printer Should Know about Paper*. Pittsburgh, Pa.: Graphic Arts Technical Foundation, 1983.

Young, L. C. *Materials in Printing Processes*. London: Focal Press, 1973.

Yule, John A. C. *The Principles of Color Reproduction*. New York: John Wiley and Sons, 1967.

**Chapter 5**

Apfelberg, Herschel L. *Maintaining Printing Equipment*. Pittsburgh, Pa.: Graphic Arts Technical Foundation, 1985.

Biegeleisen, J. I. *The Complete Book of Silk Screen Printing Production*. New York: Dover Publications, 1983.

Blair, Raymond N., ed. *The Lithographers Manual*. 7th ed. Pittsburgh, Pa.: Graphic Arts Technical Foundation, 1983.

Crouse, David B., Edward J. Kelly, and Robert R. Supansic. *Web Offset Press Operating*. 2d ed. Pittsburgh, Pa.: Graphic Arts Technical Foundation, 1984.

Field, Gary G. "Color Sequence in Four-Color Printing." *TAGA Proceedings*. Rochester, New York: Technical Association of the Graphic Arts, 1983.

Flexographic Technical Association. *Flexography Principles and Practices*. 3d ed. Huntington Station, New York: FTA and the Foundation of Flexographic Technical Association, 1980.

Geis, A. John. "Sheetfed-Press Preventive Maintenance." *Technical Services Report* No. 7230. Pittsburgh, Pa.: Graphic Arts Technical Foundation, 1982.

Gravure Technical Association. *Technical Guide for the Gravure Industry.* 3d ed. New York, N.Y.: Gravure Technical Association, 1975.

Jorgensen, George W. "Control of Color on Press: Halftones." *Research Project Report* No. 119. Pittsburgh, Pa.: Graphic Arts Technical Foundation, 1984.

————"Control of Color on Press: Overprints." *Research Project Report* No. 118. Pittsburgh, Pa.: Graphic Arts Technical Foundation, 1983.

————"Control of Color on Press: Single Ink Film Layers." *Research Project Report* No. 115. Pittsburgh, Pa.: Graphic Arts Technical Foundation, 1982.

————"Control of Color Register." *Research Project Report* No. 114. Pittsburgh, Pa.: Graphic Arts Technical Foundation, 1982.

————"Control of Ink-Water Balance." *Research Project Report* No. 113. Pittsburgh, Pa.: Graphic Arts Technical Foundation, 1981.

Jorgensen, George W. and Abrahim Lavi. *Lithographic Pressman's Handbook.* 2d ed. Pittsburgh, Pa.: Graphic Arts Technical Foundation, 1977.

Levenson, Harvey R. "Preventive Quality Control: Sheetfed Pressroom." *Technical Services Report* No. 7212. Pittsburgh, Pa.: Graphic Arts Technical Foundation, 1971.

Porter, A. S. *Lithographic Presswork.* Pittsburgh, Pa.: Graphic Arts Technical Foundation, 1980.

Strauss, Victor. *The Printing Industry.* Washington, D.C.: Printing Industries of America, 1967.

**Chapter 6**　　Besterfield, Dale H. *Quality Control.* Englewood Cliffs, N.J.: Prentice-Hall, Inc., 1979.

Canadian Government Printing Office. *Print Quality Levels.* Rev. ed. Hull, Quebec, 1980.

Field, Gary G. "Using the Reflection Densitometer for Ink Film Control." *Research Project Report* No. 91. Pittsburgh, Pa.: Graphic Arts Technical Foundation, 1972.

Hull, Harry H. "Controlling Ink Distribution in Lithography and Letterpress." *Research Project Report* No. 95. Pittsburgh, Pa.: Graphic Arts Technical Foundation, 1972.

Jorgensen, George W. "Control of Color on Press: Single Ink Film Layers." *Research Project Report* No. 115. Pittsburgh, Pa.: Graphic Arts Technical Foundation, 1982.

United States Government Printing Office. "Quality Assurance through Attributes Program—Contract Terms." GPO Pub. 310.1. Rev. ed. Washington, D.C., 1981.

**Chapter 7**    Pearson, Milton, ed. "Optimum Color Reproduction" *Inter-Society Color Council Proceedings.* Rochester, N.Y.: Rochester Institute of Technology, 1971.

**Chapter 8**    Bureau, William H. *What the Printer Should Know about Paper.* Pittsburgh, Pa.: Graphic Arts Technical Foundation, 1983.

Field, Gary G., and George Jorgensen. *Test Images for Printing.* Pittsburgh, Pa.: Graphic Arts Technical Foundation, 1979, 1984.

Jorgensen, George W. "Control of Color on Press: Halftones." *Research Project Report* No. 119. Pittsburgh, Pa.: Graphic Arts Technical Foundation, 1984.

———"Control of Color on Press: Overprints." *Research Project Report* No. 118. Pittsburgh, Pa.: Graphic Arts Technical Foundation, 1983.

———"Control of Color on Press: Single Ink Film Layers." *Research Project Report* No. 115. Pittsburgh, Pa.: Graphic Arts Technical Foundation, 1982.

———"Control of Color Register." *Research Project Report* No. 114. Pittsburgh, Pa.: Graphic Arts Technical Foundation, 1982.

———"Control of Ink-Water Balance." *Research Project Report* No. 113. Pittsburgh, Pa.: Graphic Arts Technical Foundation, 1981.

Jorgensen, George, and Abrahim Lavi. *Lithographic Pressman's Handbook*. Pittsburgh, Pa.: Graphic Arts Technical Foundation, 1973.

National Printing Ink Research Institute (NPIRI) Ink Testing Standards.

Scarlett, Terry, and Nelson Eldred. *What the Printer Should Know about Ink*. Pittsburgh, Pa.: Graphic Arts Technical Foundation, 1984.

Technical Association of the Pulp and Paper Industry (TAPPI) Paper Testing Standards.

**Chapter 9**   *GTA Gravure Copy Preparation Guide*. New York, N.Y.: Gravure Technical Association, 1972.

*Kodak Color Films*. 8th ed. Rochester, N.Y.: Eastman Kodak Company, 1980.

*Photography and Layout for Reproduction*. Q–74. Rochester, N.Y.: Eastman Kodak Company, 1978.

Pritchard, E. J. "How to Select a Color Transparency for Graphic Reproduction." *Pira Self-Instruction Manual* No. 3. Leatherhead, Surrey: Printing Industry Research Association.

*Retouching Dye Transfer Prints*. E–92. Rochester, N.Y.: Eastman Kodak Company, 1983.

*Retouching Ektachrome Transparencies*. E–68. Rochester, N.Y.: Eastman Kodak Company, 1977.

*Retouching Ektacolor Prints*. E–70. Rochester, N.Y.: Eastman Kodak Company, 1981.

"Ultraviolet Absorption in Color Reproduction." *Color Notes* No. 4. Rochester, N.Y.: Eastman Kodak Company, 1980.

"Using Kodak Ektachrome and Kodachrome Film Transparencies on Color Scanners." *Color Notes* No. 5. Rochester, N.Y.: Eastman Kodak Company, 1980.

**Chapter 10**    Burden, James Walter. *Graphic Reproduction Photography.* New York: Hastings House, 1972.

Hunt, R. W. G. *The Reproduction of Colour.* 3d ed. England: Fountain Press, 1975.

Southworth, Miles. *Color Separation Techniques.* 2d ed. Livonia, N.Y.: Graphic Arts Publishing Company, 1979.

*The Color Separation Scanner.* Q–78. Rochester, N.Y.: Eastman Kodak Company, 1981.

Wentzel, Fred, Raymond Blair, and Tom Destree. *Graphic Arts Photography: Color.* Pittsburgh, Pa.: Graphic Arts Technical Foundation, 1983.

Yule, John A. C. *The Principles of Color Reproduction.* New York: Wiley, 1967.

**Chapter 11**    Bruno, Michael H. "A Color Proofing Update." *American Printer* (July 1985): 54–57, 97.

————*Principles of Color Proofing.* Salem, N.H.: GAMA Communications, 1986.

**Chapter 12**    Birren, Faber. *Color: A Survey in Words and Pictures.* New Hyde Park, N.Y.: University Books, 1963.

————*Color Psychology and Color Therapy.* Rev. ed. New Hyde Park, N.Y.: University Books, 1961.

Humphreys, N. "Quality Control in a Publishing Office." (the Hamlyn proof markup system) *Professional Printer* 17, no. 1 (January 1973): 28–29.

Maerz, A., and M. Rea Paul. *A Dictionary of Color.* New York: McGraw-Hill Book Company, 1930.

# Index

# About the Author

Gary G. Field, a professor in the Graphic Communication Department at California Polytechnic State University, teaches courses in color technology, quality control, and printing management. He also taught graphic technology courses to graphic arts management and graphic design students at Carnegie Mellon University for three years.

As a former head of the Color and Photo Research Division of the Graphic Arts Technical Foundation for six years, Mr. Field conducted various studies pertaining to color reproduction. He continues his association with the Foundation through various writing projects.

The author has nine years of industrial experience in such positions as camera department foreman and printing technologist in trade color separation plants, printing firms, and packaging companies in Australia and England.

Mr. Field's formal printing education includes an apprenticeship in lithographic camera operating and platemaking; the Higher Trade Certificate from the Melbourne College of Printing and Graphic Arts; and a diploma in Printing Technology from Trent Polytechnic, Nottingham. He also holds an MBA degree from the University of Pittsburgh.

A frequent contributing writer to professional societies, Mr. Field is a Fellow of the Institute of Printing, a Fellow of the Royal Photographic Society, and a member of the Technical Association of the Graphic Arts, the Inter-Society Color Council, and the City and Guilds of London Institute.